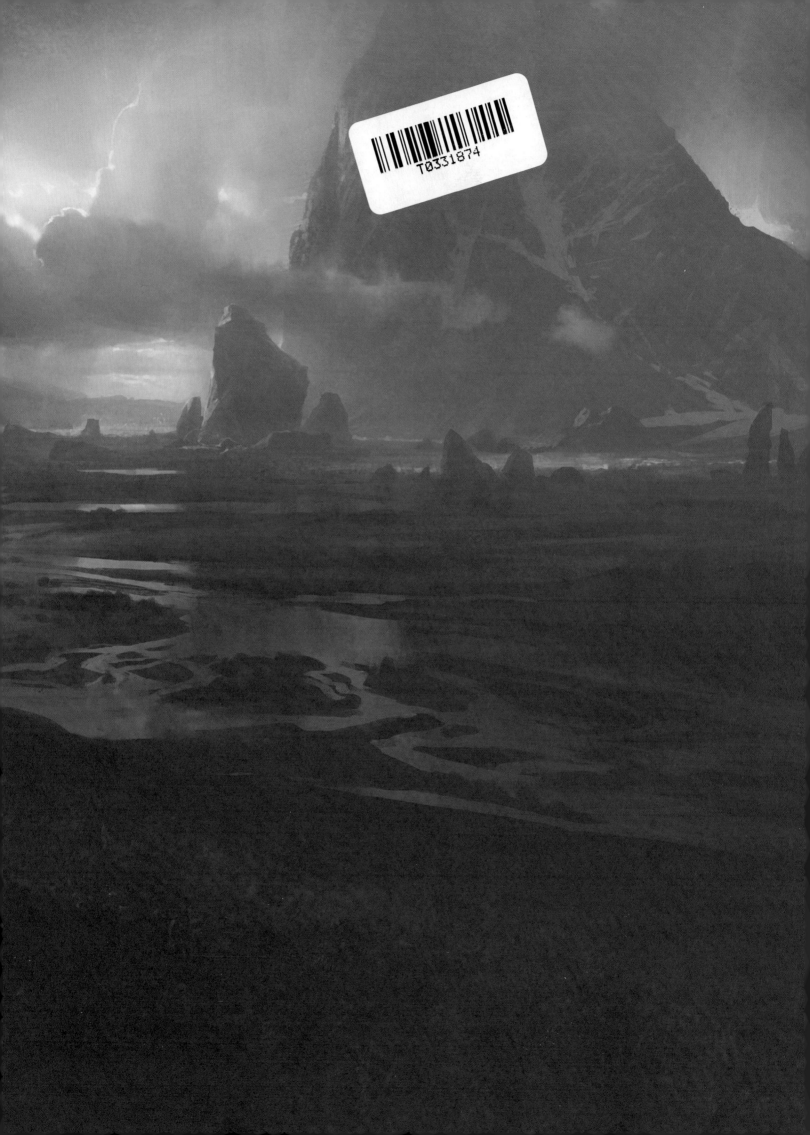

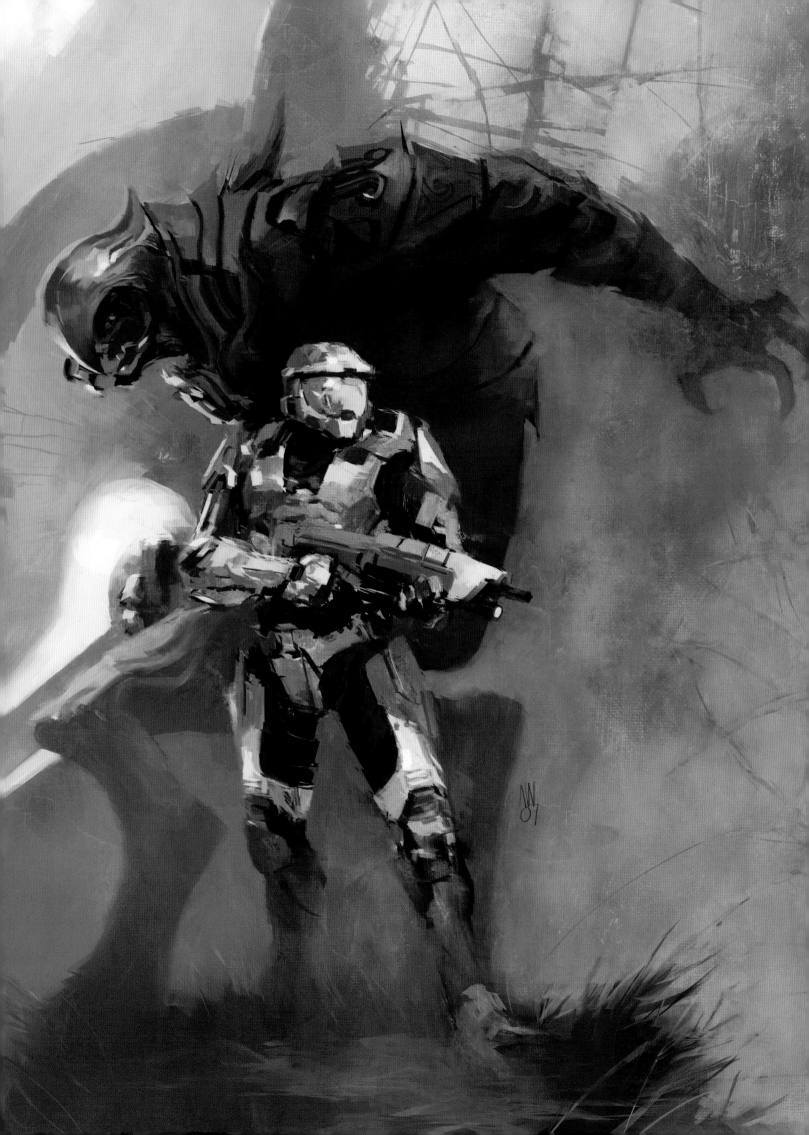

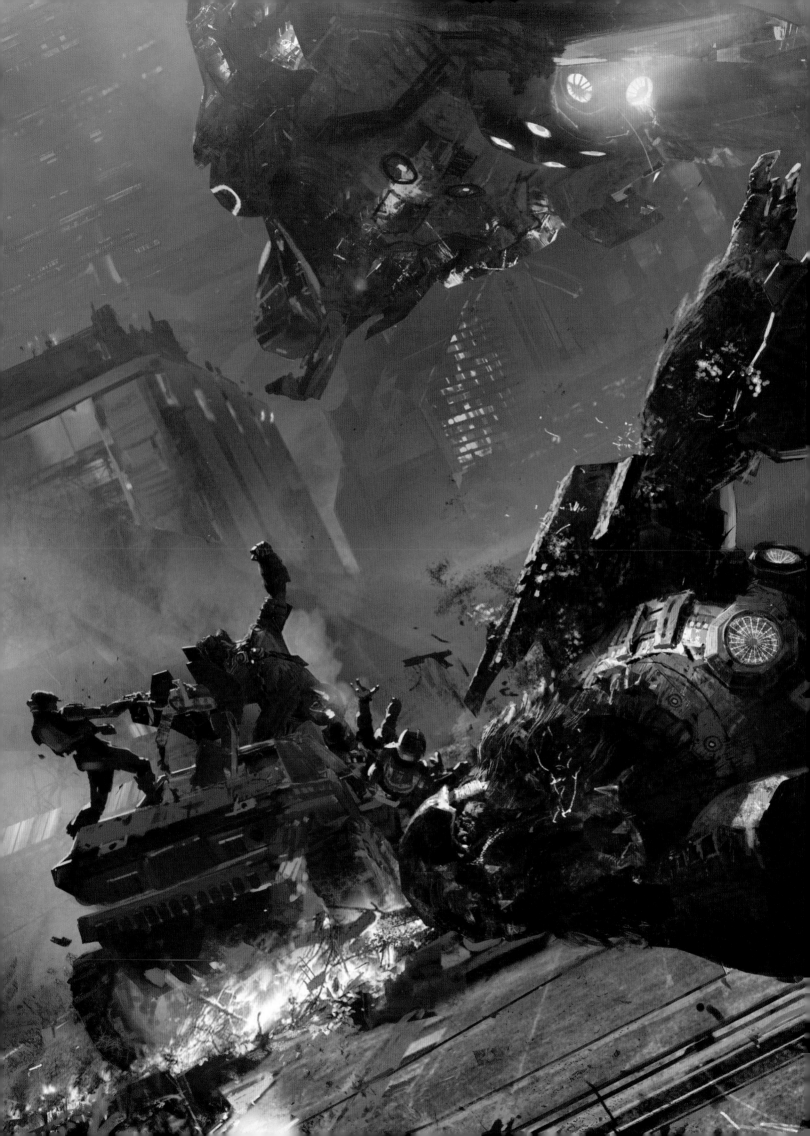

THE GREAT JOURNEY

# HALO®

## THE ART OF BUILDING WORLDS

MARTIN ROBINSON

FOREWORD BY
FRANK O'CONNOR

Titan Books

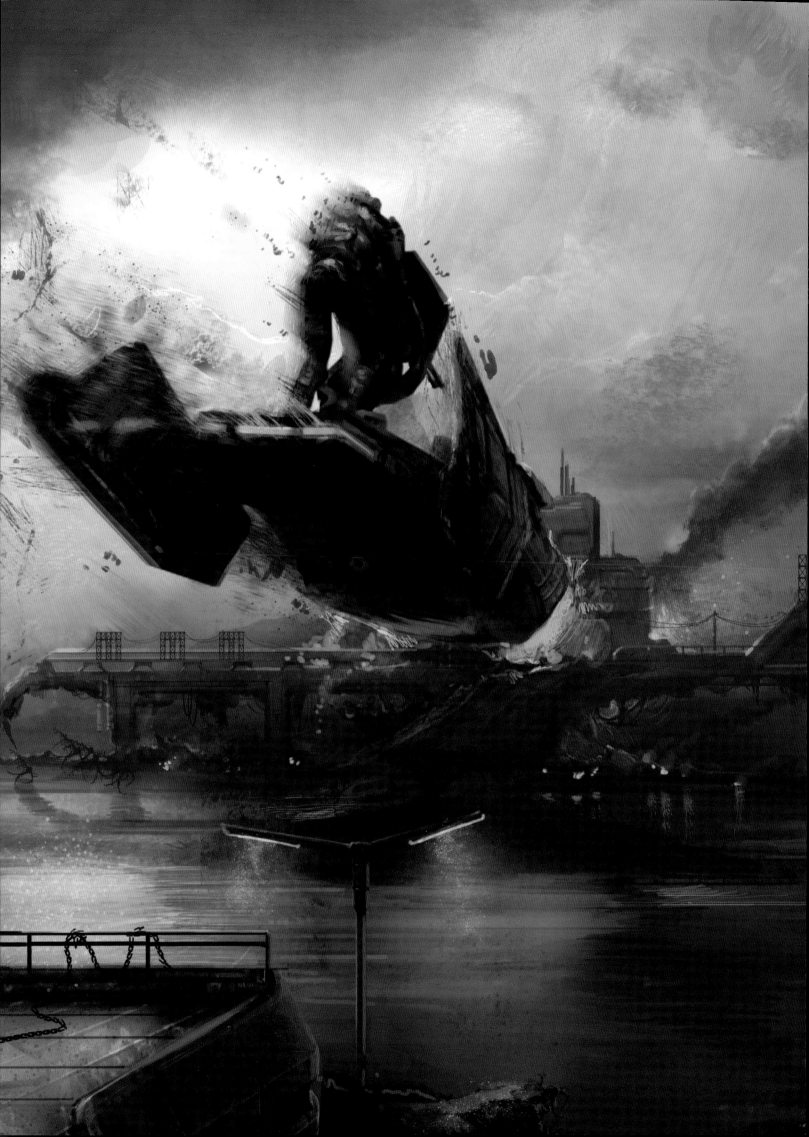

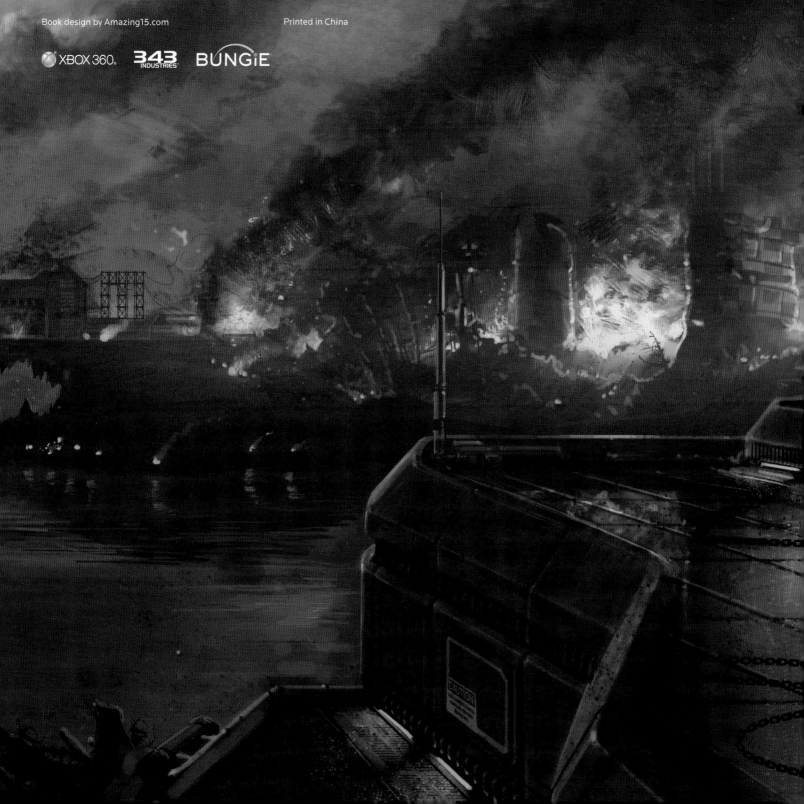

THE GREAT JOURNEY

# HALO

THE ART OF BUILDING WORLDS

ISBN: 9780857685629

Published by Titan Books
A division of Titan Publishing Group Ltd.
144 Southwark St.
London
SE1 0UP

First edition: October 2011
10 9 8 7

Book design by Amazing15.com

To receive advance information, news, competitions, and exclusive offers online,
please sign up for the Titan newsletter on our website: www.titanbooks.com

Did you enjoy this book? We love to hear from our readers. Please e-mail us at:
readerfeedback@titanemail.com or write to Reader Feedback at the above address.

# CONTENTS

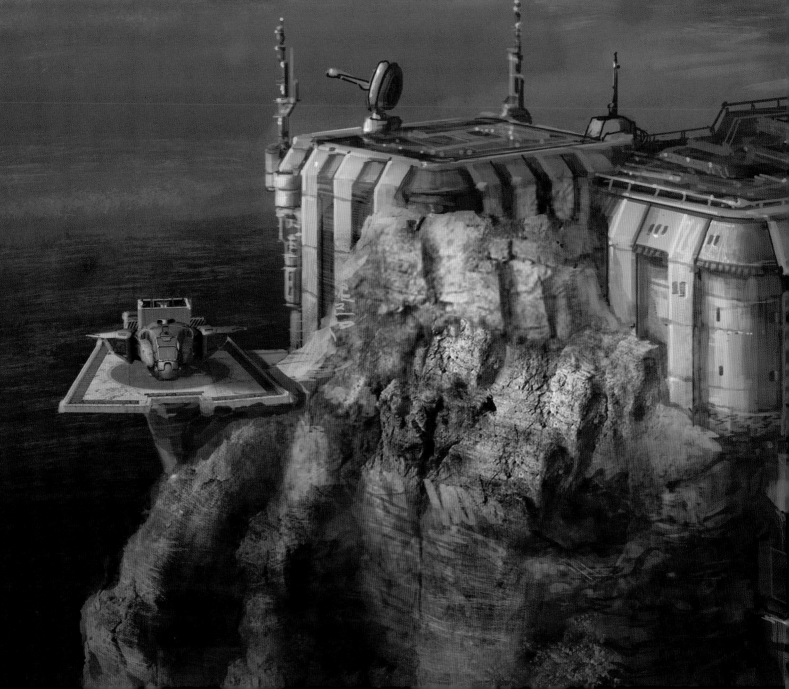

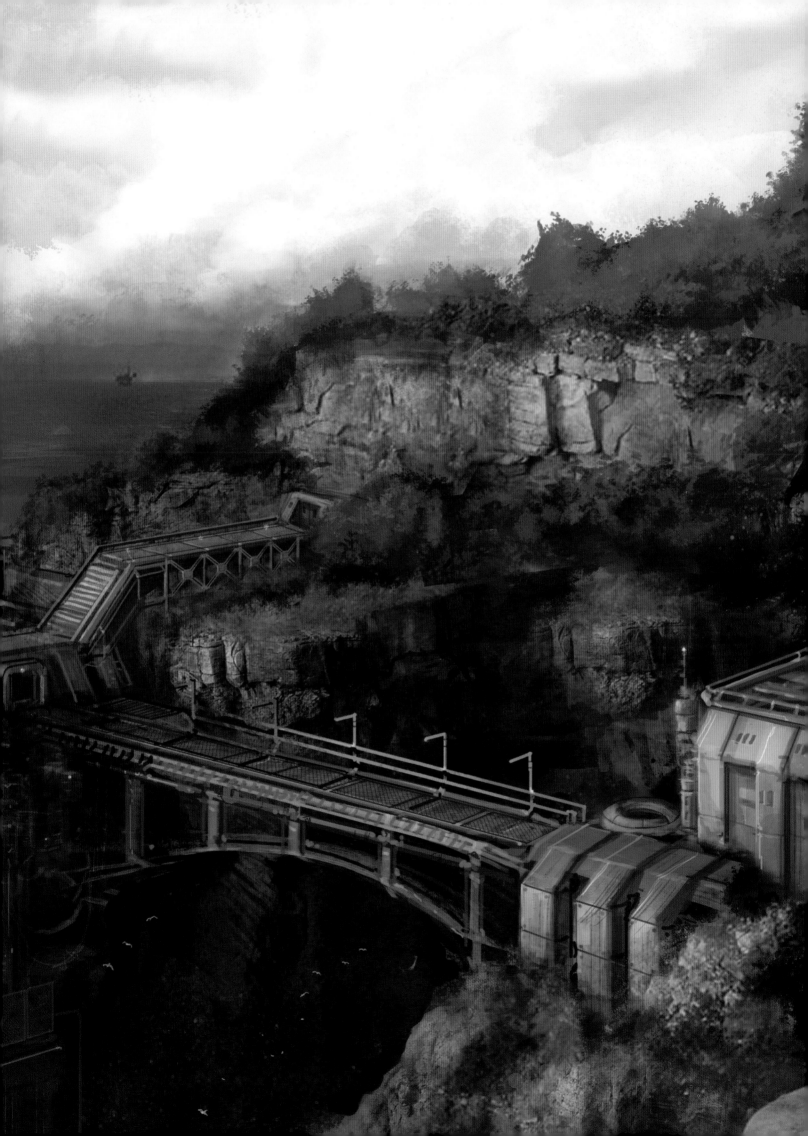

# FOREWORD

## BY FRANK O'CONNOR

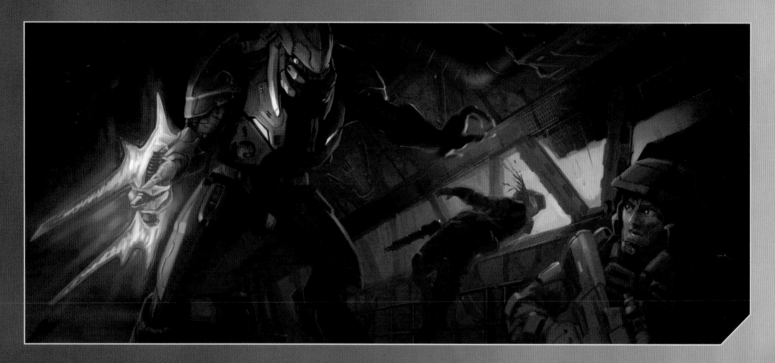

WE'VE all explored these worlds together. We've all wandered through debris-strewn ruined streets, verdant alpine gullies and foreboding alien corridors. We've all marveled at skies filled with drama and light. And we've all lived in these worlds. But we haven't quite lived in them in the way that the artists have. The painters, sketchers, modelers and visioneers who've built them from scratch with the mortar and substance of imagination, and brought these worlds into being from blank screens, or sheaves of paper.

Often, the task is deceptively simple: Envision a weary and ancient desert. Create a rage-fueled simian villain. But the results and the process are never so simple as the task's instructions infer. These artists take inspiration from their team, from history, from their experiences and from the world around them. And ex-nihilo, they bring into being places that are real enough for you and I to explore. Places that feel familiar, oppressive, terrifying and joyous.

Characters that beguile us, frighten us, or oppose our every step. They build the weapons and shields that form the aegis with which we safely discover. They paint the skies above our heads with light and imagination. They take materials, as real and gritty as chalk, as virtual and ephemeral as photons. In Black and White, in Red, Green and Blue, in Cyan, Magenta, Yellow, and here's the Key, in vivid hues and colors, they take us on the same journey they took, and plant us in the worlds they found.

So here's a toast, first and foremost, to the art and imagination of Bungie, and to the conceptors and creators of 343 Industries, with whom the keys to that kingdom have been left, and to the freelancers, contractors, partners and agencies who've helped expand and expound on the ideas, institutions and environments for a decade, and will continue to do so for decades to come.

Cheers,

Frank O'Connor

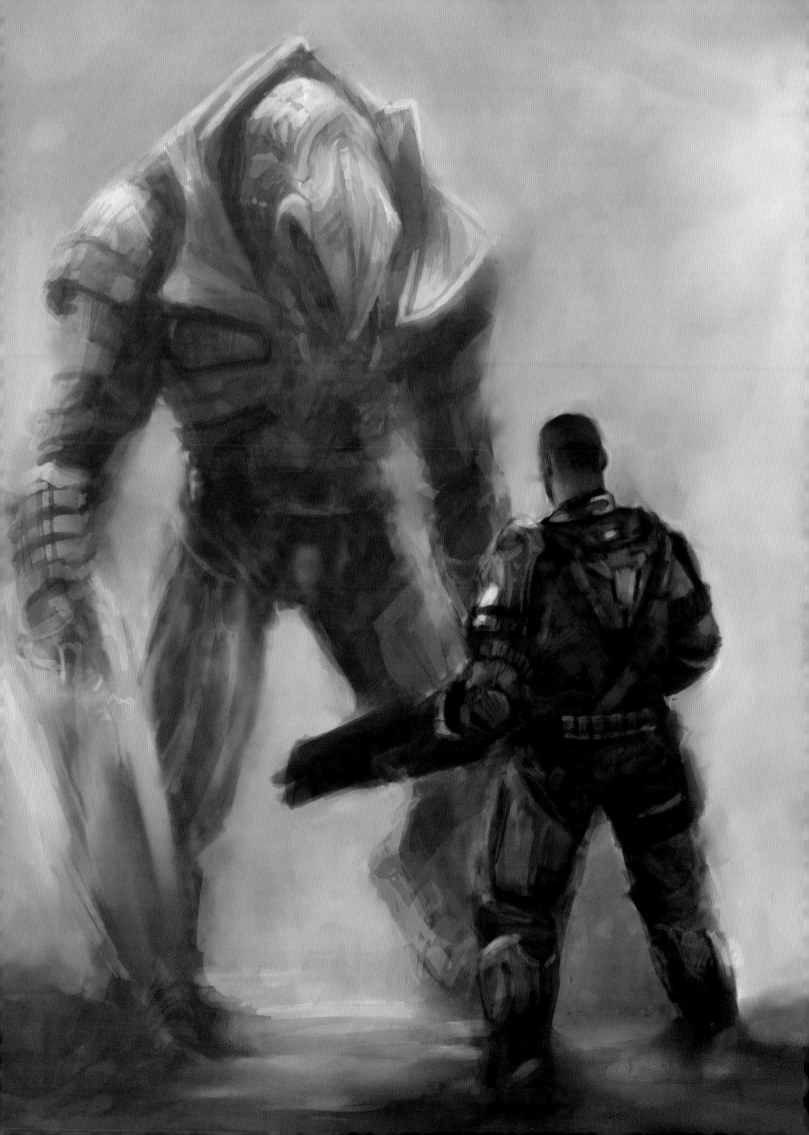

# INTRODUCTION

IT'S been ten years since players took their first steps on Halo's Installation 04, and they're ten years that have seen the video game industry change dramatically. It'd be disingenuous to say that Halo: Combat Evolved's the game responsible, but it'd be fair to point out that the series has been at the crest of the new wave of video game blockbusters—and Halo's journey towards becoming a full-blown cultural phenomenon goes hand in hand with the industry's emerging ability to create games that eclipse the box office takings of Hollywood's finest.

When Halo: Combat Evolved launched in 2001 it was clear that this wasn't going to be just another in a long line of first person shooters. Yes, the fact that its fate was so delicately woven into the fate of Microsoft's Xbox, the company's first foray into dedicated gaming hardware, helped keep interest levels at a healthy high, but there was much more that ensured its success. It was, for arguably the first time since 1997's Goldeneye, a first person shooter on consoles worth bleating about, and one of Halo: Combat Evolved developer Bungie's many achievements was getting on to one game pad the kind of control and accuracy that was previously only believed possible on the PC's mouse and keyboard. It was inventive, innovative and—not unimportantly for a video game—a whole lot of fun to play. At the heart of Halo: Combat Evolved was a perfectly honed weapon set for players to pit against computer-controlled characters that behaved with remarkable intelligence, forging a lasting template that's served much of the series since.

And it was also devastatingly beautiful. The player's first steps on Halo revealed a perfectly alien place, its royal blue skies and bright green grass giving a glimpse of a world as gloriously strange as those that had previously only existed in the imaginations of readers of sci-fi writers Larry Niven, Iain M. Banks and students of Freeman Dyson, the scientist who first posited the idea of a vast ringworld. Playing that first Halo was like treading through the very best sci-fi cover art of the sixties and seventies, the game's bizarre vistas bringing to mind the airbrushed fantasies from the likes of Chris Foss, Bruce Pennington and John Berkey. Mere moments after its release, Halo had established itself as a gaming icon.

Bungie hadn't just created a world, however. It had created an entire universe, and from that first game there spun out an amazingly dense world rich with lore. First there are the Forerunners, the mysterious, technologically advanced and long vanished architects of Halo. There's the Covenant, the consortium of alien races that worship the Forerunners, and whose twisted faith sends them on the Great Journey, a collision course with destruction that threatens to take the entire universe down with it. And then there's the UNSC, engaged in a heavenly war with the Covenant that spans galaxies, fronted by a hero cast in the classic nomadic mold, the Master Chief.

It's a universe that's expanded rapidly in the ten years since, to date taking in a huge library of further games, novels, comic books and a series of animations. The appetite for Halo isn't going away, either: the merest hint of a new game will bring the internet to its knees, pavements outside game stores will heave with expectant fans the night of a new release, and books that delve deep into the series' lore will be raked and surveyed for new clues and new insights into its many mysteries.

Halo is, to many extents and purposes, this generation's Star Wars, a cultural phenomenon that's swept millions from their feet. And like Star Wars, Halo's a universe that trades in the fantastical, a currency that the many artists involved have delivered consistently over the last ten years—be that the homespun Kivas of Reach, the metropolises that gleam in Halo Wars, or that which is set ablaze in Halo 3: ODST, or the impossible architecture of Halo 3's the Ark or, of course, the ringworlds themselves.

This book contains snapshots of the brave new worlds that Halo has taken us in the past decade, a series of postcards from the furthest reaches of the galaxy that help illustrate the scope and grandeur of the series' own Great Journey.

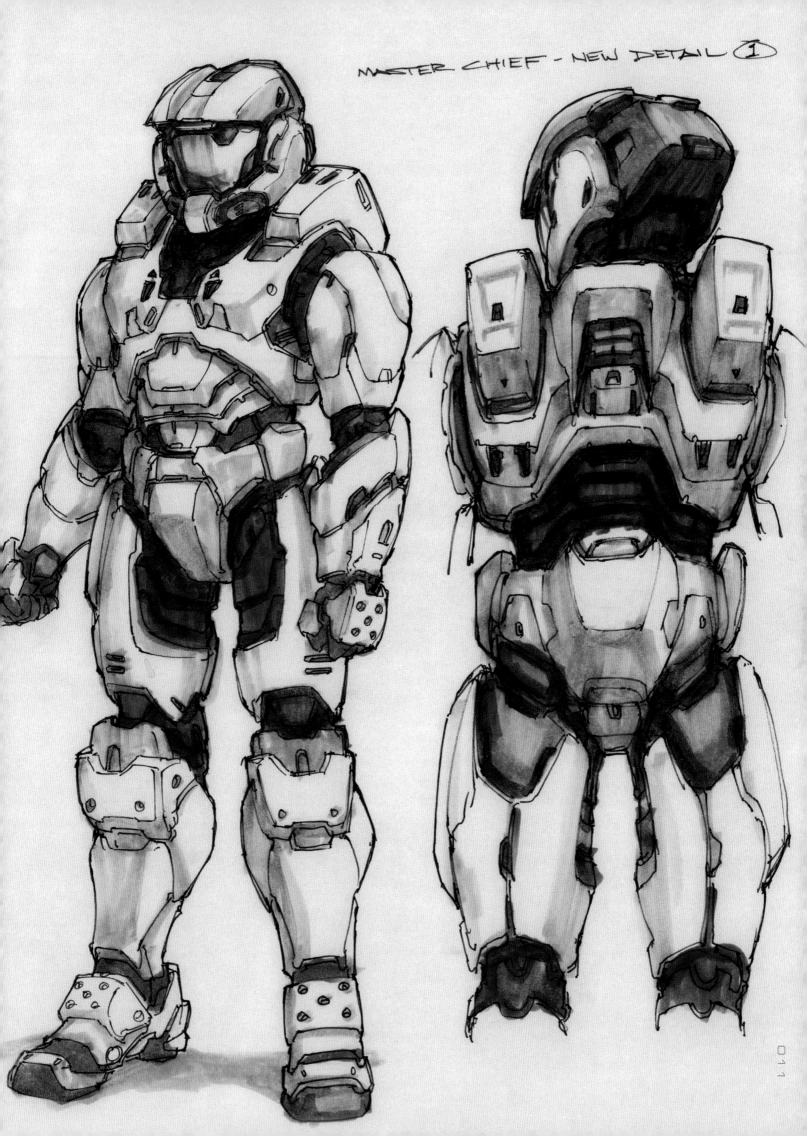

MASTER CHIEF - NEW DETAIL ①

011

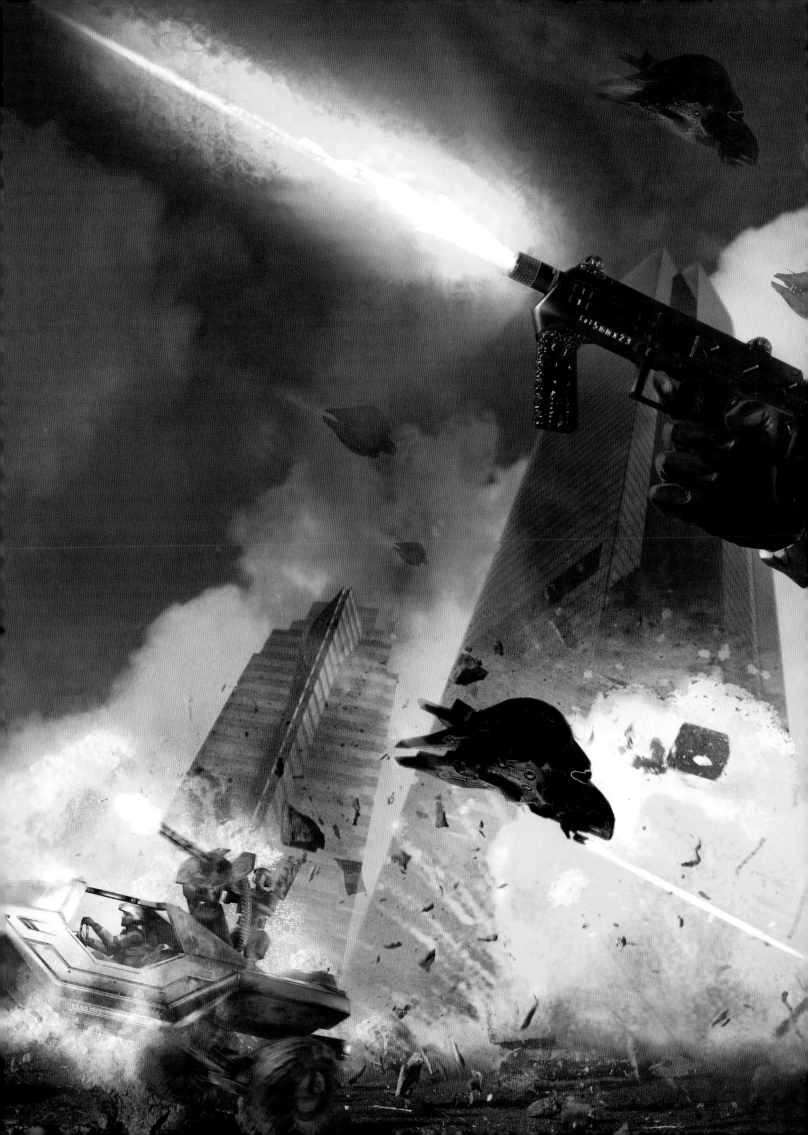

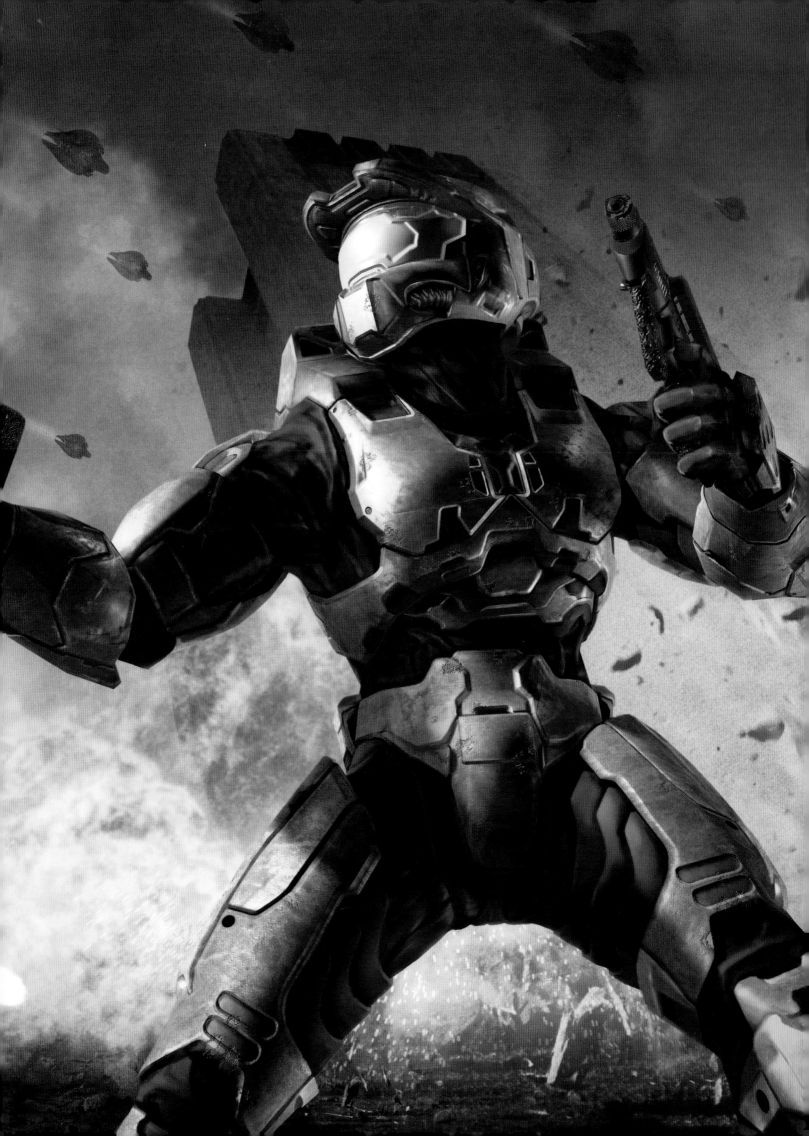

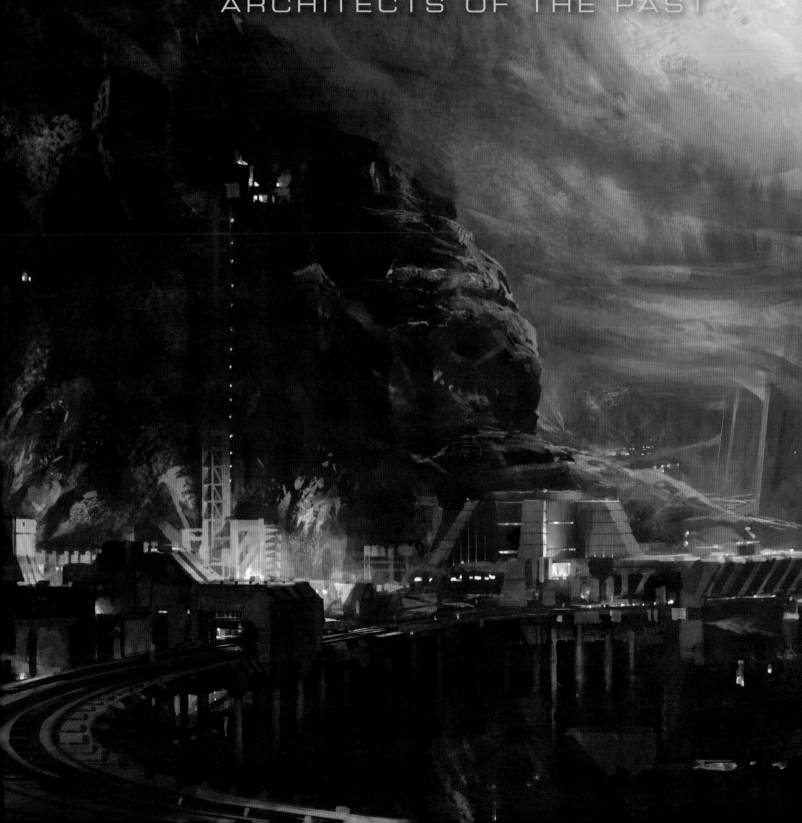

# CH.001

## ARCHITECTS OF THE PAST

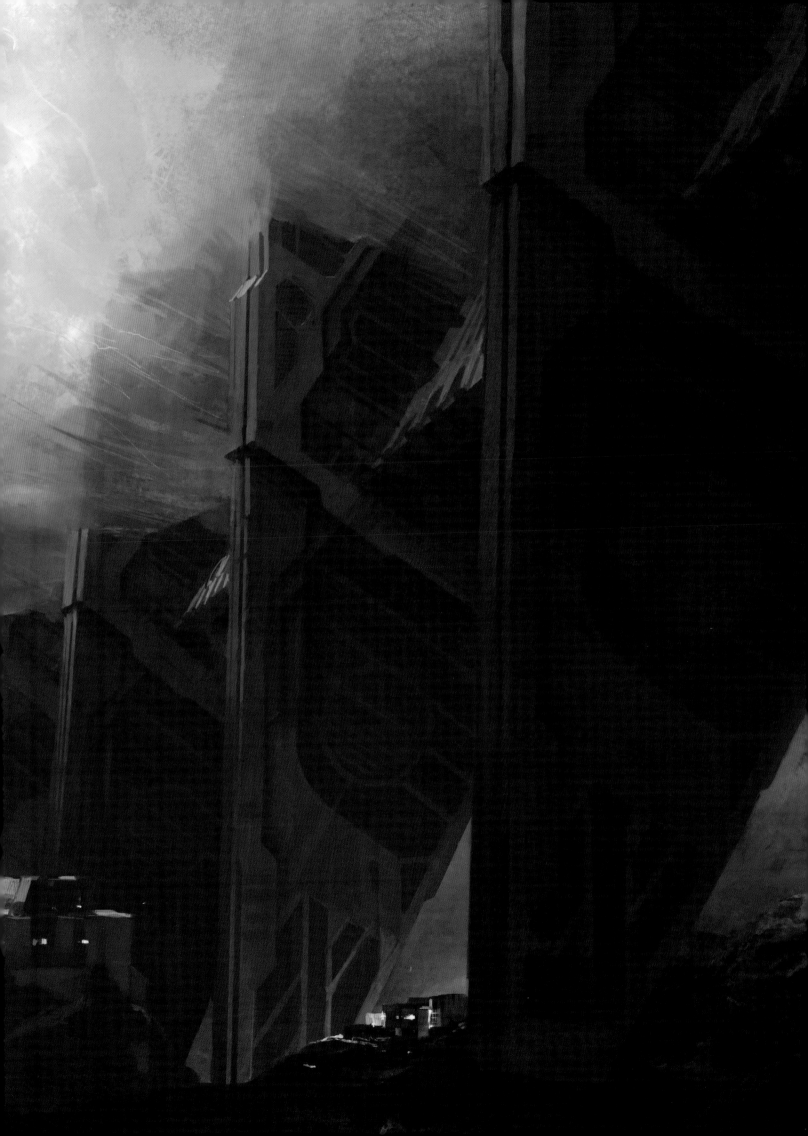

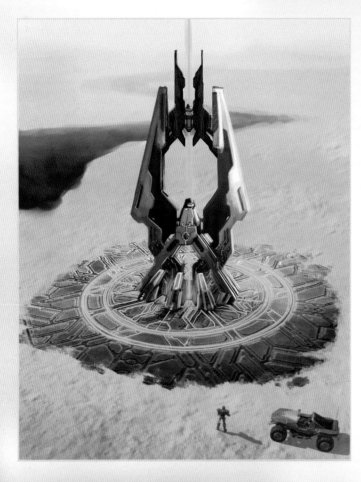

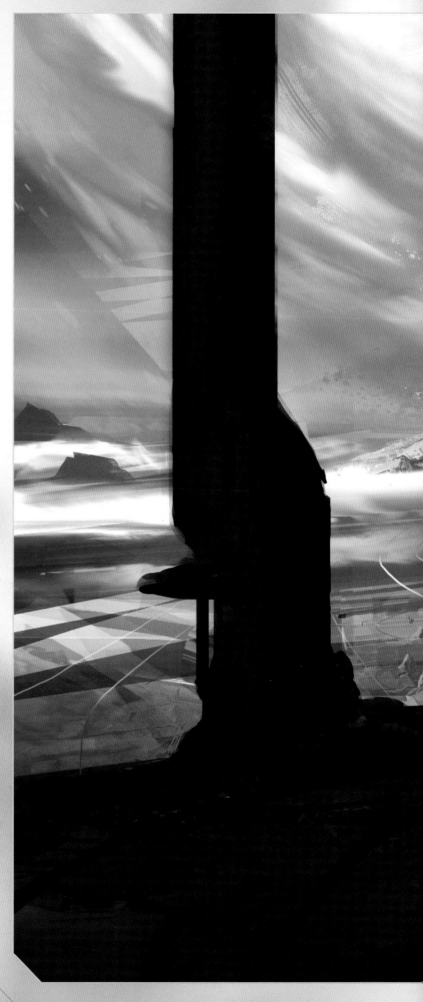

# FILE .001 //
# INTRODUCTION

HALO'S universe is built around an enigma that could bring about the galaxy's ultimate destruction. The Forerunners, an ancient race who vanished long before the Master Chief first donned his Spartan armor, are the architects of strange and beautiful alien worlds that host a terrifying secret.

Threads of the Forerunners' tale run through the entire series, told through the artifacts discovered by the humans and so violently pursued by the Covenant. A peaceful people who fostered a great and technologically advanced civilization, the threat of the Flood forced the Forerunners into building a weapon with the power to destroy all sentient life: the Halo array.

Acclaimed sci-fi novelist Greg Bear's *Halo: Cryptum* reaches back some one hundred thousand years to tell their story, and of the rifts and politics that would tear their civilization apart. It's a fascinating first-person account, telling of one rebellious Forerunner's ascent against the backdrop of the Flood's invasion and foreshadowing the conflicts that will go on to define Halo's universe.

*Halo artist Sparth's cover art (right) for Greg Bear's Halo: Cryptum, which provides a first person account of the Forerunner's strange and beautiful civilization.*

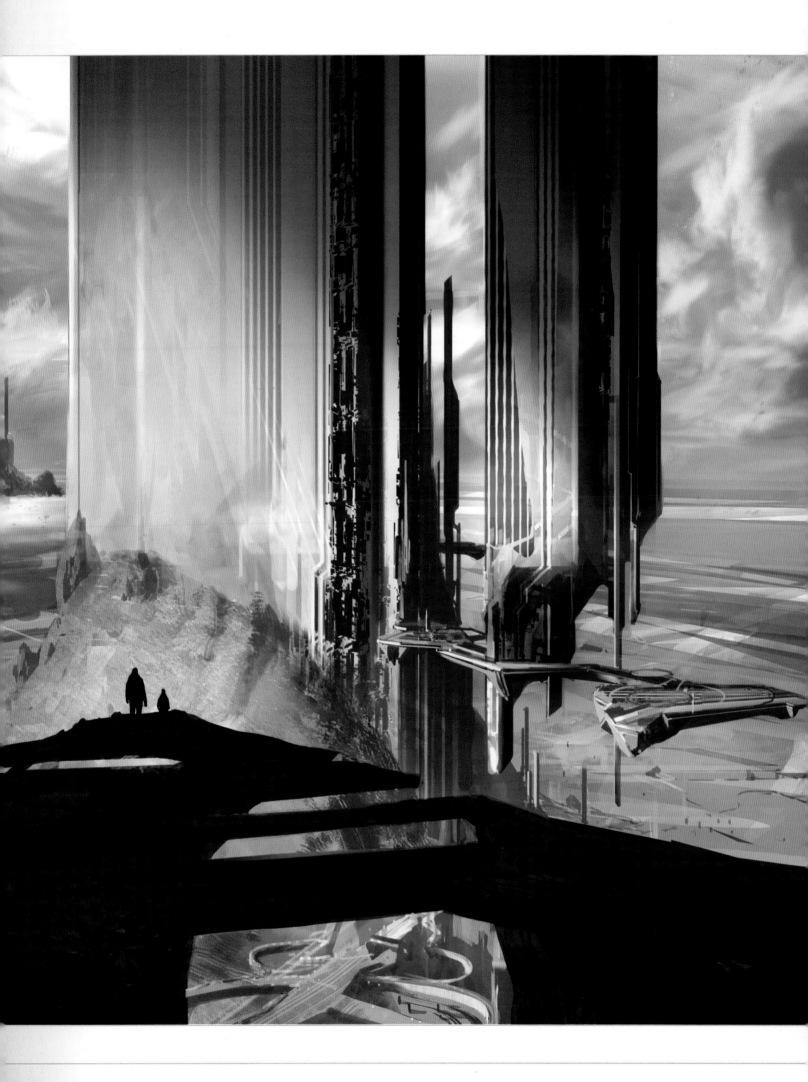

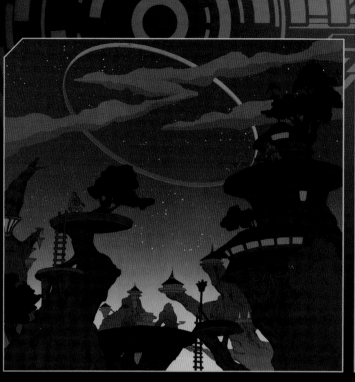

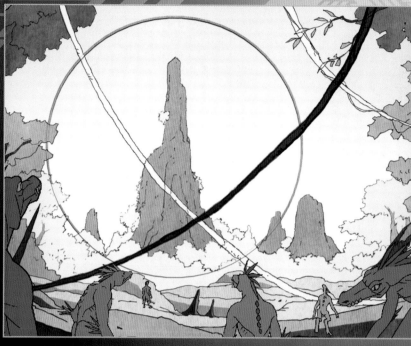

# FILE .002 //
# *HALO LEGENDS:*
# *"ORIGINS"*

GREG Bear's *Halo: Cryptum* provides a rich foundation for the Forerunners' tale, but "Origins"—one part of the *Halo Legends'* series of short films—brings it into short, sharp focus. Told with brilliant economy, "Origins" condenses thousands of years of backstory into just under 25 minutes of slick anime action. Its creator Studio 4°C had previously worked similar wonders with their entry in *The Animatrix* as well as creating *Tekkon Kinkreet*, one of the most visually striking animations of the last ten years, and their bold style found a good match in the alien blues and greens of the Halo universe.

*The Forerunners find their fight against the Flood hopeless—and their only solution lies in complete annihilation of all sentient species by firing off the Halo rings.*

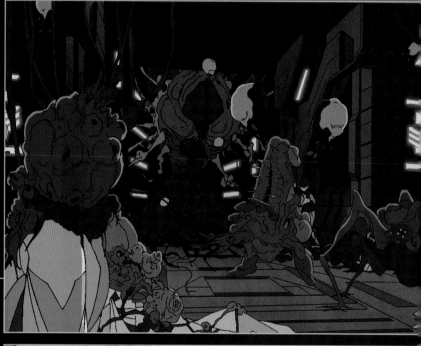

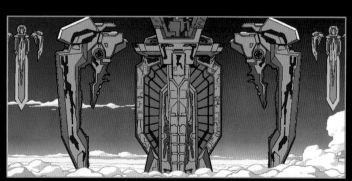

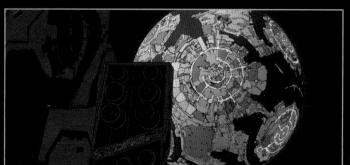

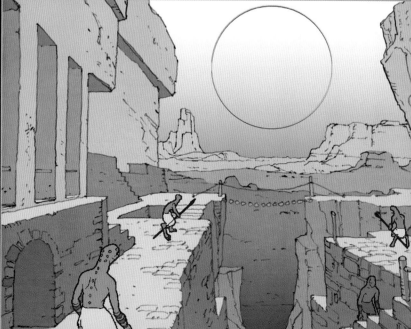

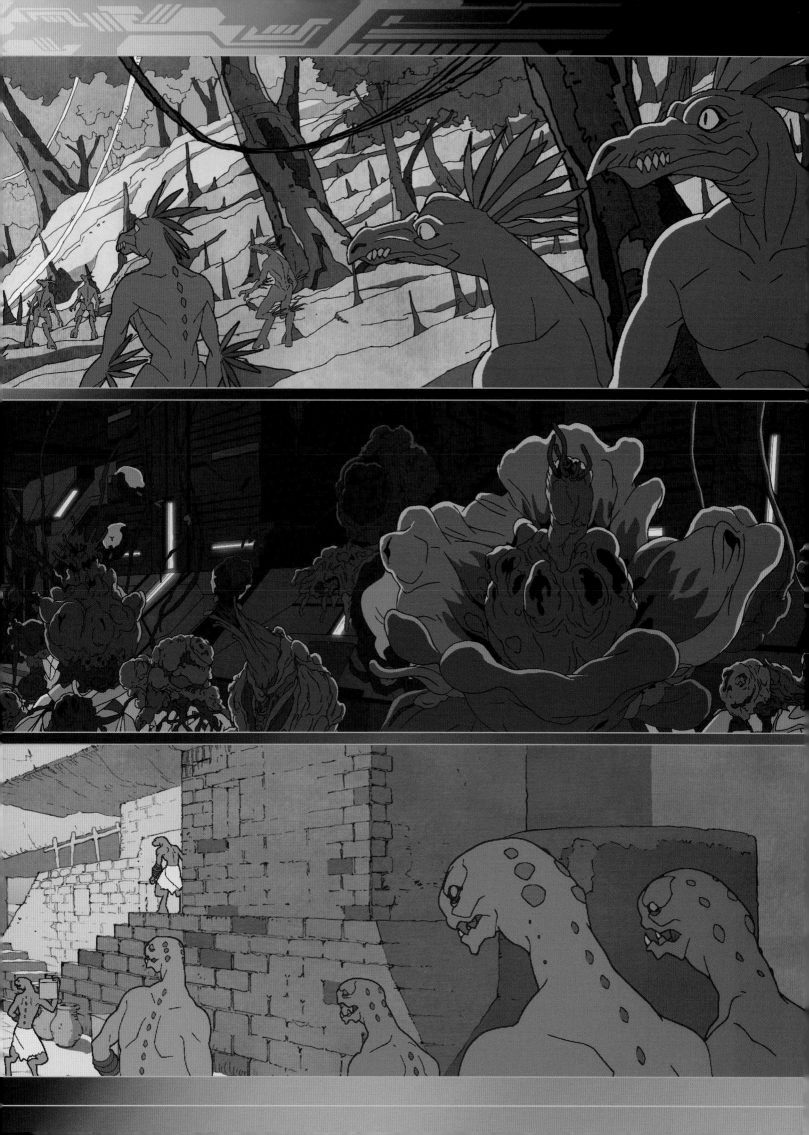

# THE ARK'S
## SKYBOX

SOMETMES it's not the plasma fire, the alien chatter or
the bizarre buildings that give you the sense you're somewhere
strange—sometimes it's something as simple as the sky, and for
this particular skybox the inspiration for the fantastical came from
somewhere surprisingly terrestrial.

"The 'Valley of Fire' outside of Las Vegas has some really great
desert rock formations I referenced for this painting," explains
Lorraine McLees, "The atmosphere was supposed to be really thin,
so you can see stars even during the day."

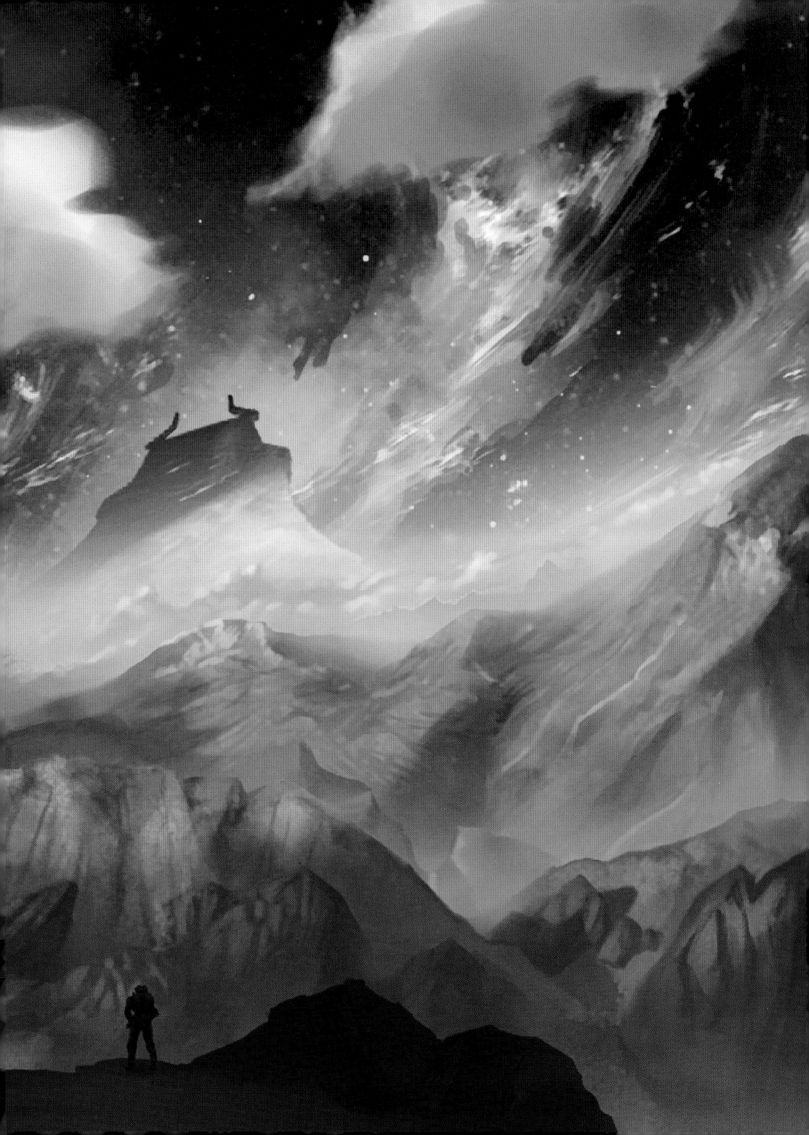

# SENTINELS

**SENTINELS** patrol and protect the Forerunner installations, often firing indiscriminately and most memorably hounding the Master Chief in *Halo: Combat Evolved*'s Library. Designed as a tool to combat the Flood, they're at the opposing end of the scale to the Halo rings though they still have the potential to be lethal. Although the Forerunners had disappeared well before humans had set foot on their worlds, their technology remains a presence, serving both as a threat and an ally in the war with the Covenant.

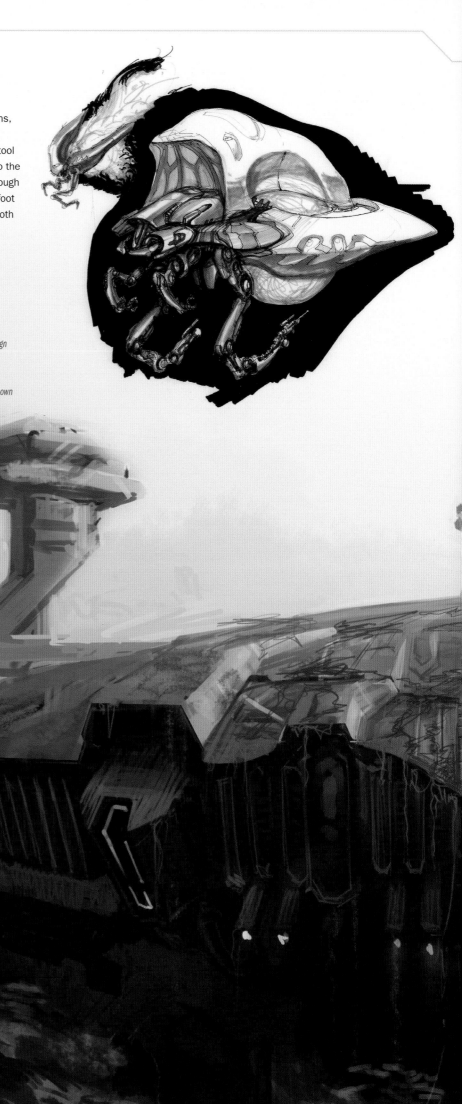

*Top: Concepts from* Halo: Combat Evolved *show insect influences on the Sentinel's design as well as a more direct, machine-like pass on the robot.*

*Bottom: Strato-sentinels, large mining robots that helped in the construction of Earth's own Forerunner artifact, were due to make an appearance in Halo 3 before being cut.*

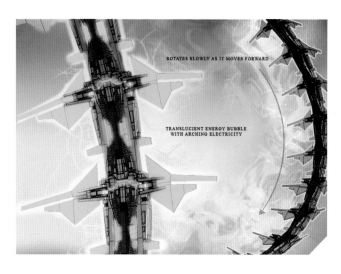

ROTATES SLOWLY AS IT MOVES FORWARD

TRANSLUCIENT ENERGY BUBBLE
WITH ARCHING ELECTRICITY

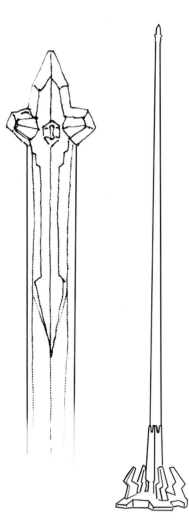

# FILE .004.1 //
# HALO WARS

*HALO WARS*, Ensemble's real-time-strategy take on the universe, brought with it a daunting sense of scale. It was not just in the elevated camera that the real-time-strategy genre came through; it was also in the huge canvas on which the game was drawn, with constructs like the Shield World and the mysterious Forerunner fleet both daunting and awe-inspiring in their dimensions.

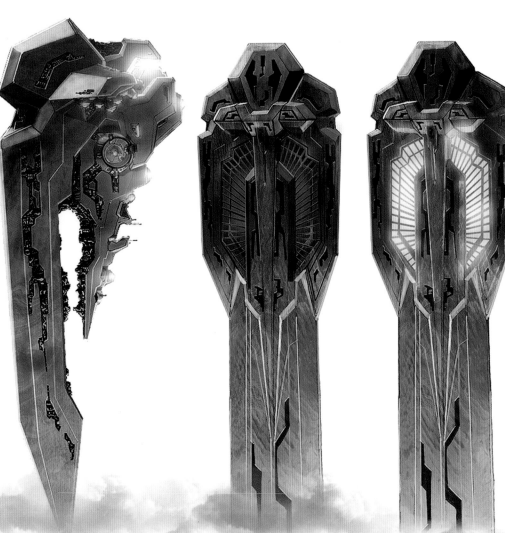

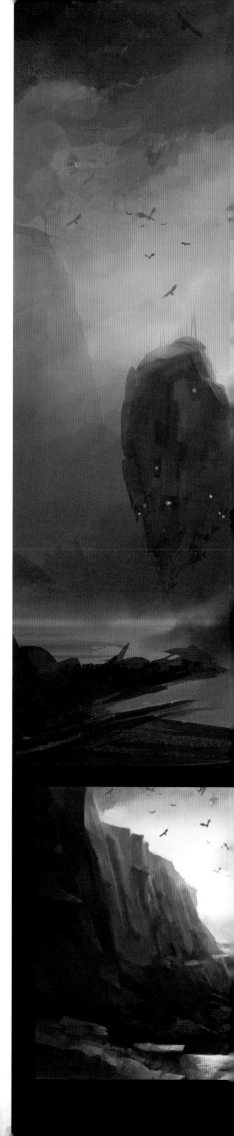

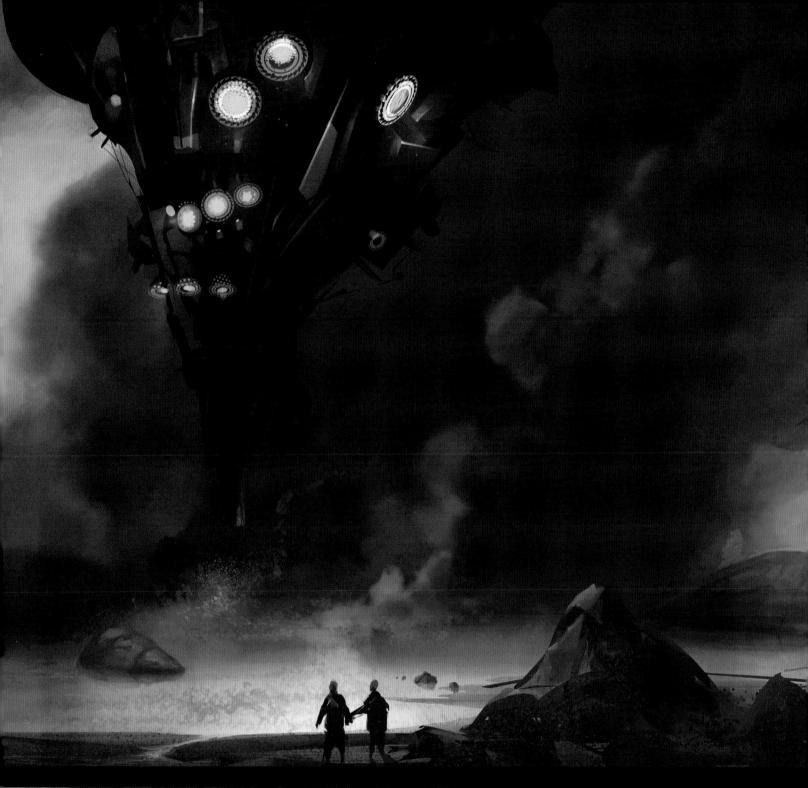

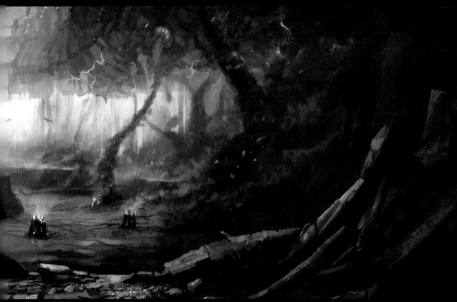

## FILE .005 //
## DELETED
## SCENES

NOT every aspect of the artist's vision can make it onto the final disc, and the cutting room floor is often littered with stunning images such as these. Omitted from *Halo Wars*, this titanic Forerunner technology lay dormant until the Covenant seized it for their ends. It's again indicative of the grand scale that marked the game.

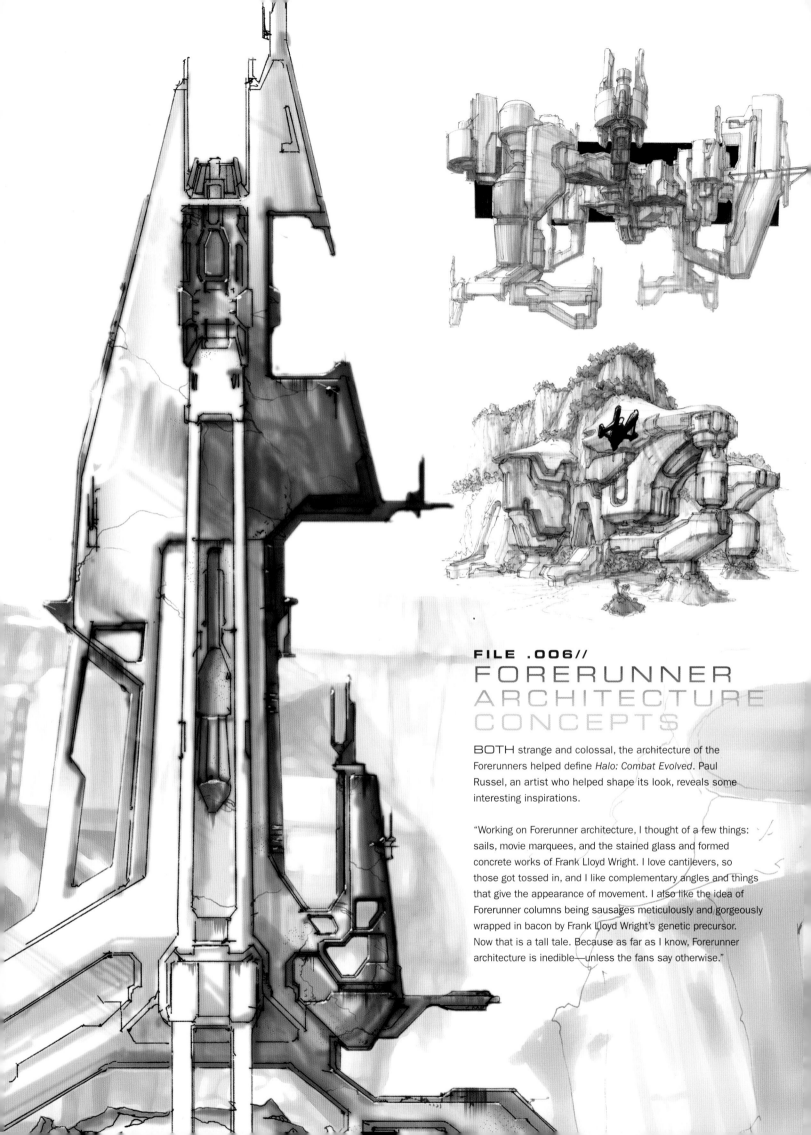

# FILE .006//
# FORERUNNER
# ARCHITECTURE
# CONCEPTS

BOTH strange and colossal, the architecture of the
Forerunners helped define *Halo: Combat Evolved*. Paul
Russel, an artist who helped shape its look, reveals some
interesting inspirations.

"Working on Forerunner architecture, I thought of a few things:
sails, movie marquees, and the stained glass and formed
concrete works of Frank Lloyd Wright. I love cantilevers, so
those got tossed in, and I like complementary angles and things
that give the appearance of movement. I also like the idea of
Forerunner columns being sausages meticulously and gorgeously
wrapped in bacon by Frank Lloyd Wright's genetic precursor.
Now that is a tall tale. Because as far as I know, Forerunner
architecture is inedible—unless the fans say otherwise."

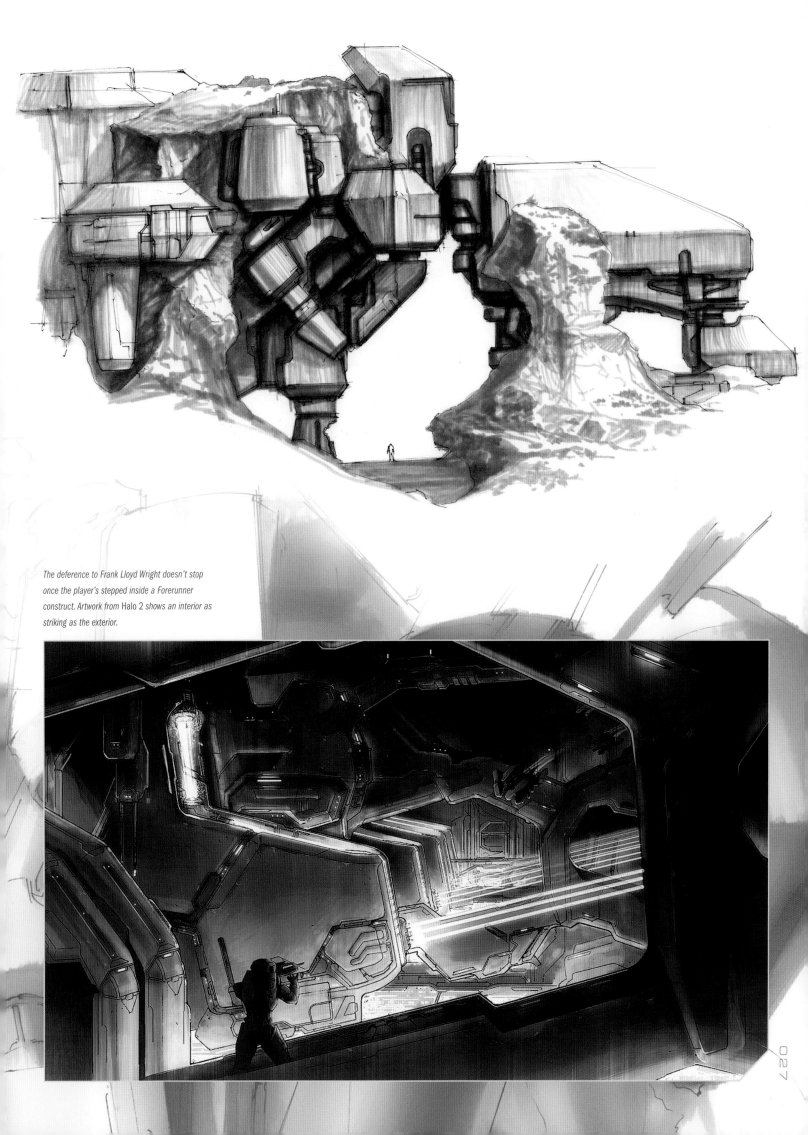

The deference to Frank Lloyd Wright doesn't stop once the player's stepped inside a Forerunner construct. Artwork from Halo 2 shows an interior as striking as the exterior.

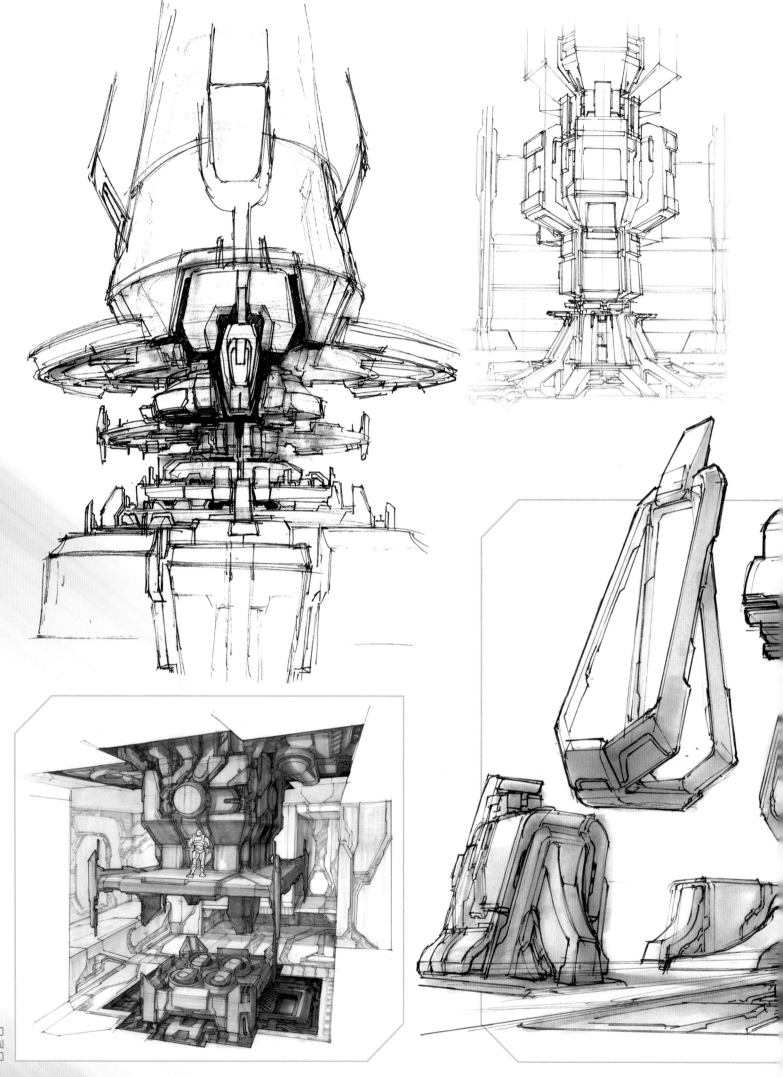

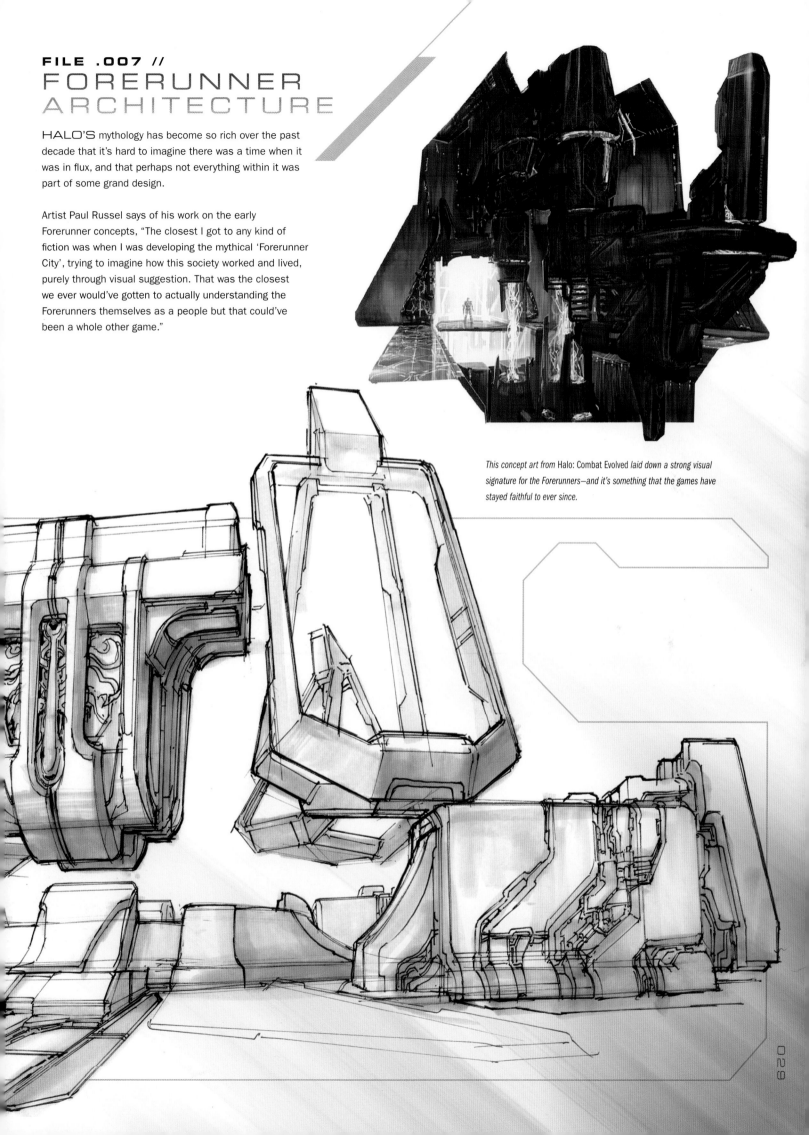

# FILE .007 //
# FORERUNNER
# ARCHITECTURE

HALO'S mythology has become so rich over the past decade that it's hard to imagine there was a time when it was in flux, and that perhaps not everything within it was part of some grand design.

Artist Paul Russel says of his work on the early Forerunner concepts, "The closest I got to any kind of fiction was when I was developing the mythical 'Forerunner City', trying to imagine how this society worked and lived, purely through visual suggestion. That was the closest we ever would've gotten to actually understanding the Forerunners themselves as a people but that could've been a whole other game."

*This concept art from Halo: Combat Evolved laid down a strong visual signature for the Forerunners—and it's something that the games have stayed faithful to ever since.*

*HALO: REACH*'s steel-eyed focus on the war between the humans and the Covenant may have put the Forerunners in the background, but they still played a pivotal part in its story. Deep beneath the planet of Reach lies a mysterious Forerunner artifact, discovered and studied by Dr. Catherine Halsey. The fruits of her research would prove pivotal in the war, as well as pushing it towards its brush with catastrophe.

Within the artifact, a set of coordinates are found that Halsey downloads to Cortana, the AI she built in her image. The data is then entrusted to Noble Team, the group of Spartans fighting to save the planet, who take it to the *Pillar of Autumn* and set it on its path into the unknown. Its destination: Installation 04, or as we know it, Halo.

Harvest, a planet that loomed large in *Halo Wars*' campaign, also played host to a Forerunner relic. First discovered by the Covenant, the huge structure that lay under the planet's northern polar region held a star map that pointed to Arcadia, another human colony touched by the prehistoric Forerunners.

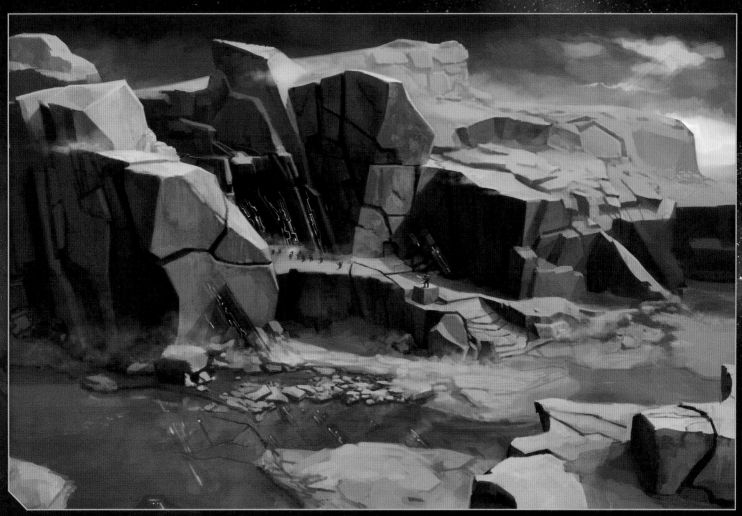

Harvest's relic forms part of a Forerunner trail that eventually leads to one of the gargantuan Shield Worlds.

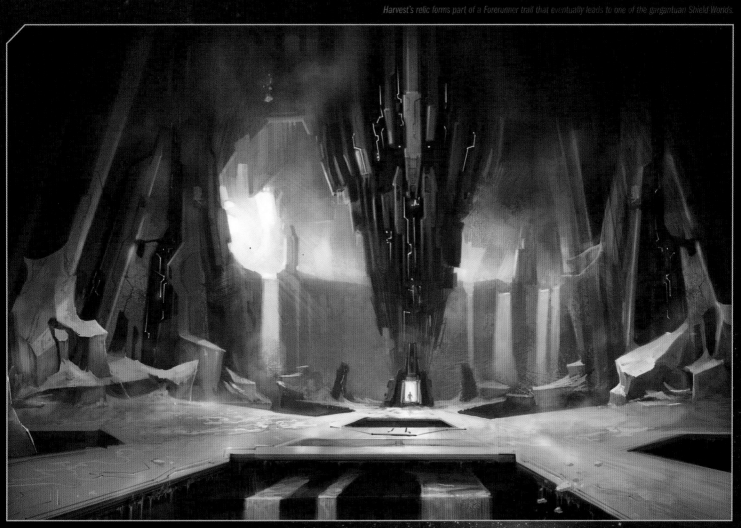

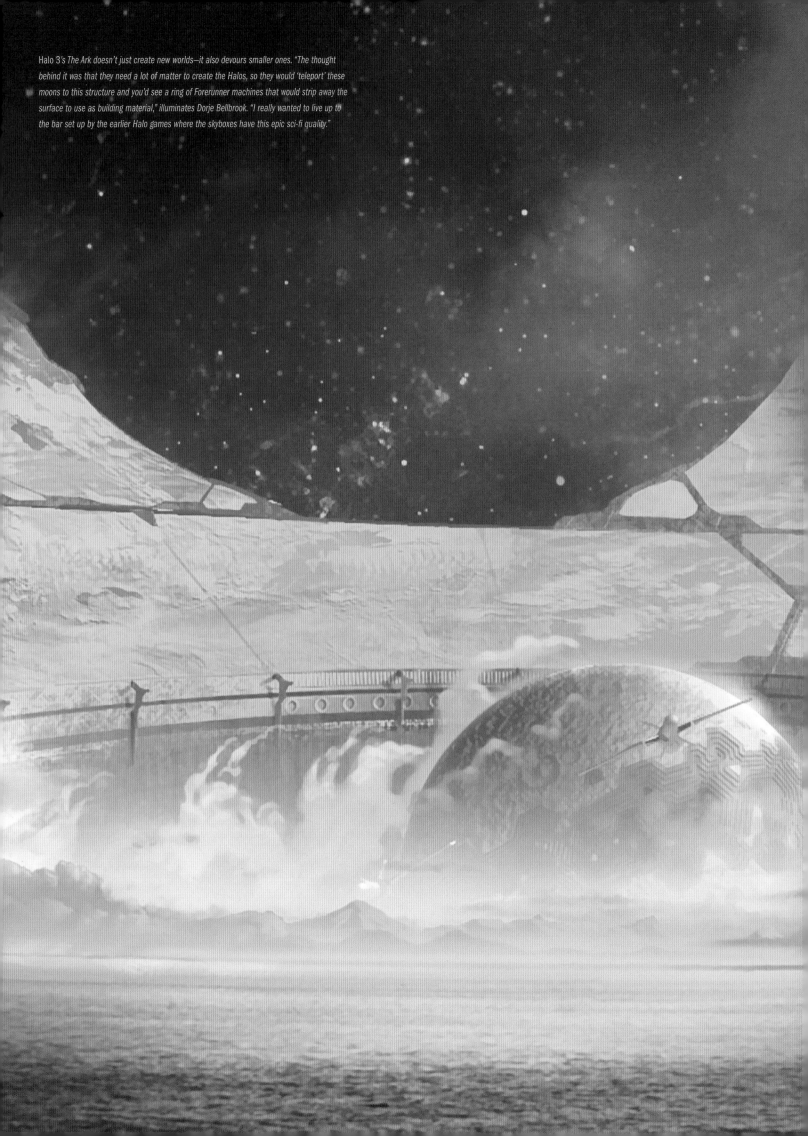

Halo 3's *The Ark* doesn't just create new worlds—it also devours smaller ones. "The thought behind it was that they need a lot of matter to create the Halos, so they would 'teleport' these moons to this structure and you'd see a ring of Forerunner machines that would strip away the surface to use as building material," illuminates Dorje Bellbrook. "I really wanted to live up to the bar set up by the earlier Halo games where the skyboxes have this epic sci-fi quality."

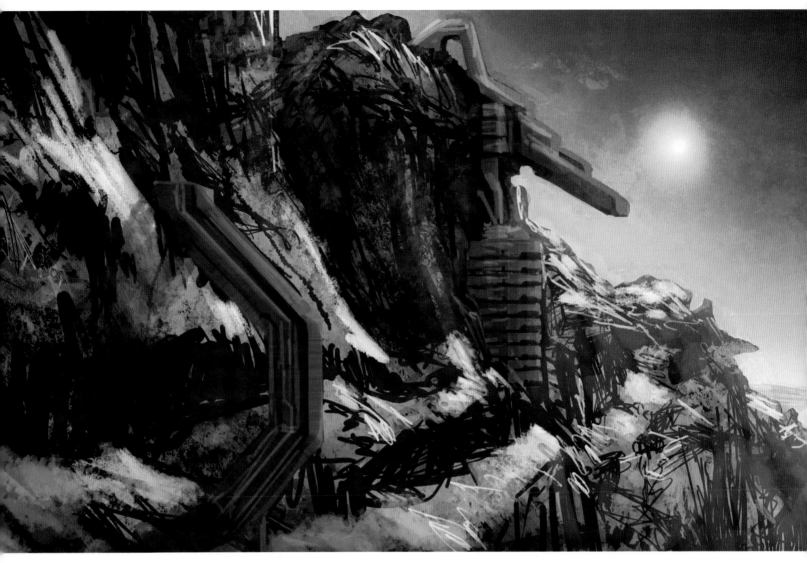

# FILE .009 //
# THE ARK

THE ARK—or Installation 00—is the one structure from which all the Halo rings can be activated, and it's here that replacement rings are constructed. *Halo 3* explored the strange contours of its landscape, and its design followed in the footsteps of those original rings in creating a bizarre and very alien world.

"We wanted to recapture that feeling when you first played Halo, of being able to see the structure you're in, like when you look up in the sky and you see the ring," artist Christopher Barrett says. "The final design did everything we wanted it to do visually with the gameplay in mind; where you'd start from the wasteland near one end, one tip, and you'd see the rest of this immense structure rising up over the horizon, like huge petals, as you make your way down toward the middle."

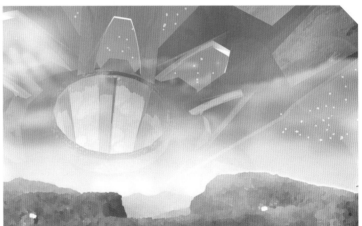

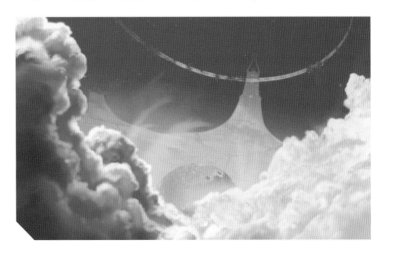

*If Halo 3's goal was to go bigger and better, then with The Ark it certainly succeeded. In its size it manages to outdo the architecture of previous games, and in its intricacy it stands as one of the Forerunner's finest monuments—and proves a fitting backdrop to Halo 3's finale.*

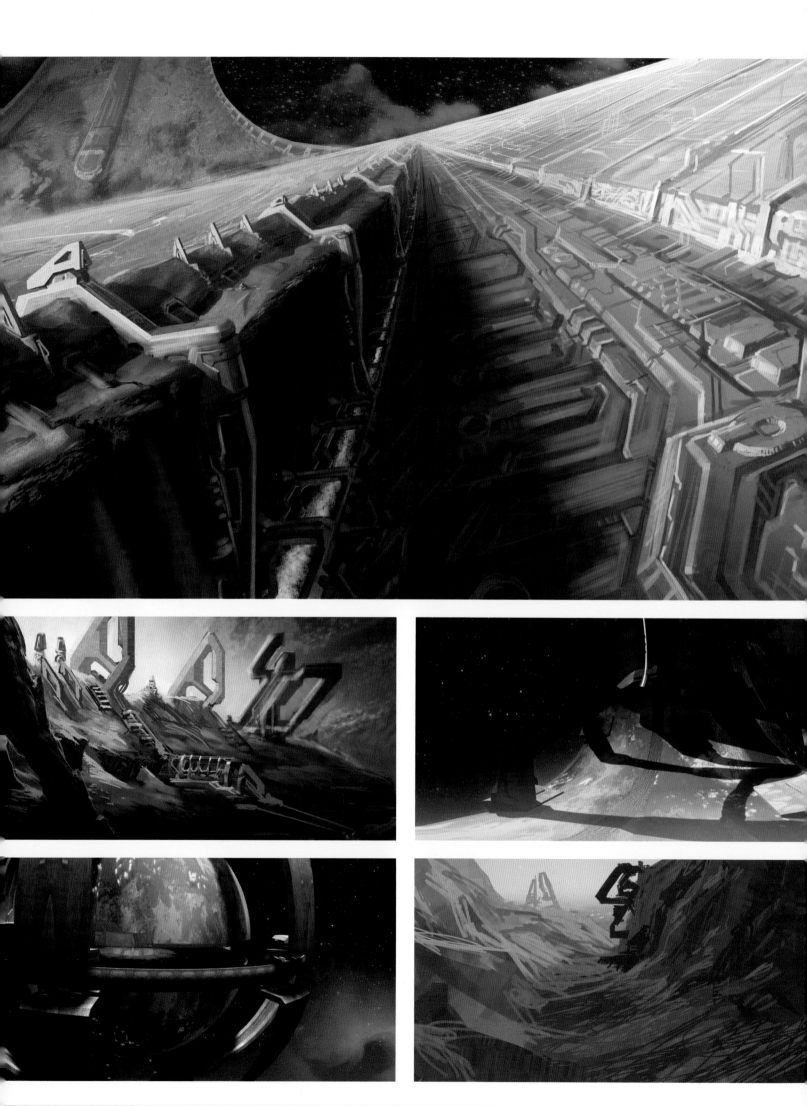

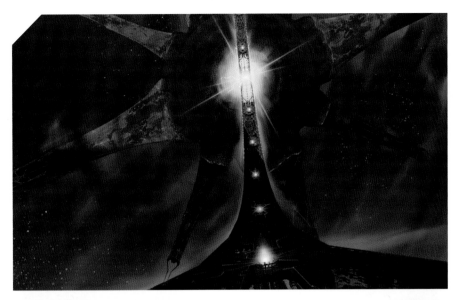

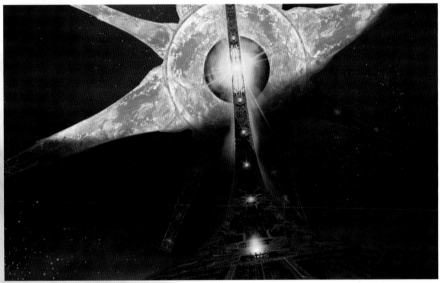

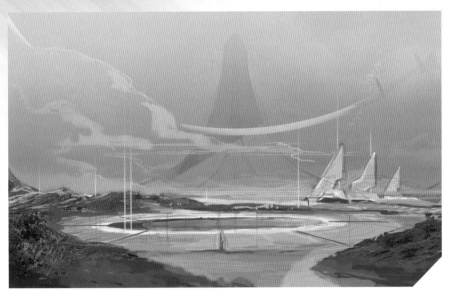

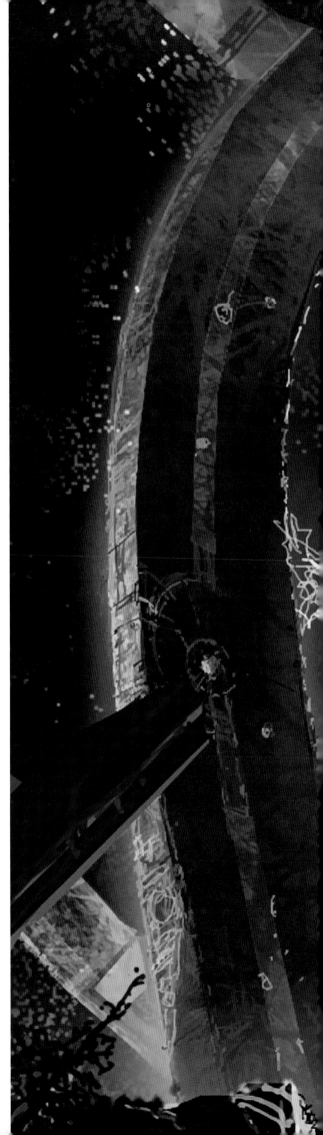

# FILE .010 //
# THE ARK

TOWARD the end of *Halo 3*, the Master Chief is tasked with destroying the replacement Halo being manufactured by the Ark. With the ring activated and the world literally tumbling around him, it's a climax with strong echoes of *Halo: Combat Evolved*—but with so much more at stake.

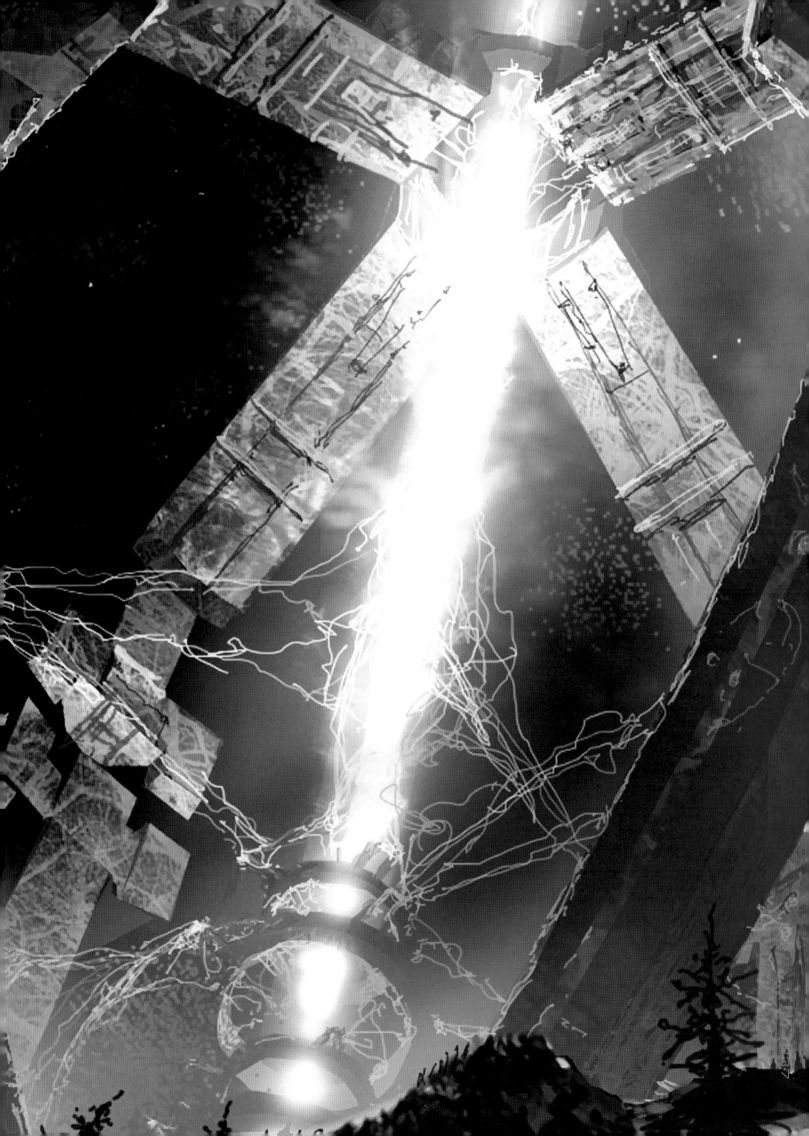

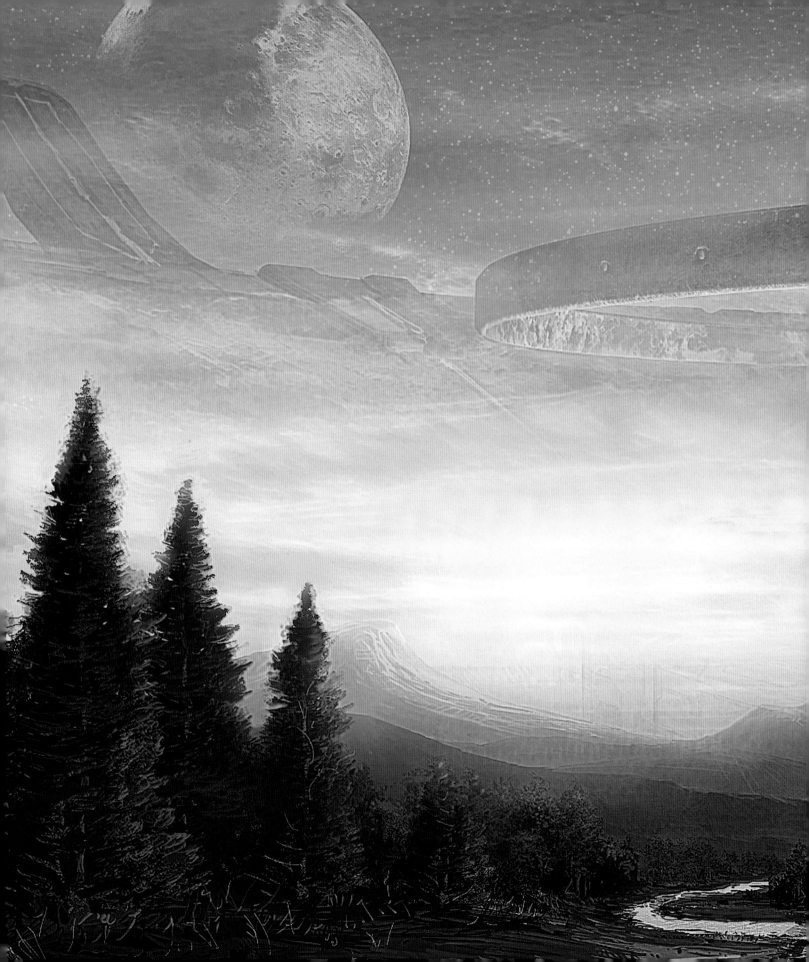

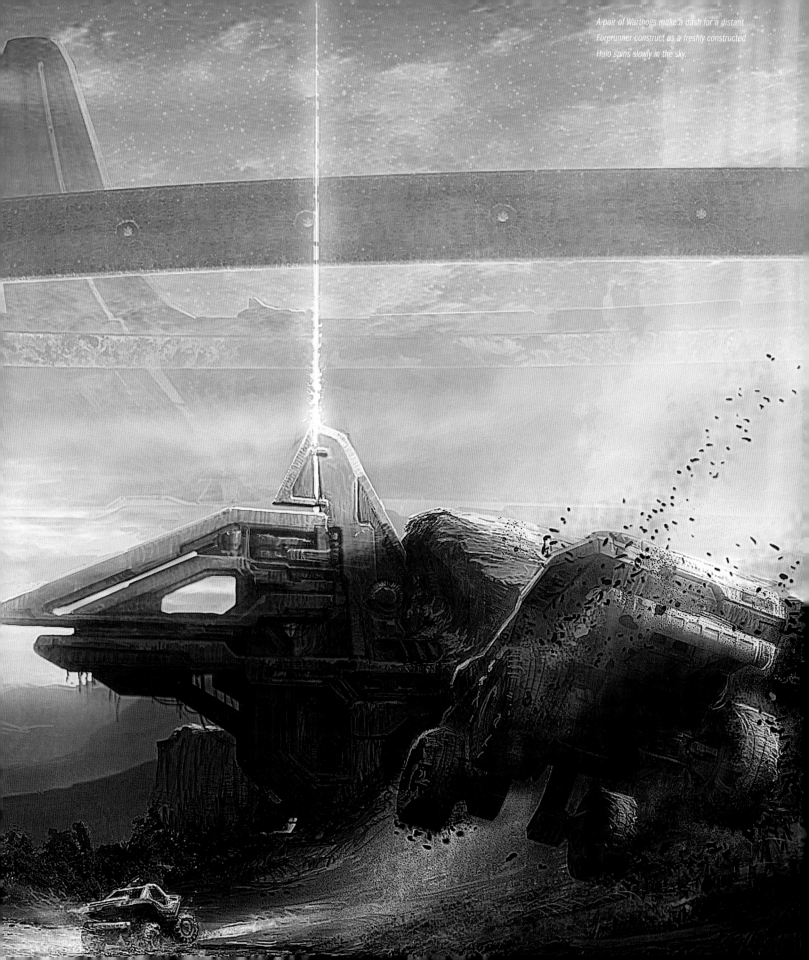

A pair of Warthogs make a dash for a distant Forerunner construct as a freshly constructed Halo spins slowly in the sky.

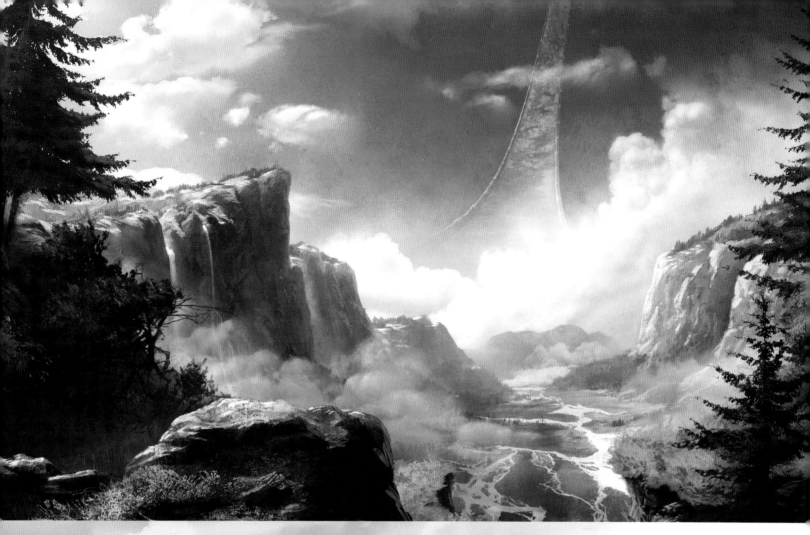

# FILE .011 //
# RINGWORLDS

THE ringworlds of science fiction authors Larry Niven and Iain M. Banks are often cited as influences on Halo, but the inspiration runs deeper. "The design of the Halo ring was influenced as much by Niven and Banks as by what influenced them: Dyson," says artist Mark Goldsworthy, alluding to the work of theoretical physicist Freeman Dyson and, more specifically, his Dyson Sphere. "The problem, however, is in scale. You need to see the Forerunner's self-confidence and their belief in the rightness of their actions—and perhaps even the hubris—in their architecture. But Niven's Ringworld was essentially invisible while you were on it, just as Dyson's shell would be. You had to be able to behold the immensity of the Forerunners' creations in order for them to work. They need to look good in the sky."

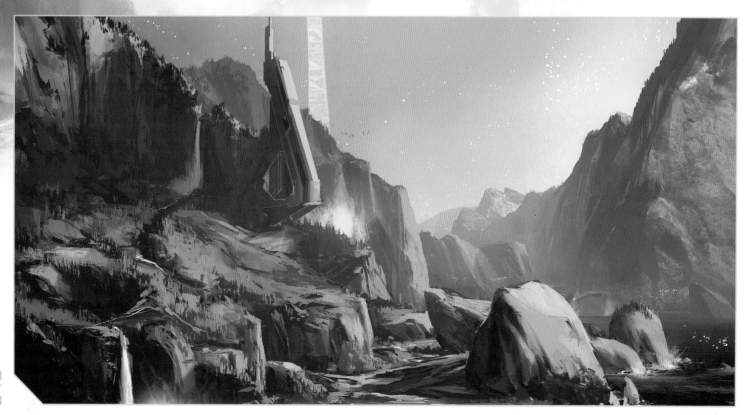

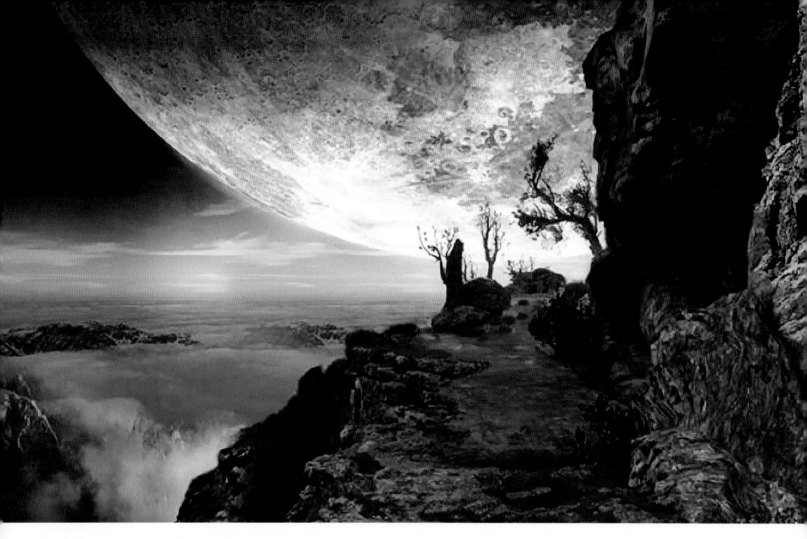

# FILE .012 //
# *HALO: COMBAT EVOLVED*

ON November 15, 2001, a new universe was born. We met a stoic fellow in green armor, his animated blue lady friend (note that does not read "ladyfriend"), a version of humanity beaten down to its last gasp, a voracious new alien threat (always a favorite of gamers), and we met Halo. This giant artificial ring world was waiting patiently for us in space, laden with mysteries and beauty and a level of immersion that changed the history of modern gaming consoles. *Halo: Combat Evolved* had groundbreaking features and gameplay a'plenty, but it was as well known for its artistic style as anything else. How could these amazing landscapes be man(alien, actually)-made? We had no idea how much fun it would be to find out again in the re-imagined *Halo: Combat Evolved* in 2011 as shown here.

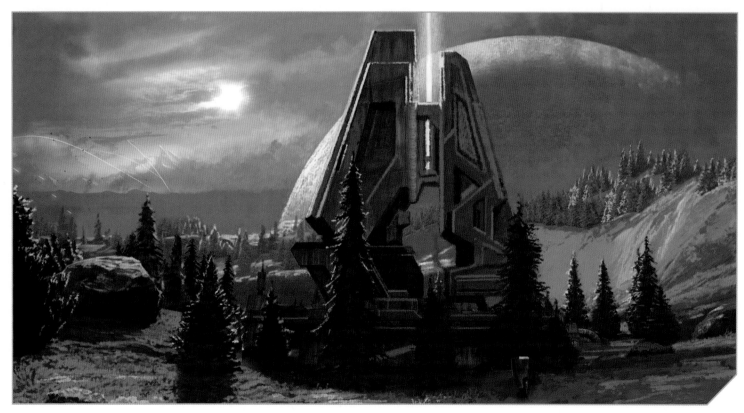

# VISIONS OF
## *HALO: COMBAT EVOLVED*

TOWERING and inexplicably ancient, strange gray spires rose out of the ground of this place...this *thing* you were exploring, constantly luring you forward with the promise of new peeks into the past and power of the Forerunners, those who built it all. From towering frozen cliffs to intricately inlaid shafts leading perhaps all the way through the Halo superstructure to the vacuum of space, we still love the mystery of why the Forerunnrers would wrap such a deadly weapon in landscapes so vibrant and alive.

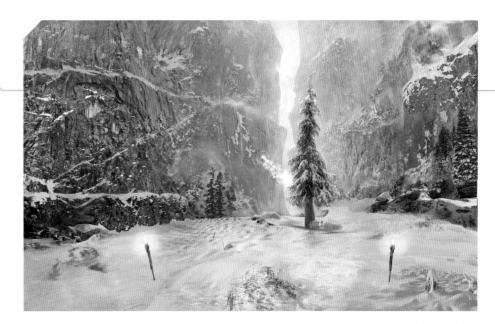

Halo: Combat Evolved's *"Assault on the Control Room"* switched out the green and blue palette of the game's opening for the stark whites of this snow-dipped landscape.

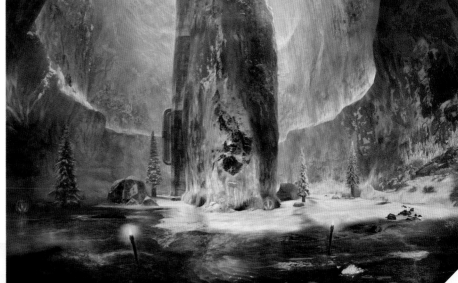

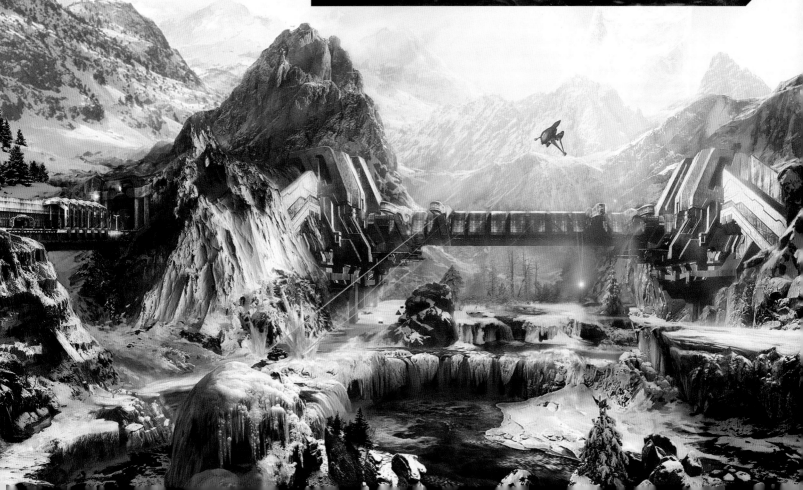

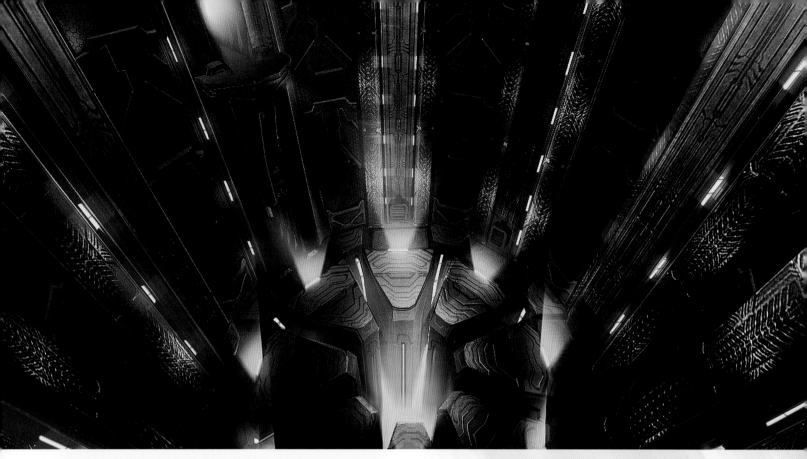

Halo: Combat Evolved's Library is one of many Forerunner structures that serve a mysterious purpose, with similar buildings making appearances in Halo 2 and making a brief cameo in Halo Legends.

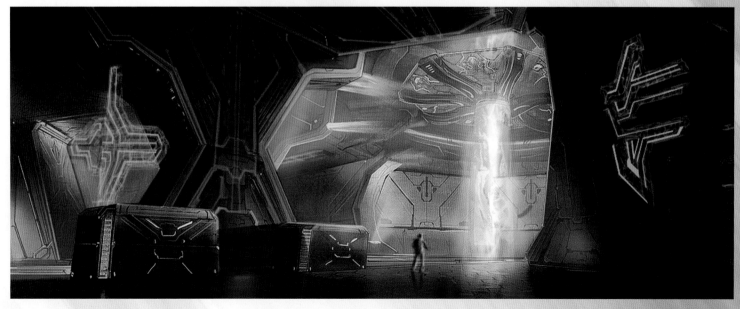

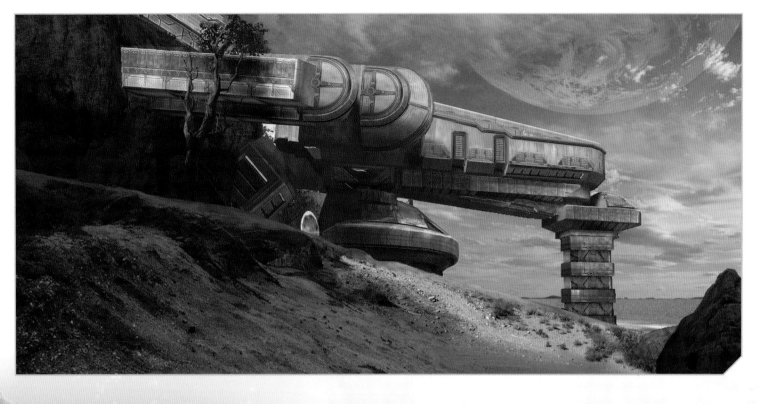

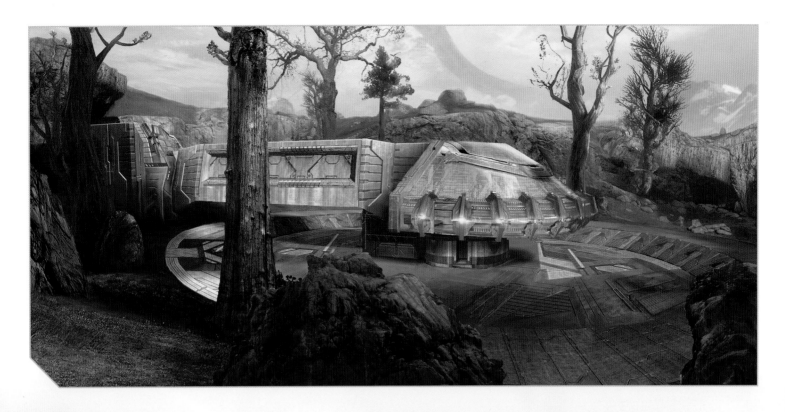

# FILE .013 //
# THE SILENT
# CARTOGRAPHER

IT'S *Halo: Combat Evolved*'s Normandy moment, where the combined forces of the UNSC join the player's side as they storm the beaches of Installation 04 in search of a map room that will reveal some of the ringworld's secrets.

"The Silent Cartographer" is one of *Halo*'s defining moments, the urge of its bombastic score combining with the crack of gunfire, the echoing boom of grenades and the sheer scale of the battle at hand.

A tough job for its remake to replicate then, but Saber Interactive does well by staying faithful to the original, using the added processing power at their fingertips to make the beach more vivid than before, and to bring this very special place a little extra life.

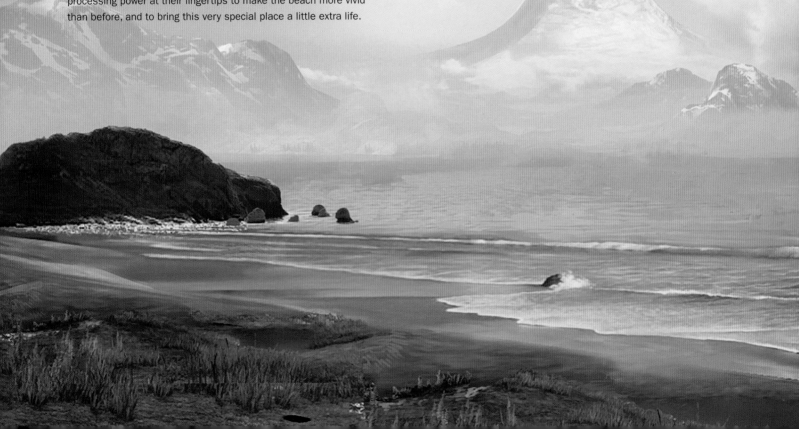

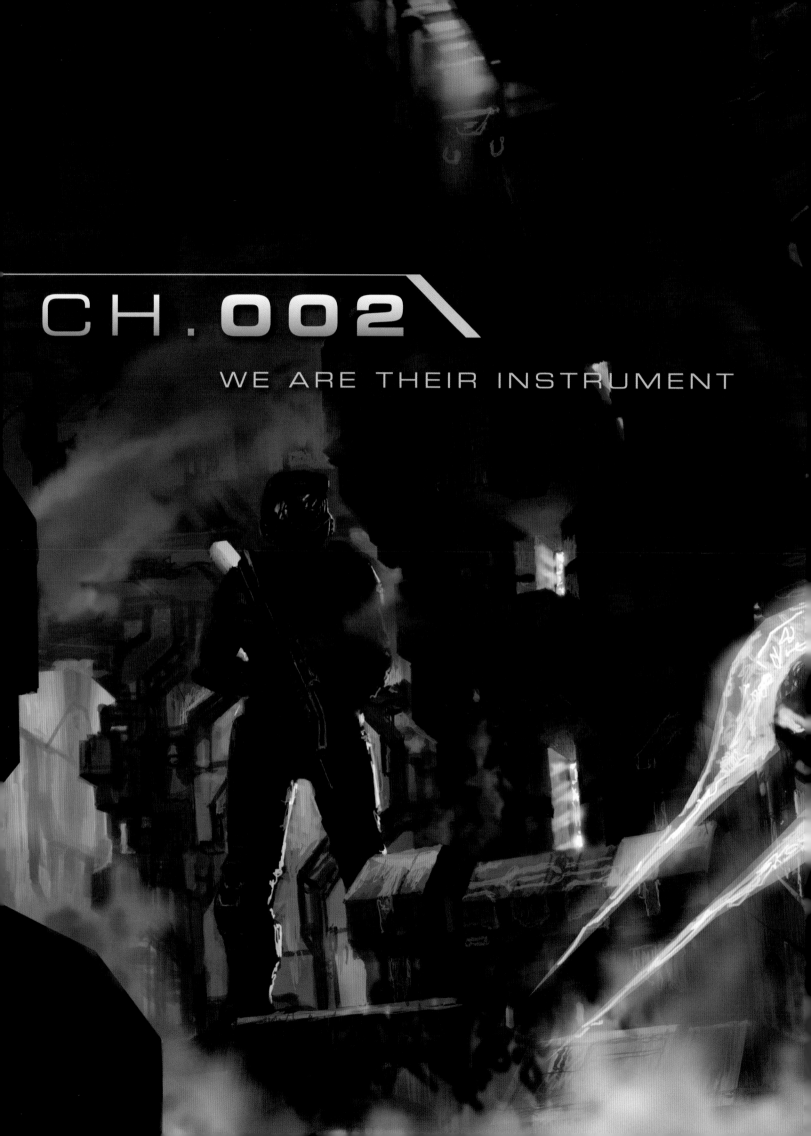

# CH.002\

WE ARE THEIR INSTRUMENT

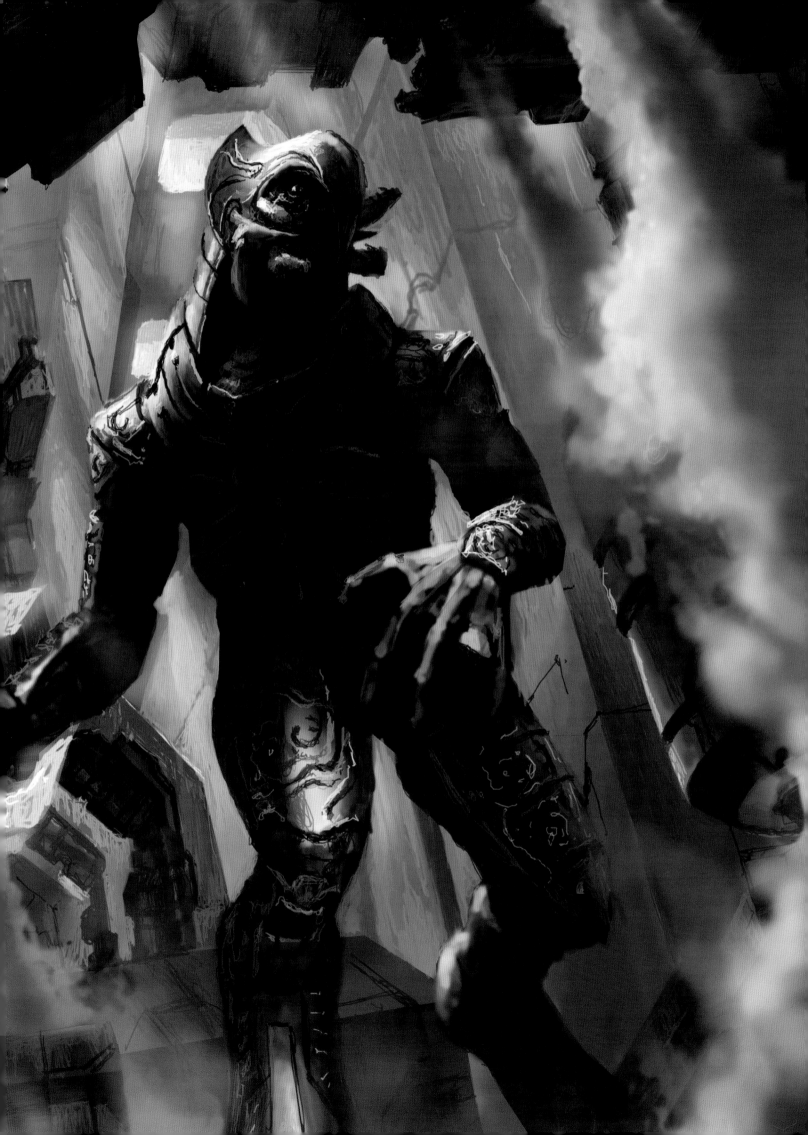

# FILE .001 //
# ELITES

A BREED of saurian warriors, the Sangheili—or Elites, as they're more commonly known—are Halo's definitive enemy. Their role in the games changes dramatically, and their evolving design reflects this—*Halo: Combat Evolved* saw them as the arch enemy, while *Halo 2* introduced the Arbiter, a playable Sangheili, and come *Halo 3* the Elites were fighting by the player's side. *Halo: Reach*—a prequel to the main series—came full circle, restoring the Elites to their nemesis status and giving them a vicious makeover.

The Elite's design was also dictated by their purpose on the battlefield, as was that of the rest of the Covenant forces. "Each race needed to fit a specific function in the role of player engagement," says Shi Kai Wang, "Each one of them, as you probably all know now, play a different role in how they interact with you, and tease you into shooting them in the face. I tried to make each one's profile fit that role. The Elite is the all around damage guy, so I designed them to be agile looking but tough."

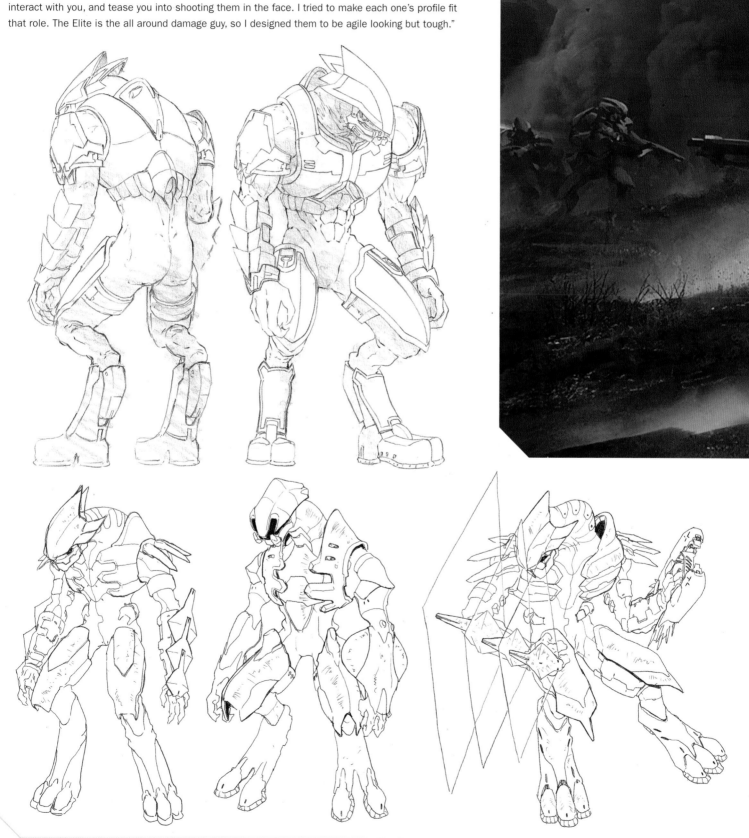

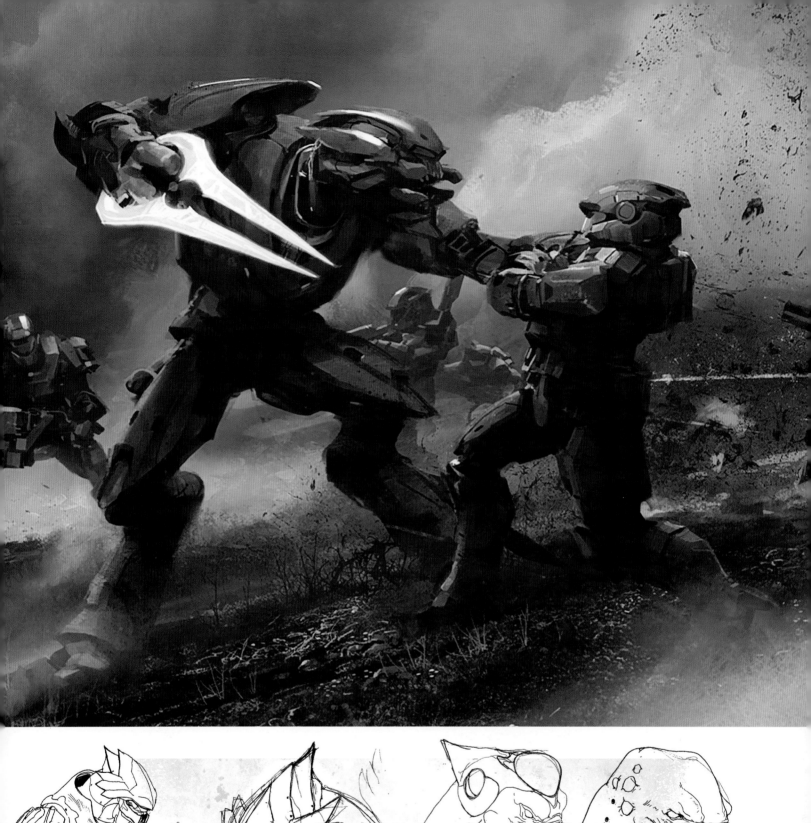

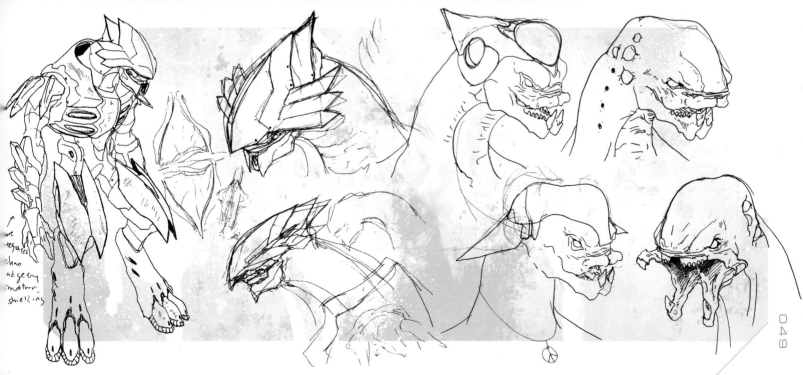

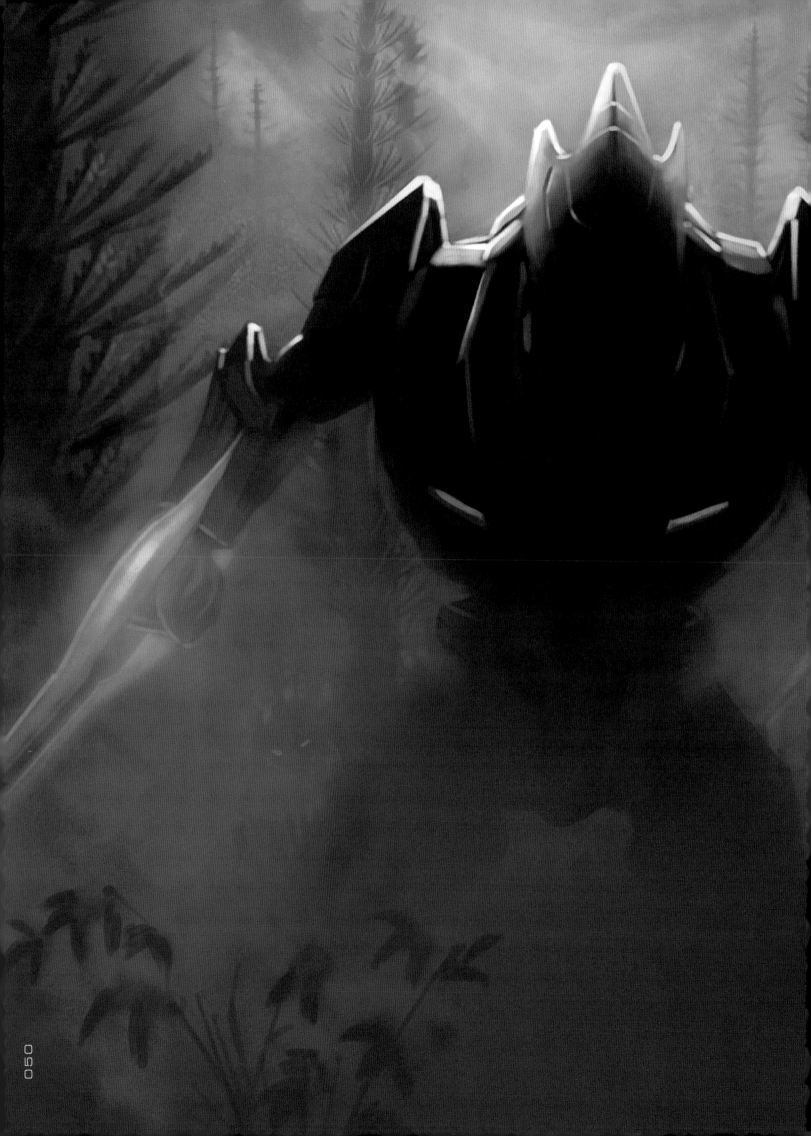

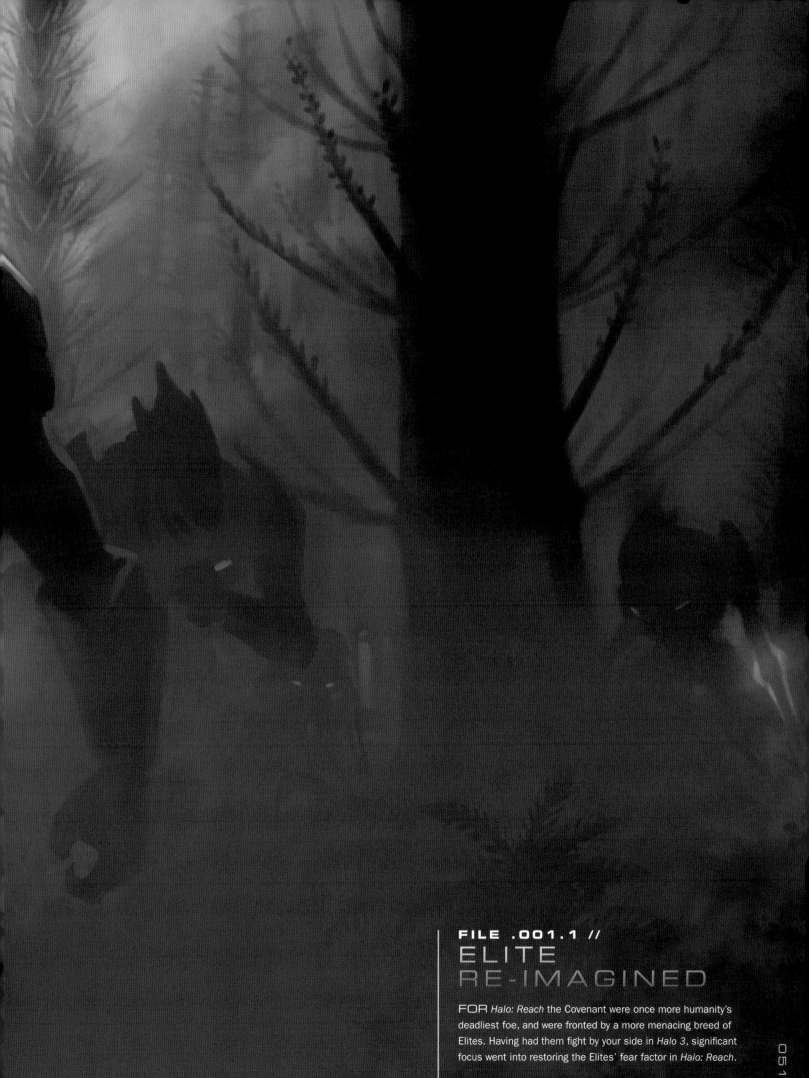

## FILE .001.1 //
# ELITE
# RE-IMAGINED

FOR *Halo: Reach* the Covenant were once more humanity's deadliest foe, and were fronted by a more menacing breed of Elites. Having had them fight by your side in *Halo 3*, significant focus went into restoring the Elites' fear factor in *Halo: Reach*.

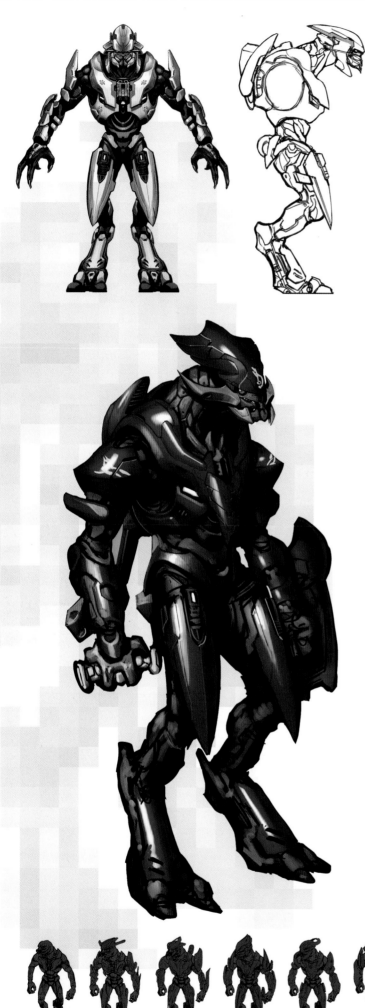

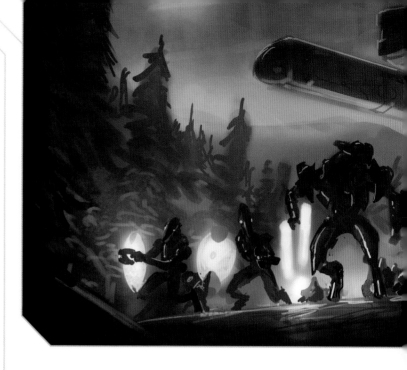

## FILE .001.2 //
# ELITES

WHILE the Elites formed the military might of the Covenant for some time, they would eventually spark the Great Schism, a civil war that brought the Covenant to its knees.

Elites have their own hierarchy, and their rank can be ascertained by the color of their armor. A useful tool on the battlefield, for sure, with gold marking out field commanders, red indicating a veteran, and blue marking out an Elite's status as standard infantry. This selection of Elites culled largely from *Halo: Reach* goes to show some of the variants that make up the game's rich mix.

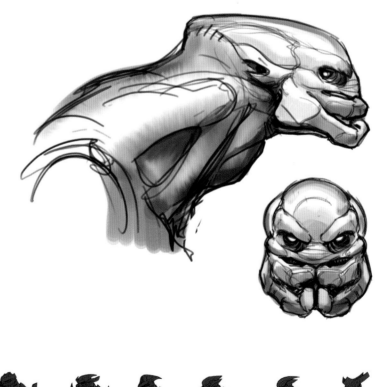

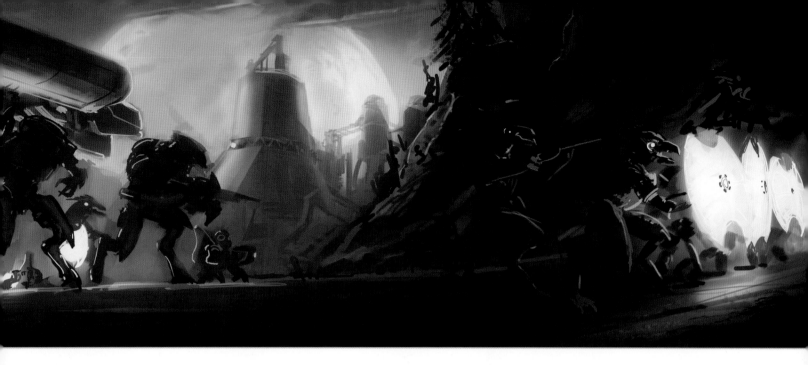

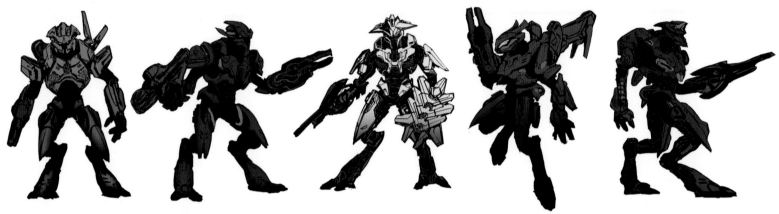

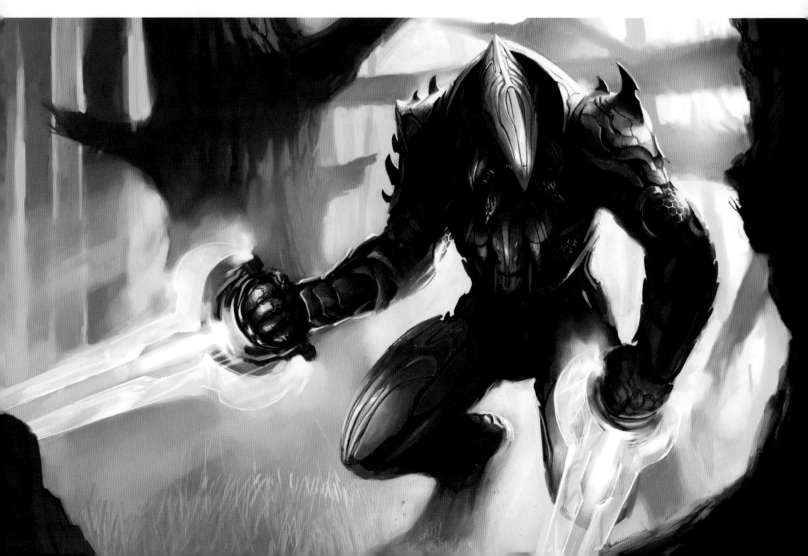

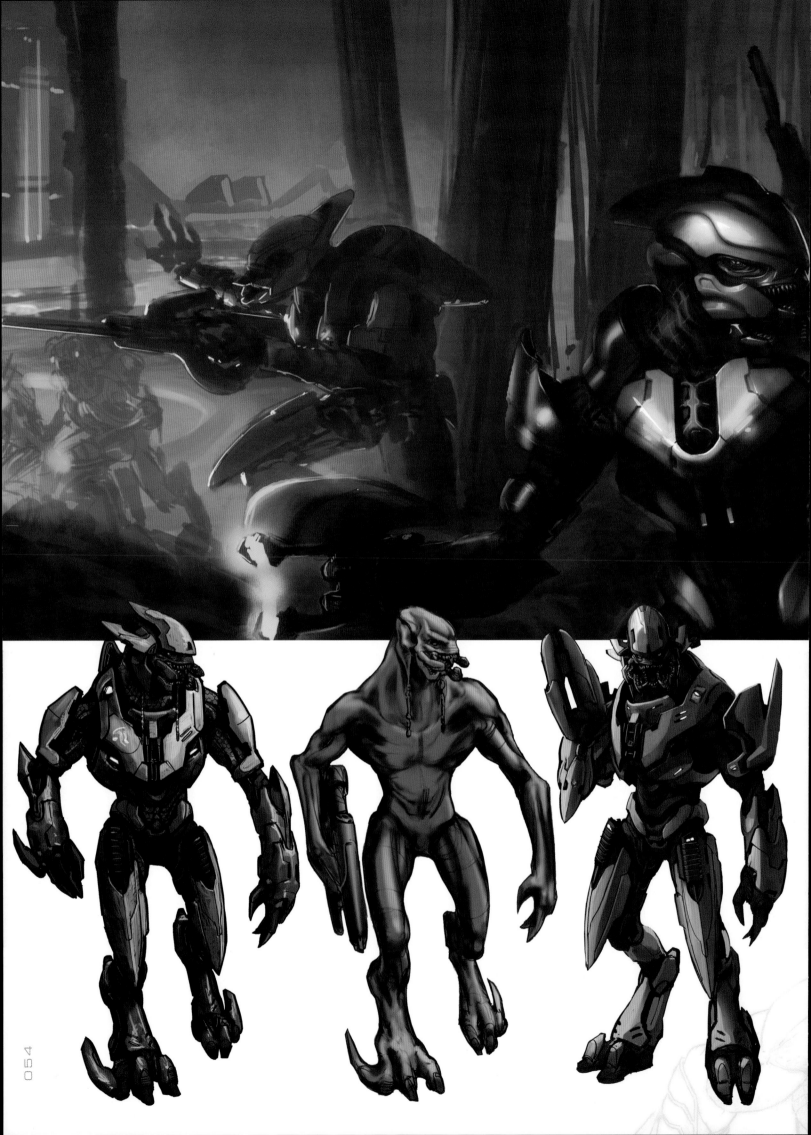

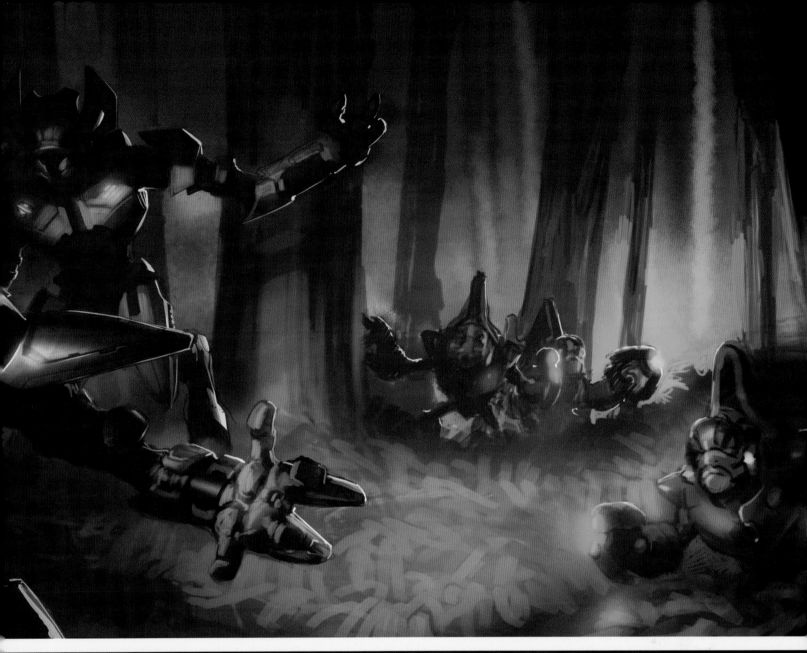

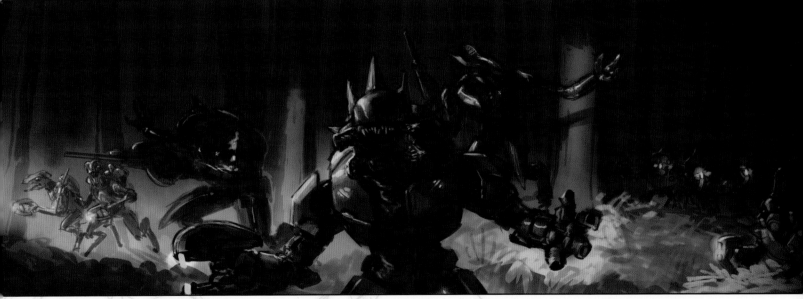

Halo: Reach's menacing breed of Elites were also backed up by stronger AI—not only did they look more terrifying, they also acted more terrifyingly, flanking and outsmarting the player with incredible cunning.

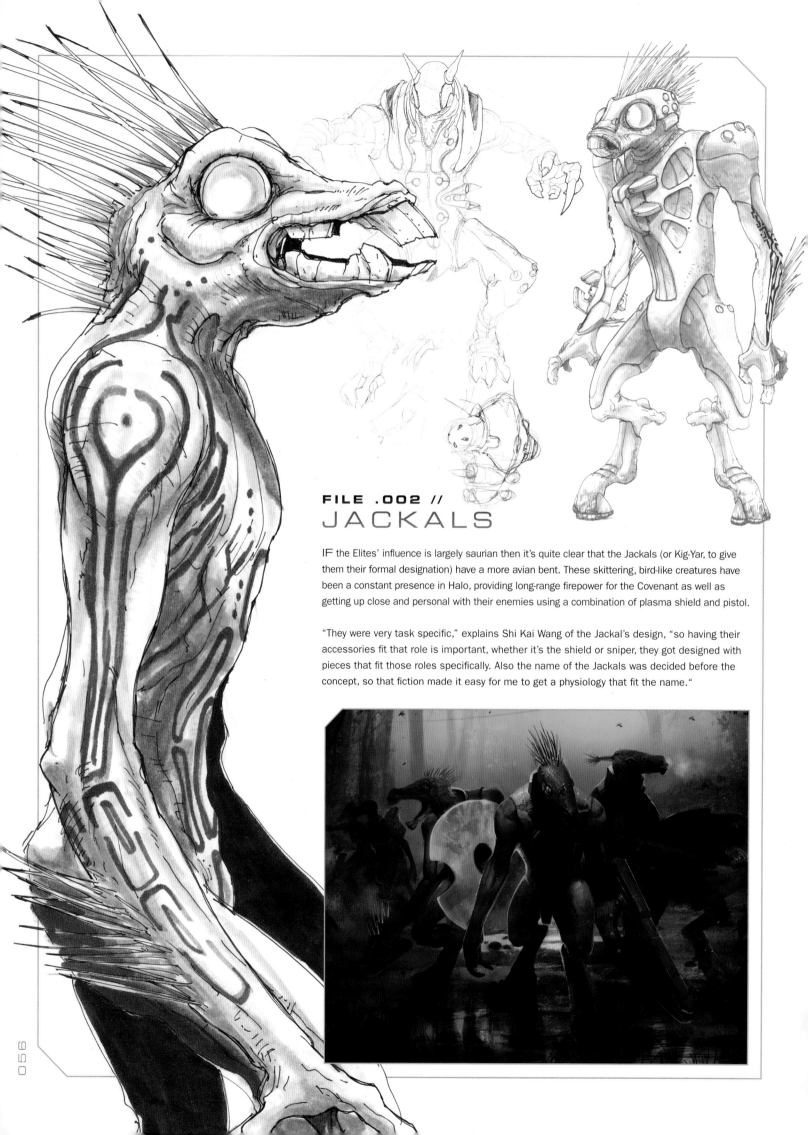

# FILE .002 //
# JACKALS

IF the Elites' influence is largely saurian then it's quite clear that the Jackals (or Kig-Yar, to give them their formal designation) have a more avian bent. These skittering, bird-like creatures have been a constant presence in Halo, providing long-range firepower for the Covenant as well as getting up close and personal with their enemies using a combination of plasma shield and pistol.

"They were very task specific," explains Shi Kai Wang of the Jackal's design, "so having their accessories fit that role is important, whether it's the shield or sniper, they got designed with pieces that fit those roles specifically. Also the name of the Jackals was decided before the concept, so that fiction made it easy for me to get a physiology that fit the name."

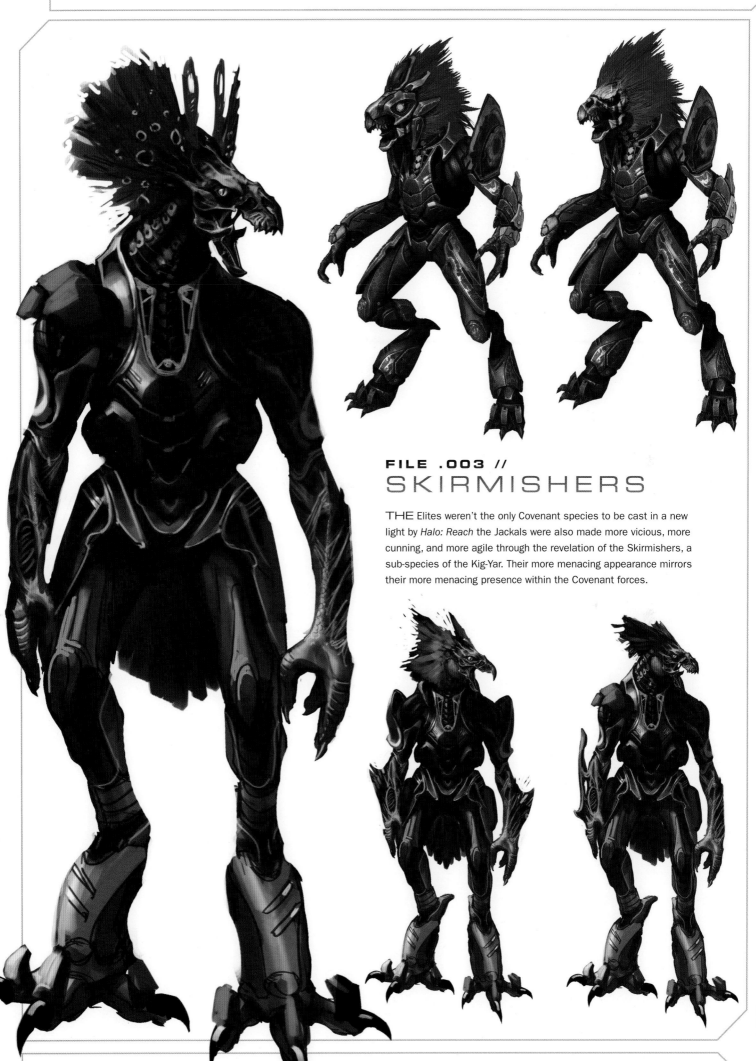

# FILE .003 //
# SKIRMISHERS

THE Elites weren't the only Covenant species to be cast in a new light by *Halo: Reach* the Jackals were also made more vicious, more cunning, and more agile through the revelation of the Skirmishers, a sub-species of the Kig-Yar. Their more menacing appearance mirrors their more menacing presence within the Covenant forces.

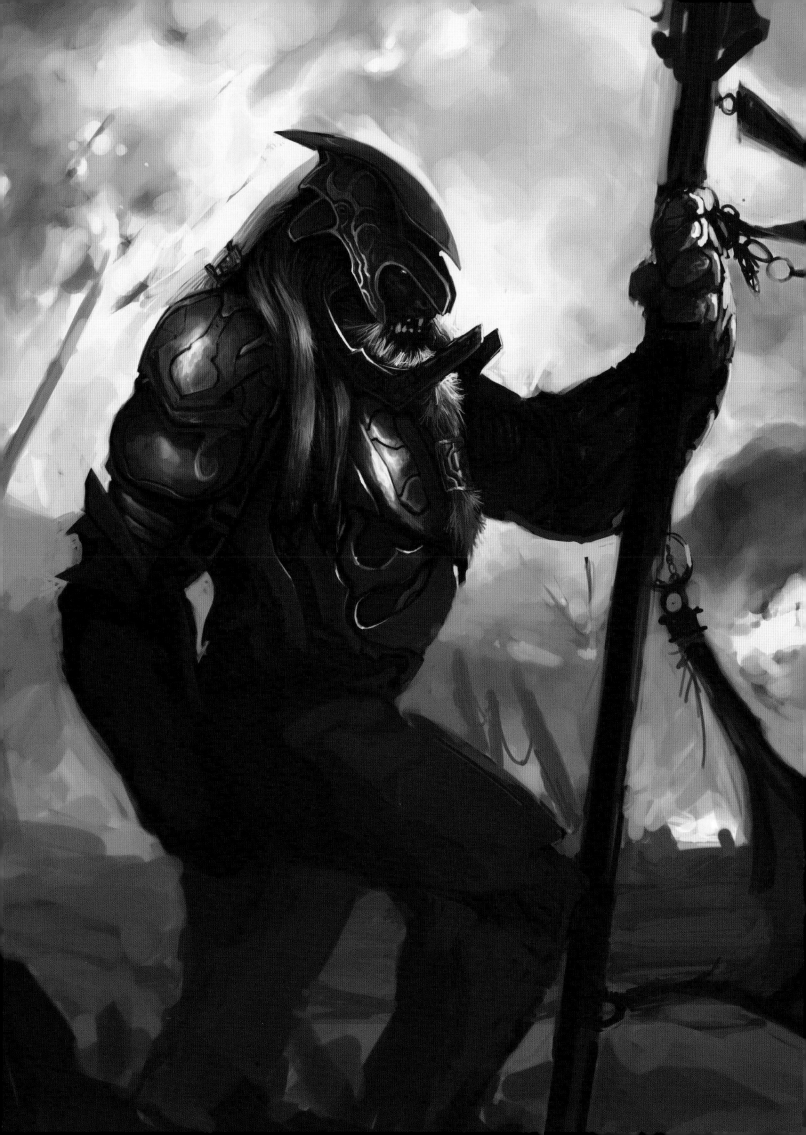

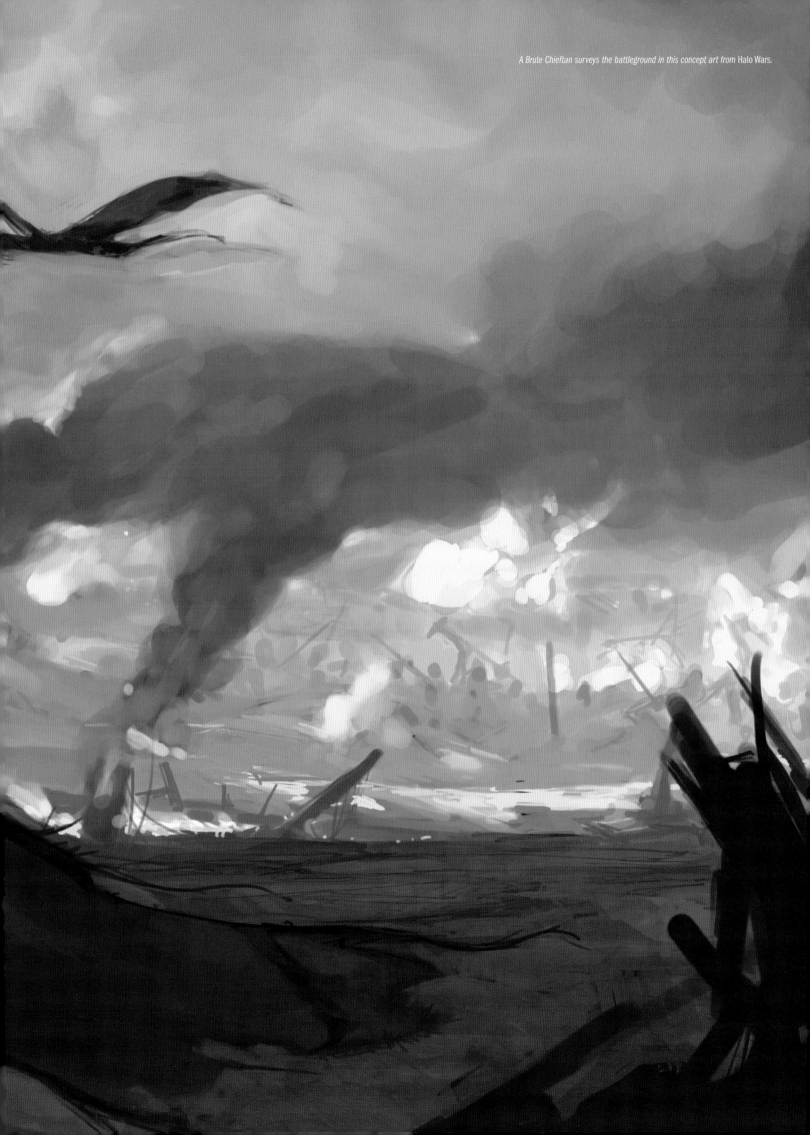

A Brute Chieftan surveys the battleground in this concept art from Halo Wars.

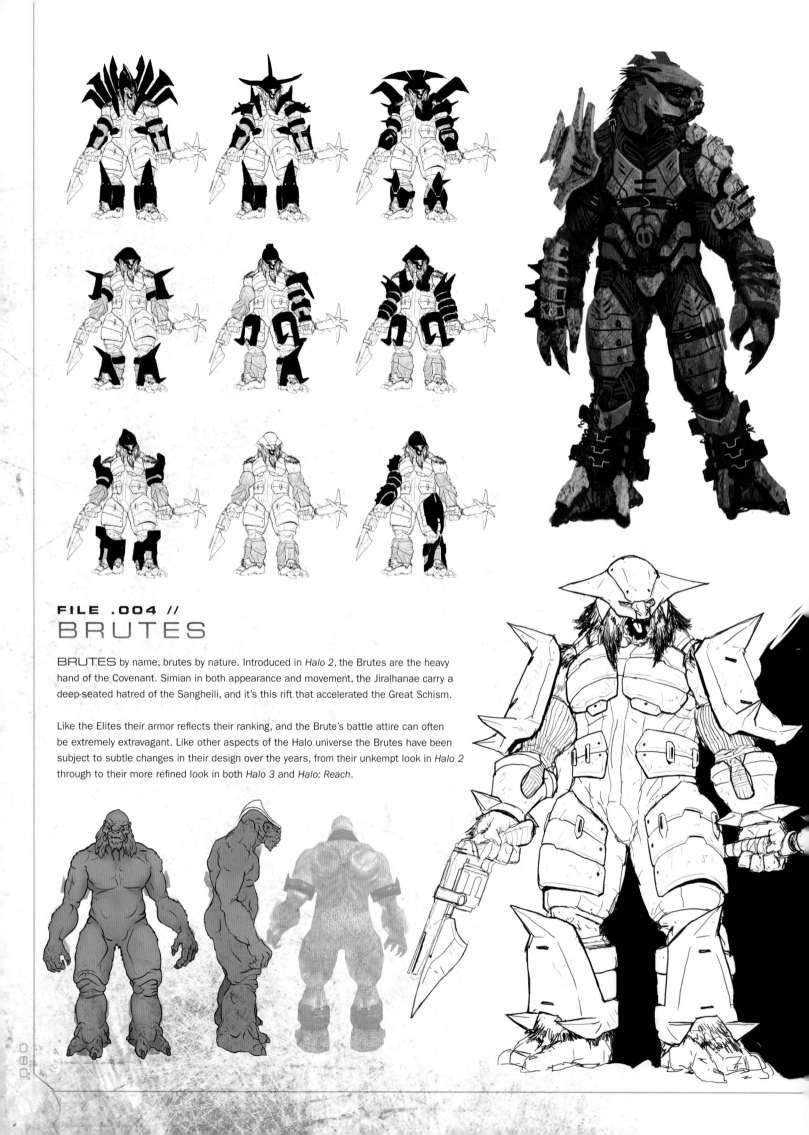

# FILE .004 //
# BRUTES

**BRUTES** by name, brutes by nature. Introduced in *Halo 2*, the Brutes are the heavy hand of the Covenant. Simian in both appearance and movement, the Jiralhanae carry a deep-seated hatred of the Sangheili, and it's this rift that accelerated the Great Schism.

Like the Elites their armor reflects their ranking, and the Brute's battle attire can often be extremely extravagant. Like other aspects of the Halo universe the Brutes have been subject to subtle changes in their design over the years, from their unkempt look in *Halo 2* through to their more refined look in both *Halo 3* and *Halo: Reach*.

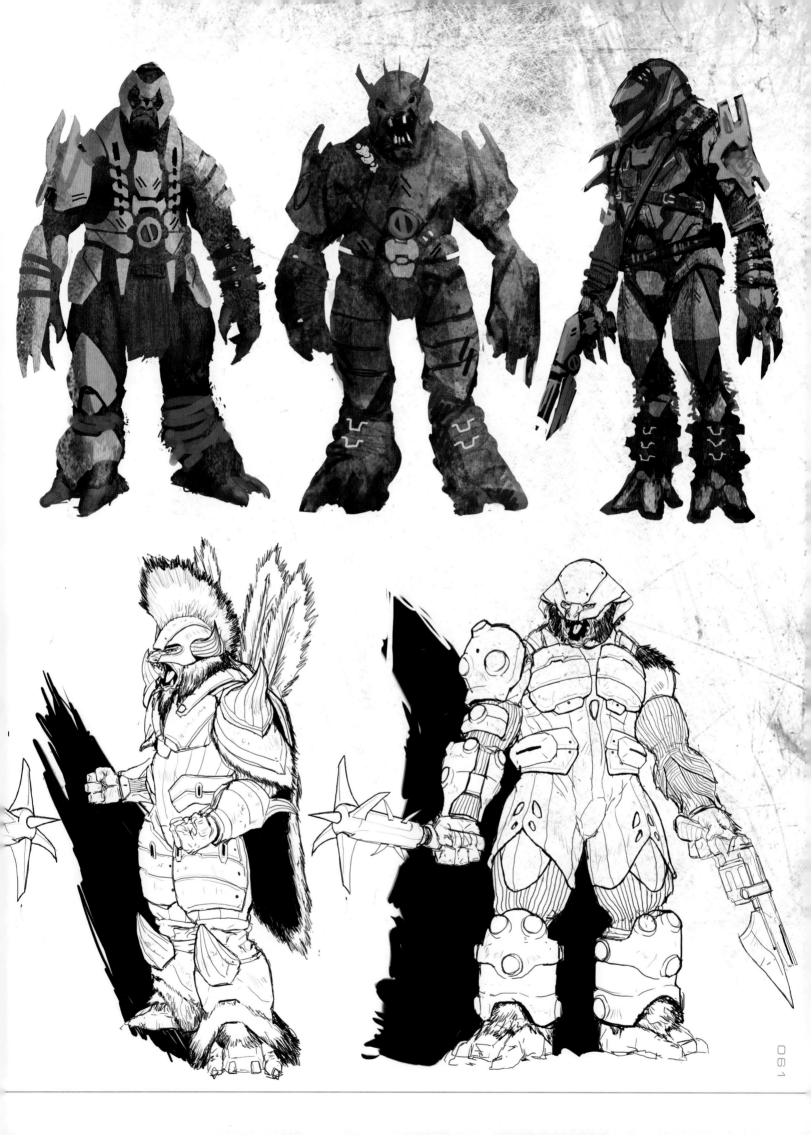

# GRUNTS

THE Unggoy—or Grunts—are the Covenant's comic relief: low in rank, poor on the battlefield, and quick with the quips, they've been a constant source of mirth throughout the series.

"The Grunts—well, they were fodders," admits Shi Kai Wang, "But I wanted to make them fodders that looked iconic, which is where the backpack came in. Later we used those backpacks as ways to differentiate between variants, and ultimately a fun way to blow them apart."

Grunts move in packs, and are often accompanied by a commanding Elite. They may be weak in battle, but in numbers they've been the undoing of many a Halo player.

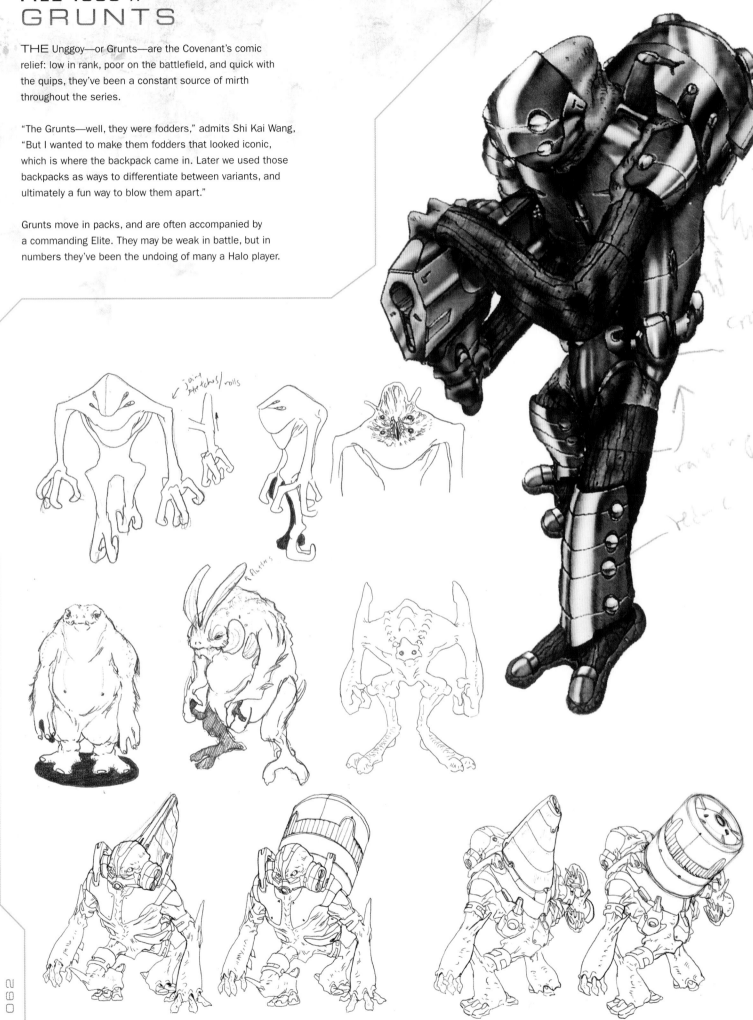

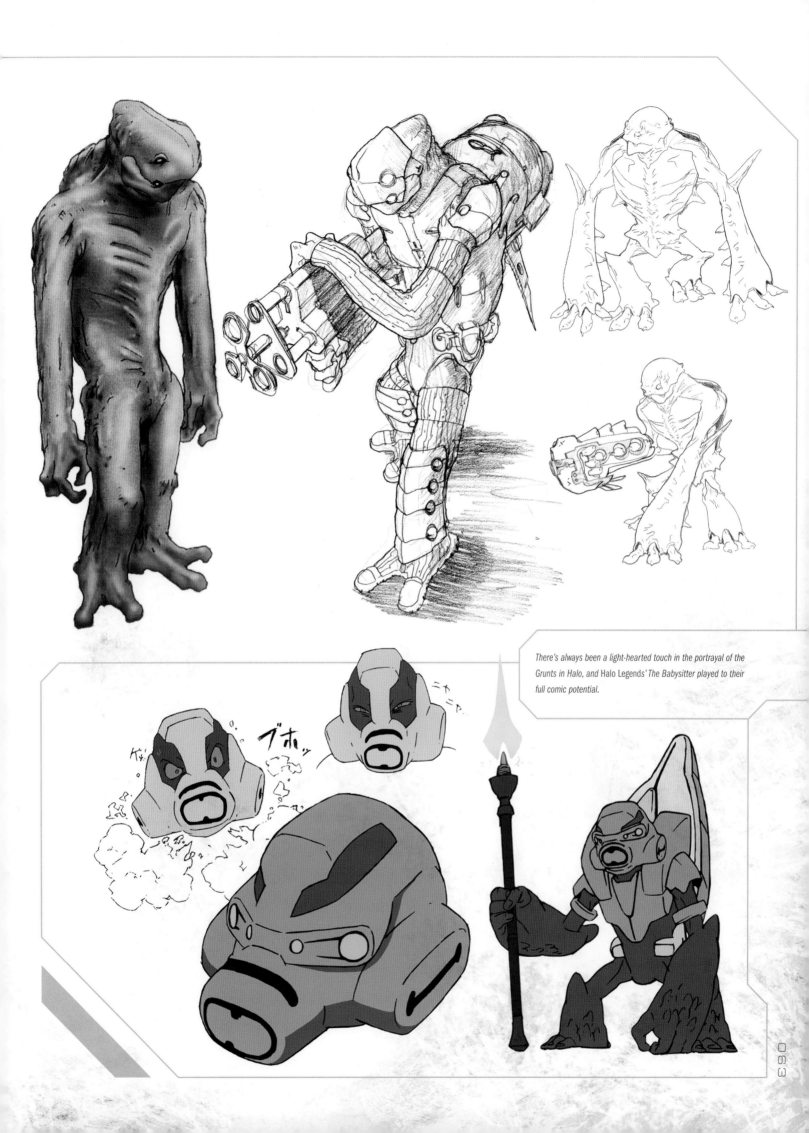

There's always been a light-hearted touch in the portrayal of the Grunts in Halo, and Halo Legends' The Babysitter played to their full comic potential.

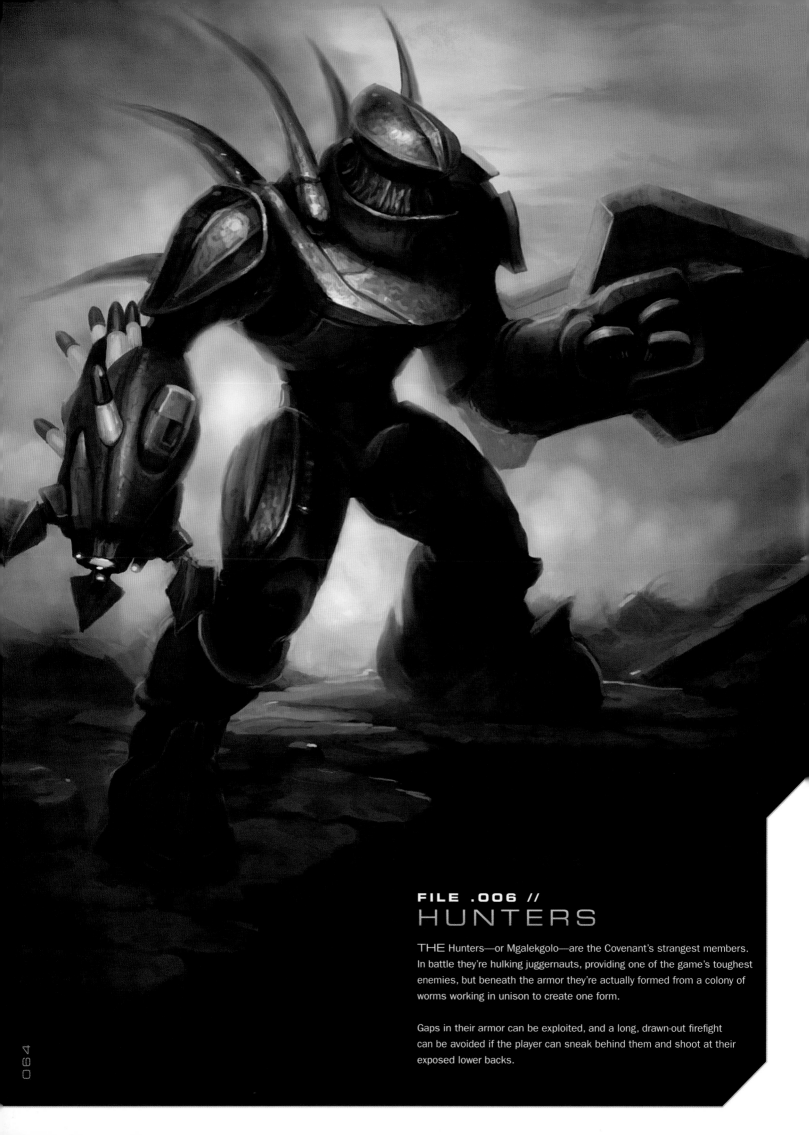

## FILE .006 //
# HUNTERS

THE Hunters—or Mgalekgolo—are the Covenant's strangest members. In battle they're hulking juggernauts, providing one of the game's toughest enemies, but beneath the armor they're actually formed from a colony of worms working in unison to create one form.

Gaps in their armor can be exploited, and a long, drawn-out firefight can be avoided if the player can sneak behind them and shoot at their exposed lower backs.

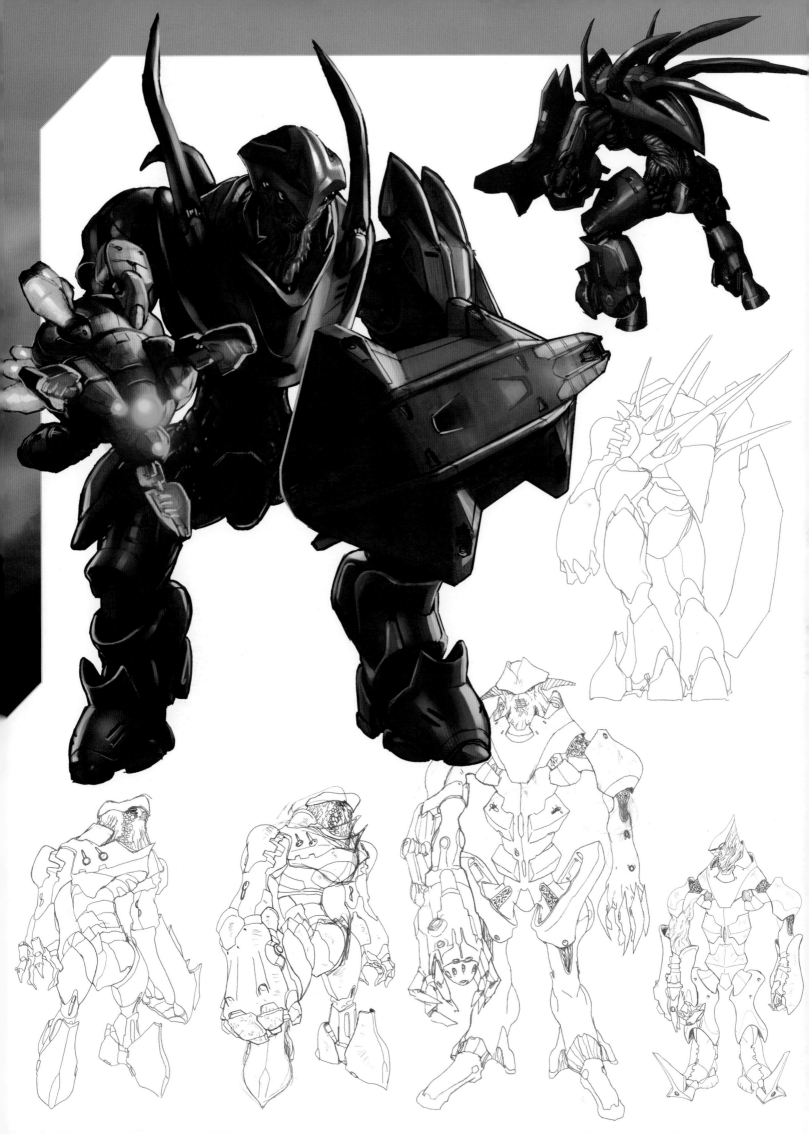

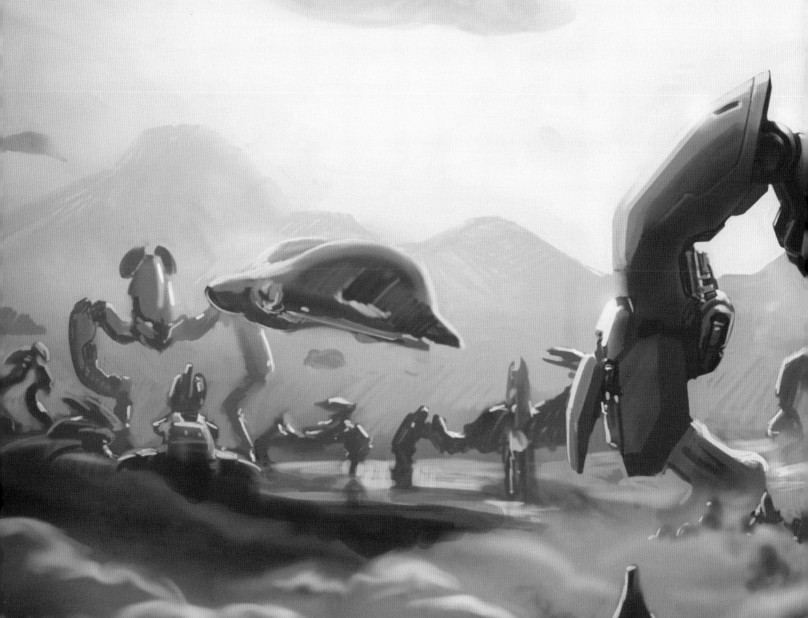

# CH.003

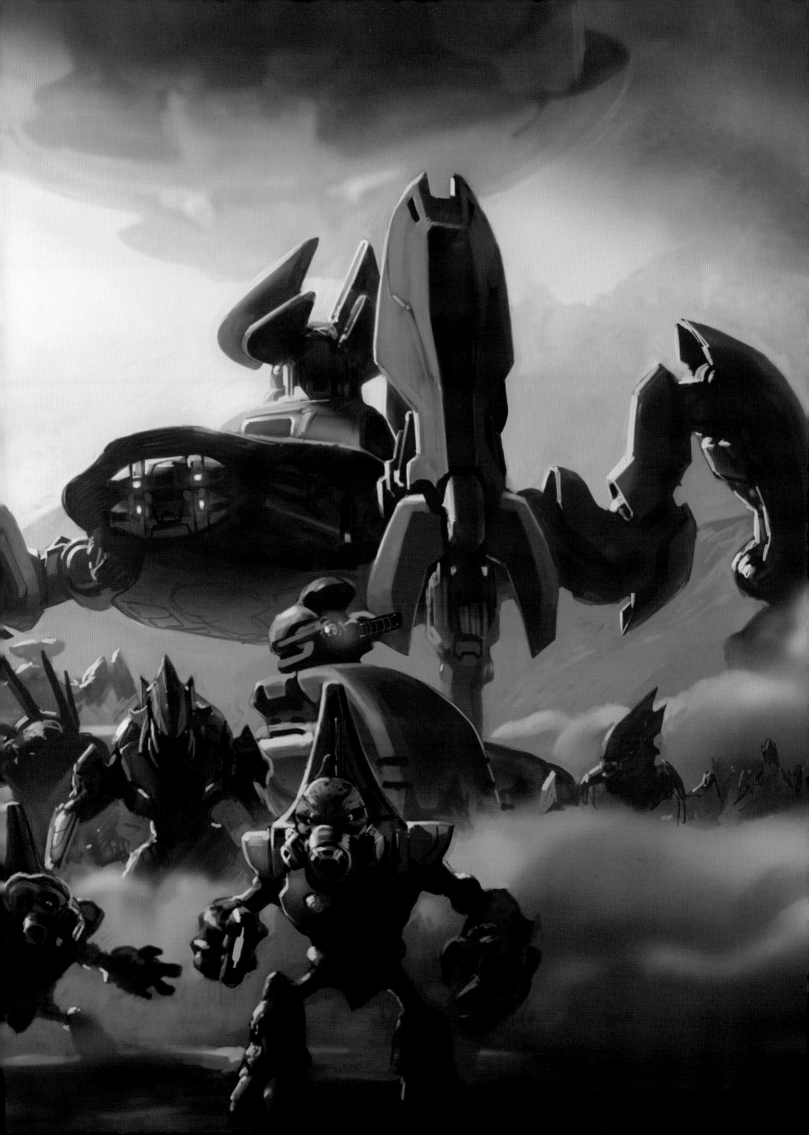

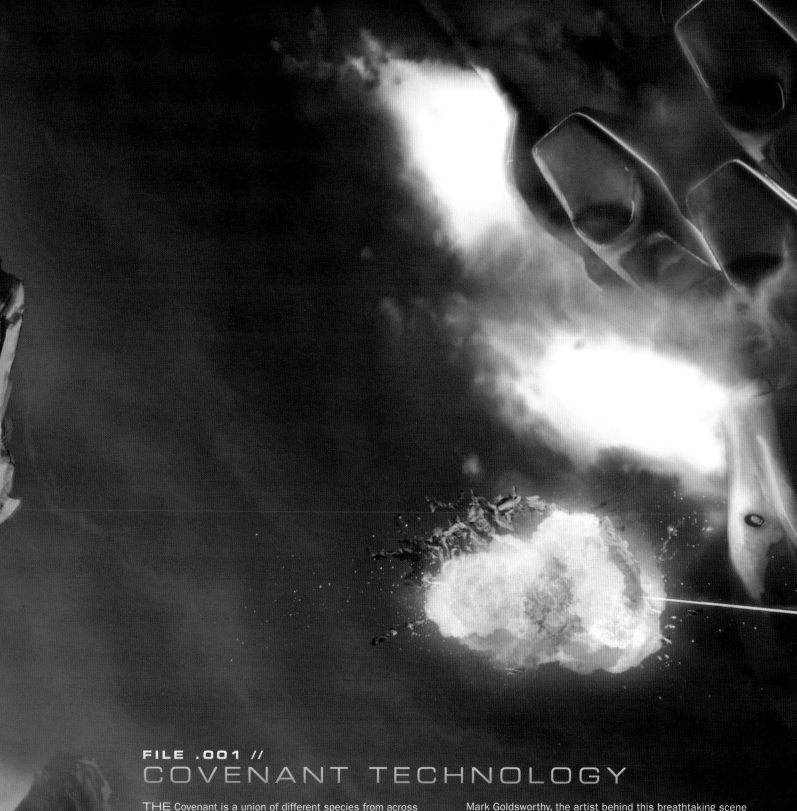

# FILE .001 //
# COVENANT TECHNOLOGY

THE Covenant is a union of different species from across the galaxy united by their religious fanaticism, and their tools in this holy war are awe-inspiring. Covenant technology exists in parallel with the tools of the UNSC—an effect of the desire to create a game world that's in perfect balance—but its alien nature makes it that much more fantastical.

The UNSC's bullets meet with luminous plasma fire from Covenant energy rifles, the Warthogs are chased down by floating purple Ghosts and the Hornets engage in dogfights with pirouetting Banshees.

A Covenant military onslaught is a fantastical sight, a fact played out on an impressive scale throughout Halo: Reach.

Mark Goldsworthy, the artist behind this breathtaking scene in Halo: Reach, tells the tale of his creation:

"The moment the Black Ship appears in Reach is a major surprise. I wanted to capture the immense and intimidating feel of the ship against the tiny UNSC frigates that were fleeing. Thus the camera angle is like an ant looking up at a giant.

"The Black Ship was a low poly in-game model that I increased the geometry resolution in order to give it a smoother look when rendered in mental ray. Then much post work was painted in Photoshop to create the illusion of the ship coming out of the clouds."

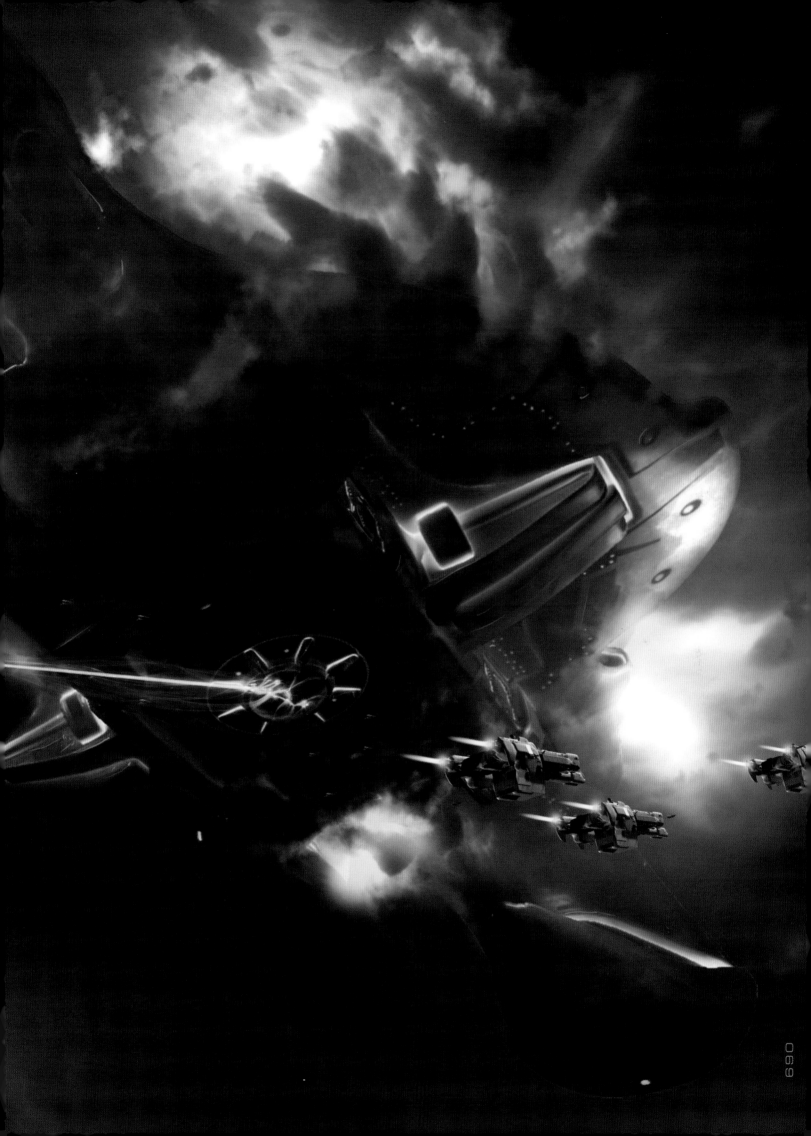

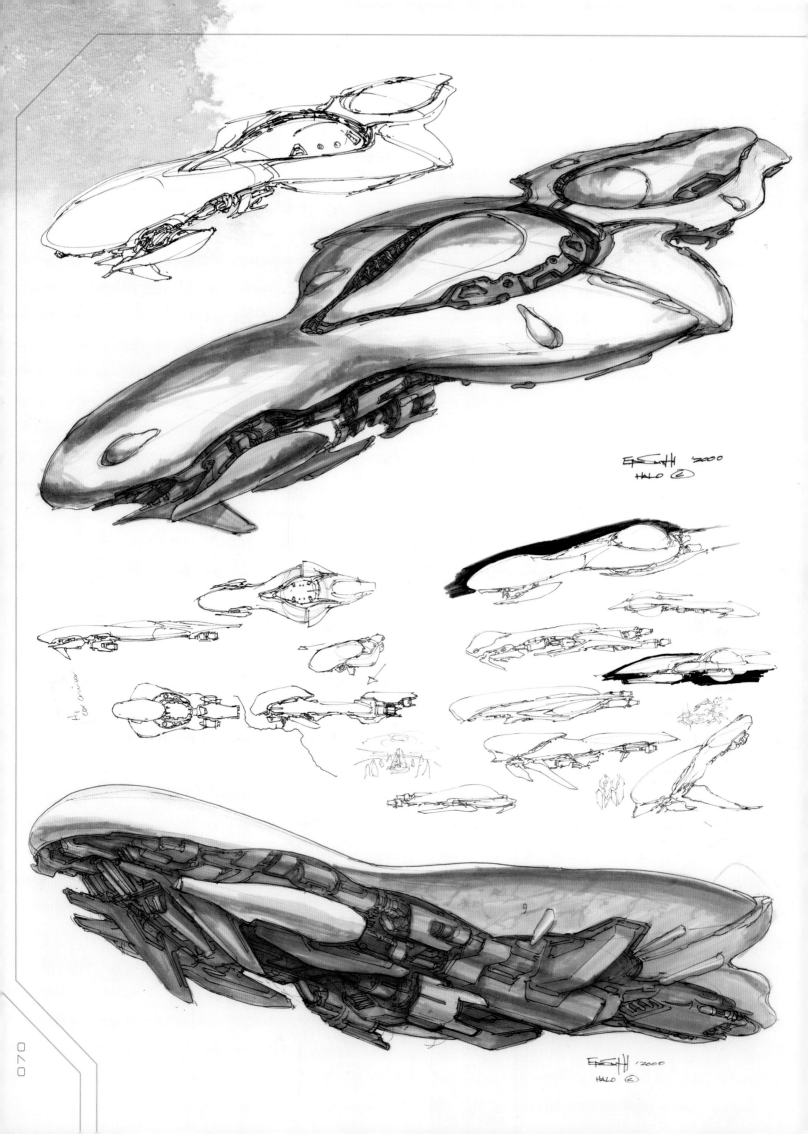

## FILE .002 //
# TRUTH AND RECONCILIATION

ONE of *Halo: Combat Evolved*'s big story beats sees the Master Chief climb aboard the *Truth and Reconciliation*, a large-scale Covenant cruiser, in an attempt to free the imprisoned Captain Keyes. It's the first time the player gets up close to Covenant technology, and its hallways and hangars are a novel creation, with smooth lines bathed in extra-terrestrial light.

Covenant interiors such as that of the *Truth and Reconciliation* have added to Halo's rich palette throughout the series, be that in *Halo 2*'s *High Charity* or the corvette of *Halo: Reach*.

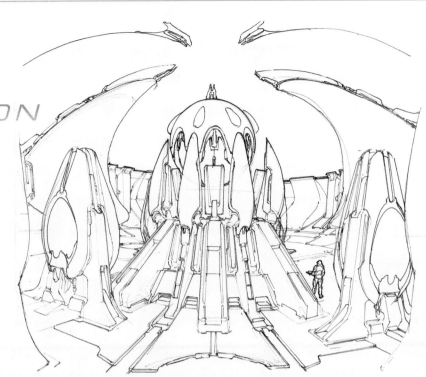

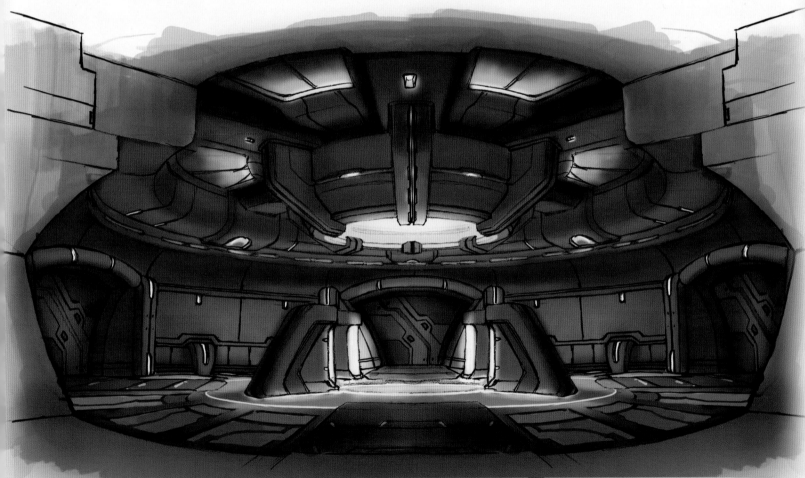

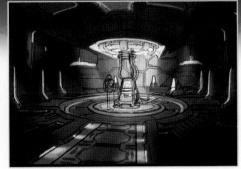

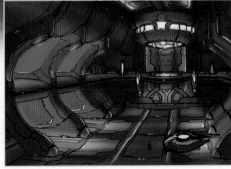

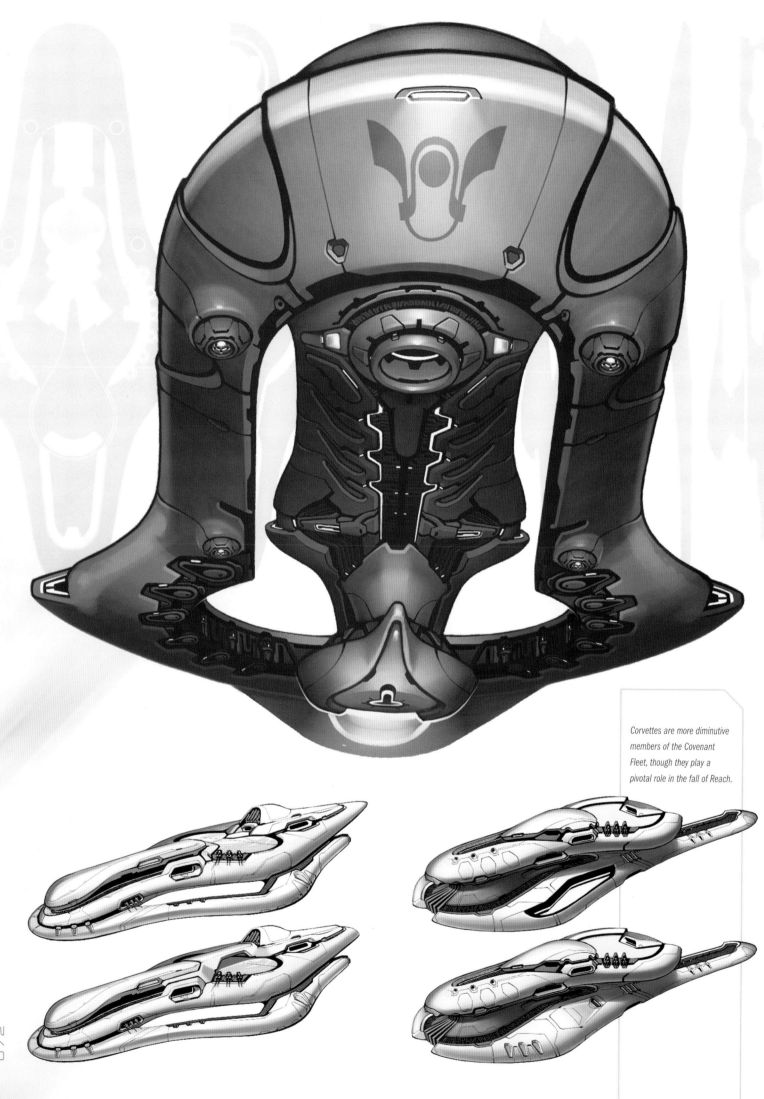

Corvettes are more diminutive
members of the Covenant
Fleet, though they play a
pivotal role in the fall of Reach.

## FILE .003 //
# CORVETTE

*FOR Halo: Reach's* corvette—which is featured at the climax of the centerpiece mission, "The Long Night of Solace"—artist Glenn Israel created something new yet familiar using motifs from the Covenant cruiser. The hatches and corridors are familiar from *Halo: Combat Evolved's Truth and Reconciliation*, but the lines have been tidied and the vision has more clarity. With the added processing power of the Xbox 360, the level of detail attainable in the final game jumped significantly.

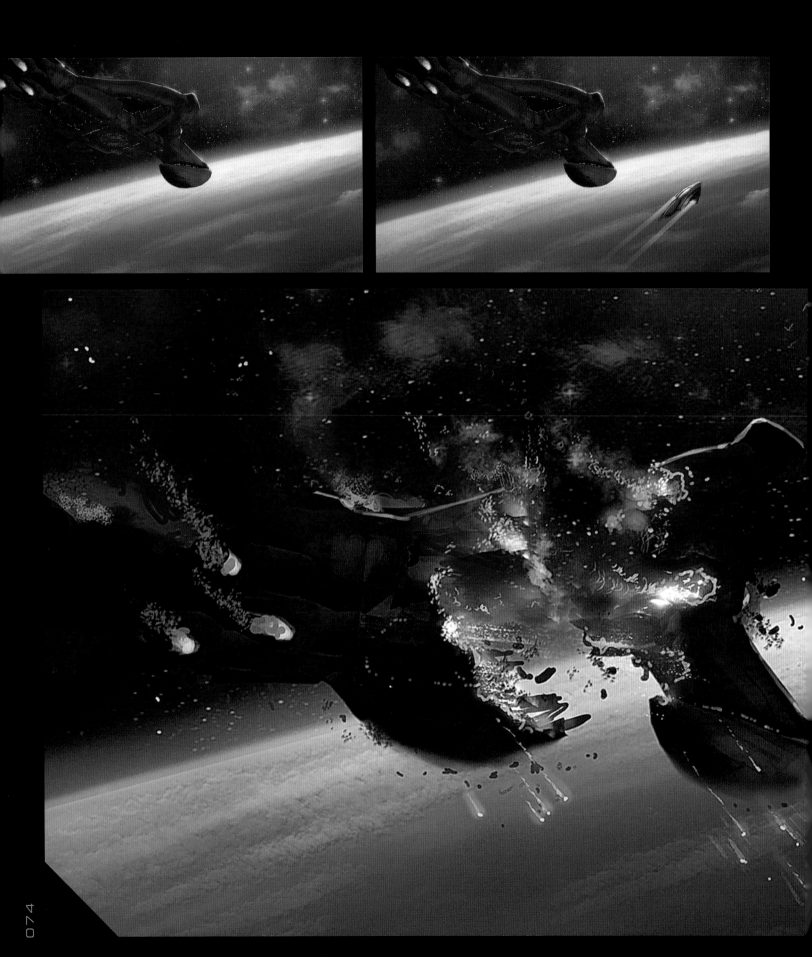

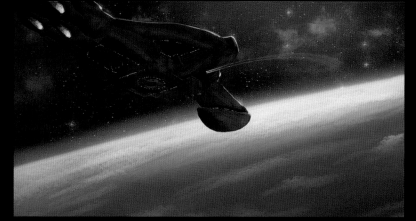

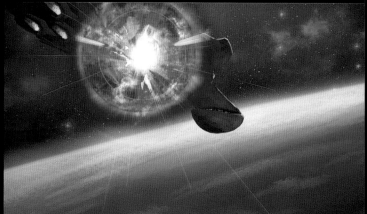

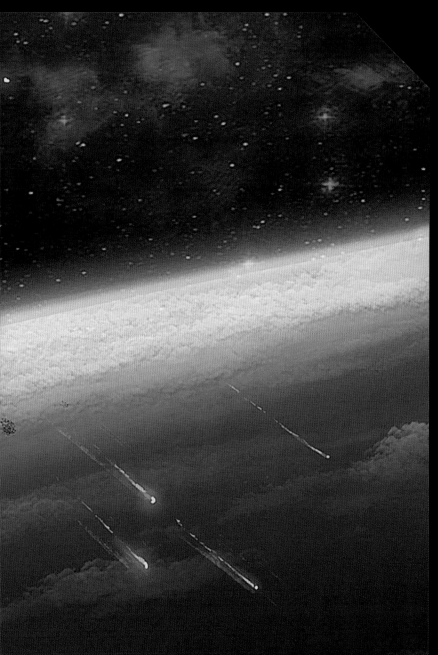

# FILE .004 //
# SUPERCARRIER
# DESTROYED

AERIAL warfare's always played a part in the Halo
story, but it wasn't until *Halo: Reach* that the player could
take to the skies behind the controls of the UNSC's Sabre.

This sequence of images from *Halo: Reach* shows one of
the many dramatic moments that take place amongst the
stars as a supercarrier is spectacularly destroyed.

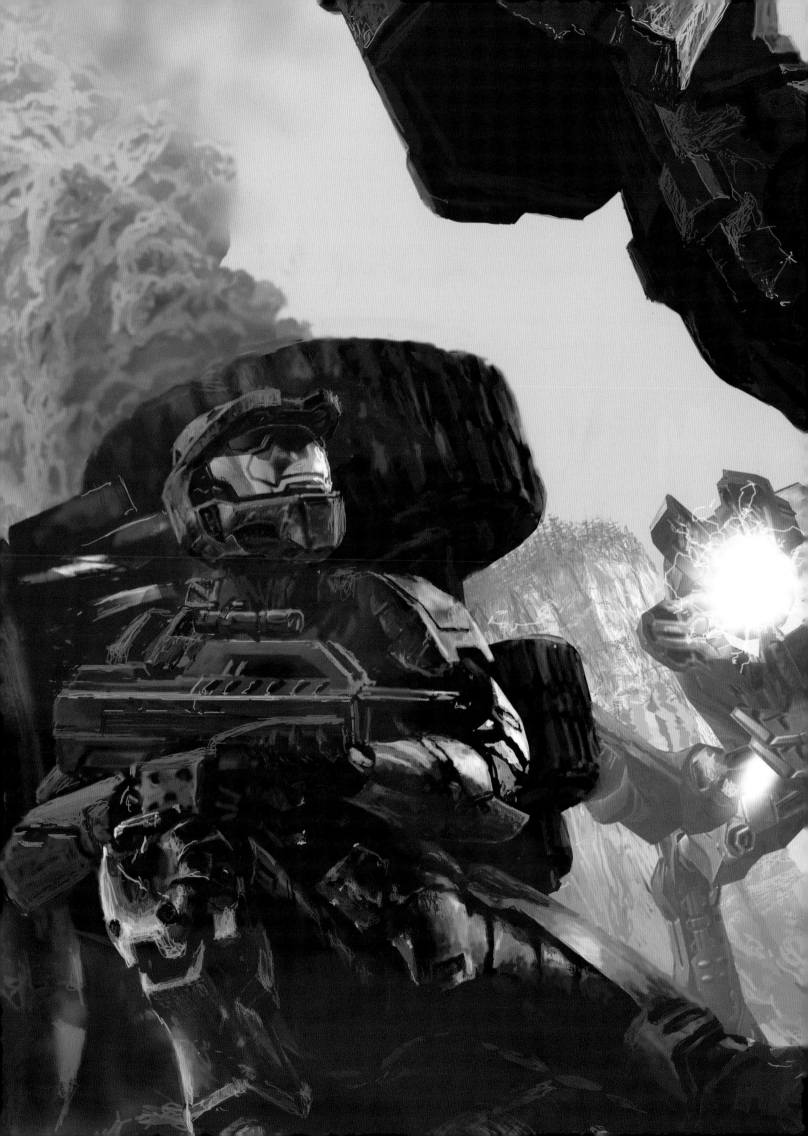

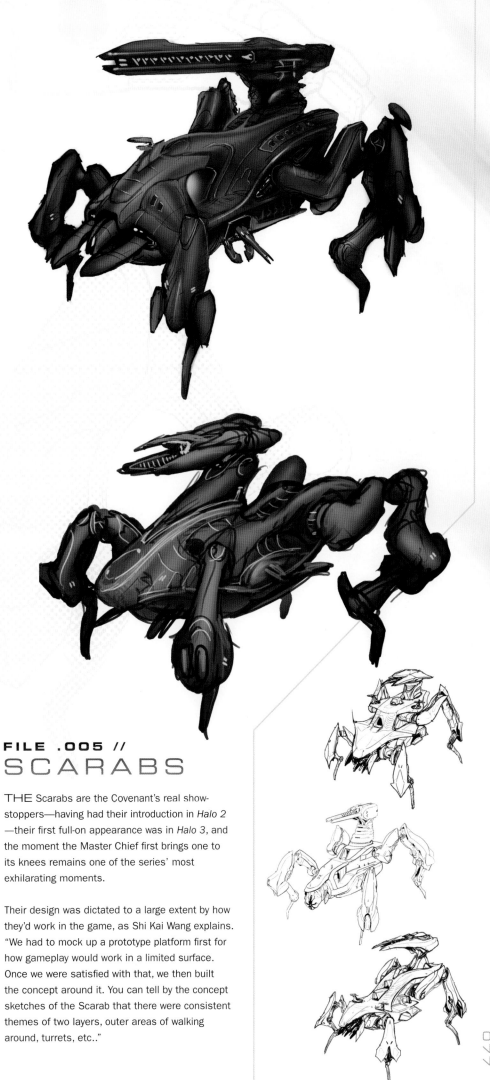

# FILE .005 //
# SCARABS

THE Scarabs are the Covenant's real show-stoppers—having had their introduction in *Halo 2* —their first full-on appearance was in *Halo 3*, and the moment the Master Chief first brings one to its knees remains one of the series' most exhilarating moments.

Their design was dictated to a large extent by how they'd work in the game, as Shi Kai Wang explains. "We had to mock up a prototype platform first for how gameplay would work in a limited surface. Once we were satisfied with that, we then built the concept around it. You can tell by the concept sketches of the Scarab that there were consistent themes of two layers, outer areas of walking around, turrets, etc.."

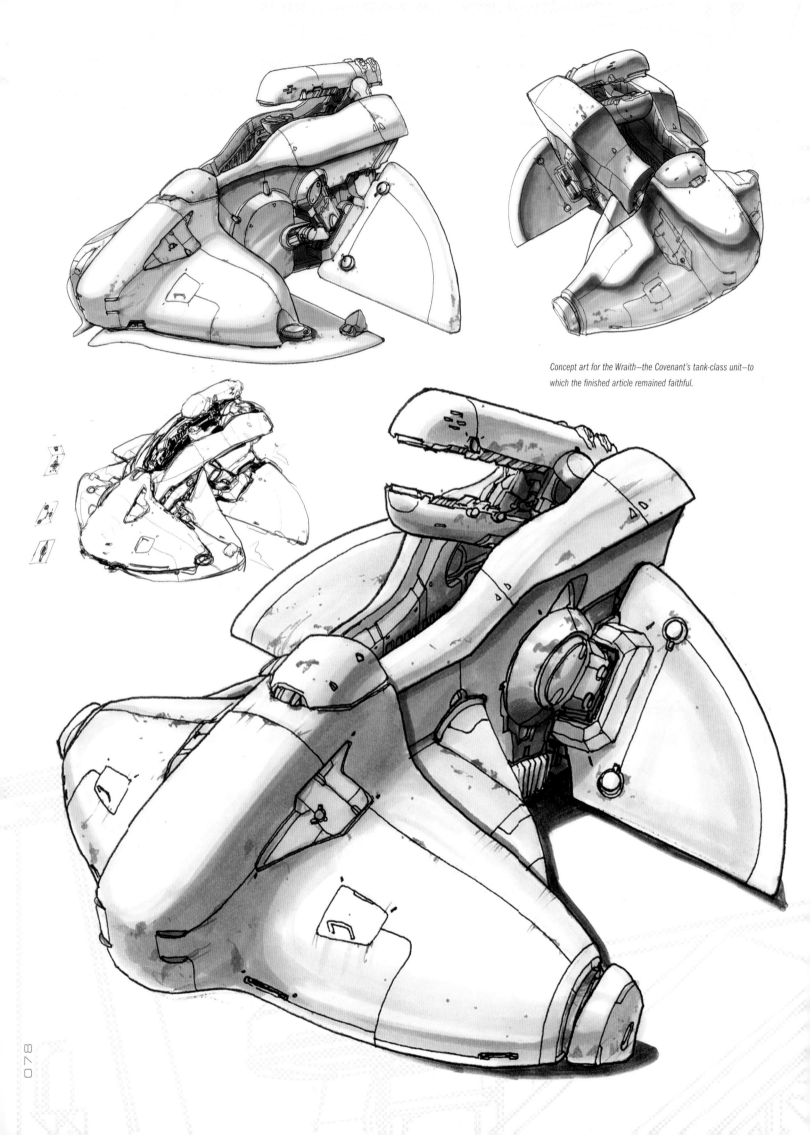

Concept art for the Wraith—the Covenant's tank-class unit—to which the finished article remained faithful.

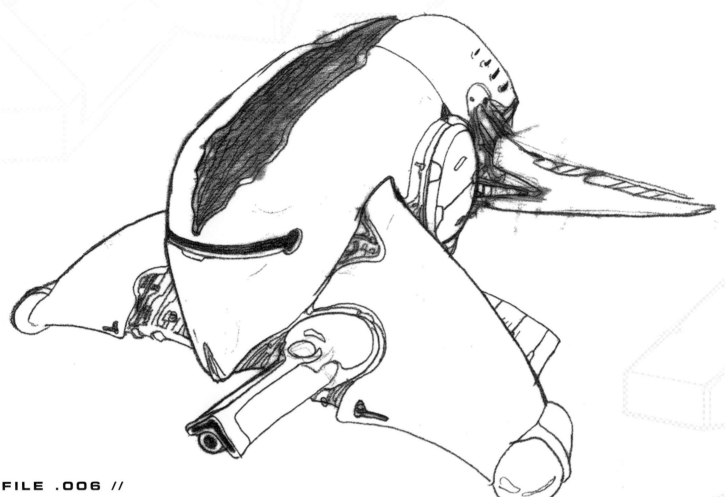

# FILE .006 //
# COVENANT
# GROUND FLEET

"The earlier designs in *Halo: Combat Evolved* had more of that sort of exploration—where the concept influenced the object's purpose in the game," says Shi Kai Wang of the birth of the Covenant's ground forces.

"For example, the Wraith was designed as some sort of Covenant tank. But there weren't any real ideas of how they should shoot and what they should shoot. But the concepts made them look more like vehicles that lobbed artillery than a straight projectile-shooting tank. I think that helped to drive the decision for how the Wraiths could be used in the game finally."

Wraiths and Ghosts are at the backbone of the Covenant military, and while other vehicles have joined them over the years they're the real bread and butter. Coming up against a Wraith and taking it down with some rifle fire and a well thrown grenade is as exciting now as it was in the first game.

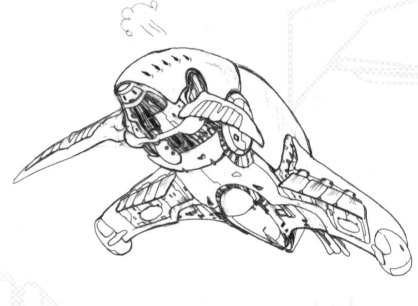

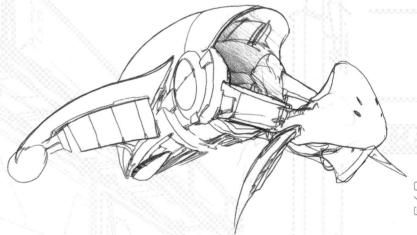

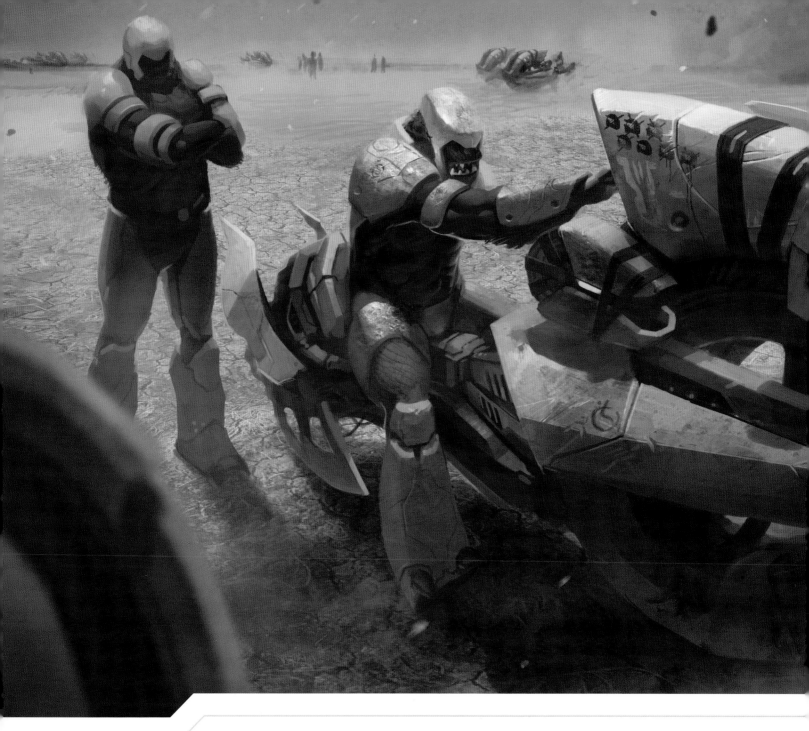

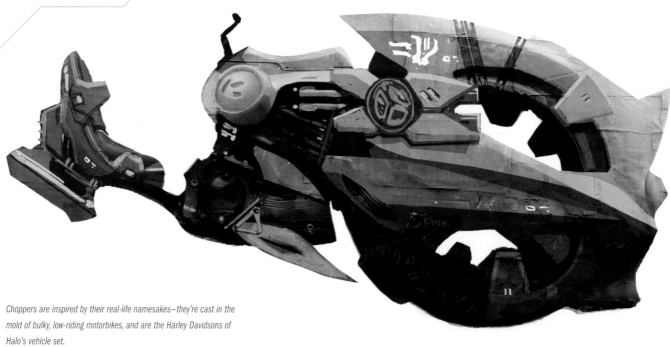

Choppers are inspired by their real-life namesakes—they're cast in the mold of bulky, low-riding motorbikes, and are the Harley Davidsons of Halo's vehicle set.

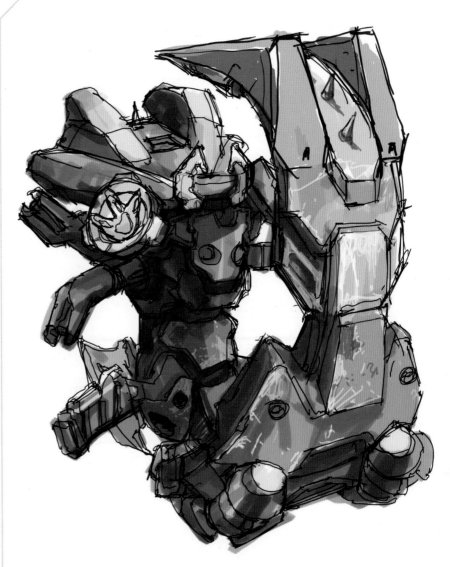

As Halo 3 brought the Brutes to the fore it also introduced some of their own vehicles. The Type-25 Rapid Assault Vehicle—or Chopper—is an apt choice of ride for the Brutes; it's thuggish, somewhat unwieldy, and utterly lethal.

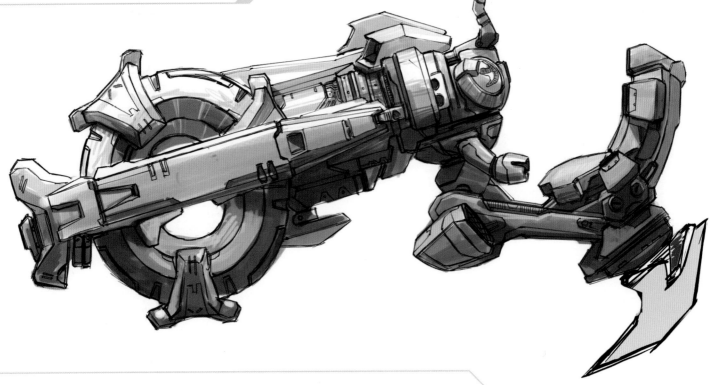

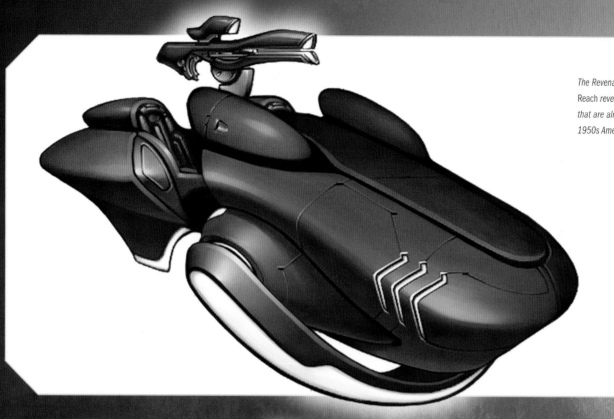

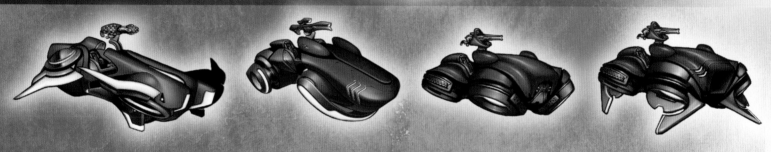

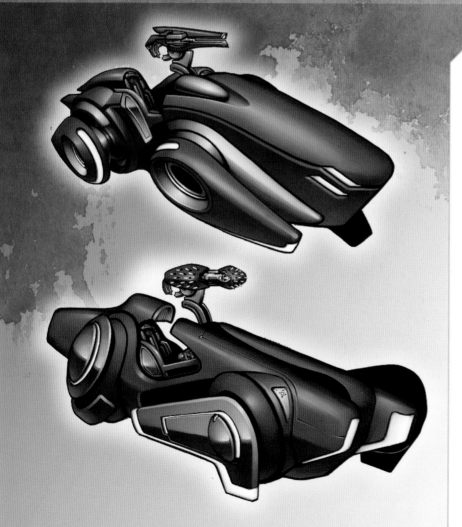

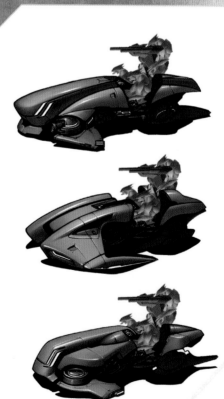

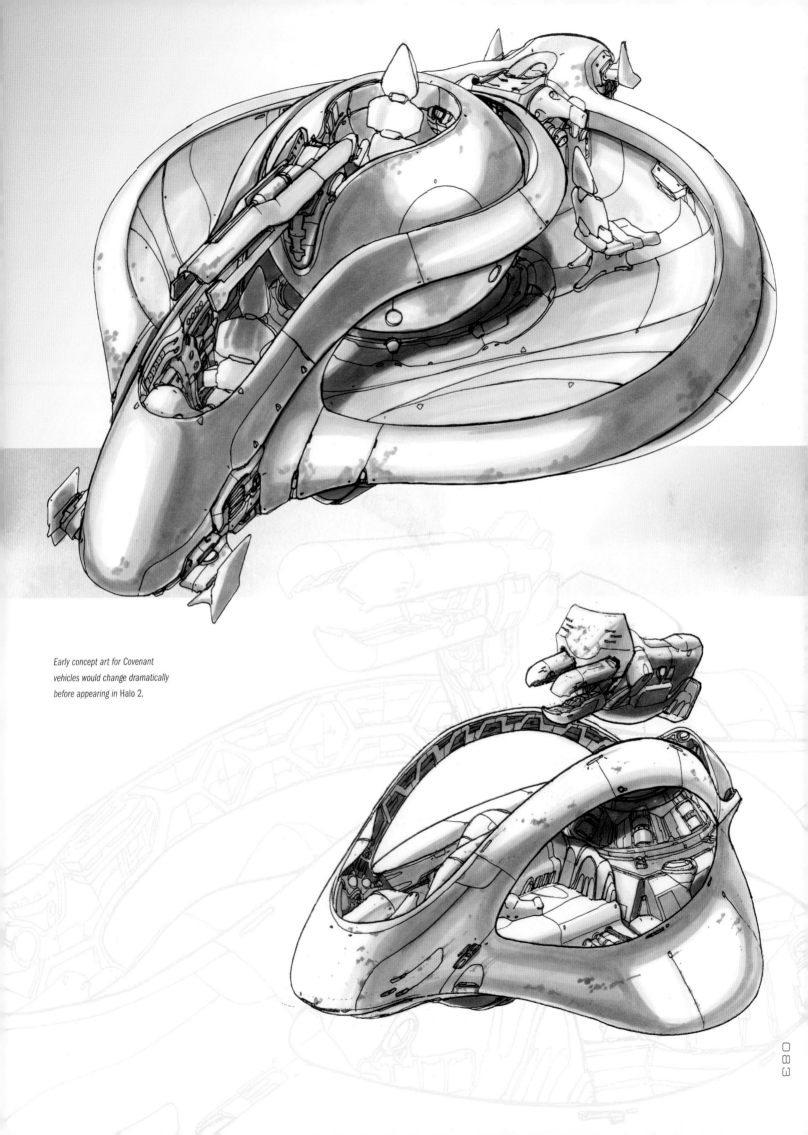

*Early concept art for Covenant vehicles would change dramatically before appearing in Halo 2.*

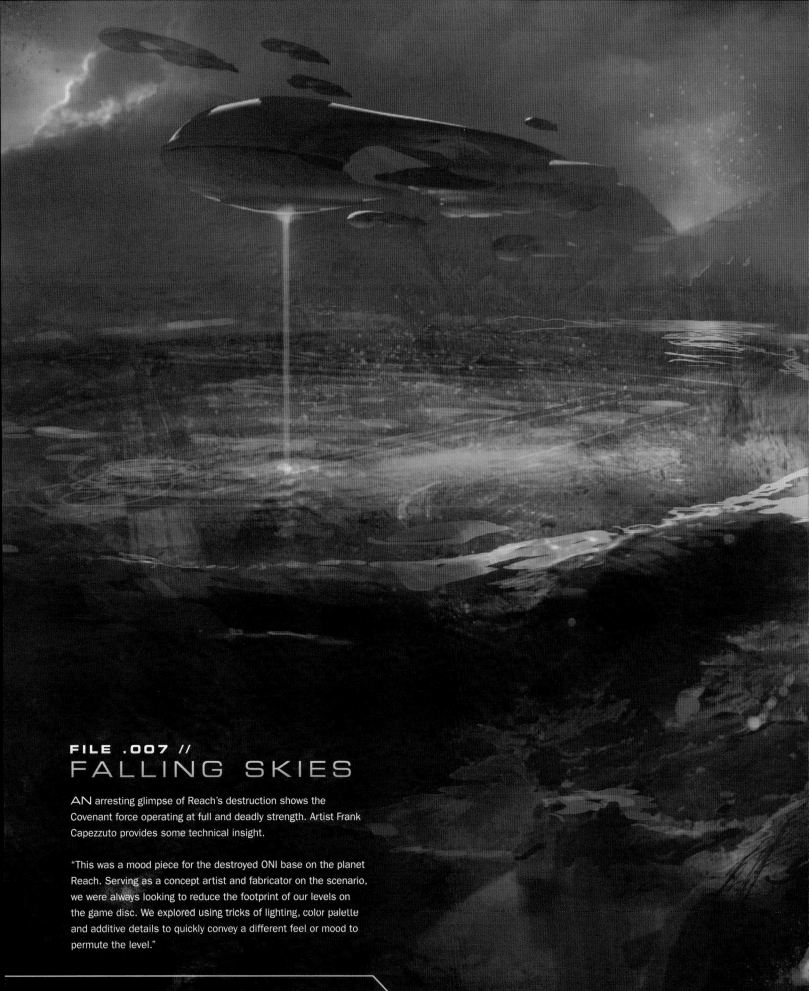

## FILE .007 //
# FALLING SKIES

AN arresting glimpse of Reach's destruction shows the
Covenant force operating at full and deadly strength. Artist Frank
Capezzuto provides some technical insight.

"This was a mood piece for the destroyed ONI base on the planet
Reach. Serving as a concept artist and fabricator on the scenario,
we were always looking to reduce the footprint of our levels on
the game disc. We explored using tricks of lighting, color palette
and additive details to quickly convey a different feel or mood to
permute the level."

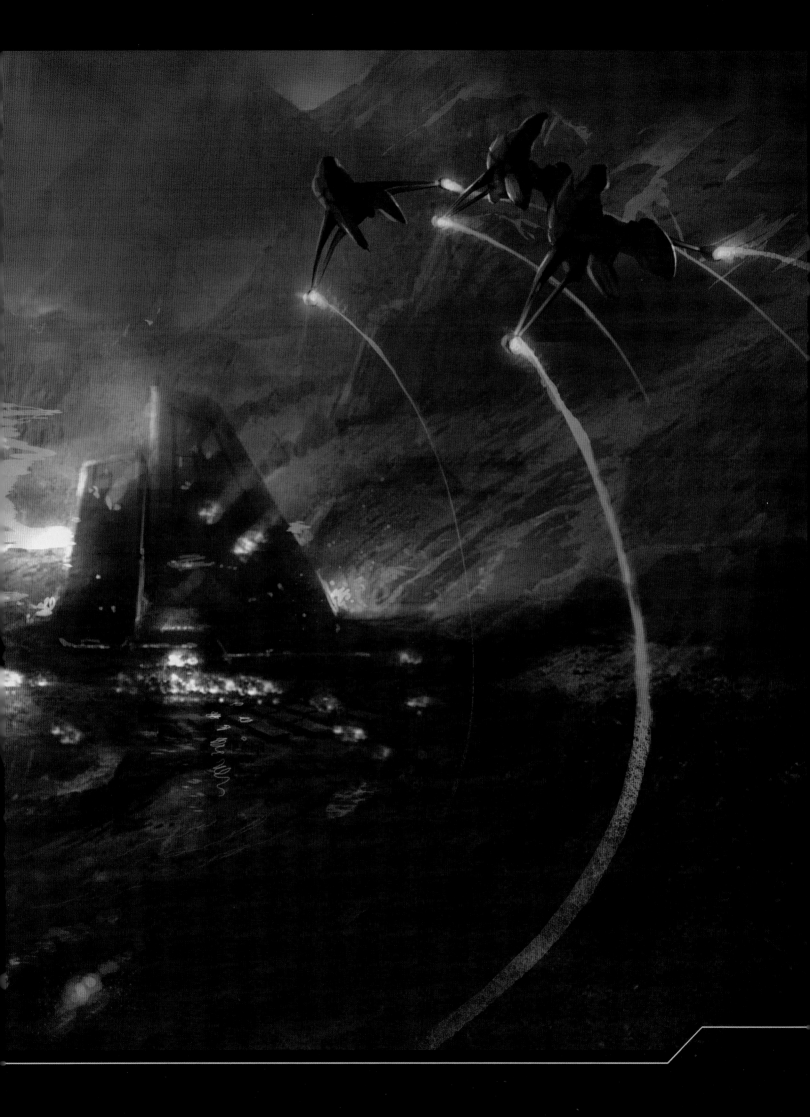

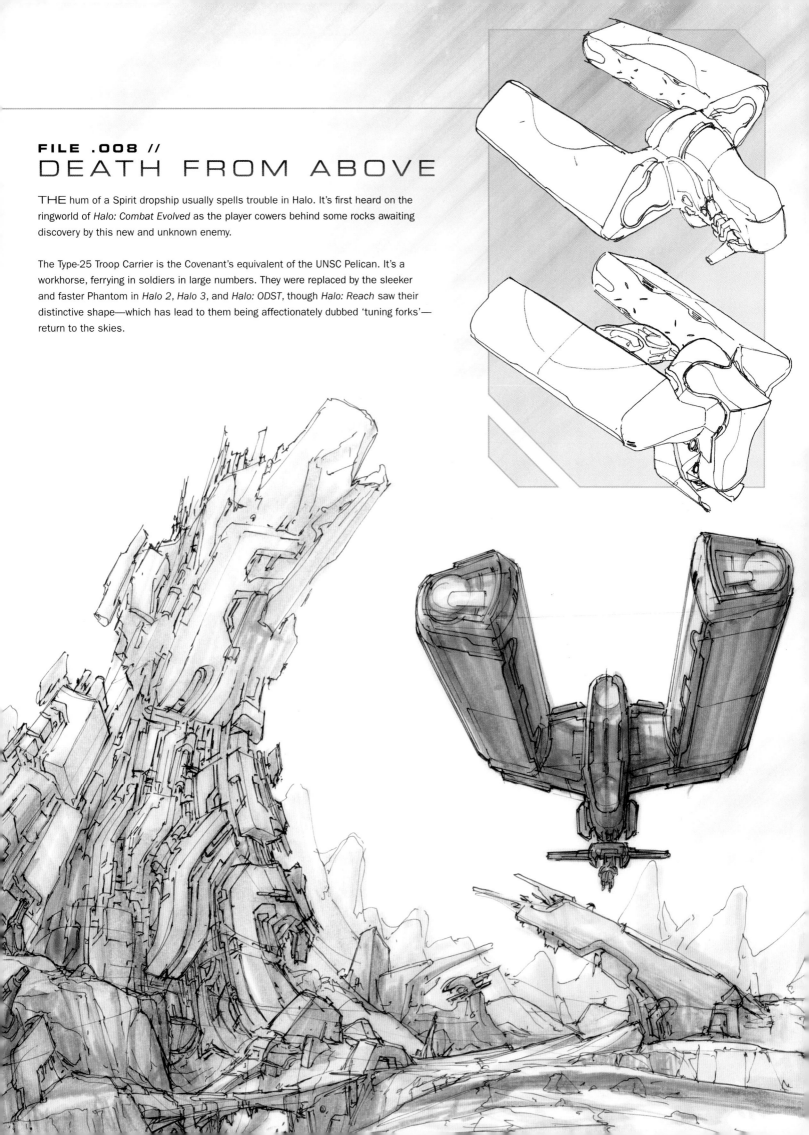

# FILE .008 //
# DEATH FROM ABOVE

THE hum of a Spirit dropship usually spells trouble in Halo. It's first heard on the ringworld of *Halo: Combat Evolved* as the player cowers behind some rocks awaiting discovery by this new and unknown enemy.

The Type-25 Troop Carrier is the Covenant's equivalent of the UNSC Pelican. It's a workhorse, ferrying in soldiers in large numbers. They were replaced by the sleeker and faster Phantom in *Halo 2*, *Halo 3*, and *Halo: ODST*, though *Halo: Reach* saw their distinctive shape—which has lead to them being affectionately dubbed 'tuning forks'—return to the skies.

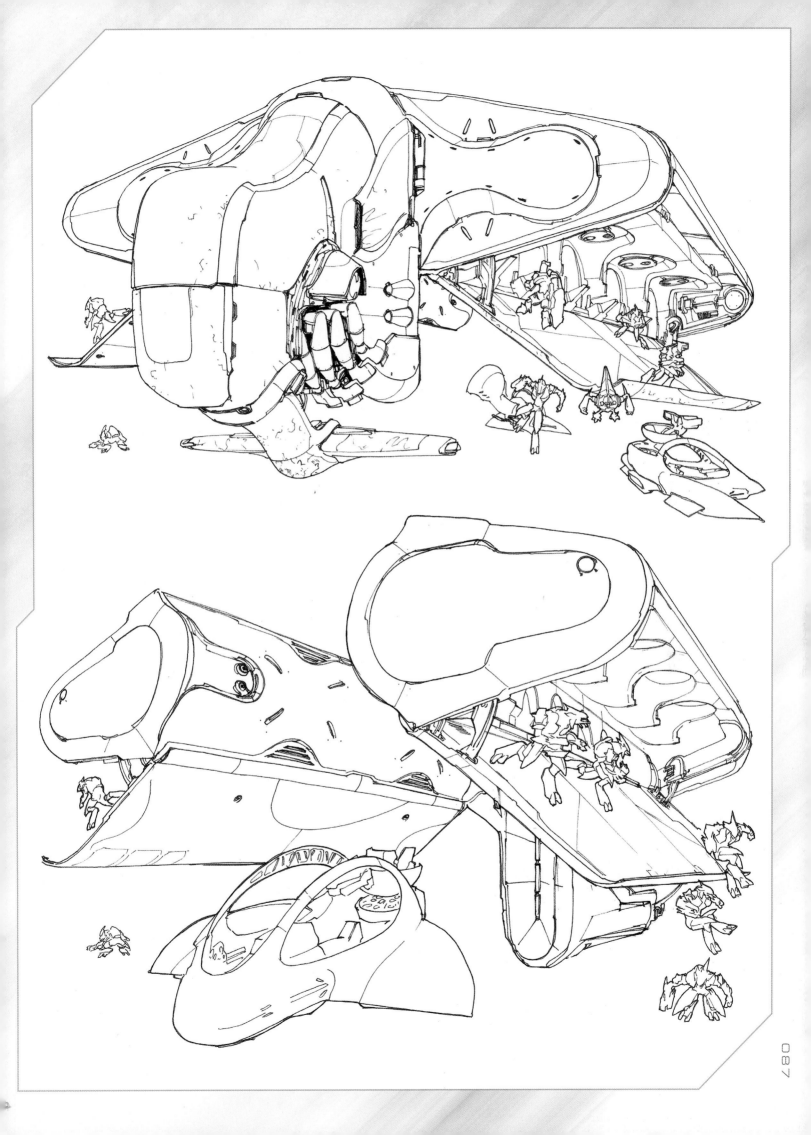

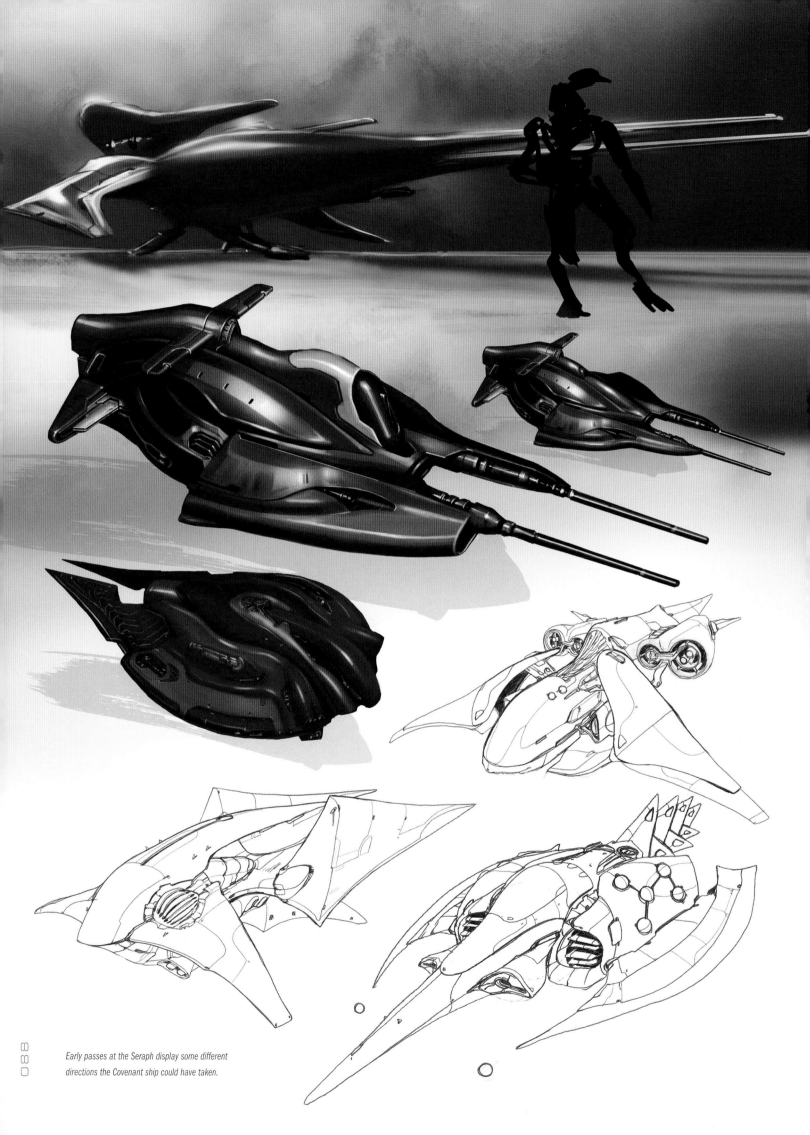

Early passes at the Seraph display some different
directions the Covenant ship could have taken.

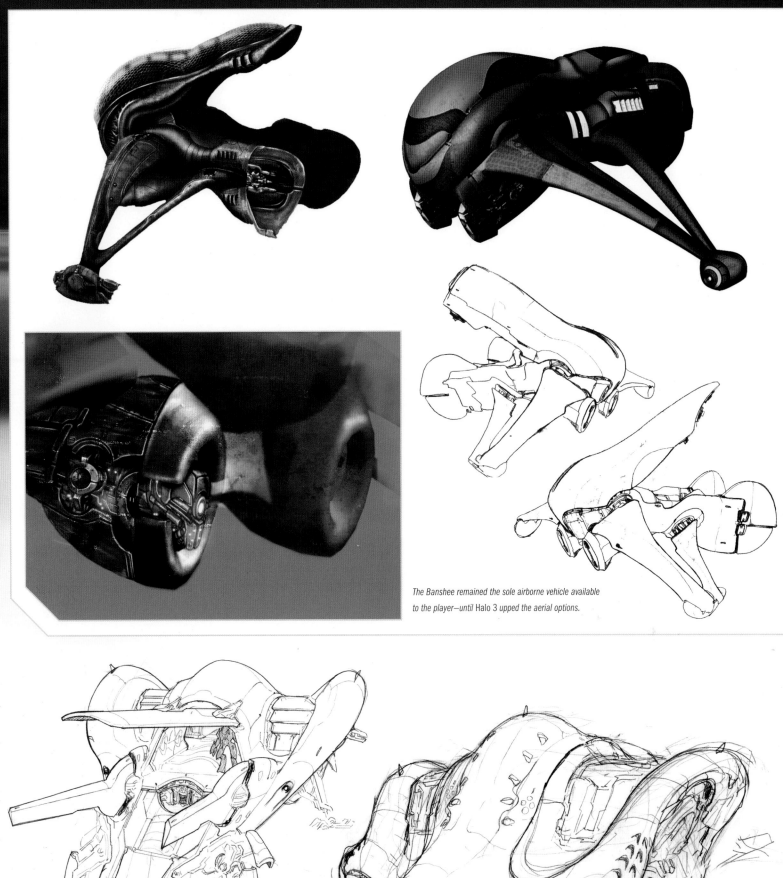

The Banshee remained the sole airborne vehicle available to the player—until Halo 3 upped the aerial options.

Phantoms replaced the Spirit after Halo: Combat Evolved as the Covenant's troop carrier of choice.

# HIGH CHARITY

AT the heart of the Covenant is *High Charity*, a colossal planetoid station that acts as both a mobile base and their capital city. It makes its game debut in *Halo 2*, where it is infested by the Flood, and *Halo 3* sees the Master Chief exploring its infected corridors in search of the entrapped Cortana.

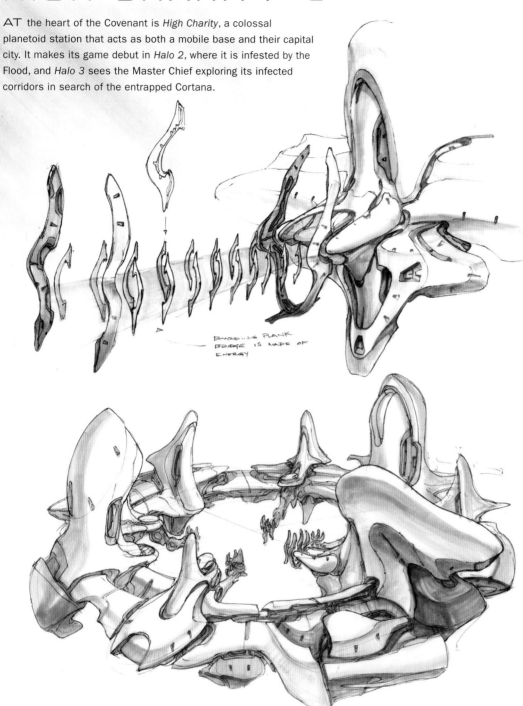

BOARDWALK PLANK BRIDGE IS MADE OF ENERGY

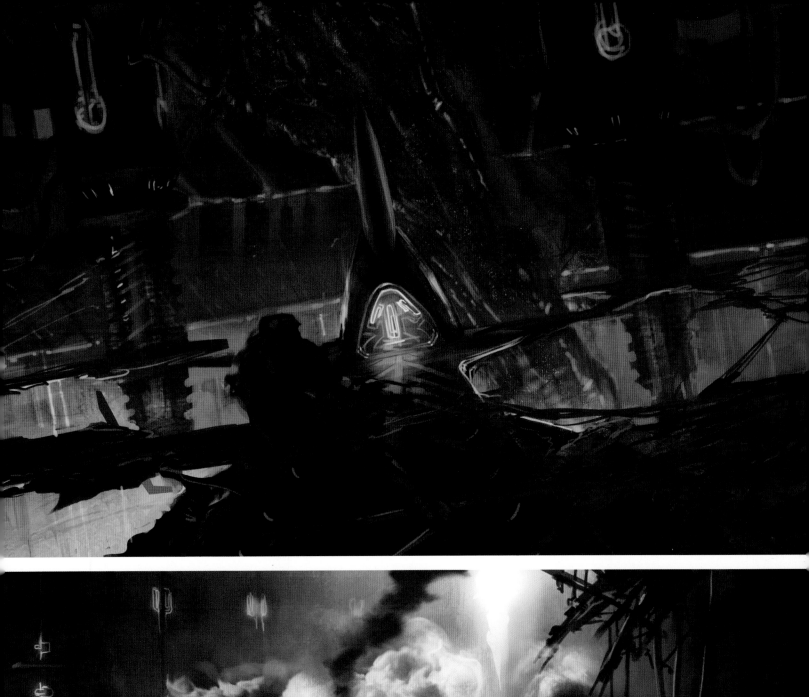
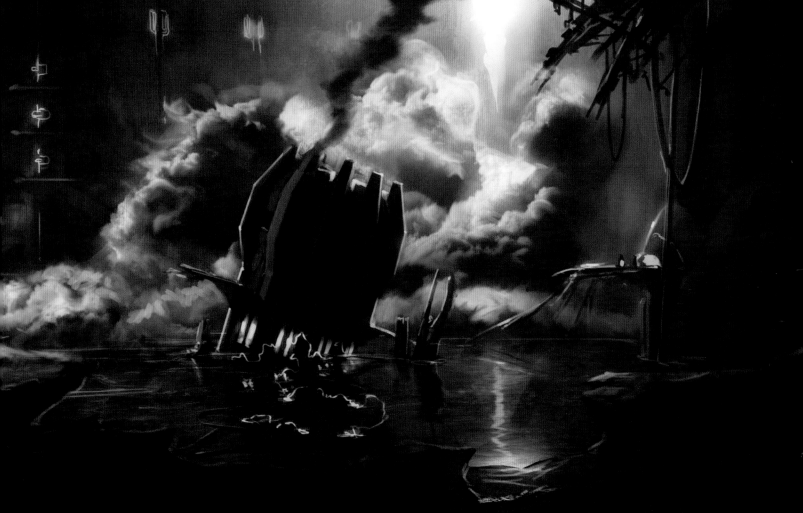

# CH.004

## A MONUMENT TO
## ALL YOUR SINS

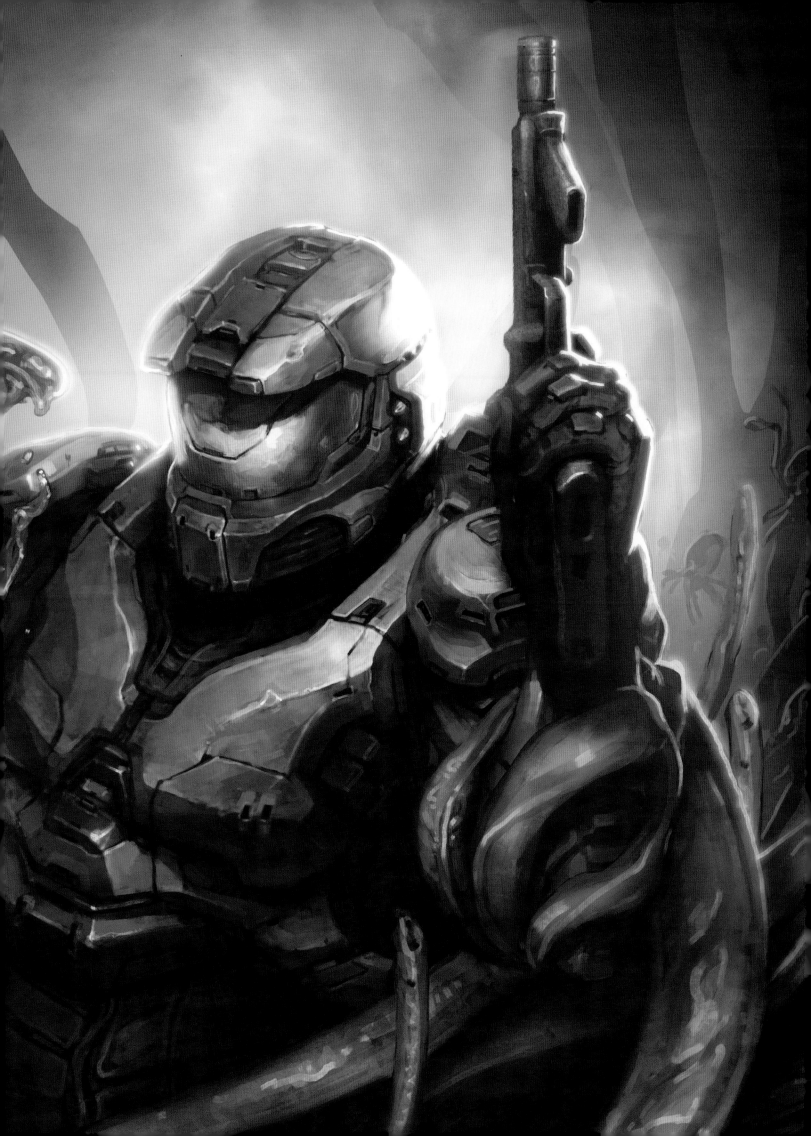

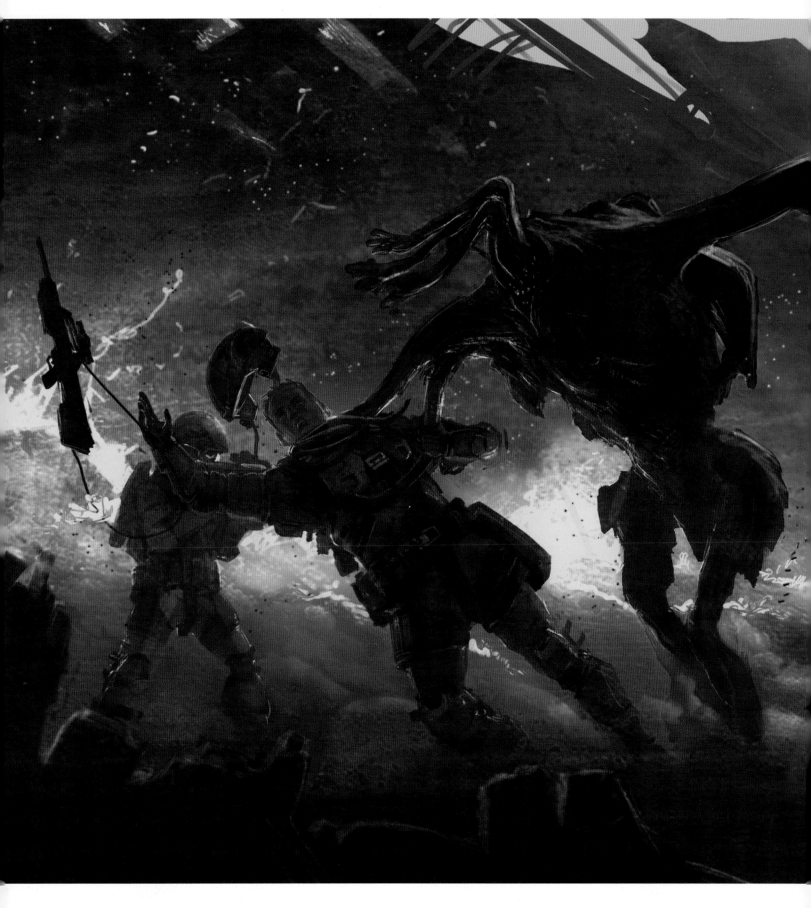

# FILE .001 //
# A THREAT TO ALL LIVING THINGS

THEY are the ultimate threat, a force that brought down one civilization and threatens to bring down our own. The Flood are a virulent, parasitic species that take over their hosts, holding the power to turn armies against each other and to consume all sentient life in the universe.

The threat of the Flood overshadows the Human-Covenant War in Halo, and the ringworlds themselves are the solution to the problem they pose.

They're also responsible for the three-way fights that marked out the latter stages of *Halo: Combat Evolved*, with the player able to slip between the battles that raged between the infected and the Covenant forces across Installation 04.

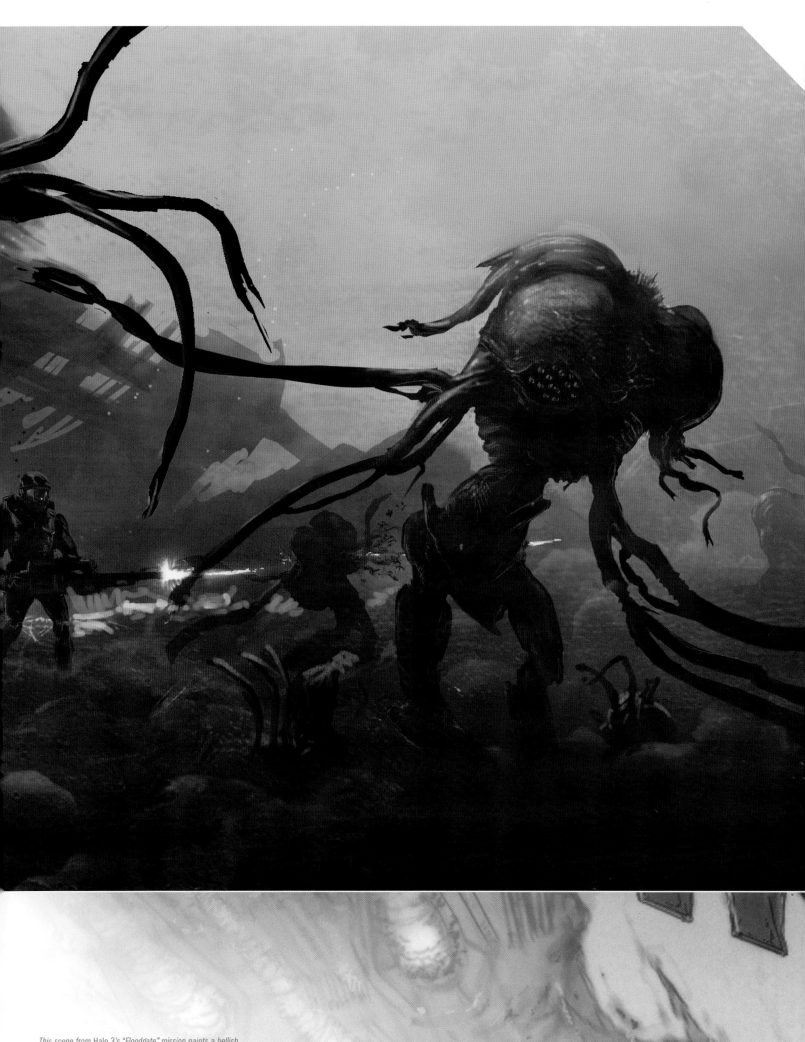

This scene from Halo 3's "Floodgate" mission paints a hellish picture as Voi is overrun by those infected by the Flood. It's a sci-fi apocalypse and it's one of the game's more chilling moments.

Scenes from the Halo remake's take on the level "343 Guilty Spark" show the phosphorescent calm before first contact is made with the Flood.

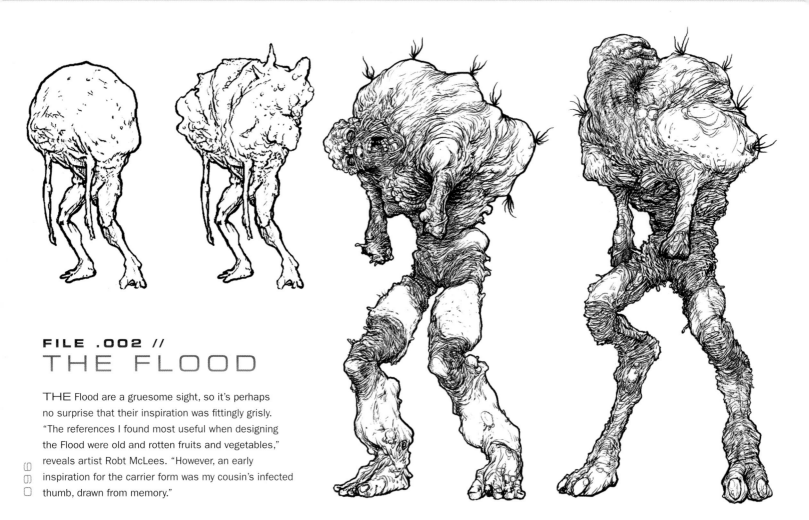

## FILE .002 //
# THE FLOOD

THE Flood are a gruesome sight, so it's perhaps no surprise that their inspiration was fittingly grisly. "The references I found most useful when designing the Flood were old and rotten fruits and vegetables," reveals artist Robt McLees. "However, an early inspiration for the carrier form was my cousin's infected thumb, drawn from memory."

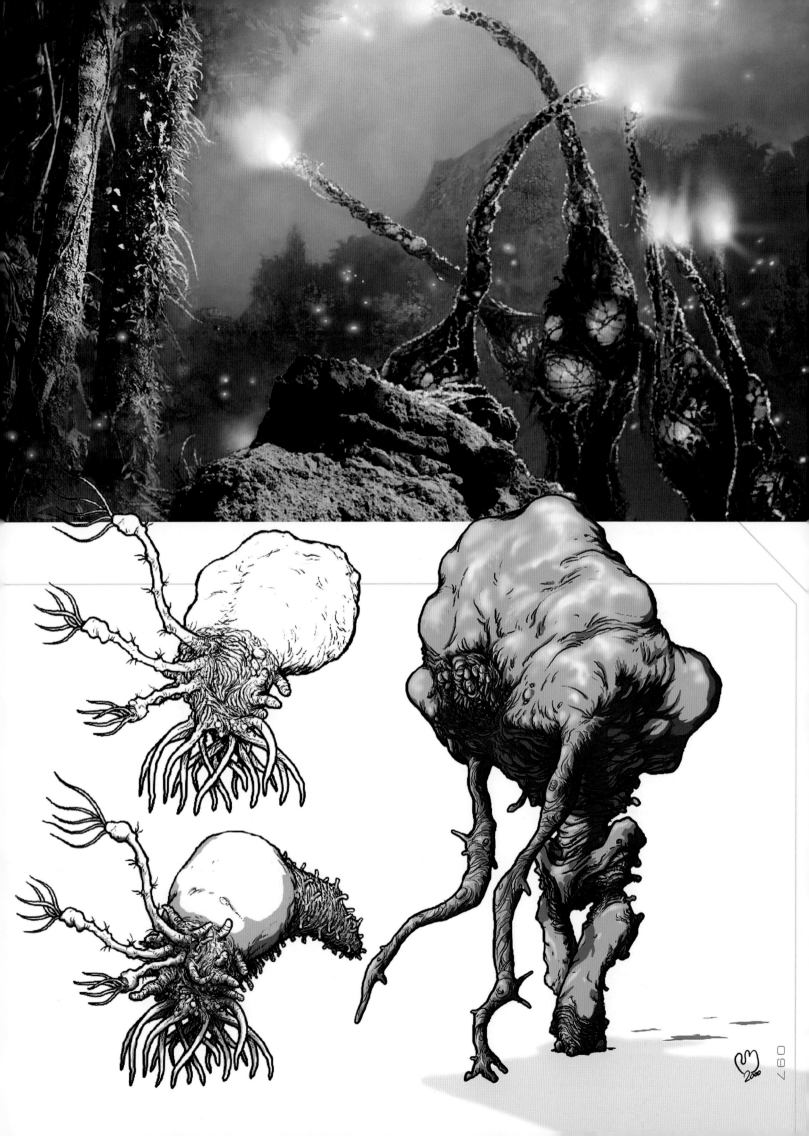

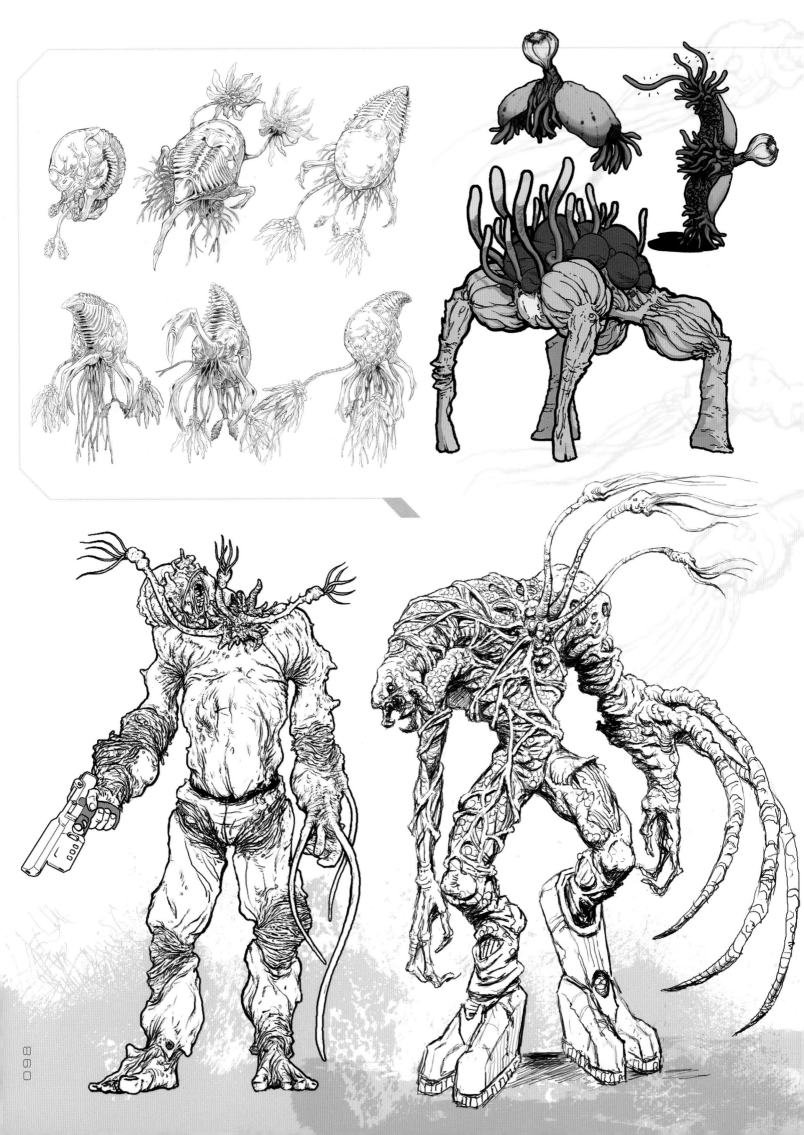

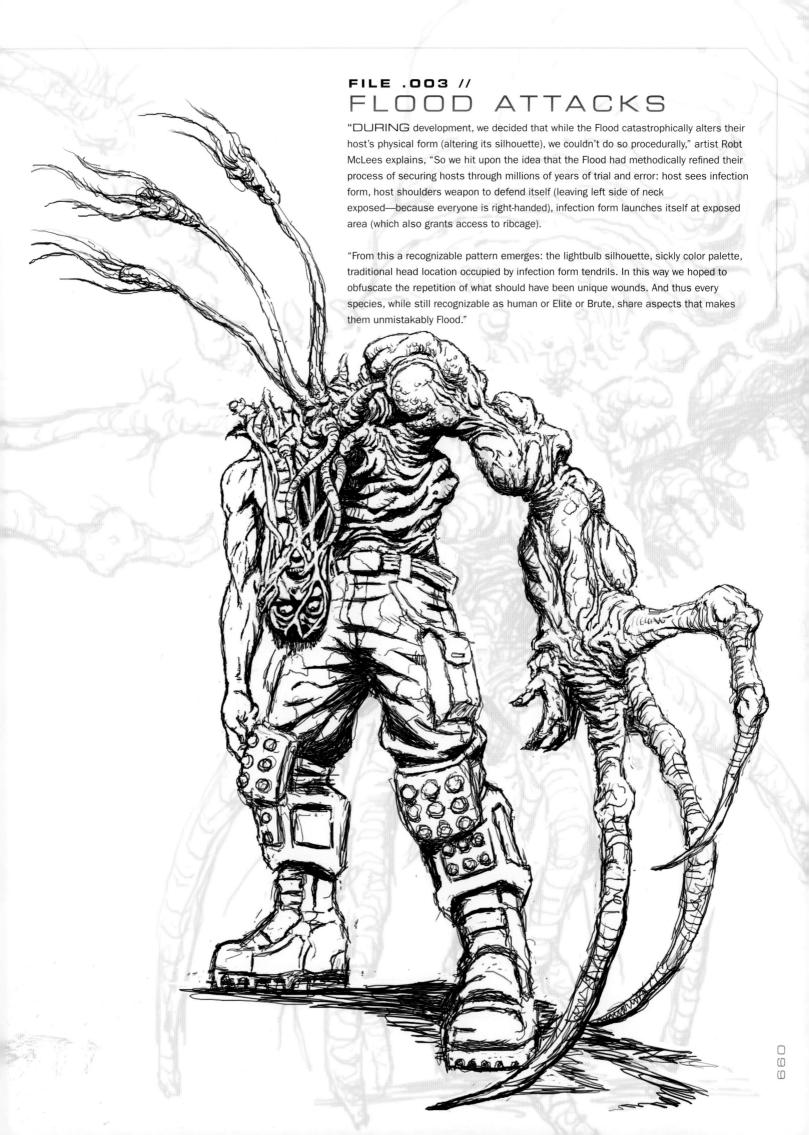

## FILE .003 //
# FLOOD ATTACKS

"DURING development, we decided that while the Flood catastrophically alters their host's physical form (altering its silhouette), we couldn't do so procedurally," artist Robt McLees explains, "So we hit upon the idea that the Flood had methodically refined their process of securing hosts through millions of years of trial and error: host sees infection form, host shoulders weapon to defend itself (leaving left side of neck exposed—because everyone is right-handed), infection form launches itself at exposed area (which also grants access to ribcage).

"From this a recognizable pattern emerges: the lightbulb silhouette, sickly color palette, traditional head location occupied by infection form tendrils. In this way we hoped to obfuscate the repetition of what should have been unique wounds. And thus every species, while still recognizable as human or Elite or Brute, share aspects that makes them unmistakably Flood."

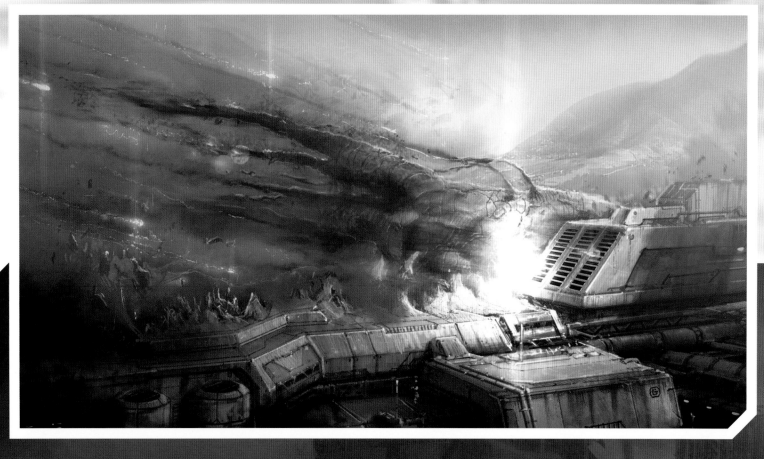

# FILE .004 //
## "FLOODGATE"

THESE early concepts for the *Halo 3* mission "Floodgate"—in which the Flood infests the town of Voi—gives some impression of how Halo's world is visualized before any polygons are committed. "It's like a "blue sky" inspirational kick-off painting very early on in the project to help visualize and inspire people for the sequence itself since the game engine was in a primitive state at the time," says artist Frank Capezzuto of the image on the right, "It's pretty rough and created during a time when we didn't really have a whole lot of detail about what we're going to do in that part of the game."

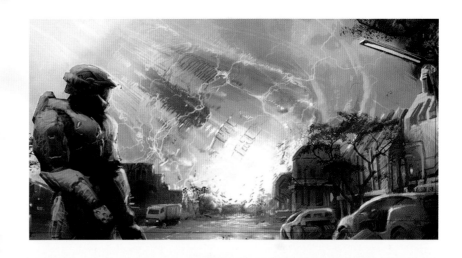

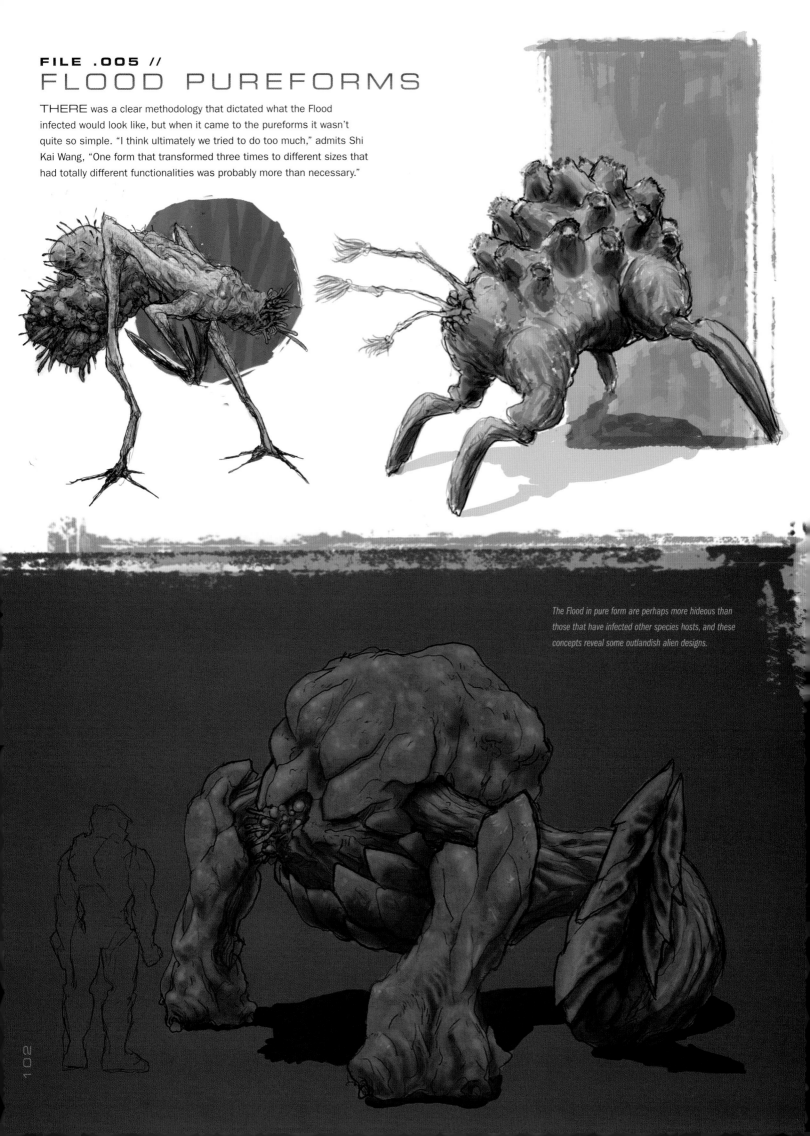

# FLOOD PUREFORMS

THERE was a clear methodology that dictated what the Flood infected would look like, but when it came to the pureforms it wasn't quite so simple. "I think ultimately we tried to do too much," admits Shi Kai Wang, "One form that transformed three times to different sizes that had totally different functionalities was probably more than necessary."

*The Flood in pure form are perhaps more hideous than those that have infected other species hosts, and these concepts reveal some outlandish alien designs.*

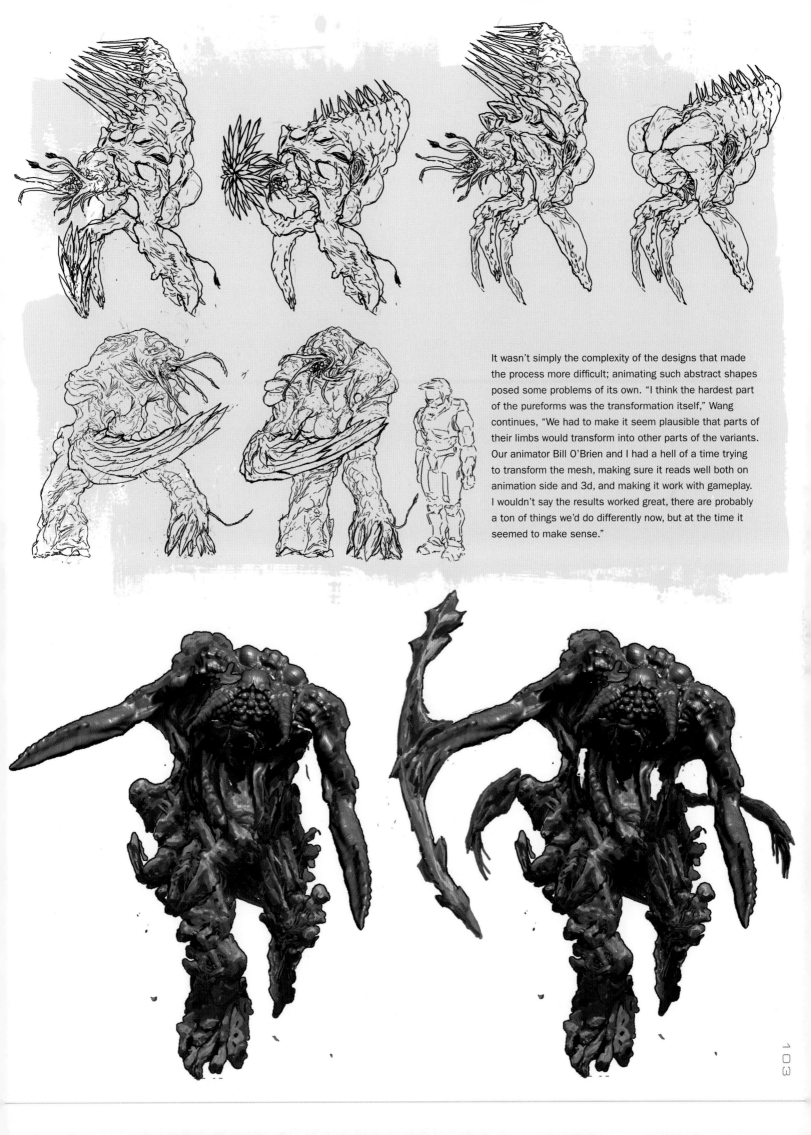

It wasn't simply the complexity of the designs that made the process more difficult; animating such abstract shapes posed some problems of its own. "I think the hardest part of the pureforms was the transformation itself," Wang continues, "We had to make it seem plausible that parts of their limbs would transform into other parts of the variants. Our animator Bill O'Brien and I had a hell of a time trying to transform the mesh, making sure it reads well both on animation side and 3d, and making it work with gameplay. I wouldn't say the results worked great, there are probably a ton of things we'd do differently now, but at the time it seemed to make sense."

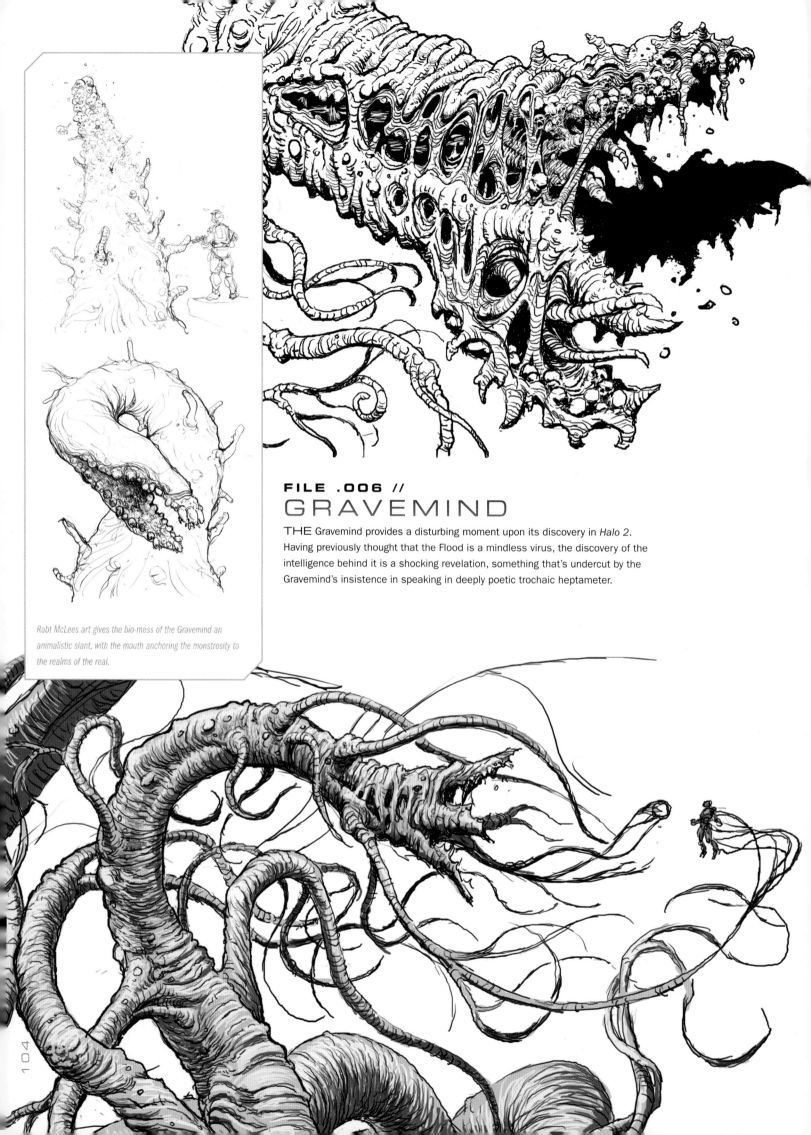

# FILE .006 //
# GRAVEMIND

THE Gravemind provides a disturbing moment upon its discovery in *Halo 2*. Having previously thought that the Flood is a mindless virus, the discovery of the intelligence behind it is a shocking revelation, something that's undercut by the Gravemind's insistence in speaking in deeply poetic trochaic heptameter.

*Robt McLees art gives the bio-mess of the Gravemind an animalistic slant, with the mouth anchoring the monstrosity to the realms of the real.*

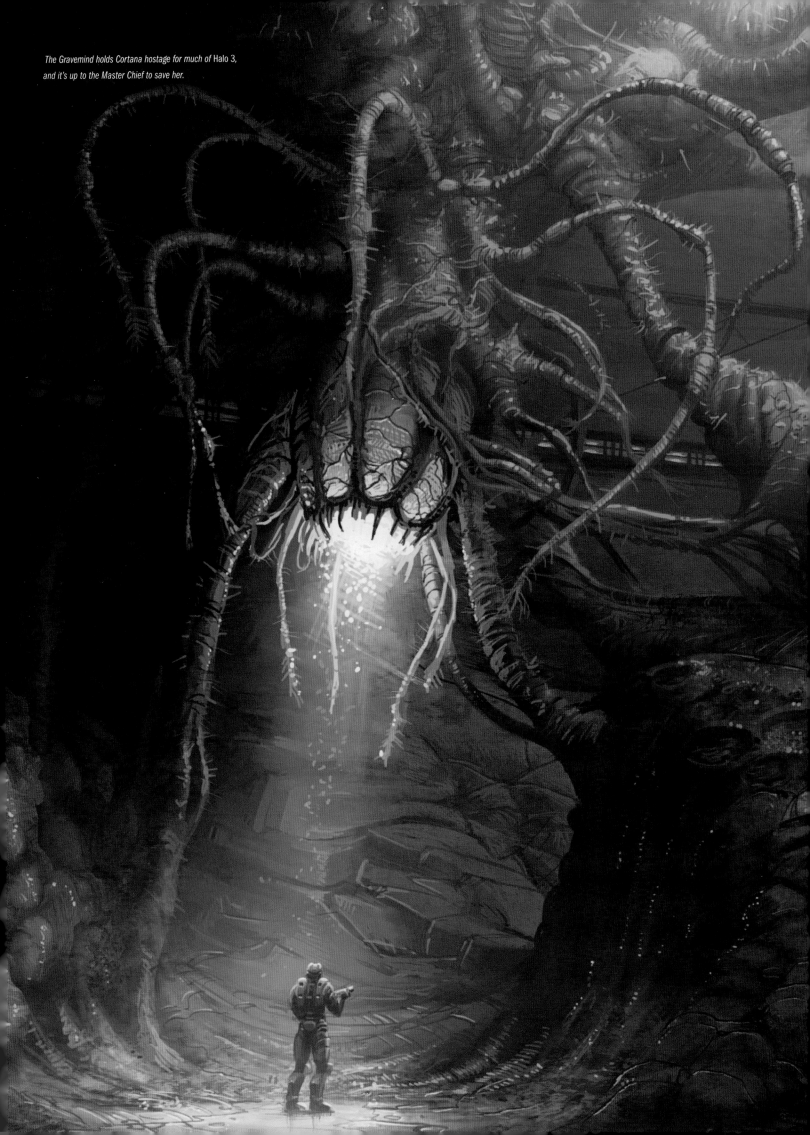

The Gravemind holds Cortana hostage for much of Halo 3,
and it's up to the Master Chief to save her.

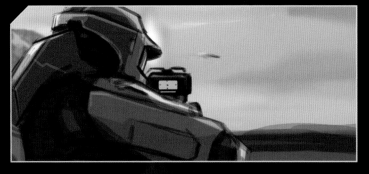

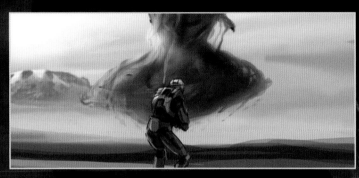

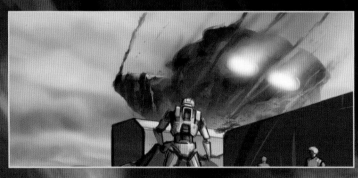

PANELS show the storyboarding for the Flood's descent into Voi, as described by artist Lee R. Wilson. "This sequence was meant to evoke a familiar feeling of an immense thing flying overhead," explains Wilson, "like if you were at the end of the runway at an airport and this huge 747 flies overhead—this moment of 'am I safe over here?'"

Later in *Halo 3* the Master Chief is thrown into the darkest recesses of the Flood as he explores the infected *High Charity*. It's a dark, foreboding and visceral arena for one of the game's climactic battles.

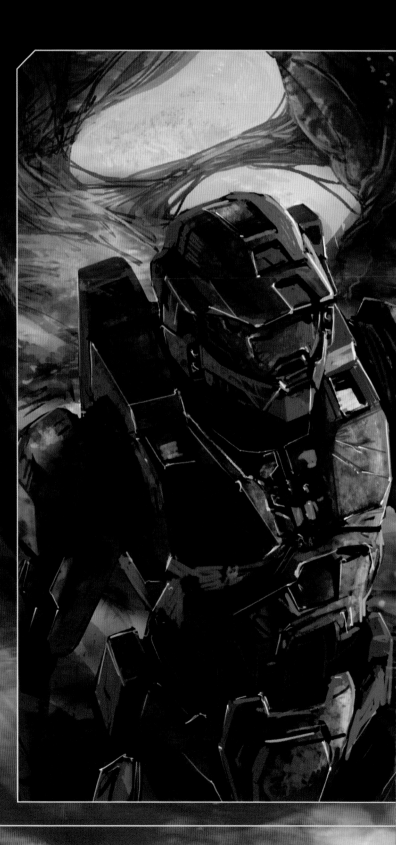

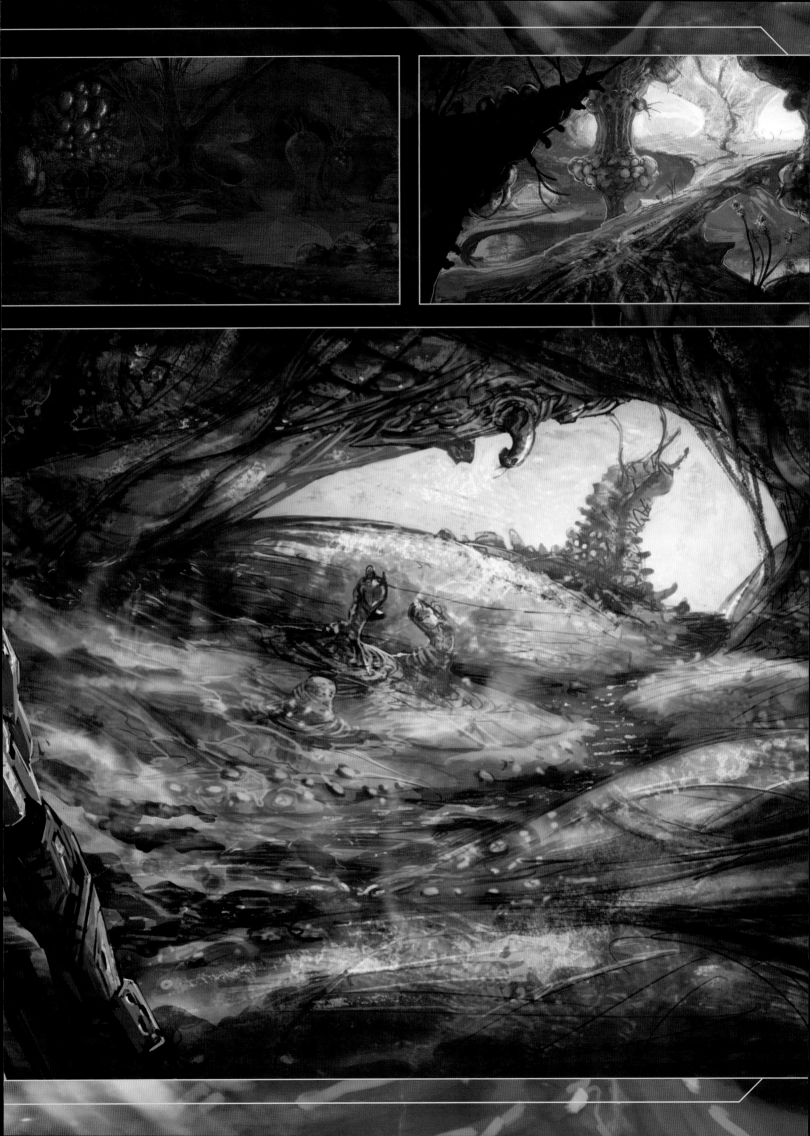

# CH.005

WELCOME TO THE CORPS

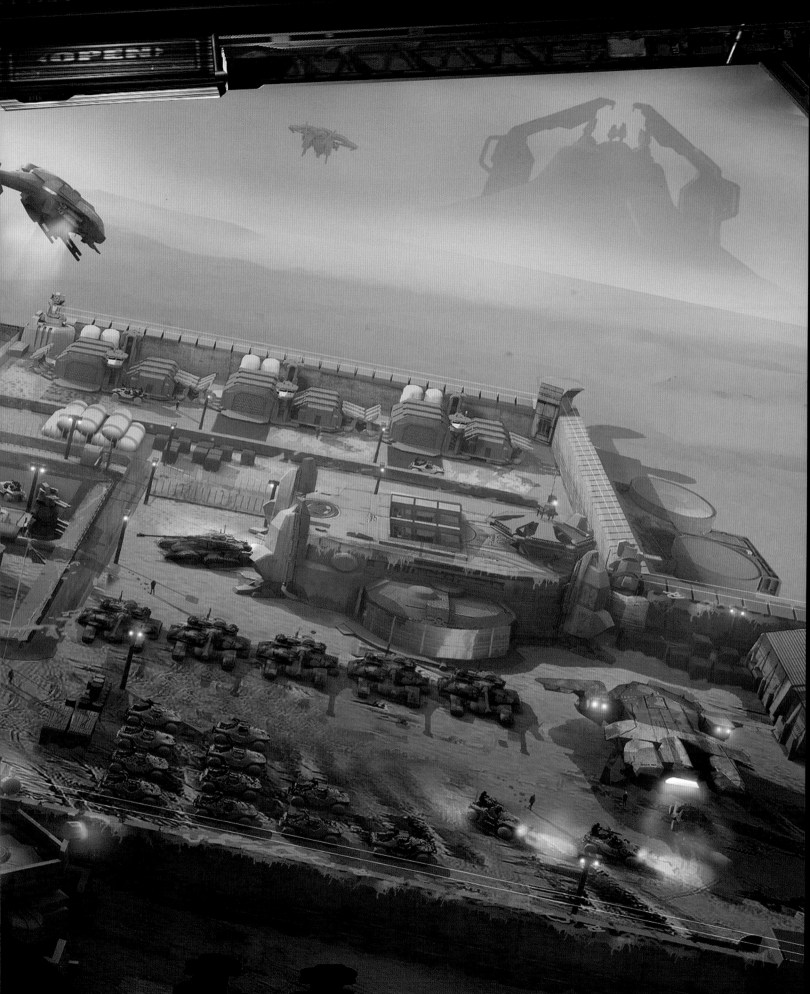

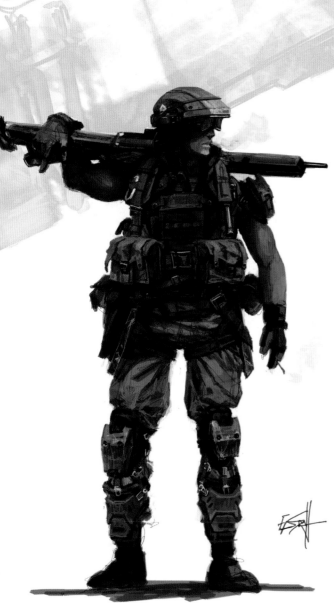

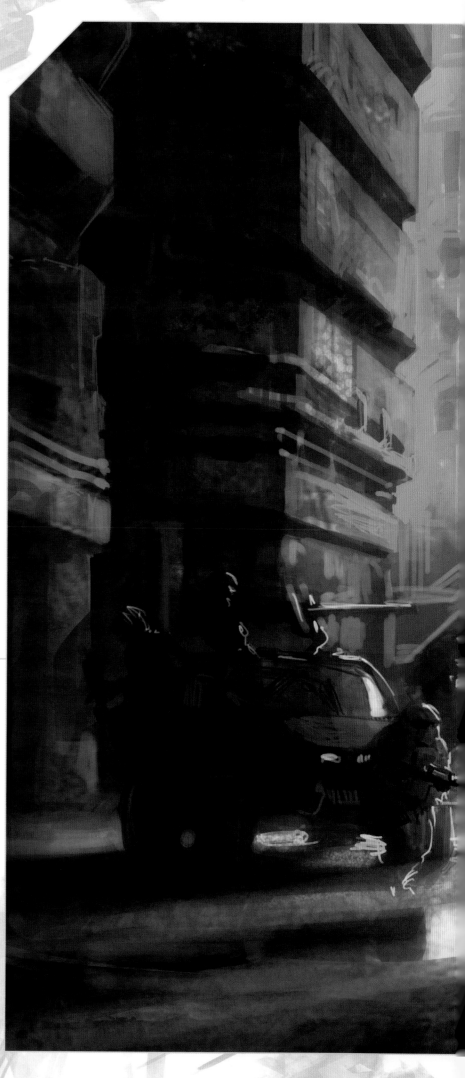

## FILE .001 //
# UNSC

THEY'RE the men and women at the front line of every battle, the soldiers facing a war against an alliance of aliens in a fight for the very future of humanity. Good job they've also got the hardware to back them up.

Formed in the 22$^{nd}$ Century, the United Nations Space Command is the military arm of the United Earth Government, and throughout the war with the Covenant is the one thing keeping humanity from extinction.

In the Halo games they're personified by the UNSC leaders such as Lord Hood, the thinkers such as Dr. Catherine Halsey and perhaps most importantly by the marines themselves, spearheaded by Sgt. Avery Johnson. Halo's a characterful game, and much of this character comes from the colorful backchat provided by the soldiers that accompany the player.

Halo's also a game that revels in its technology, and much of this comes from the UNSC itself. Whether it's the iconic battle rifle, a bounding Warthog or the Spartans themselves, the hardware supplied by the UNSC is often center stage.

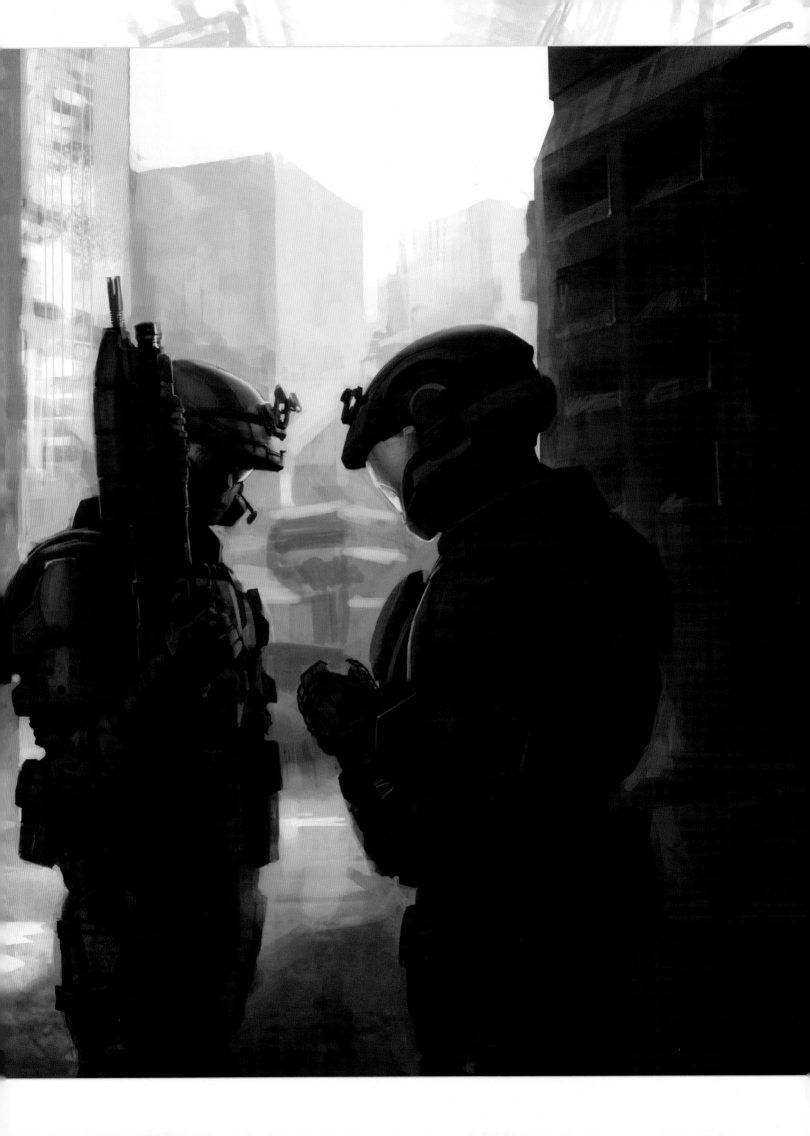

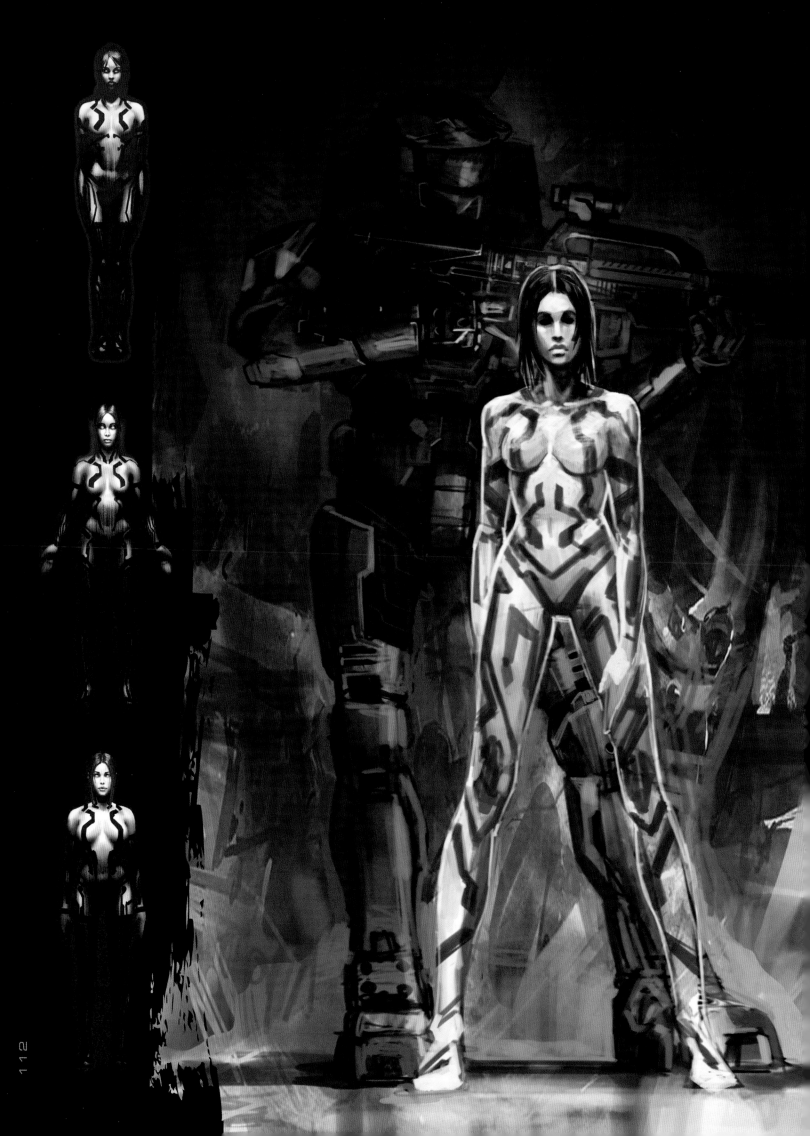

# FILE .002 //
# CORTANA

THROUGH her quips, wit, and insight, Cortana is one element of the Halo universe that's almost as iconic as the Master Chief. She certainly rivals him in importance; having identified Spartan-117 as her partner, the AI steers him on the course that ensures his legendary status, saving the entire universe in the process as her role strengthens throughout the series.

Cortana also provides the Halo universe with a welcome shot of humor, and her relationship with the Master Chief at times plays out like a sci-fi Bogart and Bacall. Her strength is in her character and her unique design, making her one of the more positive female characters in games.

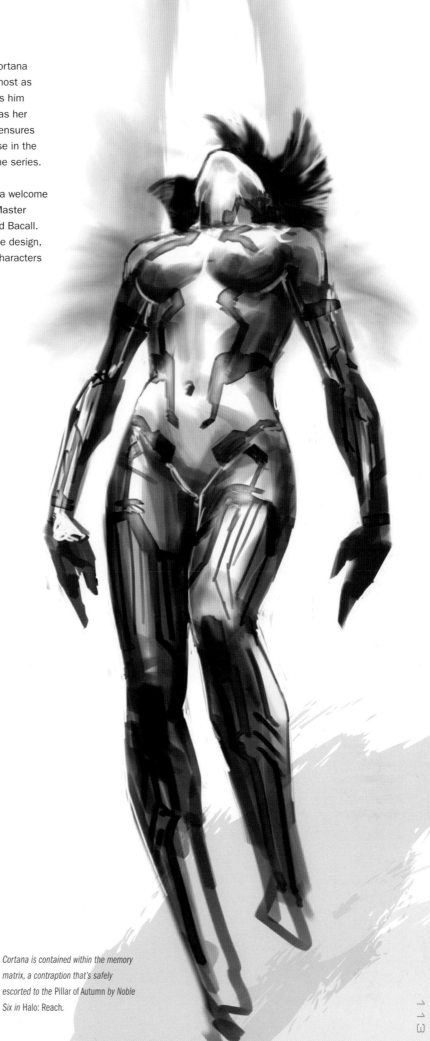

*Cortana is contained within the memory matrix, a contraption that's safely escorted to the* Pillar of Autumn *by Noble Six in* Halo: Reach.

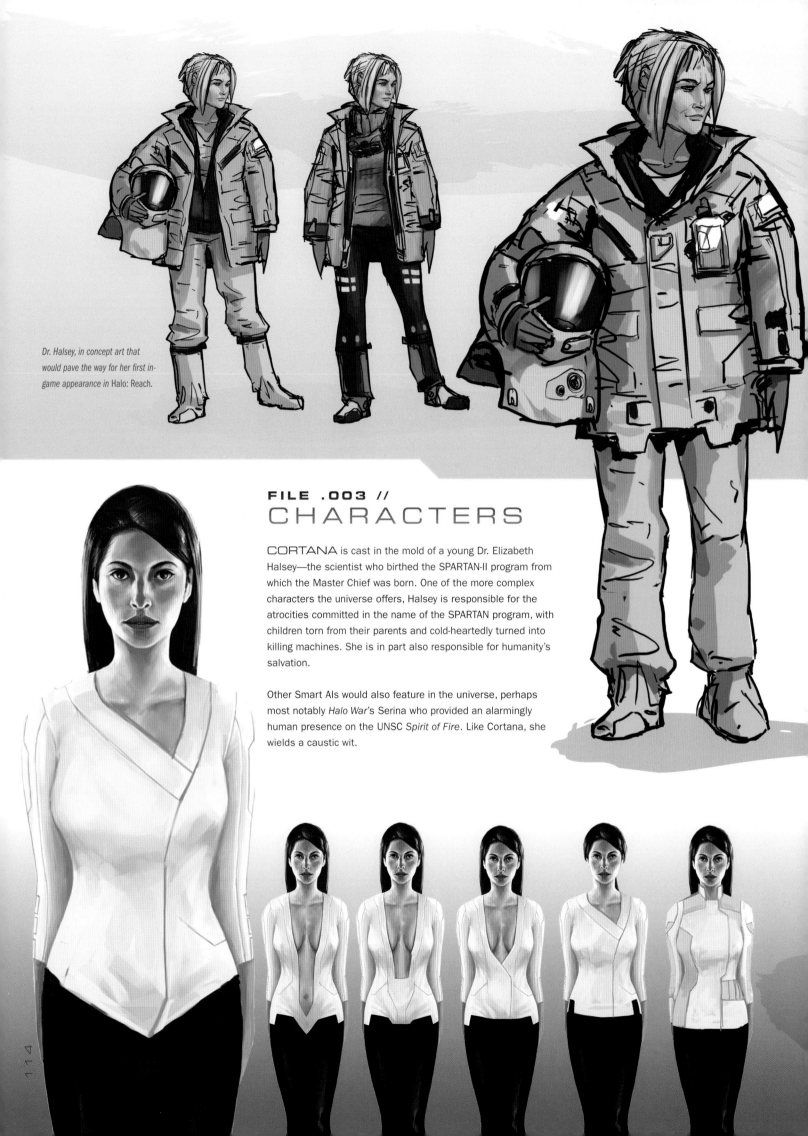

Dr. Halsey, in concept art that would pave the way for her first in-game appearance in Halo: Reach.

## FILE .003 //
# CHARACTERS

CORTANA is cast in the mold of a young Dr. Elizabeth Halsey—the scientist who birthed the SPARTAN-II program from which the Master Chief was born. One of the more complex characters the universe offers, Halsey is responsible for the atrocities committed in the name of the SPARTAN program, with children torn from their parents and cold-heartedly turned into killing machines. She is in part also responsible for humanity's salvation.

Other Smart AIs would also feature in the universe, perhaps most notably *Halo War*'s Serina who provided an alarmingly human presence on the UNSC *Spirit of Fire*. Like Cortana, she wields a caustic wit.

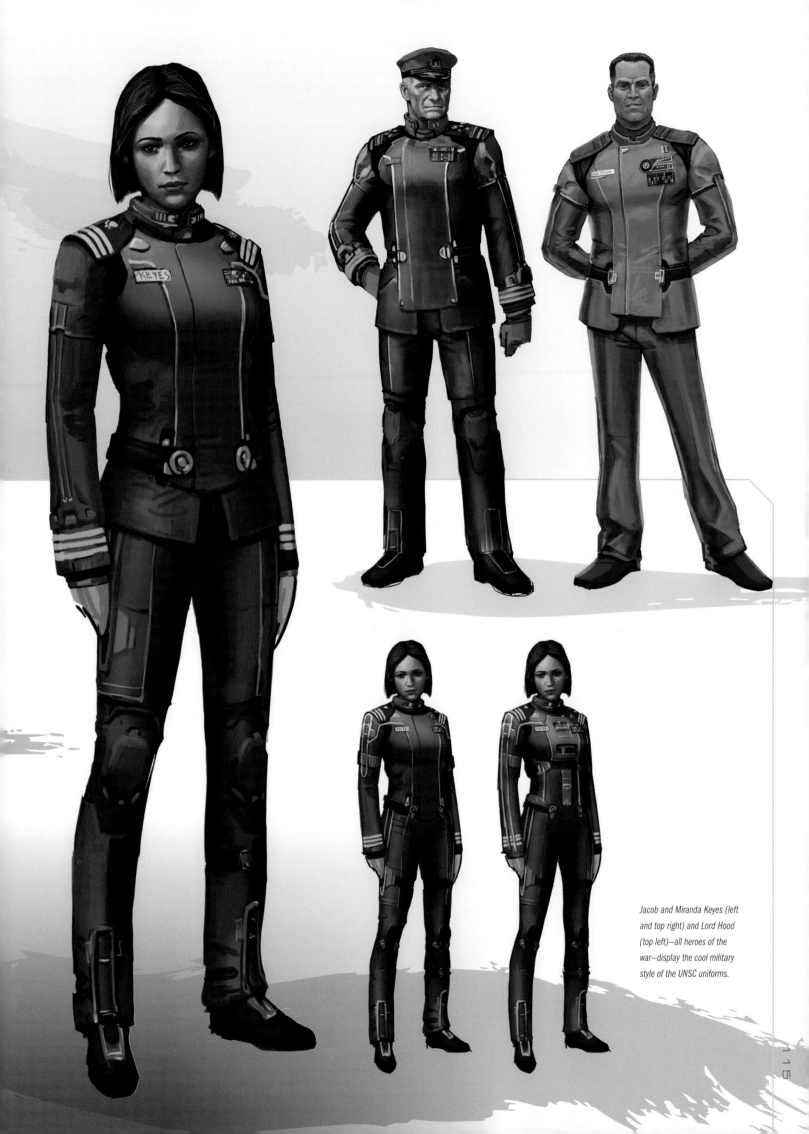

Jacob and Miranda Keyes (left and top right) and Lord Hood (top left)—all heroes of the war—display the cool military style of the UNSC uniforms.

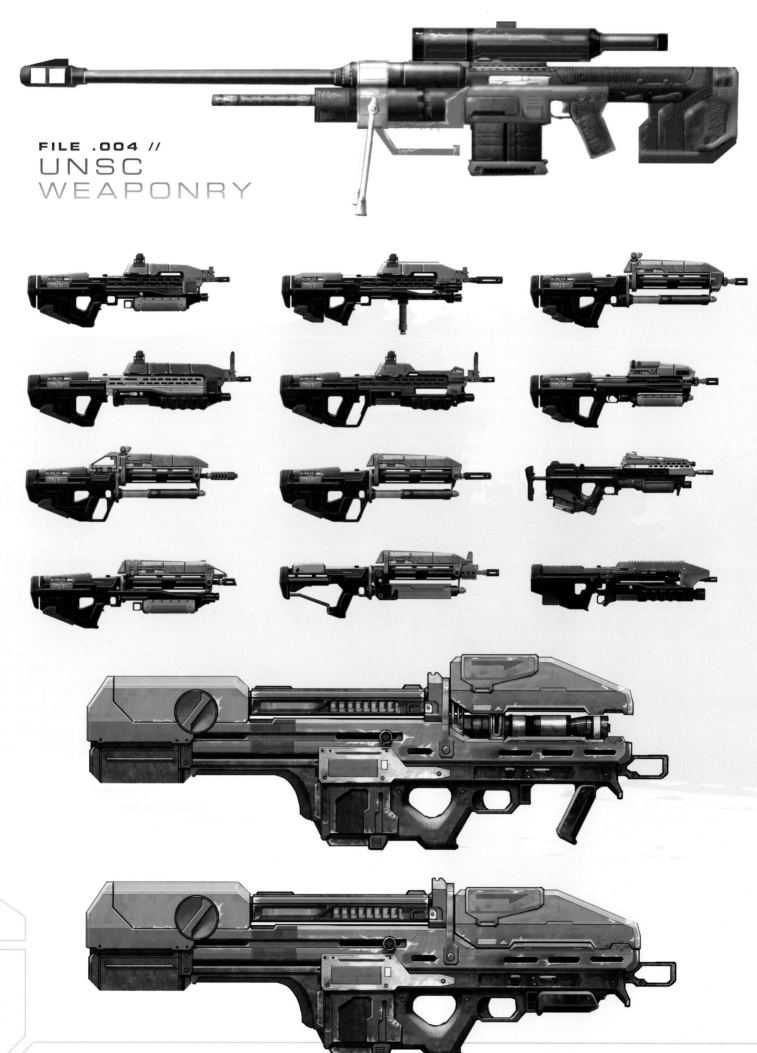

# UNSC
# WEAPONRY

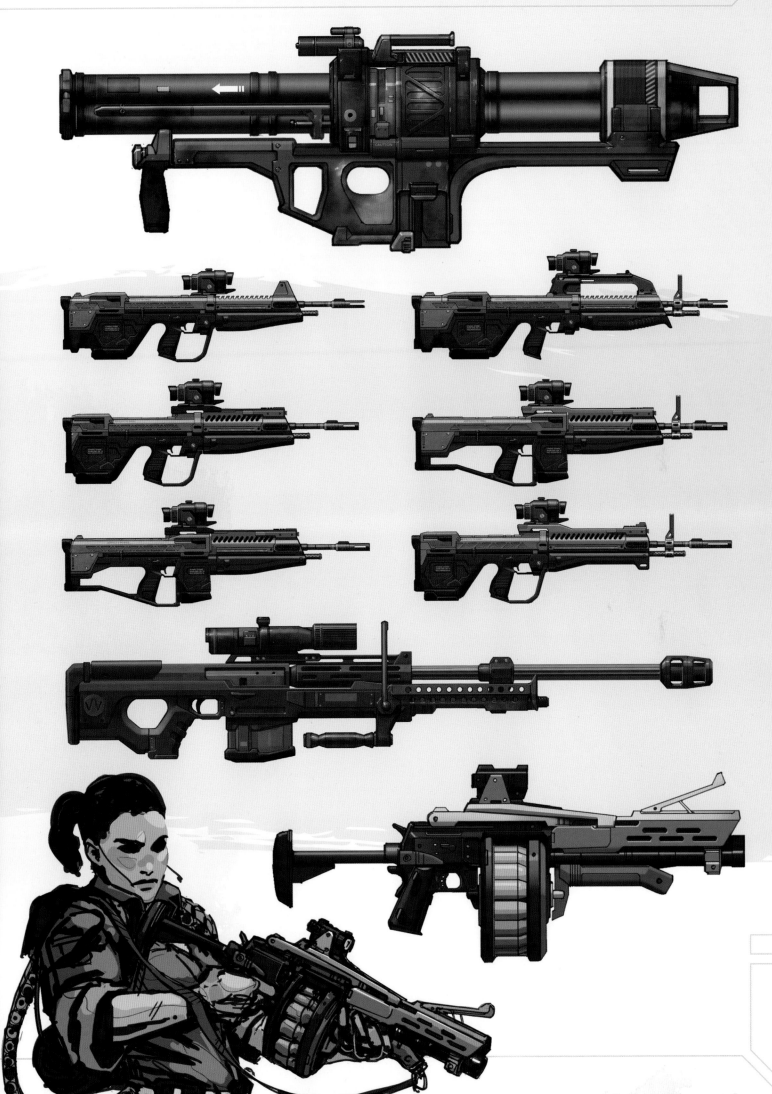

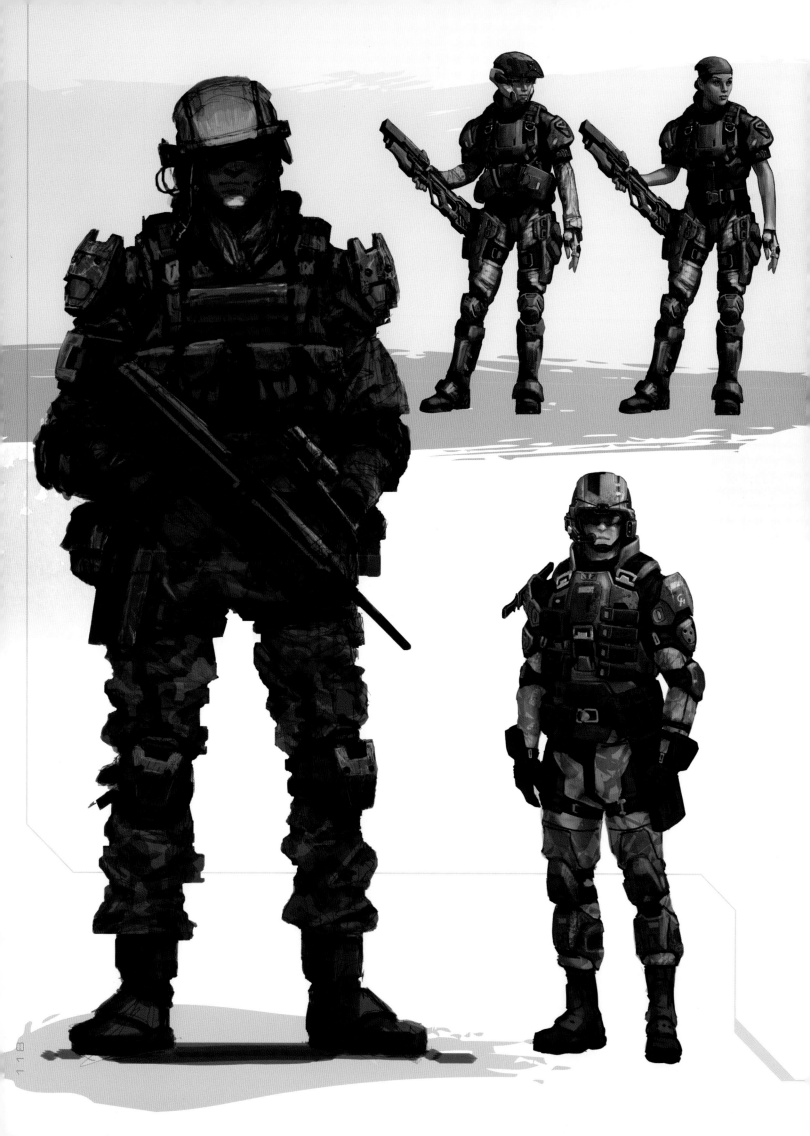

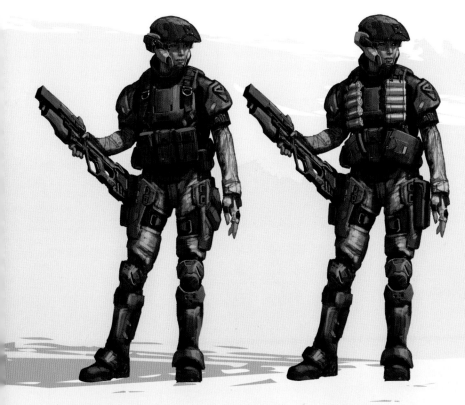

# FILE .005 //
# MARINES

THERE may be more space marines in video games than there are stars in the sky, but it's Halo's soldiers that shine the brightest. It was their varied and amusing backchat that helped mark out the original *Halo: Combat Evolved*, and it ensured that the marines that served by the player's side were more than just cannon fodder; they were believable human companions.

The marine's look—and indeed their gung-ho attitude—are part of a long line that can be traced back to James Cameron's *Aliens* and the earlier fiction of Robert Heinlein and Joe Haldeman. It's to Halo's credit that its own marines stand tall in such company.

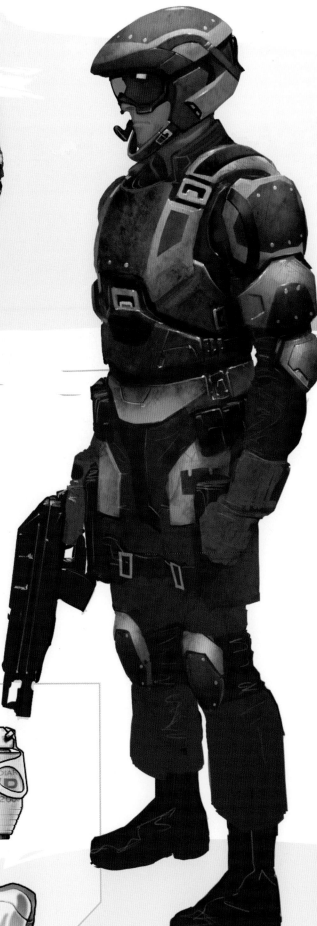

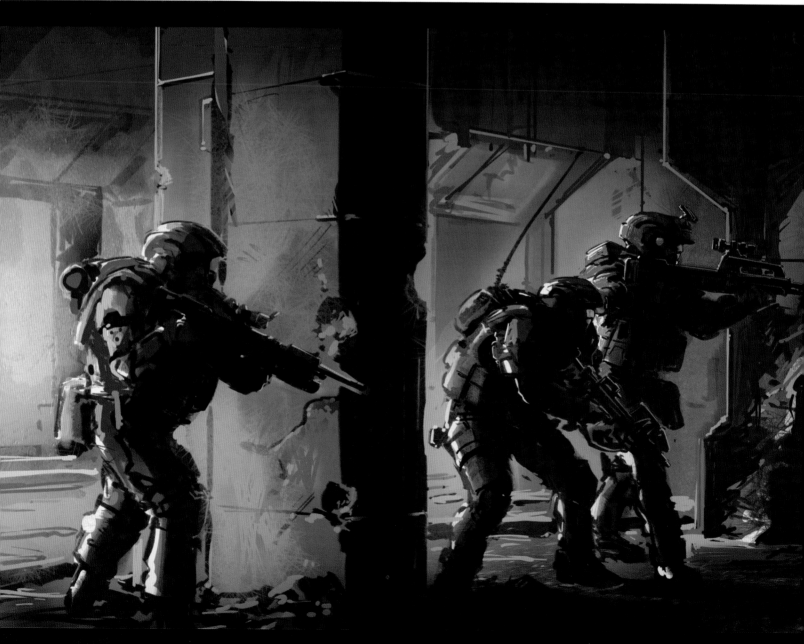

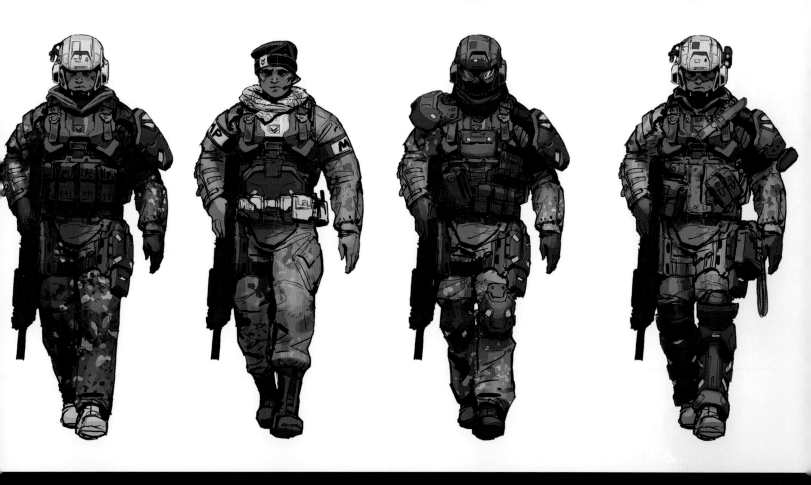
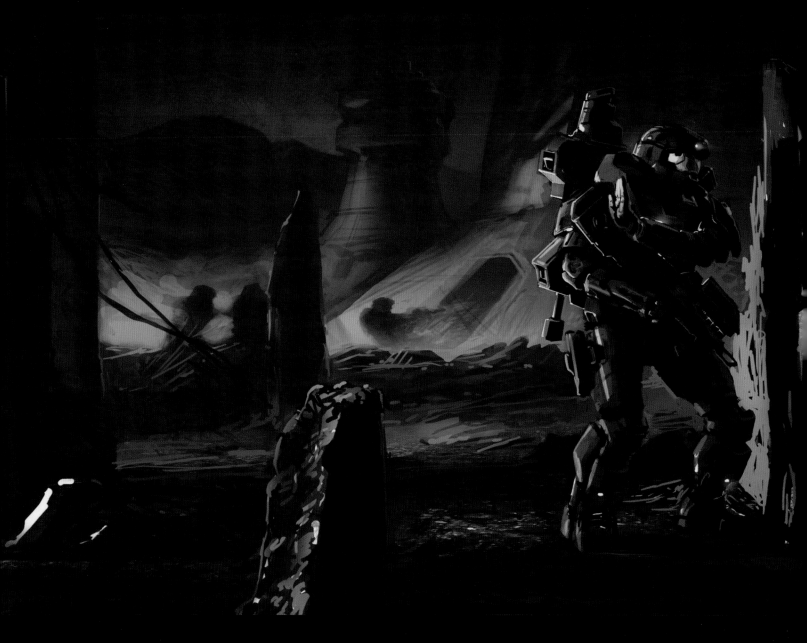

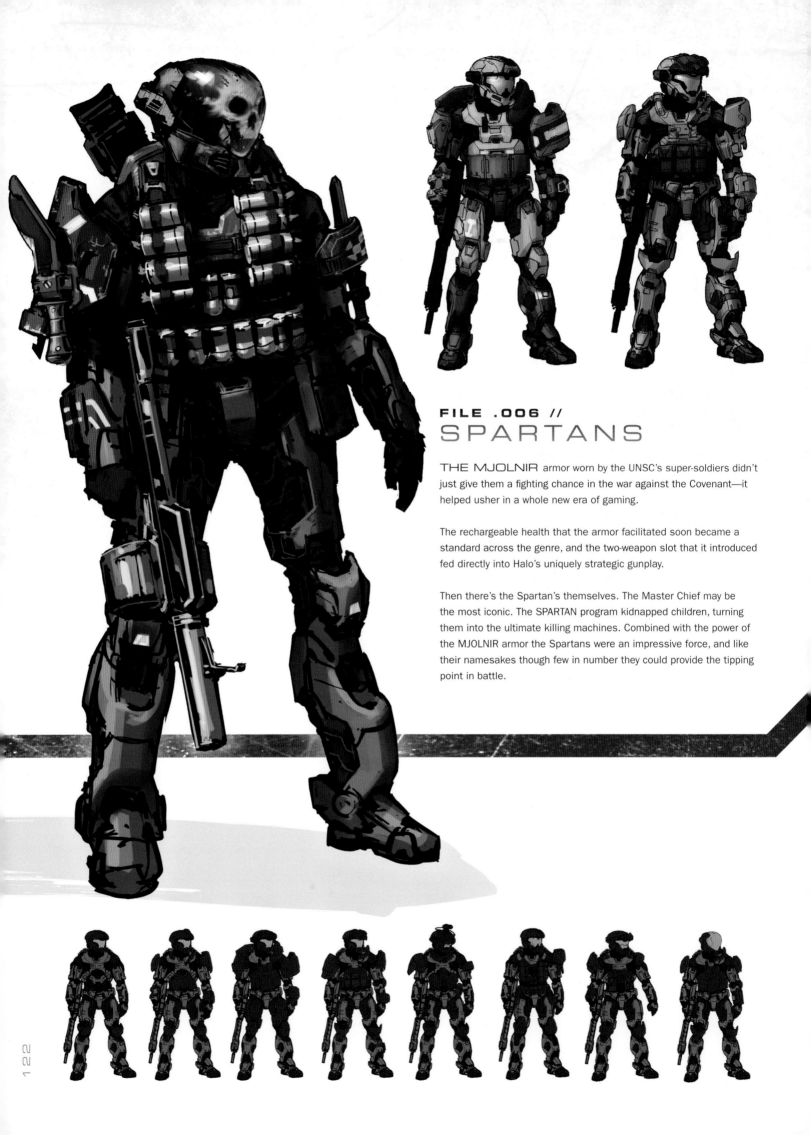

# FILE .006 //
# SPARTANS

THE MJOLNIR armor worn by the UNSC's super-soldiers didn't just give them a fighting chance in the war against the Covenant—it helped usher in a whole new era of gaming.

The rechargeable health that the armor facilitated soon became a standard across the genre, and the two-weapon slot that it introduced fed directly into Halo's uniquely strategic gunplay.

Then there's the Spartan's themselves. The Master Chief may be the most iconic. The SPARTAN program kidnapped children, turning them into the ultimate killing machines. Combined with the power of the MJOLNIR armor the Spartans were an impressive force, and like their namesakes though few in number they could provide the tipping point in battle.

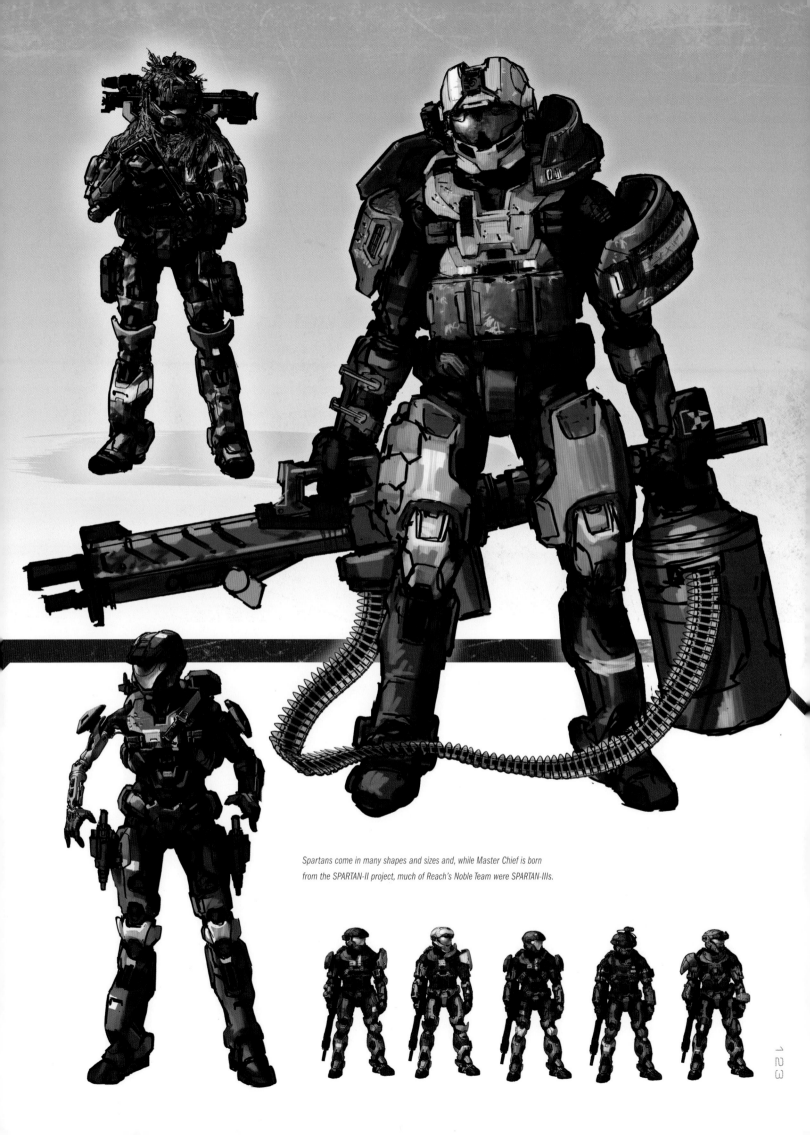

Spartans come in many shapes and sizes and, while Master Chief is born
from the SPARTAN-II project, much of Reach's Noble Team were SPARTAN-IIIs.

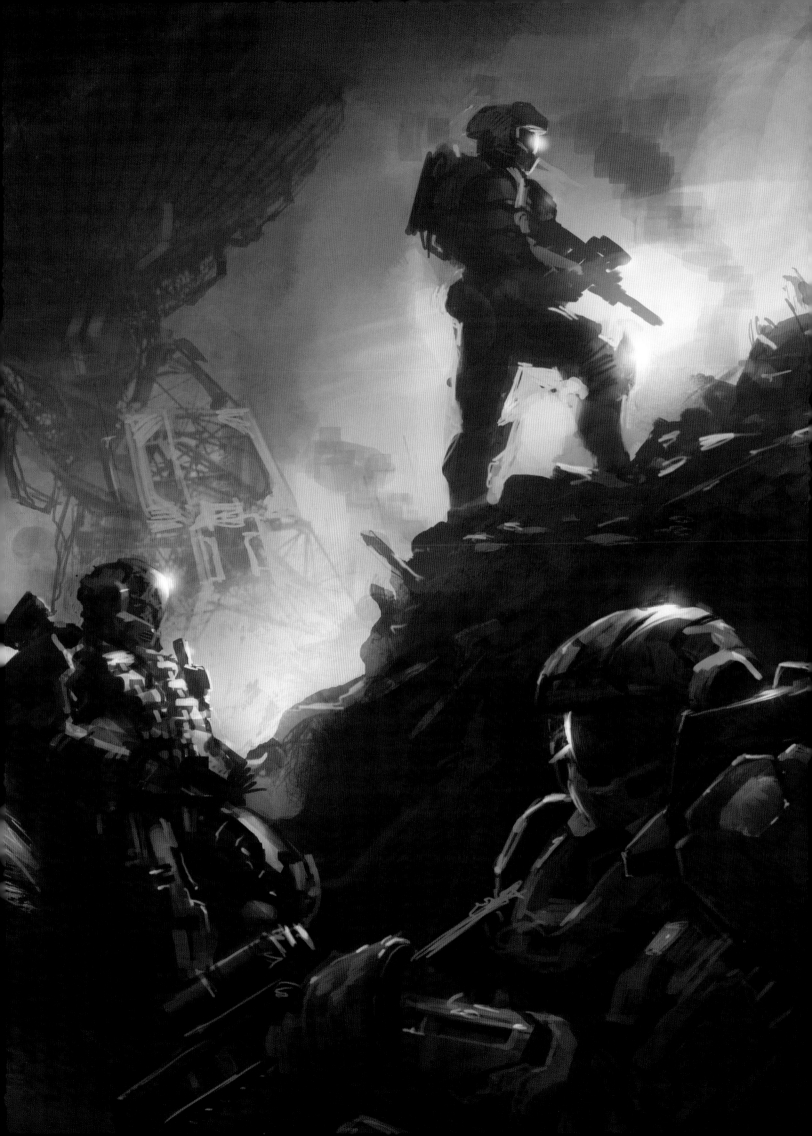

## FILE .006.1 //
# NOBLE TEAM

*HALO: REACH* placed a special emphasis on the people behind the suits, highlighting Halo's Noble Team. The characters of Carter, Kat, Emile, Jun, and Jorge shone through the armor, but the star of the show was Noble Six.

In an interesting diversion from previous games in the series, *Halo: Reach* allowed the player almost complete control over their character, with Noble Six's gender and armor free for customization.

It's a feature that's been a part of Halo's multiplayer for some time, though its transposition to the single player element of the game allowed for a stronger bond to form with the avatar.

Such customization also meant a wealth of assets would have to be produced to accommodate the various visual paths the player could take their character—below are a selection of helmet concepts created for the game.

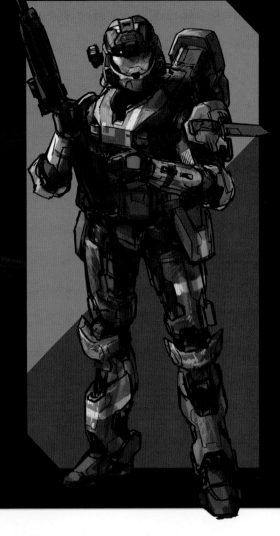

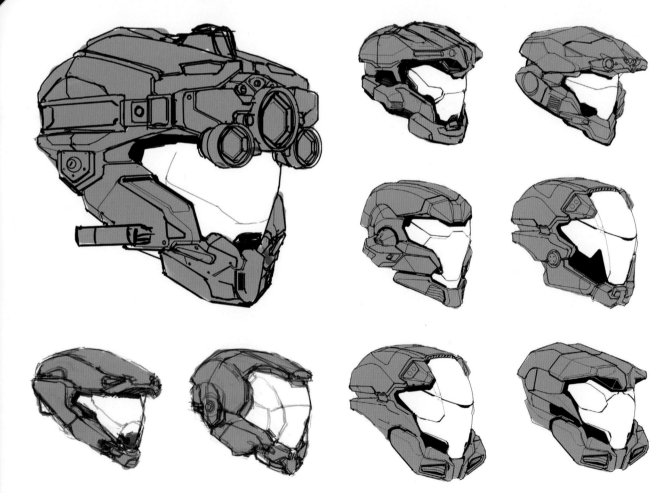

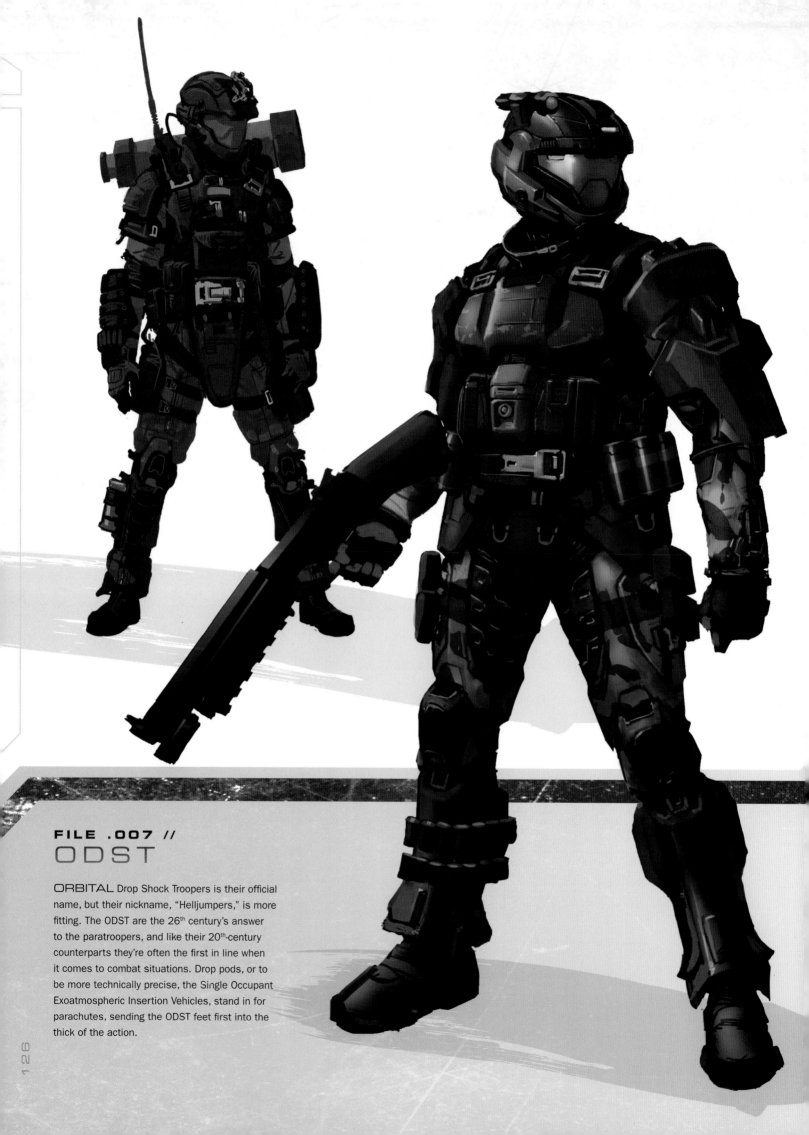

# FILE .007 //
# ODST

ORBITAL Drop Shock Troopers is their official name, but their nickname, "Helljumpers," is more fitting. The ODST are the 26th century's answer to the paratroopers, and like their 20th-century counterparts they're often the first in line when it comes to combat situations. Drop pods, or to be more technically precise, the Single Occupant Exoatmospheric Insertion Vehicles, stand in for parachutes, sending the ODST feet first into the thick of the action.

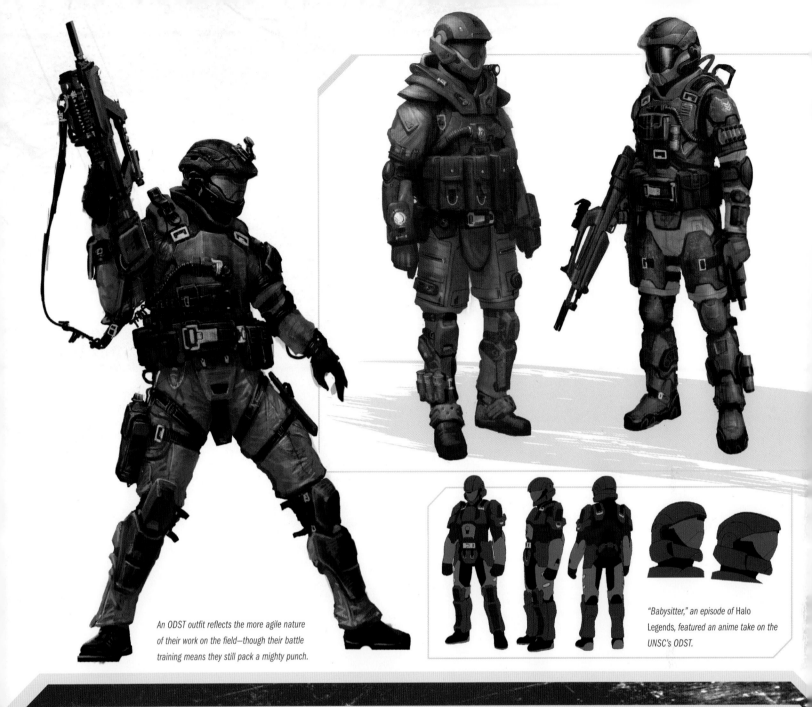

An ODST outfit reflects the more agile nature of their work on the field—though their battle training means they still pack a mighty punch.

"Babysitter," an episode of Halo Legends, featured an anime take on the UNSC's ODST.

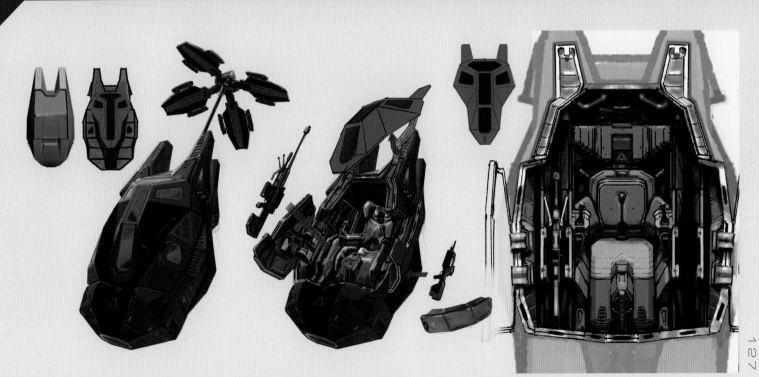

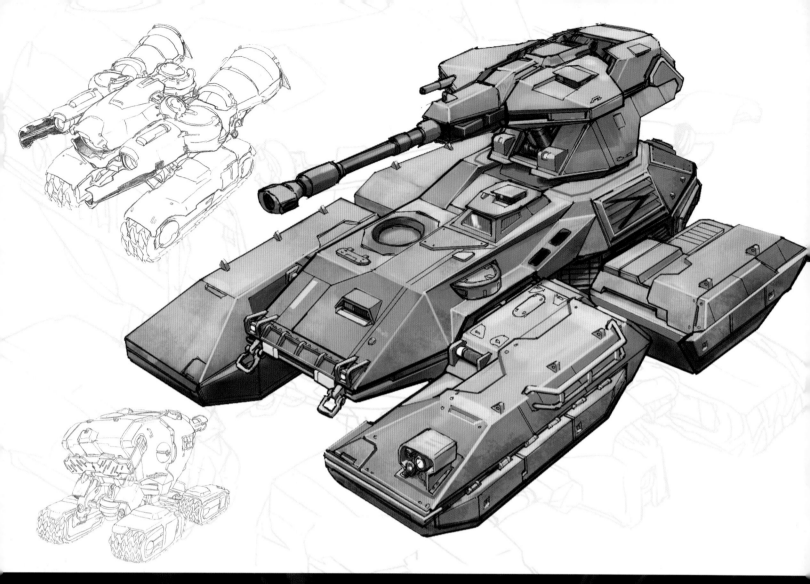

# FILE .008 //
# WARTHOG & SCORPION CONCEPTS

JUST as much as *Halo: Combat Evolved*'s appeal was in its beautiful alien worlds and its sleek gunplay, its allure was also in its vehicles. Their presence in the game was somewhat of a happy accident, though in their way they also proved a catalyst for what Halo would become.

*Halo: Combat Evolved* began as a real time strategy, a game where the player sat detached from the action, giving orders from a heavenly perspective. The problem was, the action on the battlefield looked like too much fun not to get involved in, the vehicles that bounded around the colorful landscapes just begging to be played with.

So the emphasis shifted to the ground, the perspective shifting to a first person one and birthing an entirely new take on the genre. The vehicles remained a star to a large extent—getting to command a Warthog for the first time remains one of the series most electric moments—and in designing them like chunky, robust Tonka toys the artists created the perfect playthings.

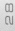

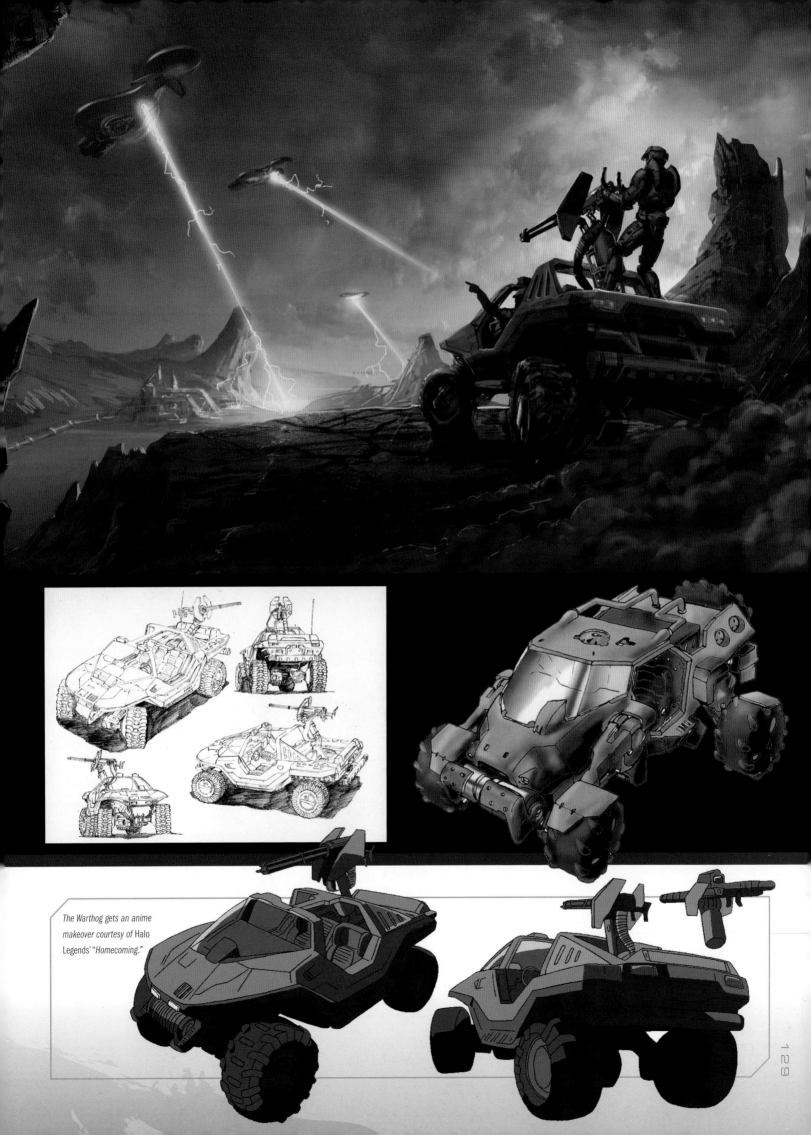

The Warthog gets an anime makeover courtesy of Halo Legends' "Homecoming."

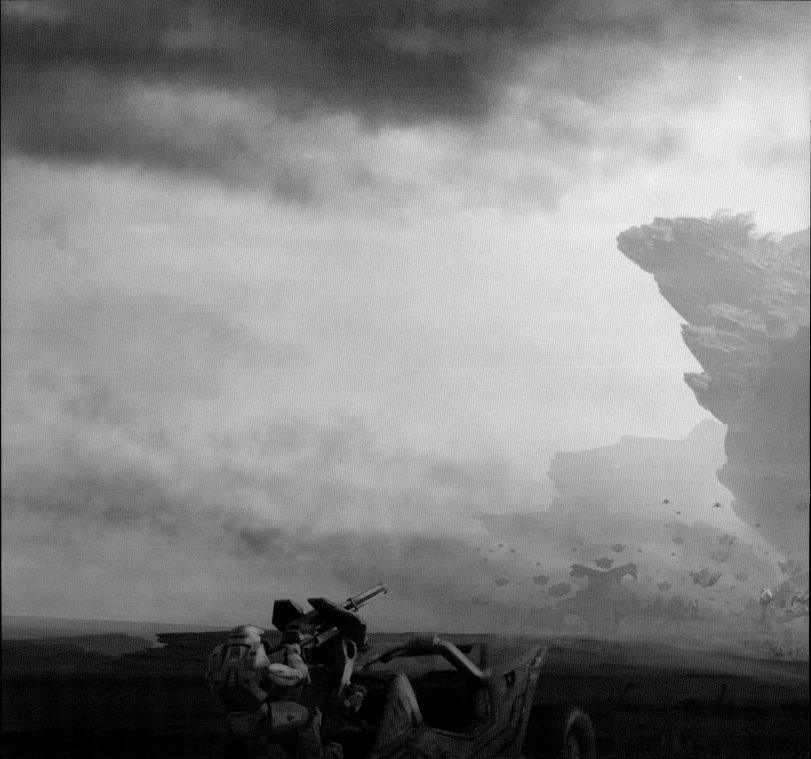

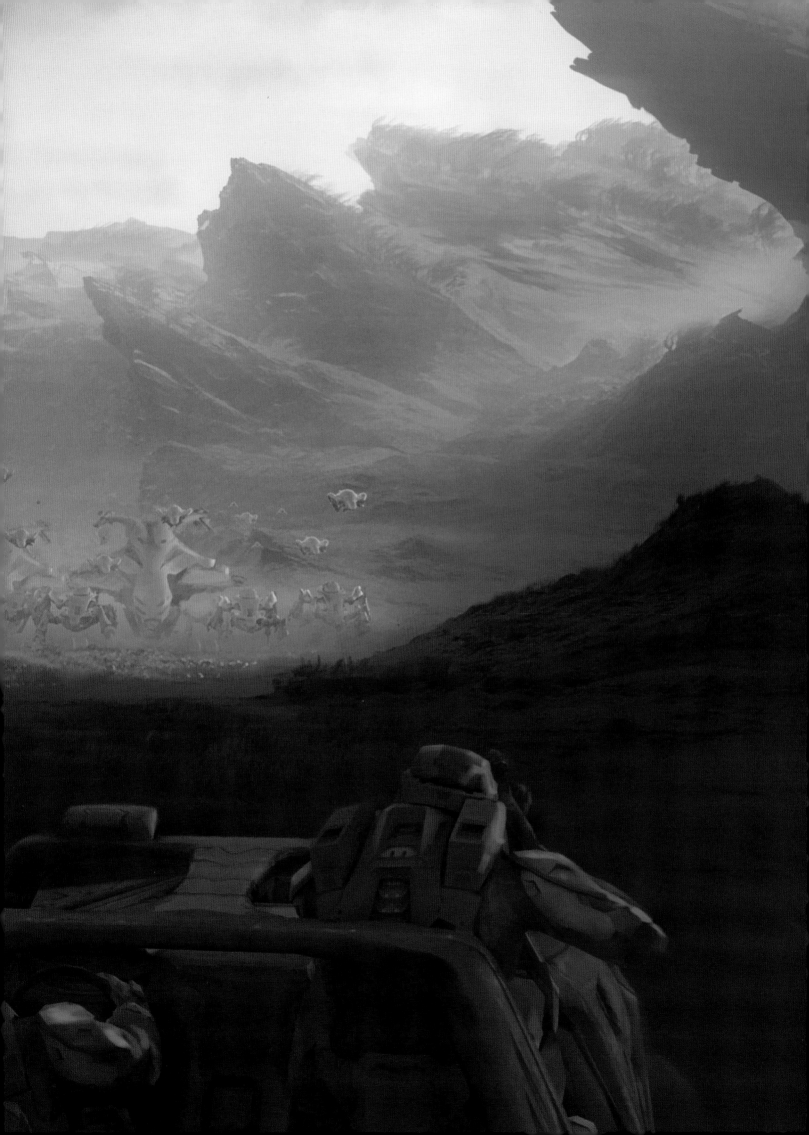

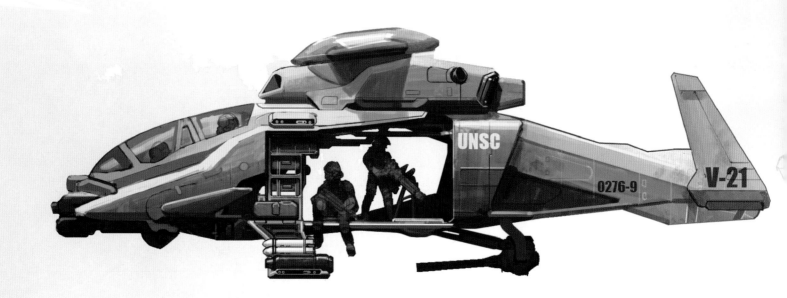

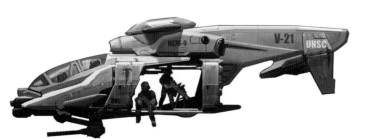

## FILE .009 //
# AIR POWER

BACKING up the UNSC's ground force is its own impressive aerial support. Frigates, dropships, and destroyers may darken the skyboxes with their incredible scale—like the Pelican opposite—but it's the likes of the Hornet and the Falcon that are more likely to leave in indelible mark on the player.

Both these smaller aerial assault vehicles arc drawn up almost in direct opposition to the Covenant's Banshee, in an example of the neat interweaving and counter-balancing that helps keep Halo's game of rock, paper, and Spartan laser in check. Their design again plays into their function; for the Hornet, it's a more nimble machine that's put through its paces in *Halo 3*'s "The Covenant," while the Falcon's bulkier frame takes the player through the charred skies of "New Alexandria" in one of *Halo: Reach*'s many memorable set-pieces.

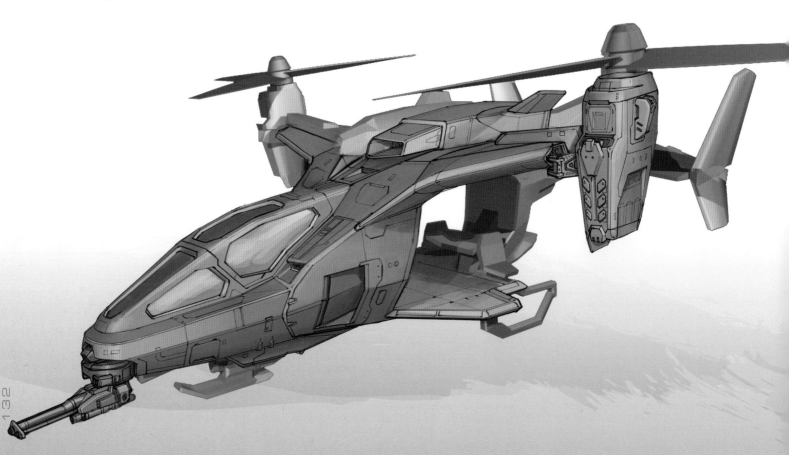

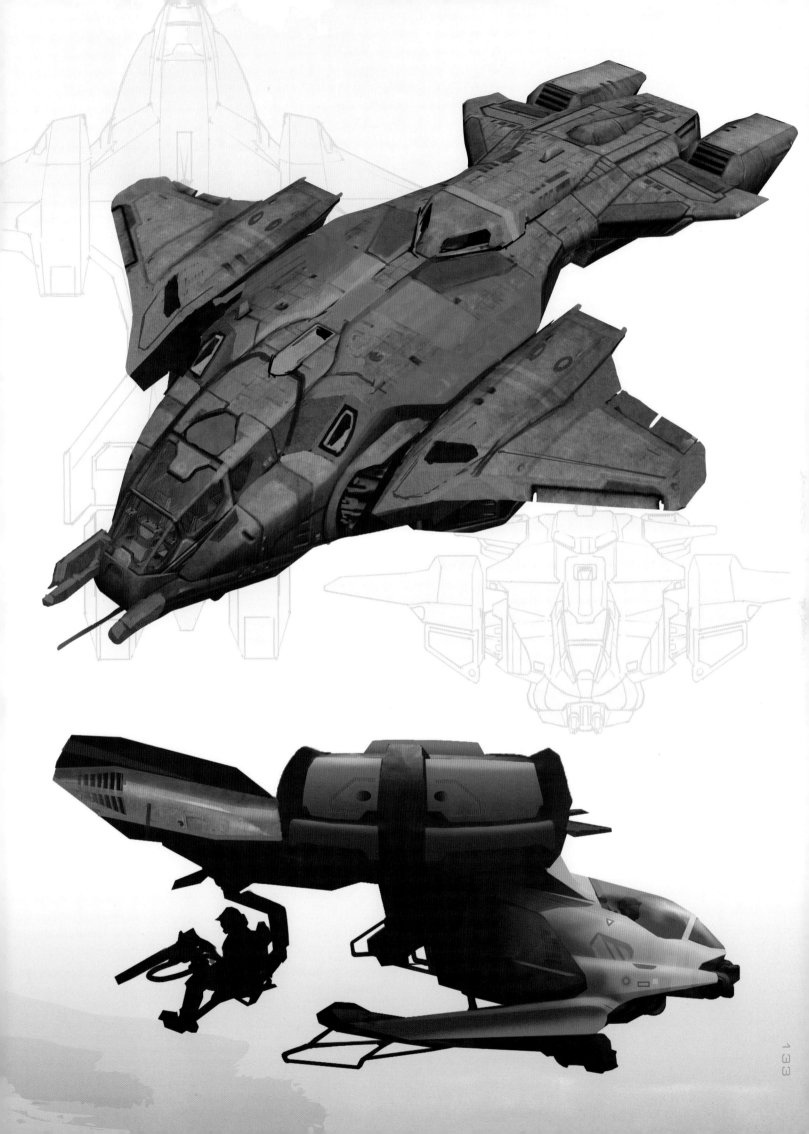

# FILE .010 //
# PELICAN

THE Pelican's the UNSC's workhorse of the sky, ferrying troops, supplies, and vehicles across the series' many battlefields. The Dropship-77 Heavy Troop Carrier has undergone several tweaks throughout the series, but it's remained an integral part of the UNSC's aerial force.

The Pelican also continues Halo's trend of naming its vehicles after animals, and of displaying traits of its namesake. For the Pelican, it shares the large storage capacity of the large bird; the UNSC dropship can transport Warthogs and Scorpions as well as leagues of troops.

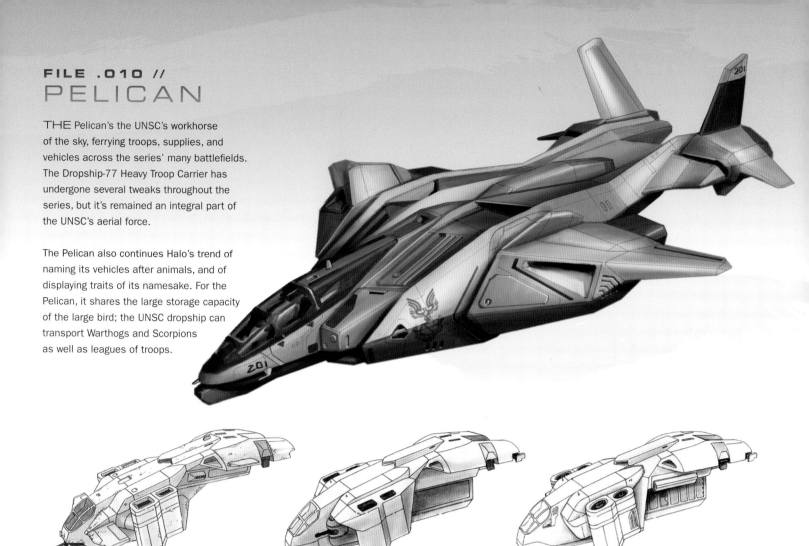

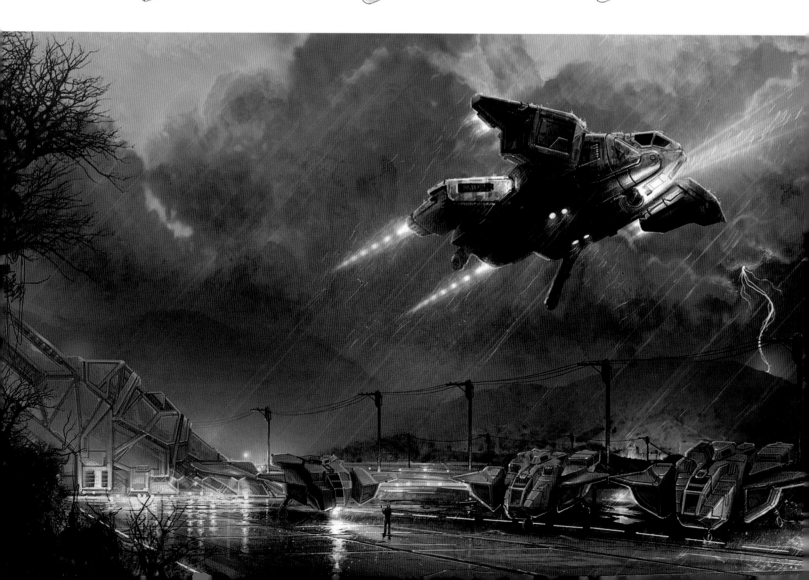

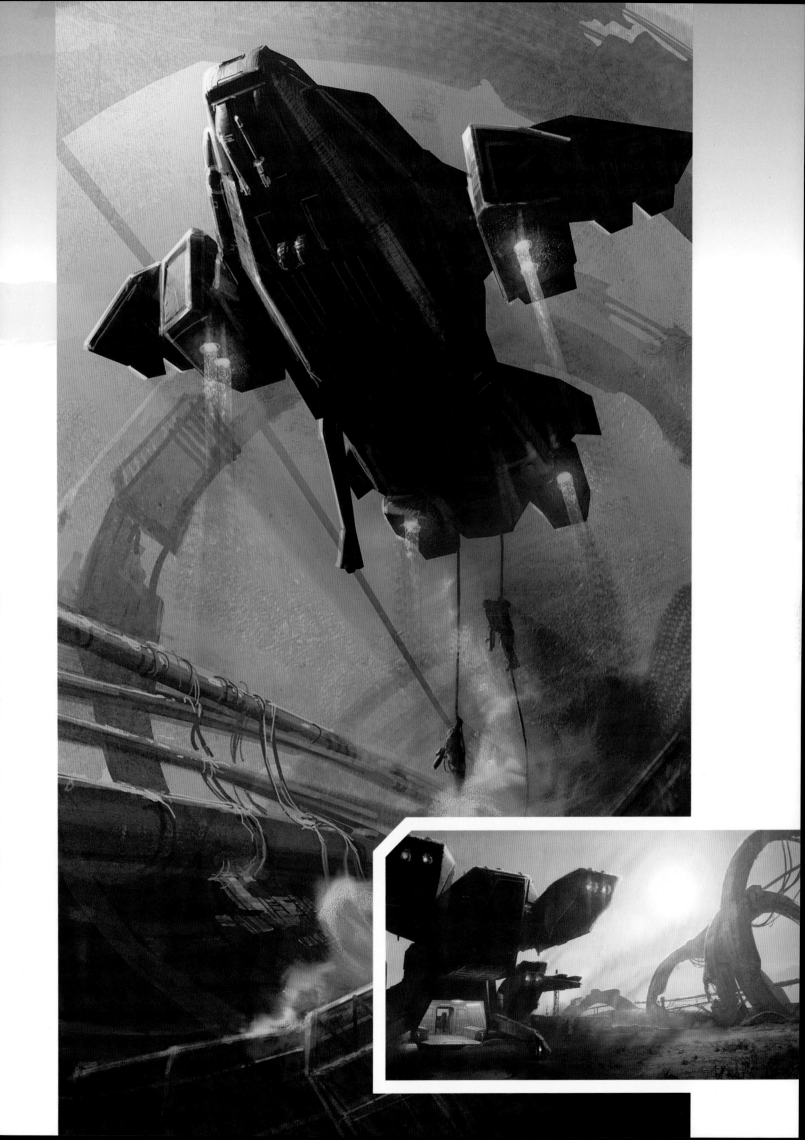

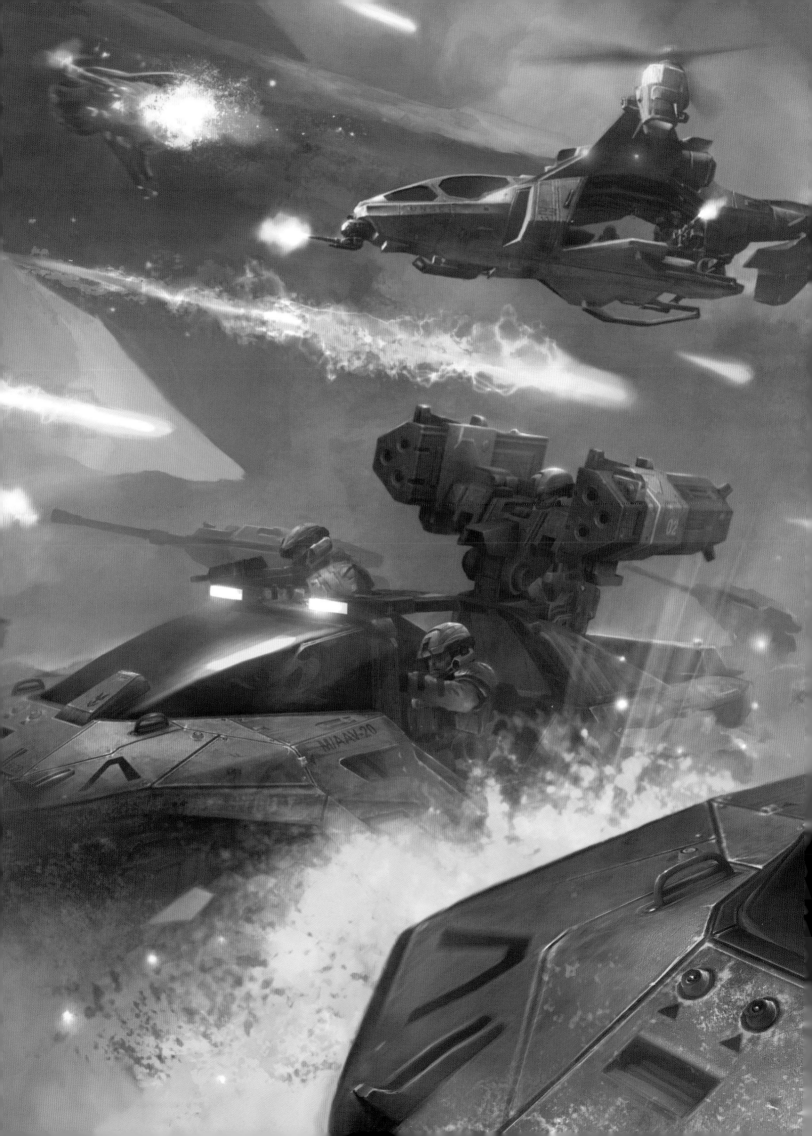

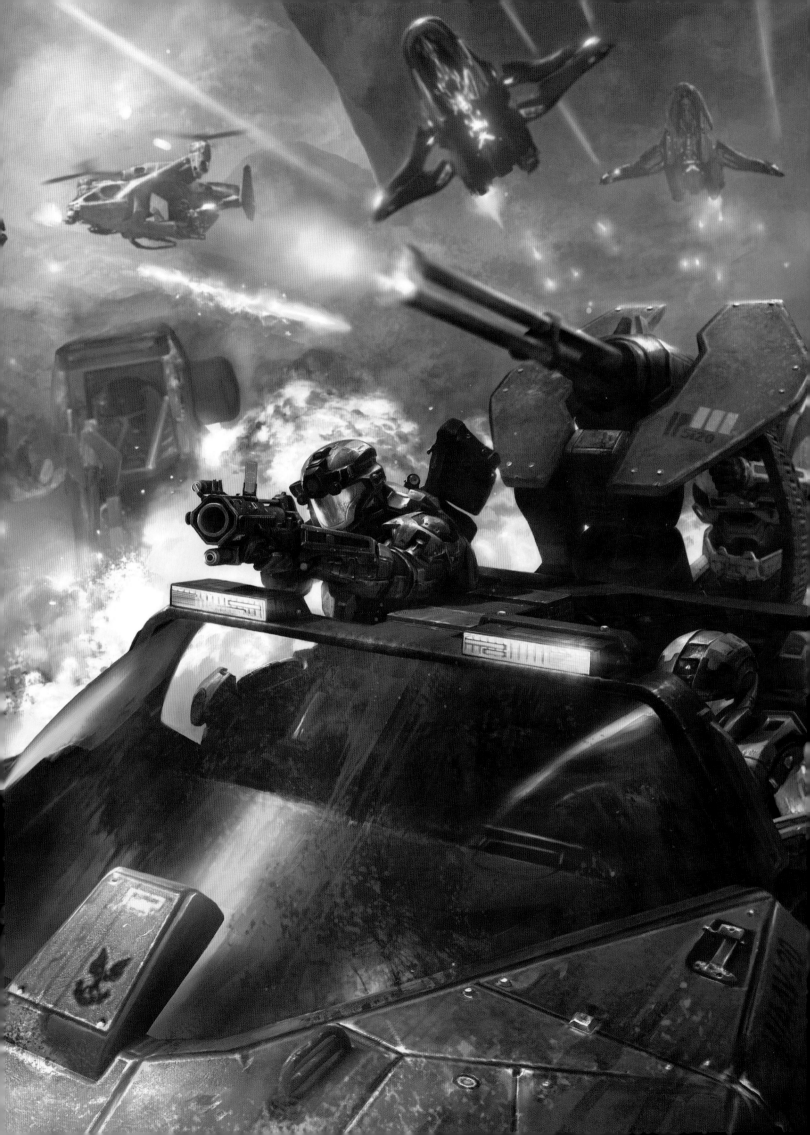

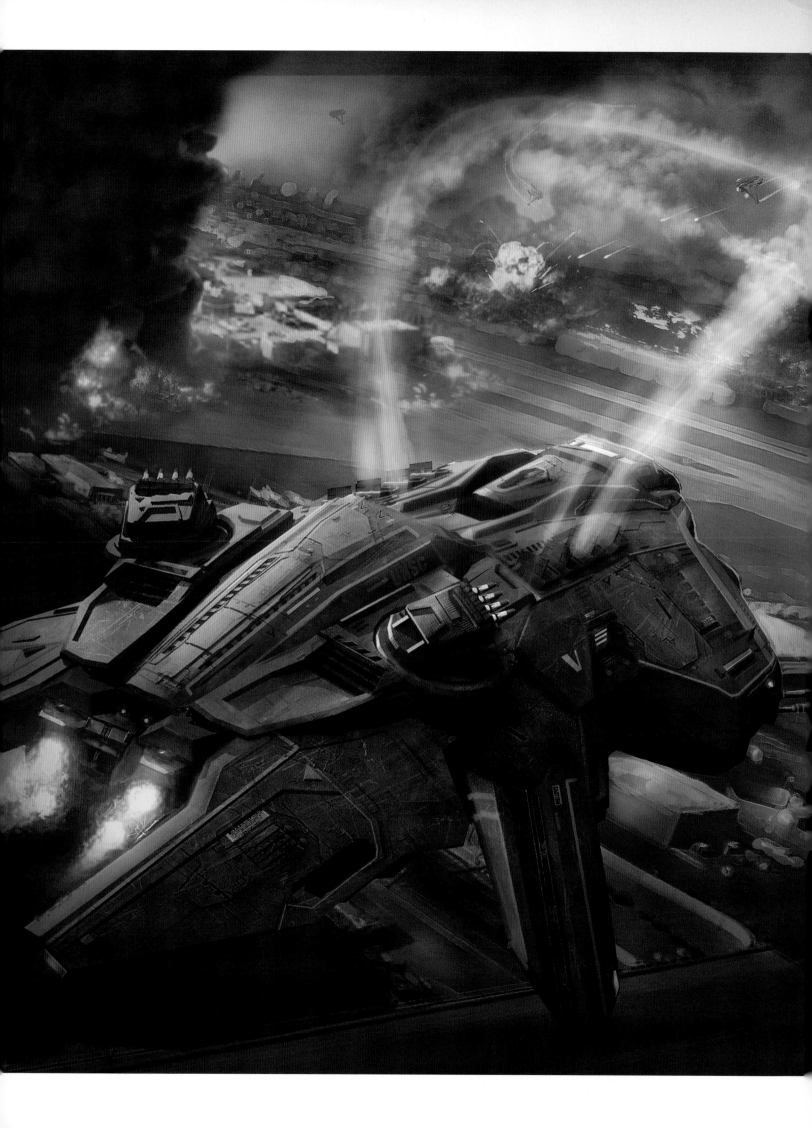

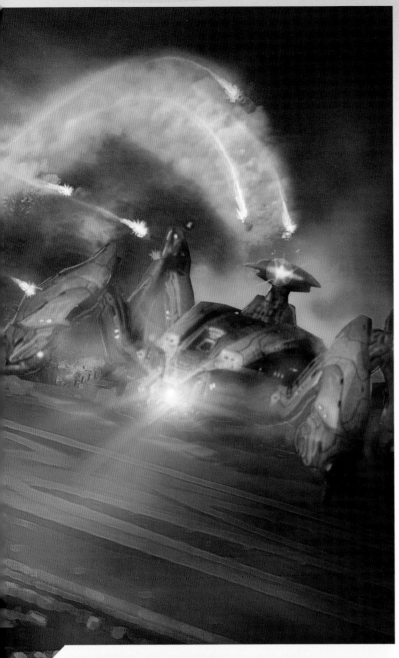

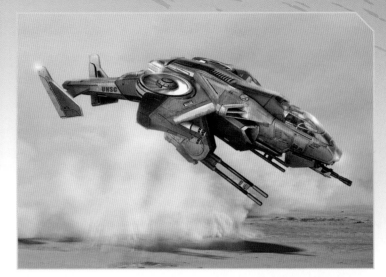

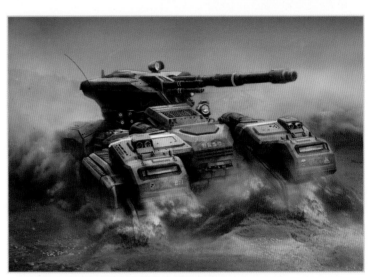

A shift to epic and large-scale skirmishes meant that Halo Wars enjoys the most diverse set of hardware of any Halo games to date—and alongside the variations of such staples as the Scorpion and Warthog are some fascinating and curious one-offs.

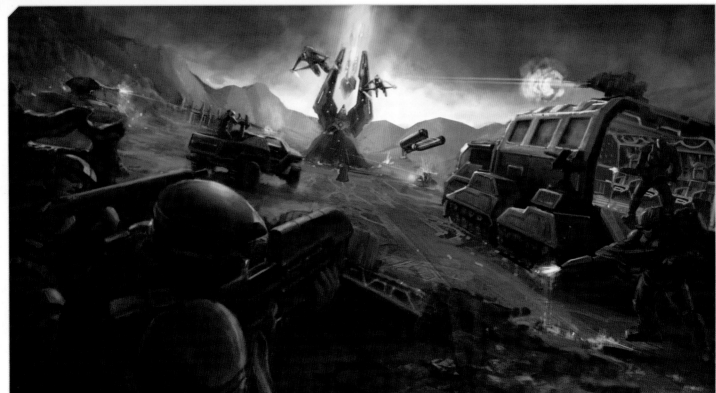

# FILE .011 //
# PILLAR OF AUTUMN

IT'S the ship with the honor of transporting humans to their very first contact with Halo, and it's arguably one of the most significant members of the UNSC's fleet. The *Pillar of Autumn*, helmed by Captain Keyes, has played an instrumental part in the Halo series, from hosting those very first moments of *Halo: Combat Evolved* to making a weighty cameo at *Halo: Reach*'s climax.

"At the time I drew the sketches for the *Pillar of Autumn*, I followed design cues from the Chief's Assault Rifle and looked to inspirational images from

an animated film called *Mobile Suit Gundam*," explains Lorraine McLees, "The *Autumn* was essentially a big gun with engines that will carry the crew to Halo, complete with centrifuge for the crew quarters housed beneath angled ablative armor."

Over the years, the *Pillar of Autumn* has become an icon in itself. Indeed, it's a fascinating study of how the design of Halo has evolved, having bookmarked Bungie's tenure on the series and kick-starting the more recent remake.

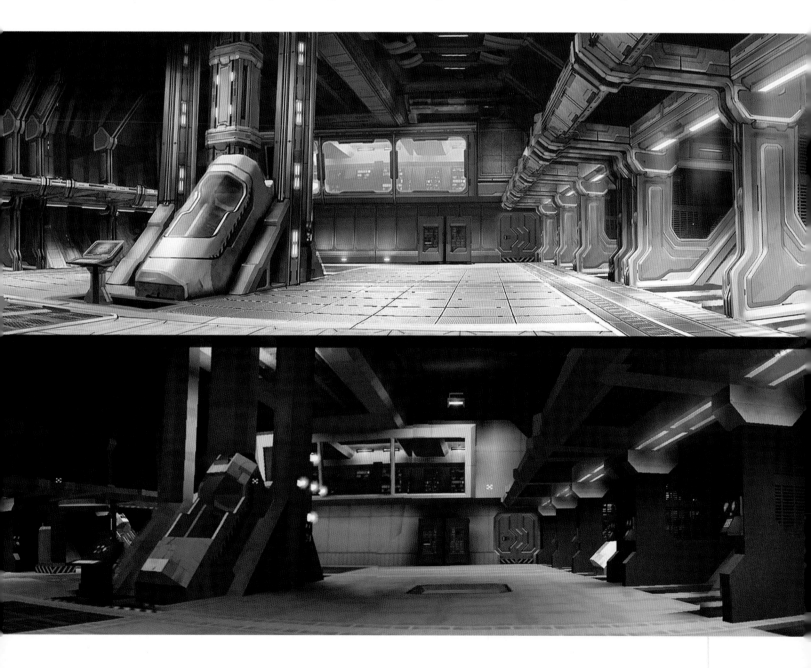

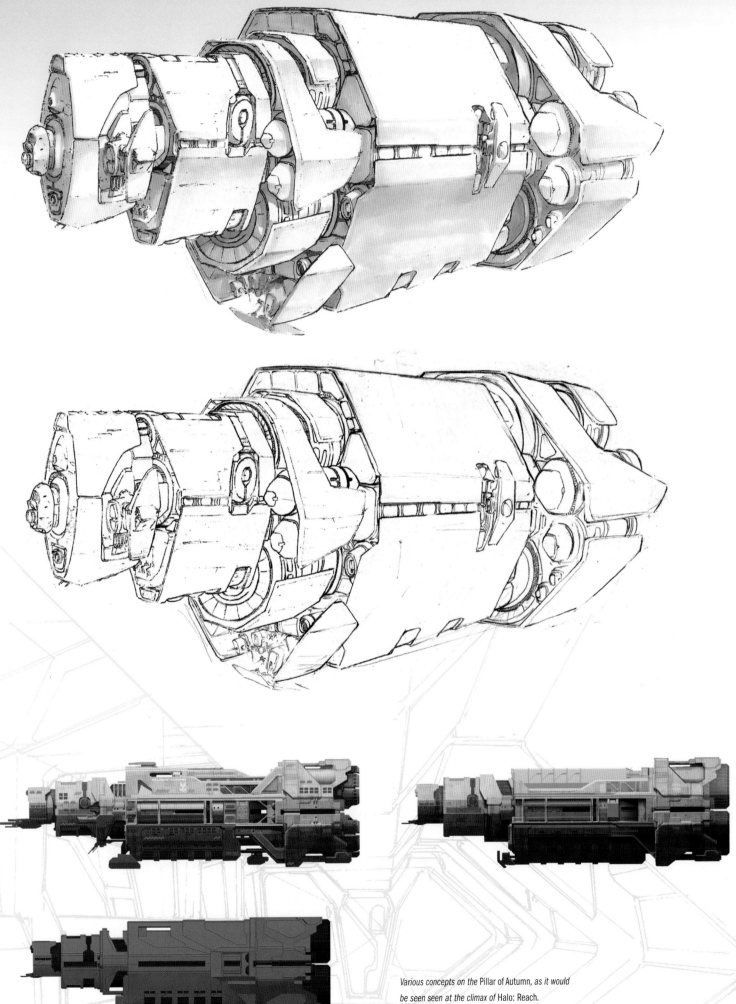

Various concepts on the Pillar of Autumn, as it would
be seen seen at the climax of Halo: Reach.

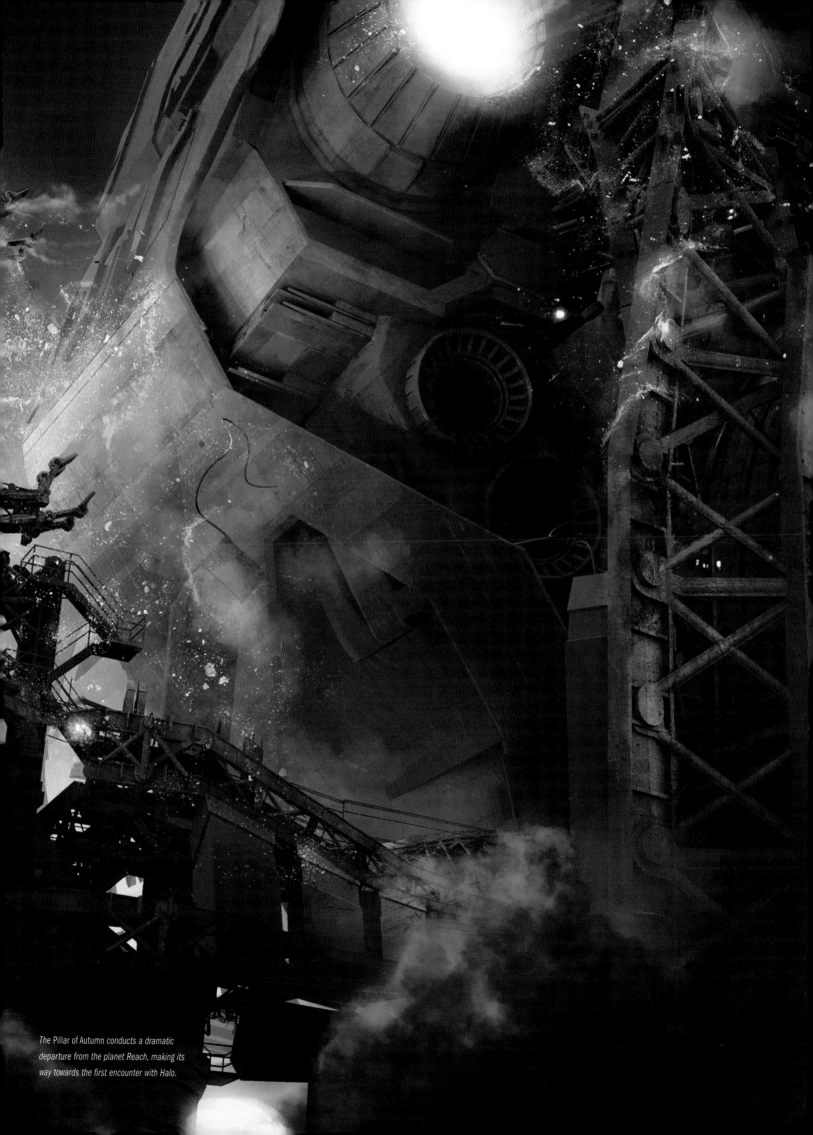

*The Pillar of Autumn conducts a dramatic
departure from the planet Reach, making its
way towards the first encounter with Halo.*

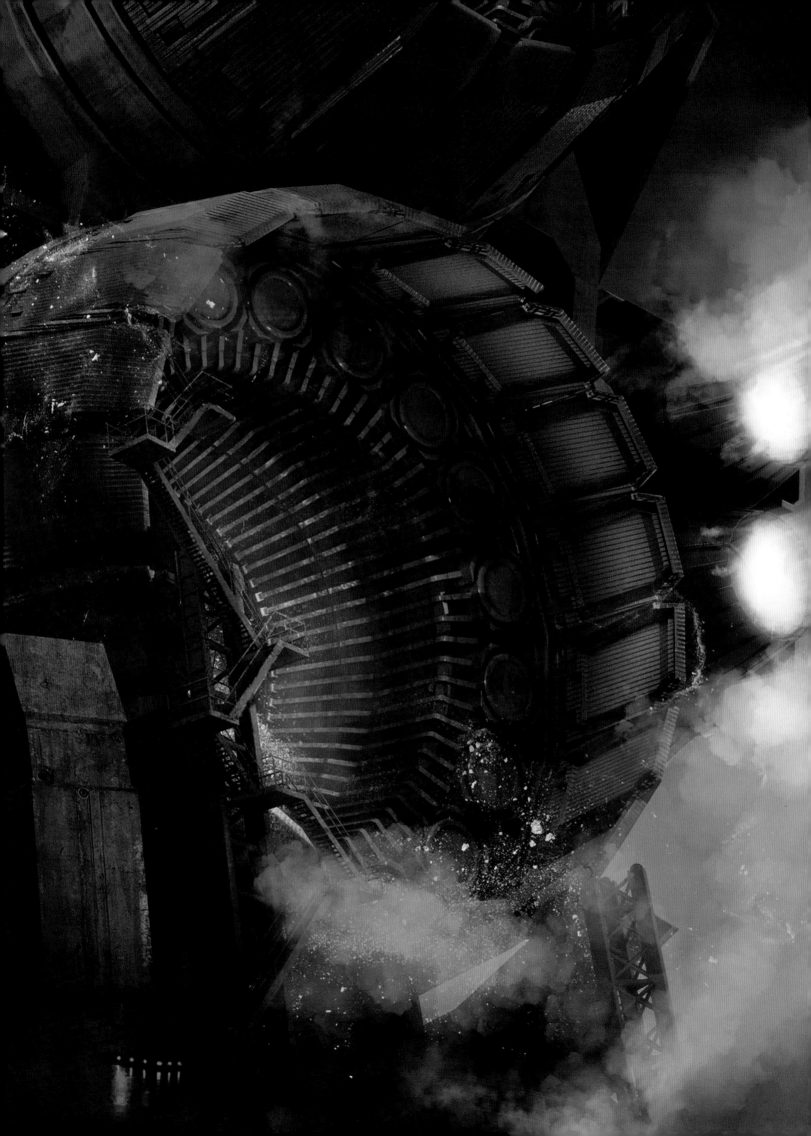

# CH.006

## FOLKS NEED HEROES

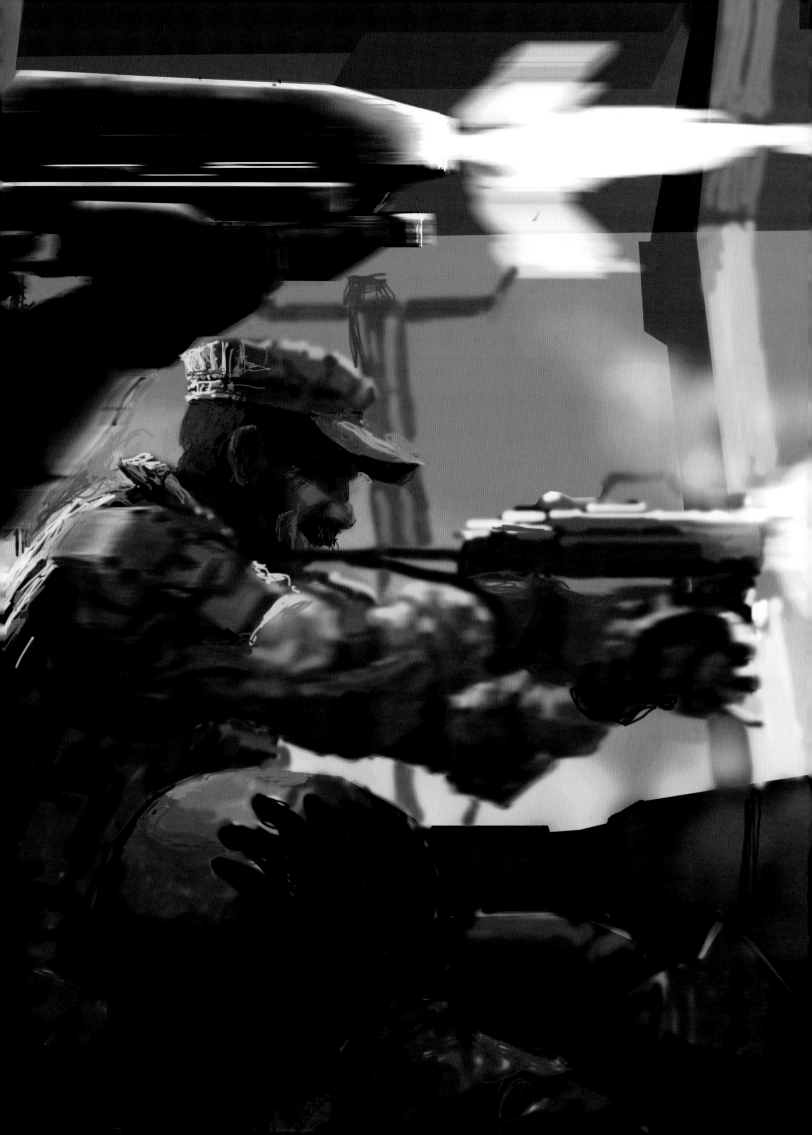

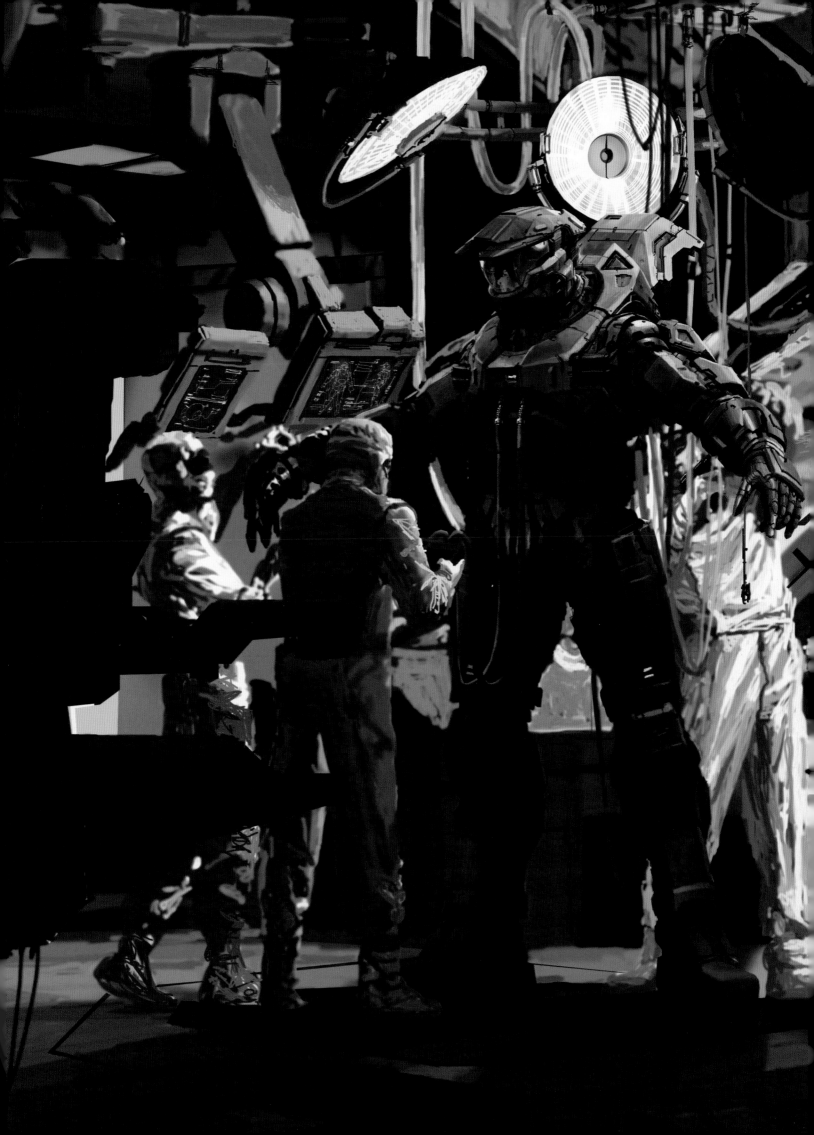

## FILE .001 //
# THE STOIC HERO

**THERE'S** one character that looms largest over the Halo universe: the Master Chief.

A soldier born from the SPARTAN-II project, John-117 is the ultimate savior of the universe, but one of gaming's greatest icons came from humble beginnings.

"For the longest time, we referred to the Master Chief as "the cyborg," which was just one type of infantry unit in the game," explains artist Robt McLees, "but that's back when Halo was an RTS.

"Later on, it seemed like a better idea to make it one guy. But the other characters would need to refer to him by name, or, more appropriately, by rank. I particularly liked "Chief" because my friends and I used to call each other "Chief" back in the day, and it didn't particularly sound like a modern military designation. It felt more colloquial."

Indeed, the Master Chief's appeal can be attributed to his broad and malleable personality. When in the player's command the Chief never speaks, placing him in the long line of mute video game heroes populated by the likes of *Half Life*'s Gordon Freeman.

When the Chief does open his mouth he reveals a character that's deliberate, heroic and stoic. "One of the first directions I gave to Steve Downes when he was doing the voice for the Master Chief… was that he is like 'the Man with No Name', a man of few words," recalls Halo's audio maestro Marty O'Donnell. "He would say one to three words and he's done. Think Clint Eastwood."

The Master Chief's appeal is much like that of the Man with No Name, but his lineage goes back further than that. He's the descendant of the classic Homeric hero, a nomadic sufferer who travels the furthest reaches of the galaxy in his quest. Not forgetting that he totally kicks ass.

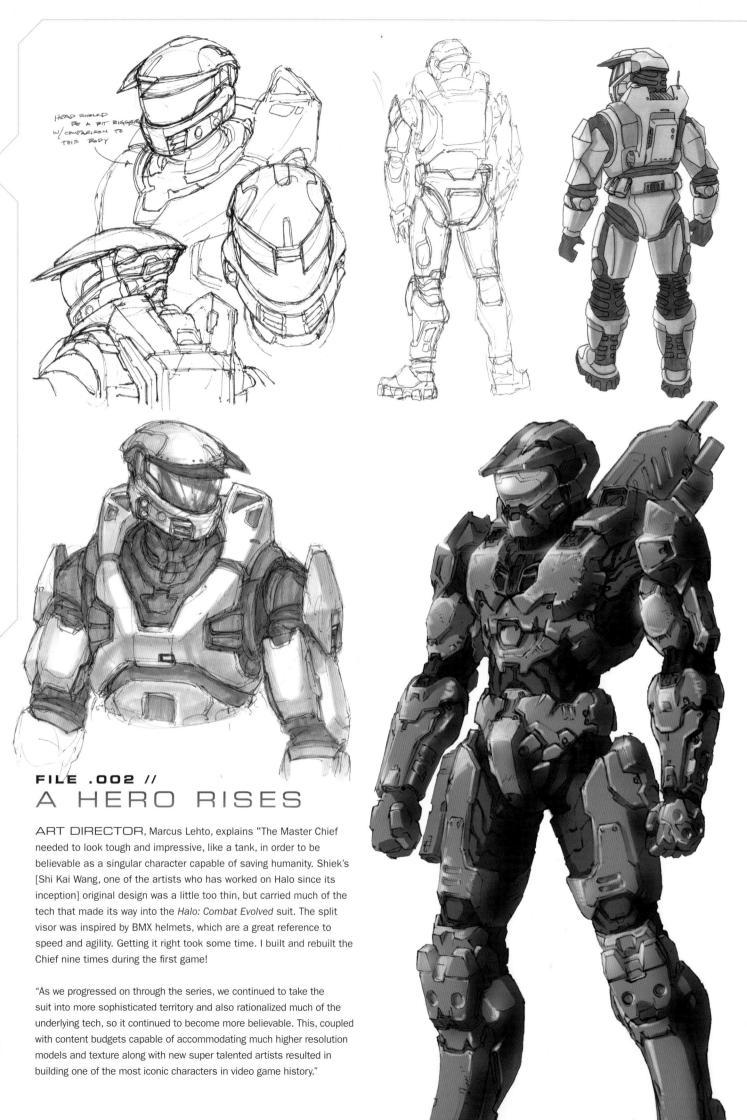

# FILE .002 //
# A HERO RISES

ART DIRECTOR, Marcus Lehto, explains "The Master Chief needed to look tough and impressive, like a tank, in order to be believable as a singular character capable of saving humanity. Shiek's [Shi Kai Wang, one of the artists who has worked on Halo since its inception] original design was a little too thin, but carried much of the tech that made its way into the *Halo: Combat Evolved* suit. The split visor was inspired by BMX helmets, which are a great reference to speed and agility. Getting it right took some time. I built and rebuilt the Chief nine times during the first game!

"As we progressed on through the series, we continued to take the suit into more sophisticated territory and also rationalized much of the underlying tech, so it continued to become more believable. This, coupled with content budgets capable of accommodating much higher resolution models and texture along with new super talented artists resulted in building one of the most iconic characters in video game history."

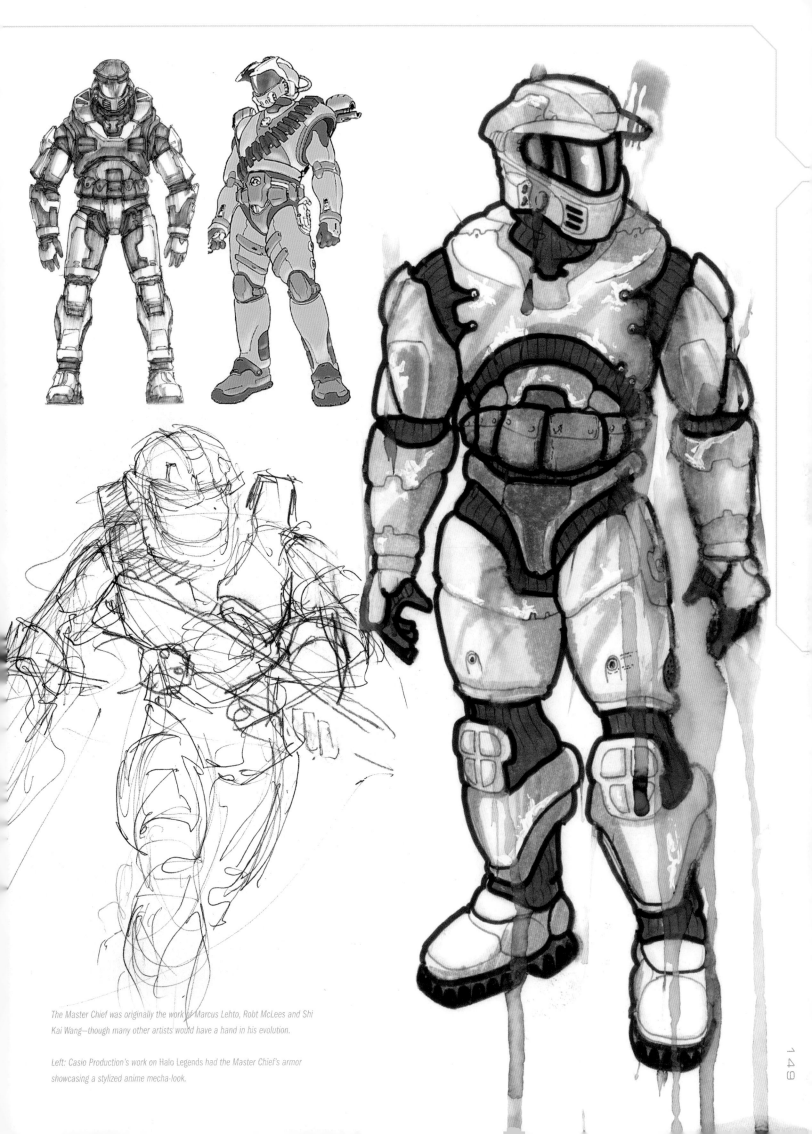

The Master Chief was originally the work of Marcus Lehto, Robt McLees and Shi Kai Wang—though many other artists would have a hand in his evolution.

Left: Casio Production's work on Halo Legends had the Master Chief's armor showcasing a stylized anime mecha-look.

# FILE .003 //
## HALO 2

AT the outset of *Halo 2* the Master Chief is handed the new MJOLNIR Mark VI armor, a neat excuse both for his new powers and the subtle makeover he received for the sequel. Robt McLees details the thinking behind the redesign: "We wanted to preserve his iconic look, maybe toned down a little: The gold faceplate, the two-pronged visor and the proportions on his armor that was either soft or that hard green."

It's a look that stuck—the MJOLNIR Mark VI armor reappeared in *Halo 3*, and although the increased processing power of the Xbox 360 allowed for more detail the design fundamentals remained the same.

Here, in this cover for *Edge* magazine by artist Eddie Smith, the Master Chief surveys an Earth under attack as troopers stream out of a Pelican in the distance.

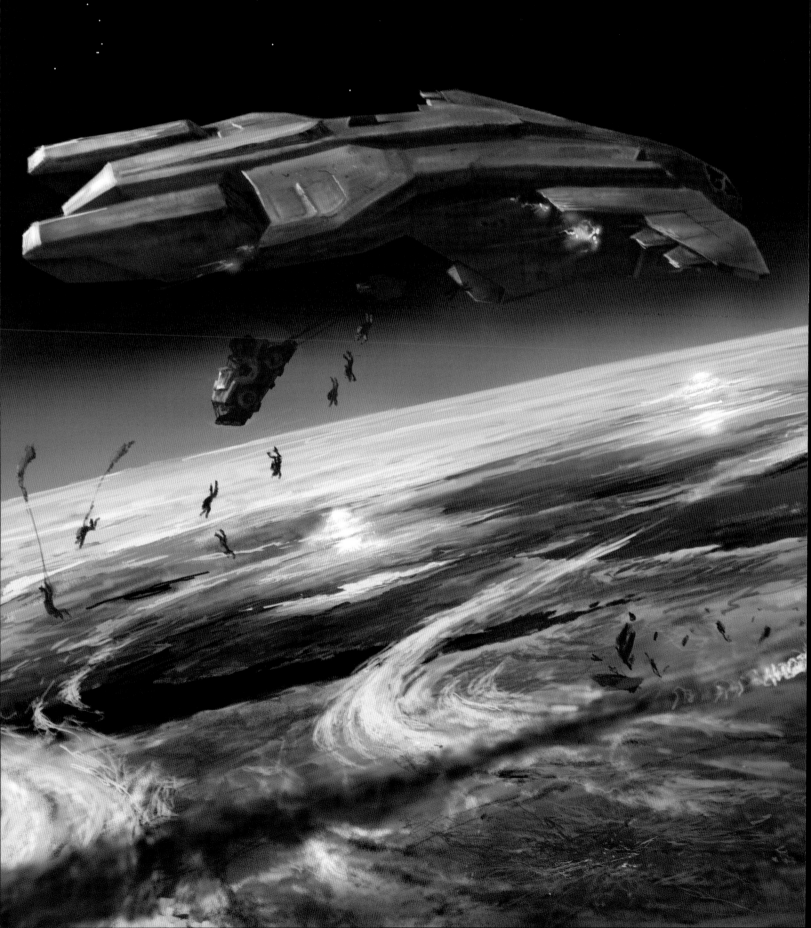

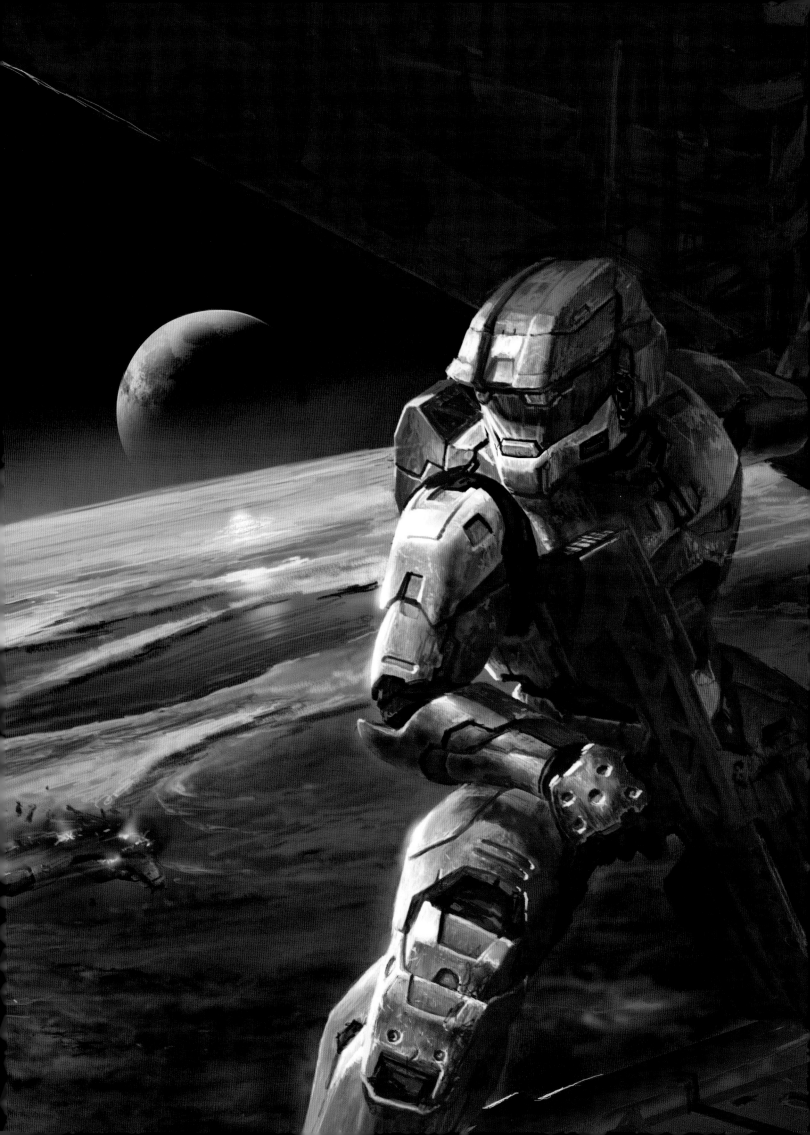

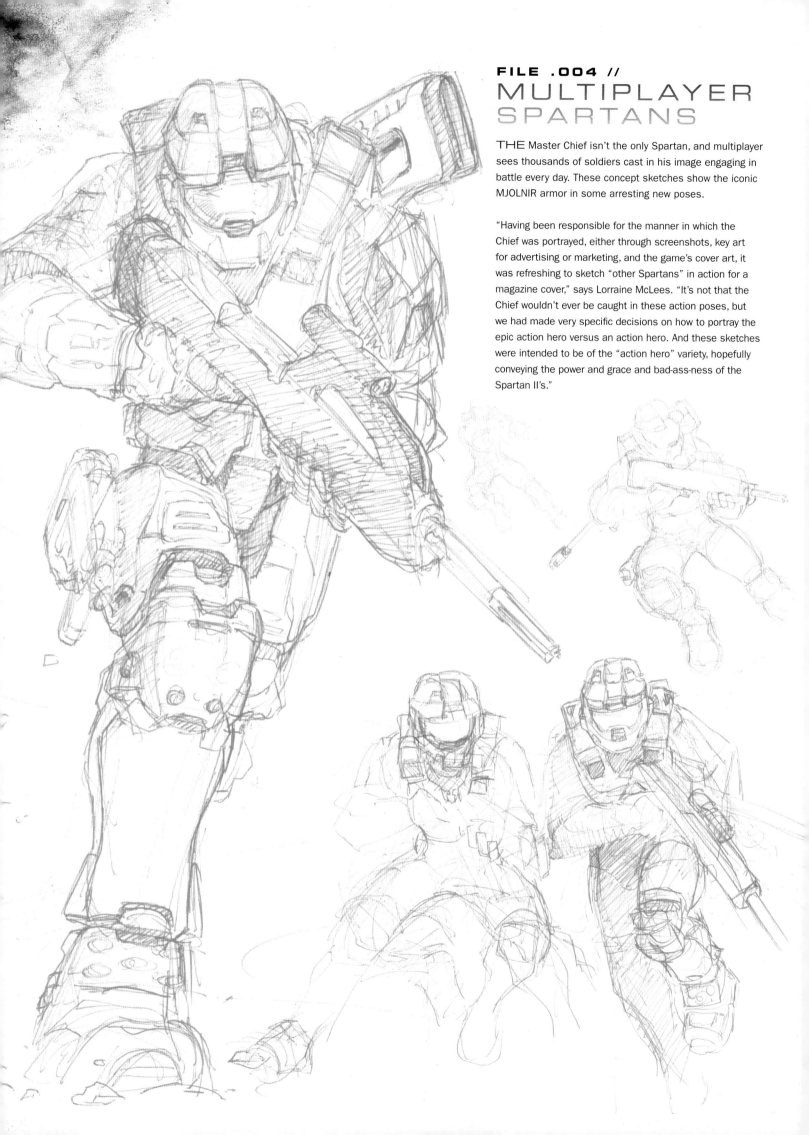

# FILE .004 //
# MULTIPLAYER
## S P A R T A N S

THE Master Chief isn't the only Spartan, and multiplayer sees thousands of soldiers cast in his image engaging in battle every day. These concept sketches show the iconic MJOLNIR armor in some arresting new poses.

"Having been responsible for the manner in which the Chief was portrayed, either through screenshots, key art for advertising or marketing, and the game's cover art, it was refreshing to sketch "other Spartans" in action for a magazine cover," says Lorraine McLees. "It's not that the Chief wouldn't ever be caught in these action poses, but we had made very specific decisions on how to portray the epic action hero versus an action hero. And these sketches were intended to be of the "action hero" variety, hopefully conveying the power and grace and bad-ass-ness of the Spartan II's."

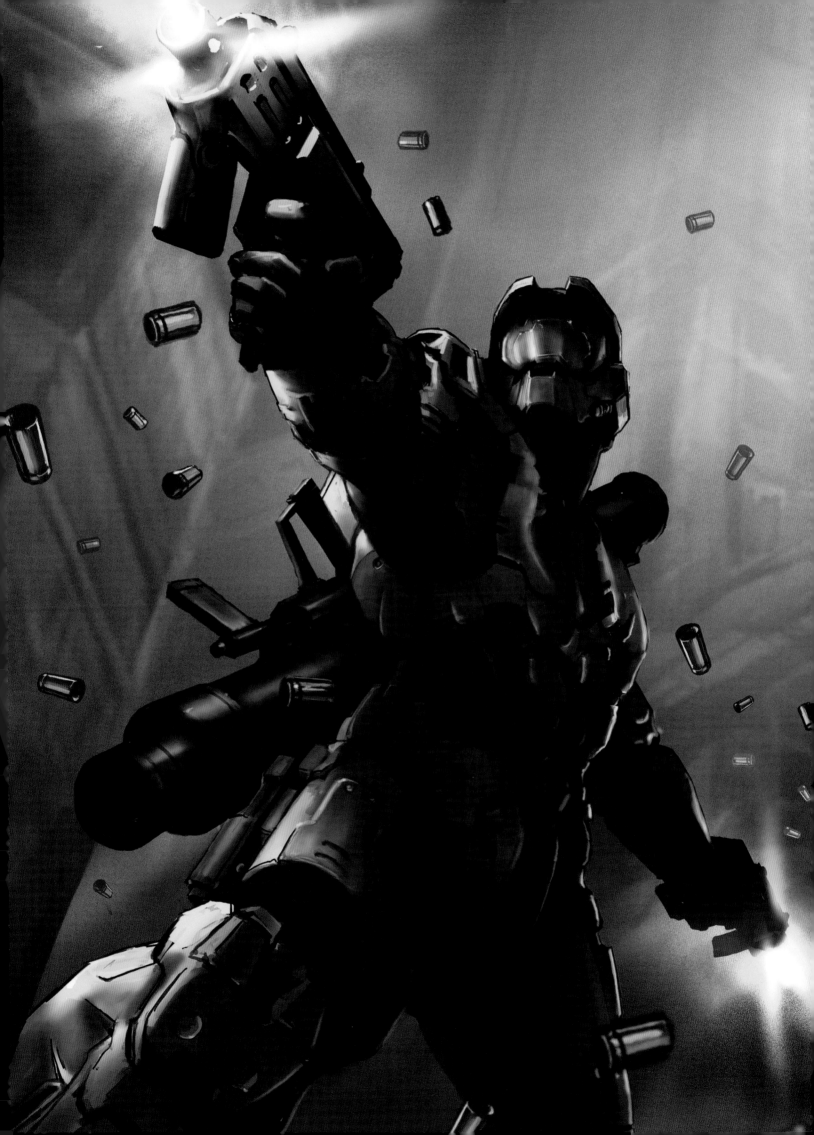

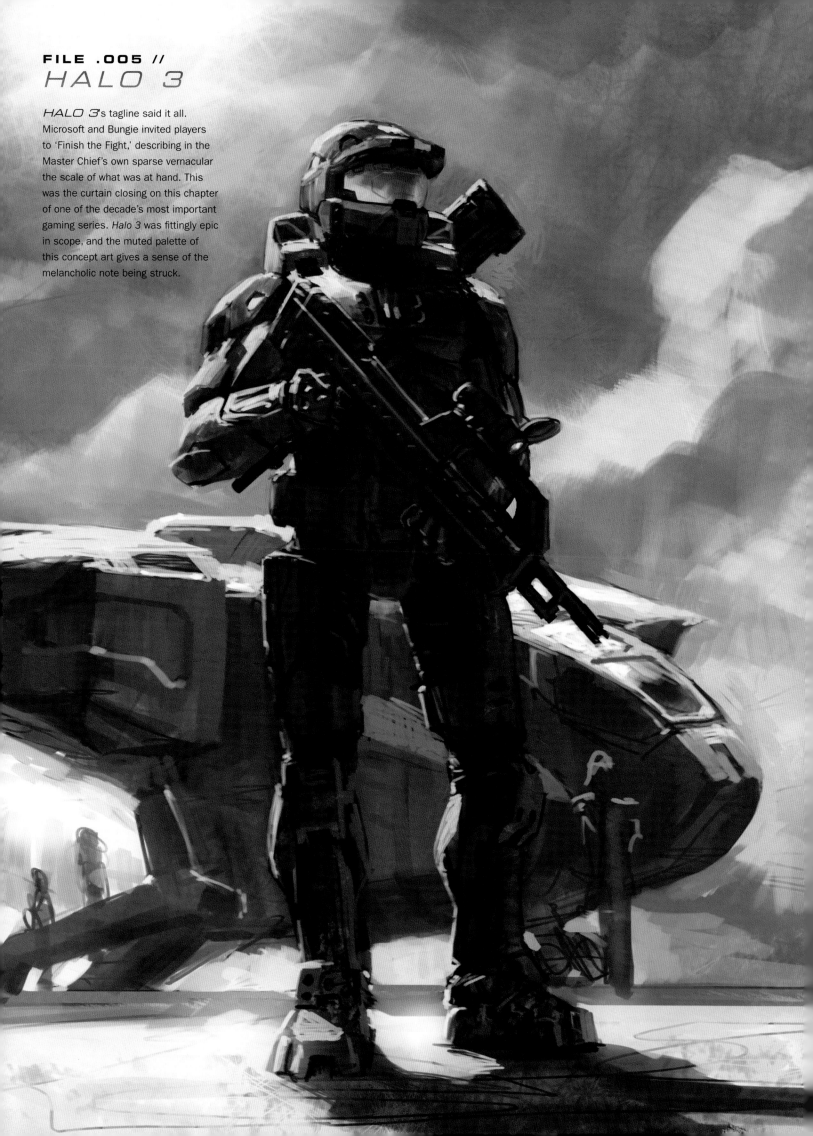

# FILE .005 //
# HALO 3

*HALO 3*'s tagline said it all. Microsoft and Bungie invited players to 'Finish the Fight,' describing in the Master Chief's own sparse vernacular the scale of what was at hand. This was the curtain closing on this chapter of one of the decade's most important gaming series. *Halo 3* was fittingly epic in scope, and the muted palette of this concept art gives a sense of the melancholic note being struck.

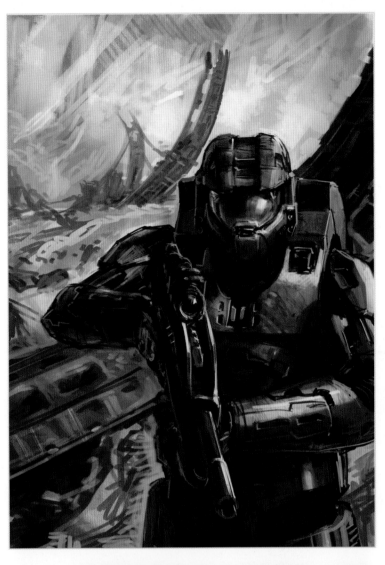
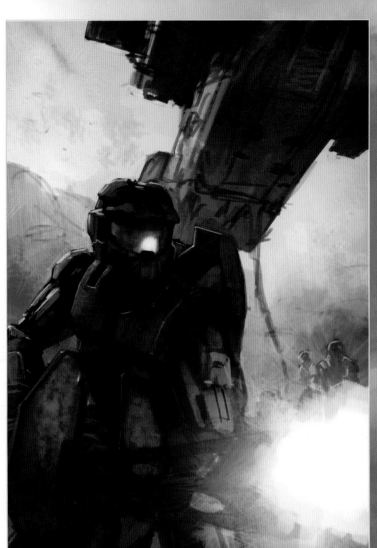
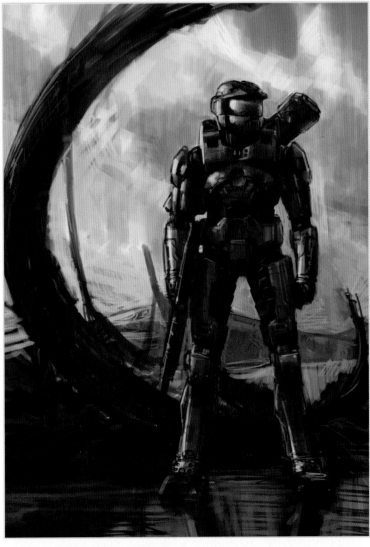
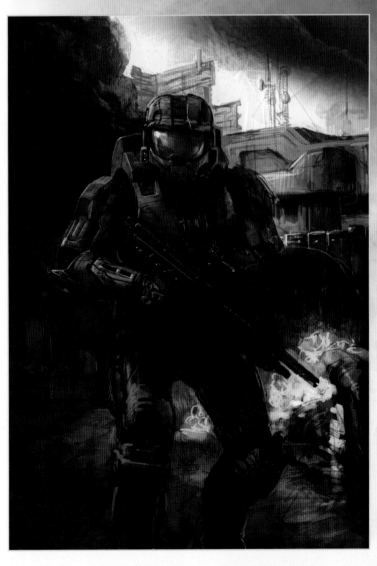

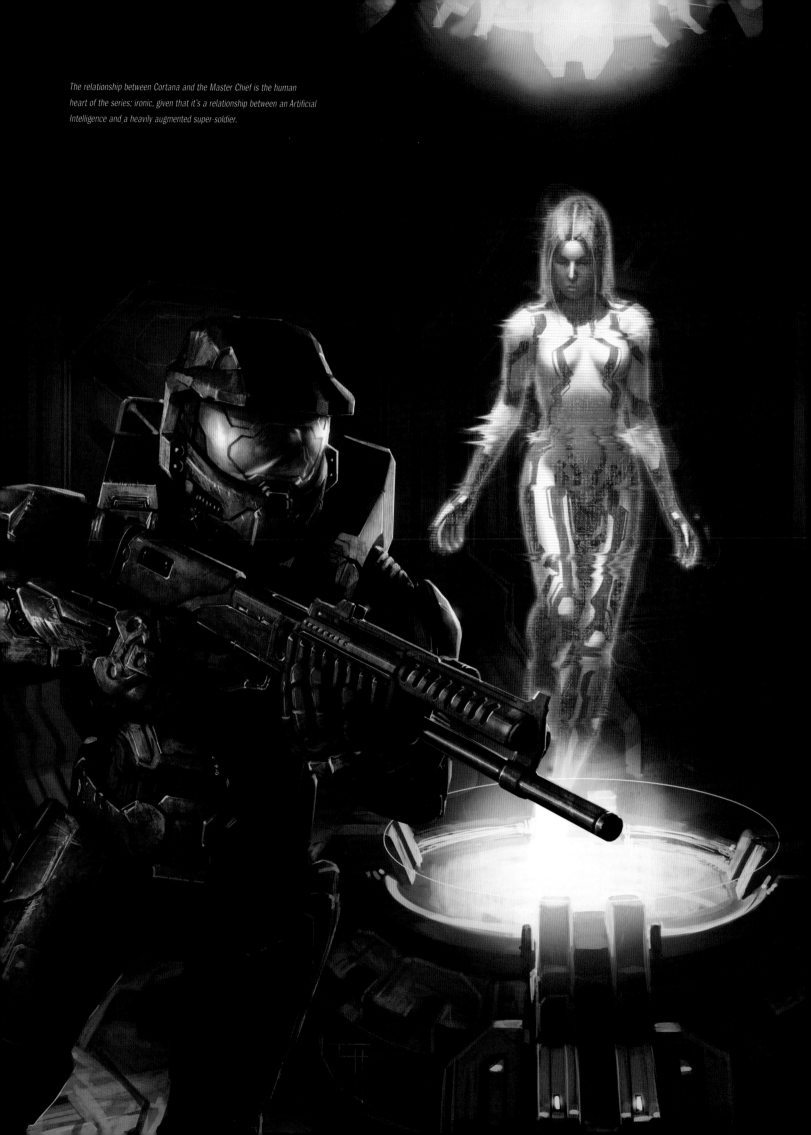

The relationship between Cortana and the Master Chief is the human heart of the series; ironic, given that it's a relationship between an Artificial Intelligence and a heavily augmented super-soldier.

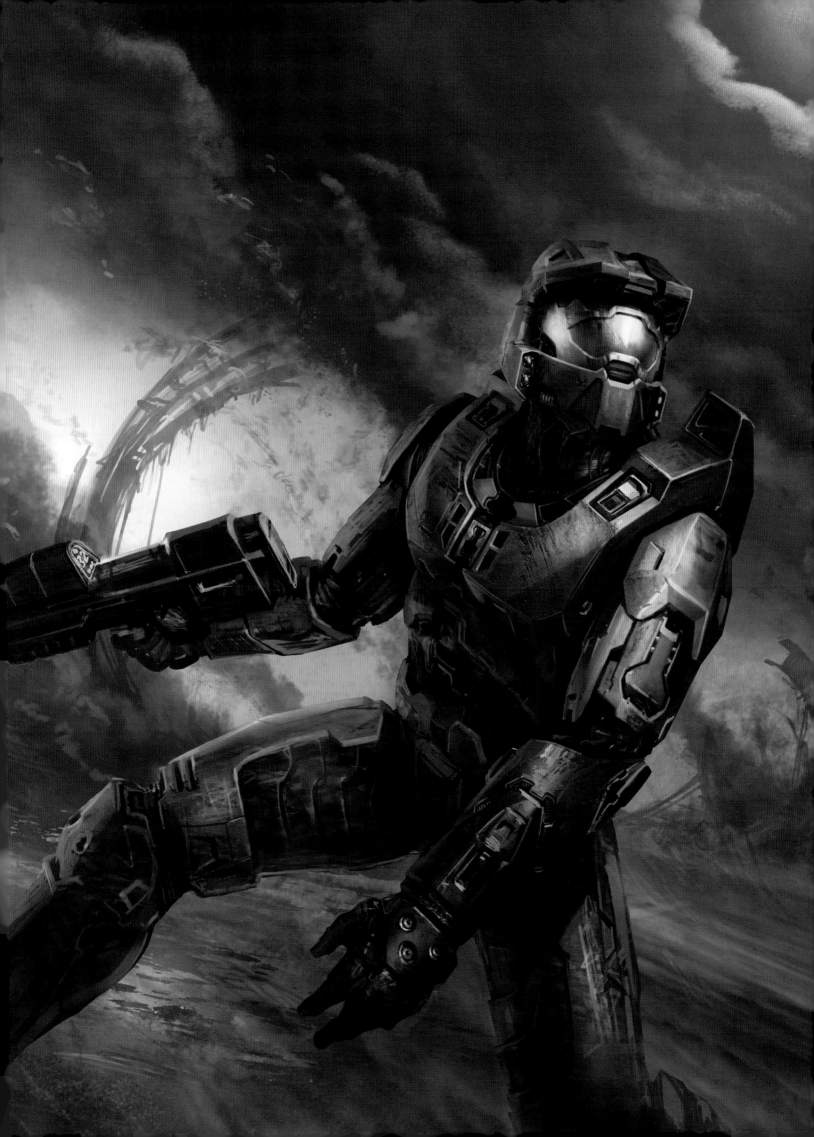

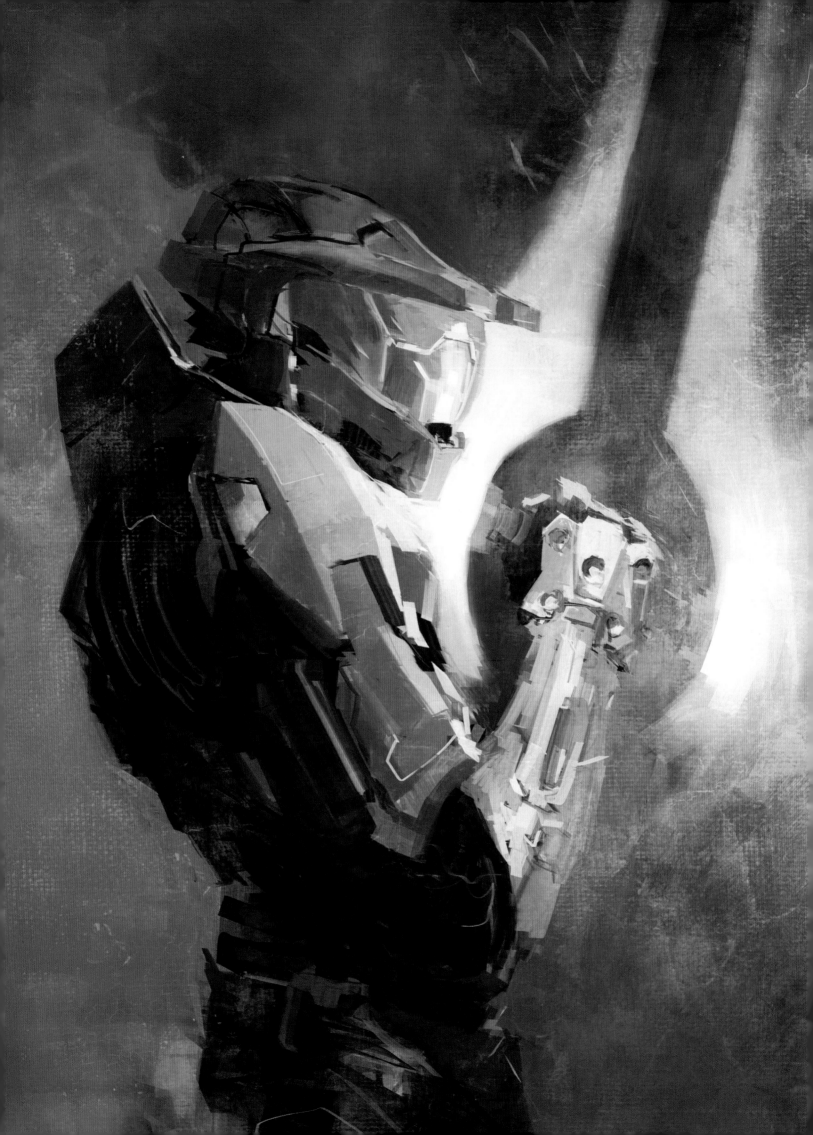

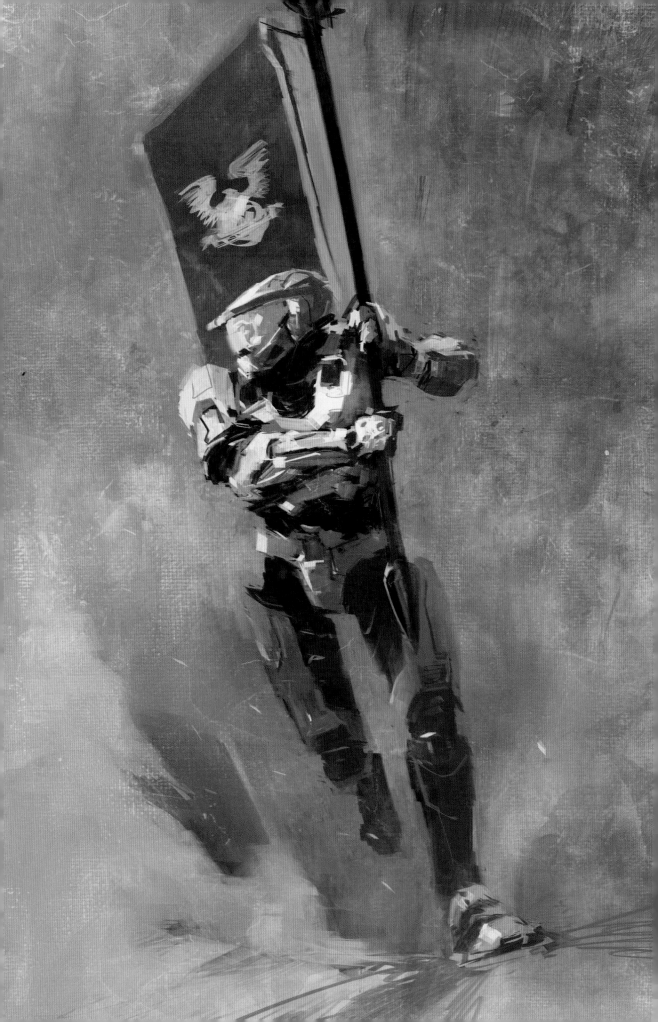

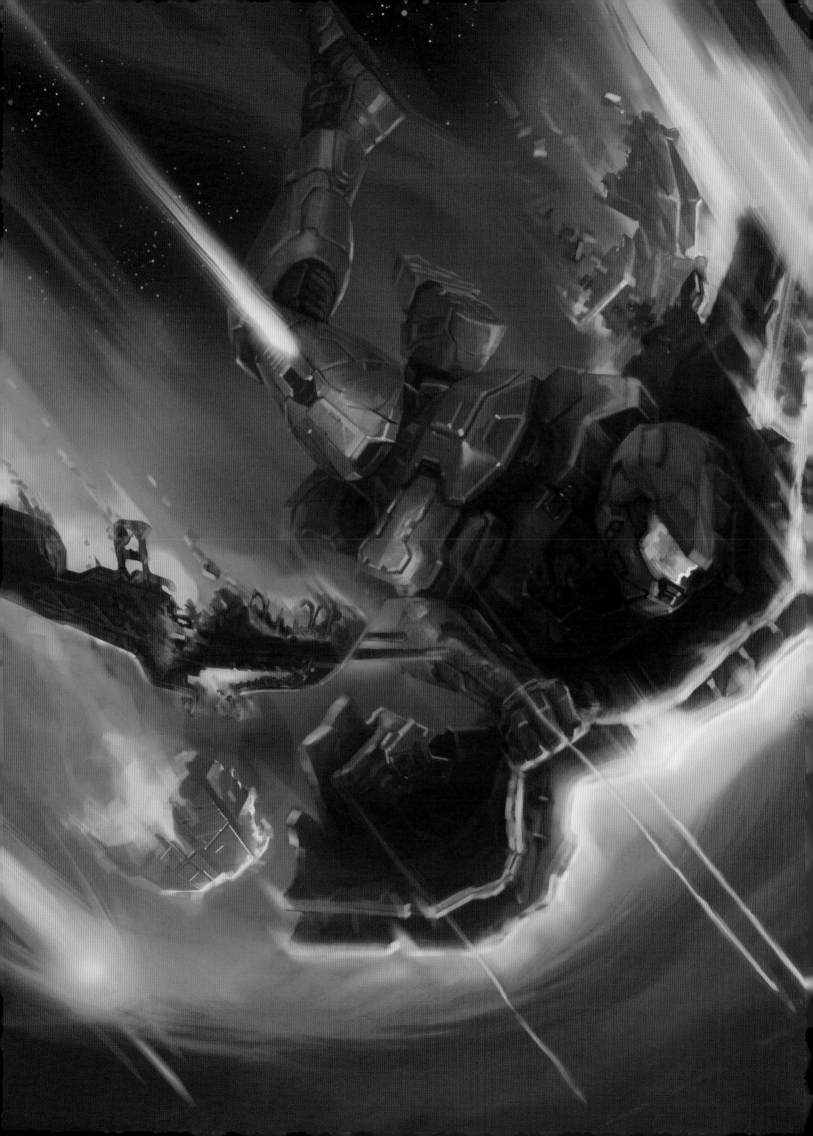

**FILE .006 //**

# A HERO FOR ALL AGES

THE Master Chief makes a fiery descent from the Forerunner dreadnought in a piece of artwork excised from *Halo 3*. Halo's hero ended his journey frozen in stasis with Cortana overseeing him, his work seemingly done as he left behind a world freed from the threat of the Flood. Subsequent tales have retraced his steps and expanded the back story, though there's hope that he'll awake from his slumber in the future. After all, folks always need heroes.

# CH.007

## HOMEWORLDS

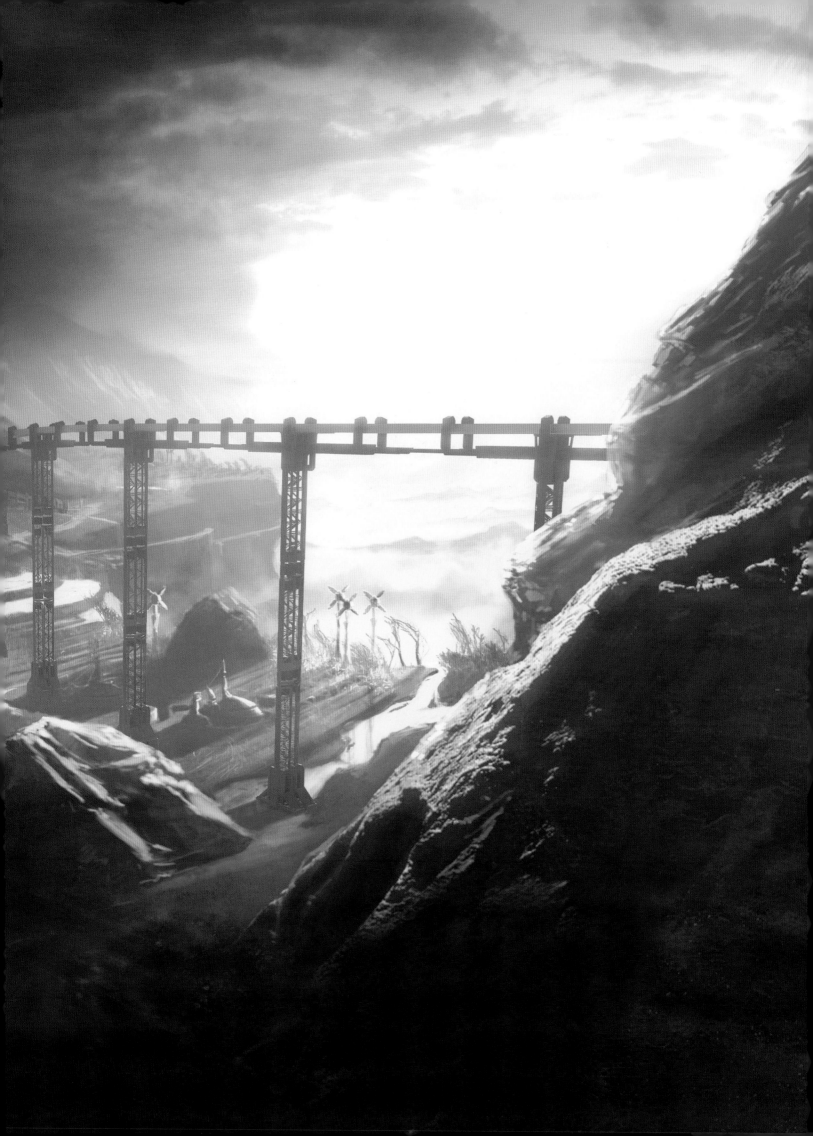

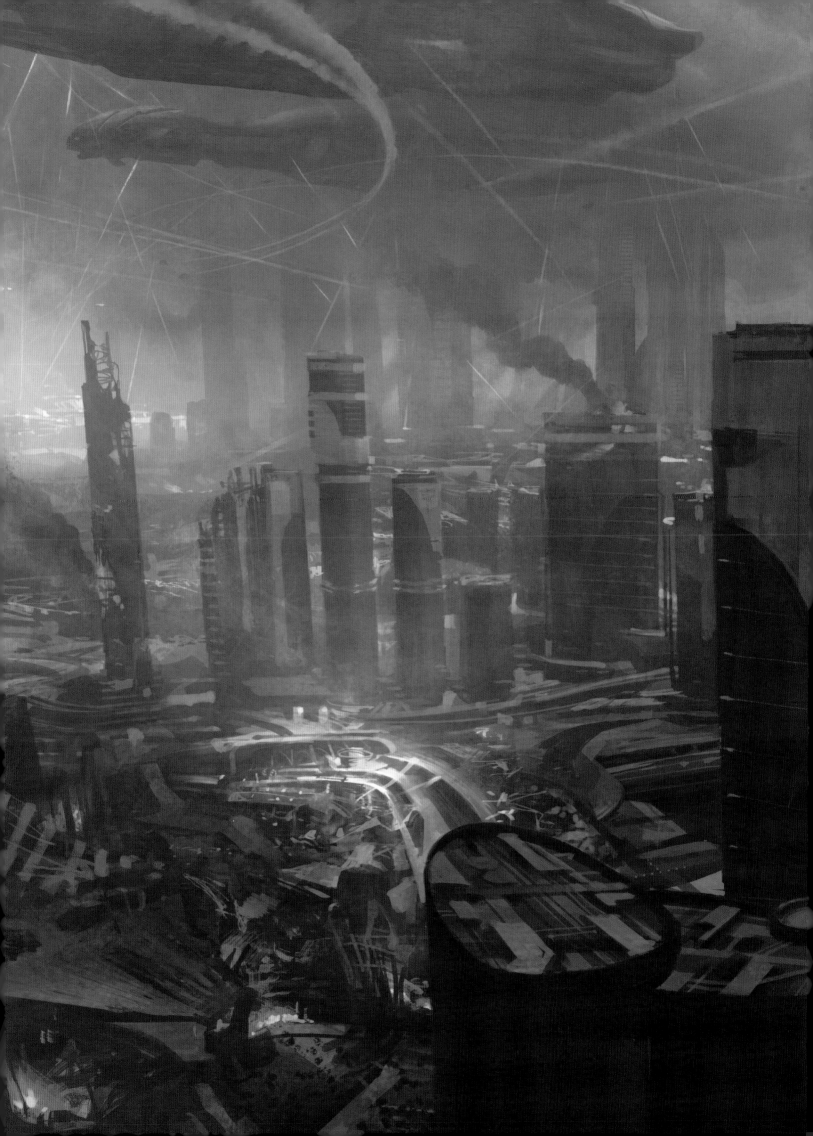

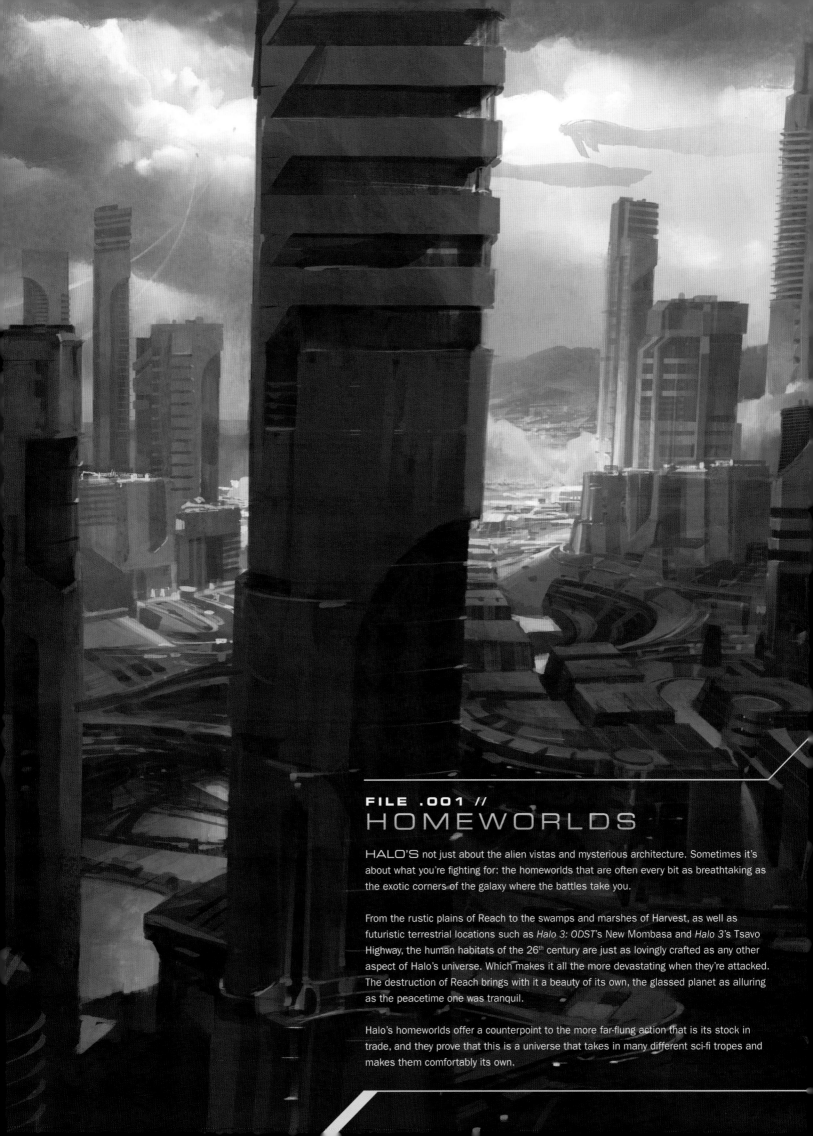

# FILE .001 //
# HOMEWORLDS

HALO'S not just about the alien vistas and mysterious architecture. Sometimes it's about what you're fighting for: the homeworlds that are often every bit as breathtaking as the exotic corners of the galaxy where the battles take you.

From the rustic plains of Reach to the swamps and marshes of Harvest, as well as futuristic terrestrial locations such as *Halo 3: ODST*'s New Mombasa and *Halo 3*'s Tsavo Highway, the human habitats of the 26th century are just as lovingly crafted as any other aspect of Halo's universe. Which makes it all the more devastating when they're attacked. The destruction of Reach brings with it a beauty of its own, the glassed planet as alluring as the peacetime one was tranquil.

Halo's homeworlds offer a counterpoint to the more far-flung action that is its stock in trade, and they prove that this is a universe that takes in many different sci-fi tropes and makes them comfortably its own.

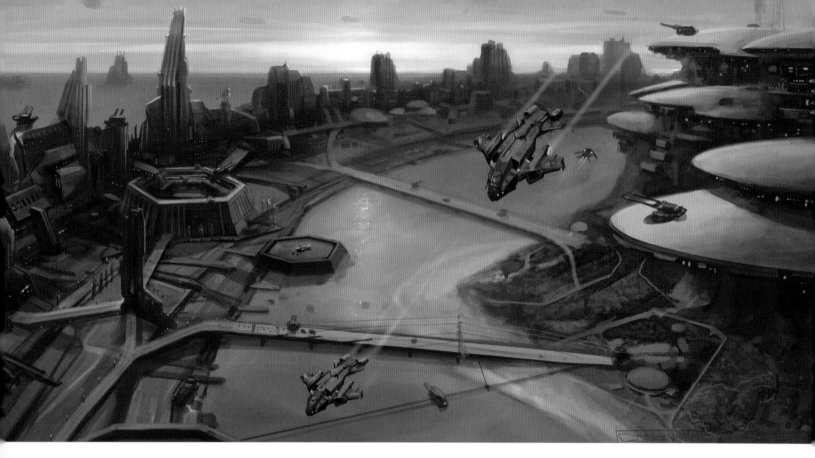

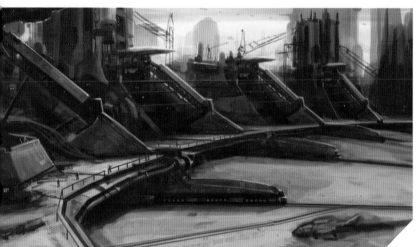

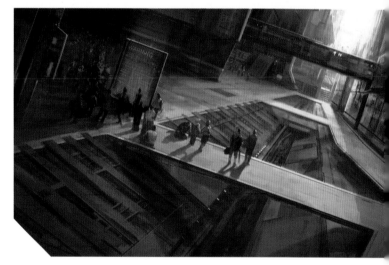

# FILE .002 //
# *HALO WARS*

*HALO WARS* turned the clock back on the series, exploring the very early days of the war between the humans and the Covenant. Set 21 years before the events of *Halo: Combat Evolved*, *Halo Wars* features a prolonged sample of some of the UNSC's homeworlds with the introduction of the human colony, Arcadia, and the first in-game look at Harvest.

Exploring these homeworlds gives a glimpse of the human toll of the war, and *Halo Wars* puts civilian life front and center in some of its missions. Both Harvest and Arcadia hold Forerunner artifacts, and the Covenant lays waste to both in their bid to attain them—and one of *Halo Wars'* missions sees the player hastily evacuate an Arcadian city that's soon to come under Covenant fire.

It was an interesting change of pace for a game that's still stands out in the Halo series as the only one to deviate from the first person shooter template.

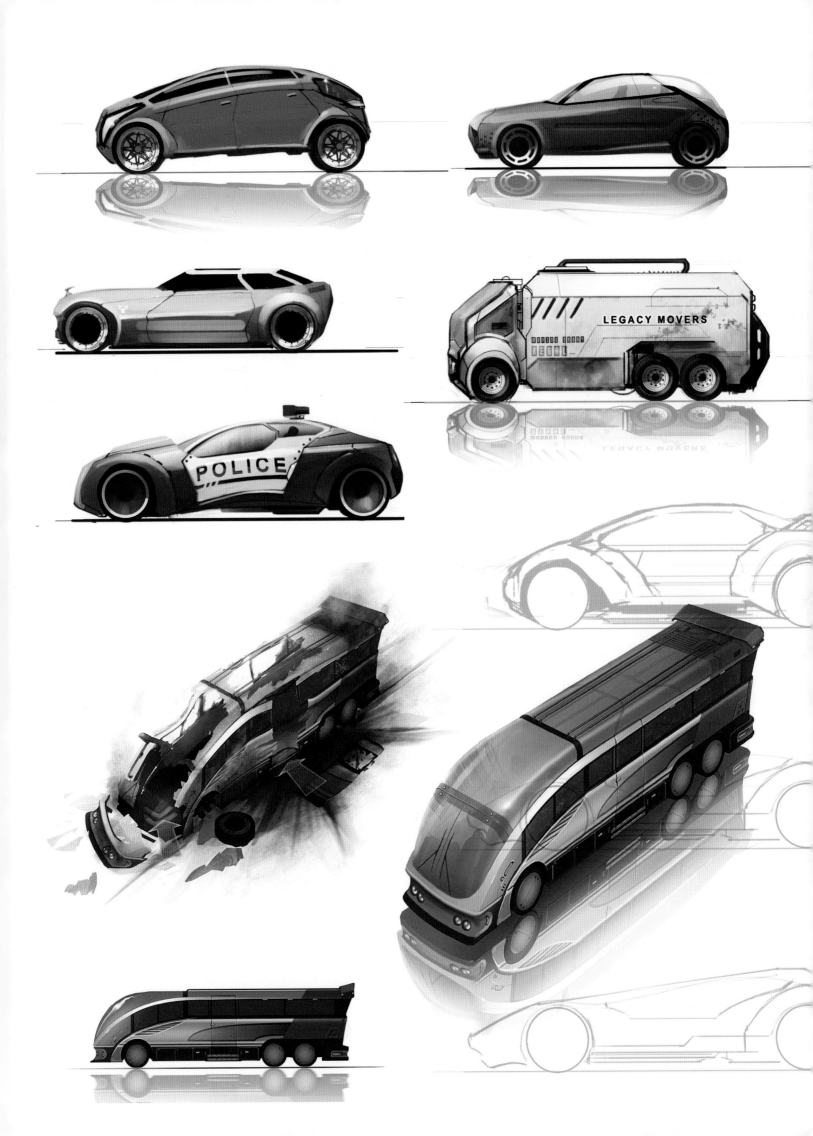

LEGACY MOVERS
REGAL

POLICE

# FILE .003 //
# REACH

'REMEMBER Reach' stated the marketing campaign—'Remember Where It All Began'.

With its achingly beautiful vistas, the planet Reach would prove hard to forget. The game's aim was to bring the war home, to make it more emotional and more personal. Reach itself plays a large part in that strategy, and it often looks like an idyllic version of Earth itself, a view backed up by one of the artists who helped bring it to life.

"Planet Reach had to look healthy, habitable and thus Earth-like but not look as if it can be mistaken for Earth," says Mark Goldsworthy, and it's the occasional extra-terrestrial touches that give Reach its impact; the juxtaposition of a countryside retreat that looks like it's been plucked from Kansas with an alien skybox proves quite stirring.

Reach was also at the epicenter of the war, and the game told the story of one of the UNSC's darkest days. It's no wonder that the melancholy that's always bubbled under the series—think of that mournful music, for example—rose to the surface. Reach's landscape played a significant part in the game's sad symphony.

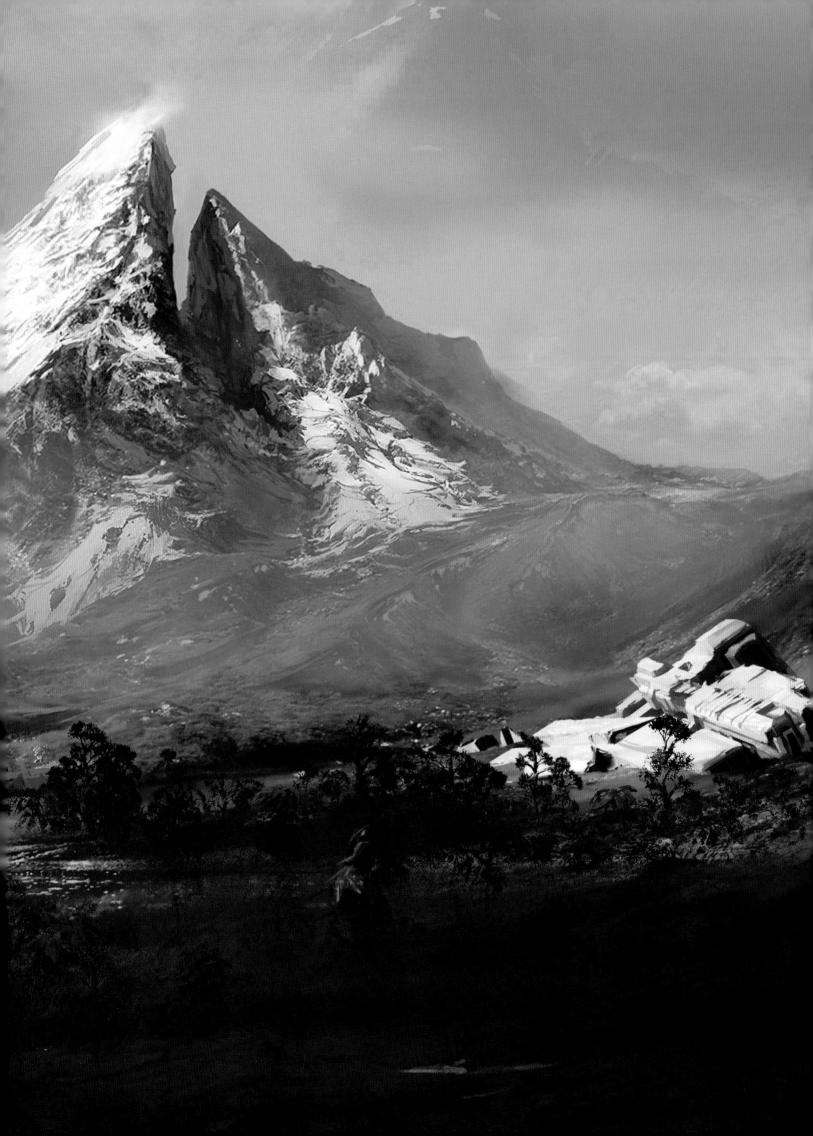

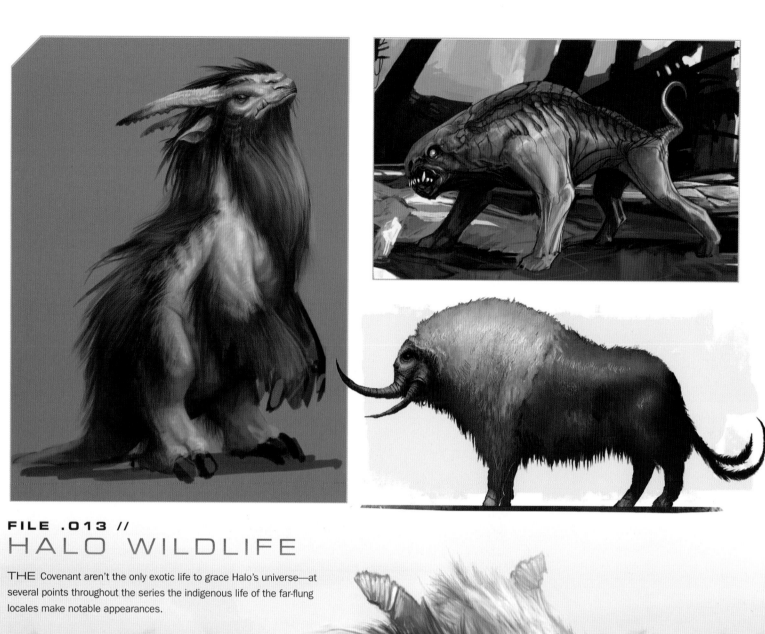

# FILE .013 //
# HALO WILDLIFE

THE Covenant aren't the only exotic life to grace Halo's universe—at several points throughout the series the indigenous life of the far-flung locales make notable appearances.

Reach has shown us the most diverse fauna, with the debut of the Moa (an ostrich-like creature based on a species now extinct on Earth) and the towering Guta, a Rancor-like creature that tears through both the human and Covenant forces.

Many more species never quite made the cut, from the blind wolves omitted from *Halo: Combat Evolved* to some of the examples imagined here.

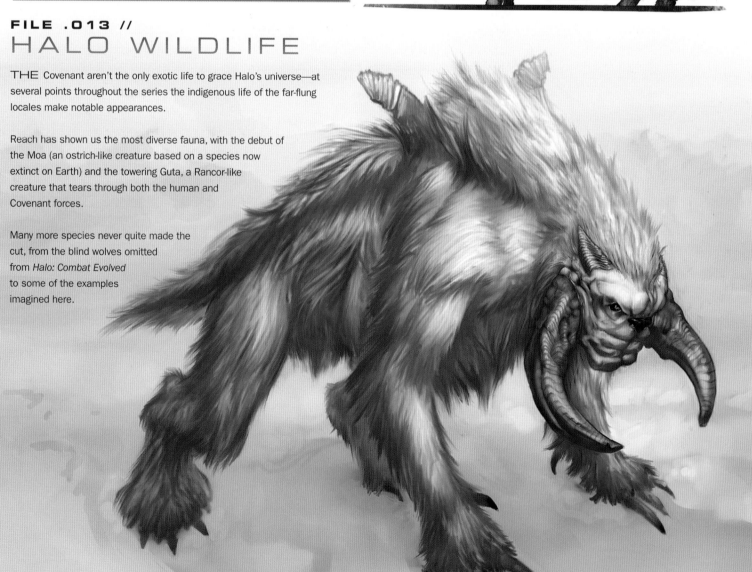

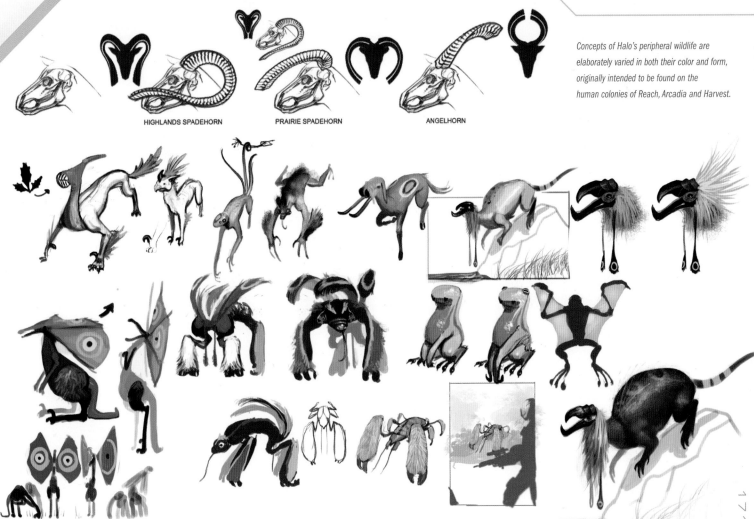

HIGHLANDS SPADEHORN    PRAIRIE SPADEHORN    ANGELHORN

Concepts of Halo's peripheral wildlife are elaborately varied in both their color and form, originally intended to be found on the human colonies of Reach, Arcadia and Harvest.

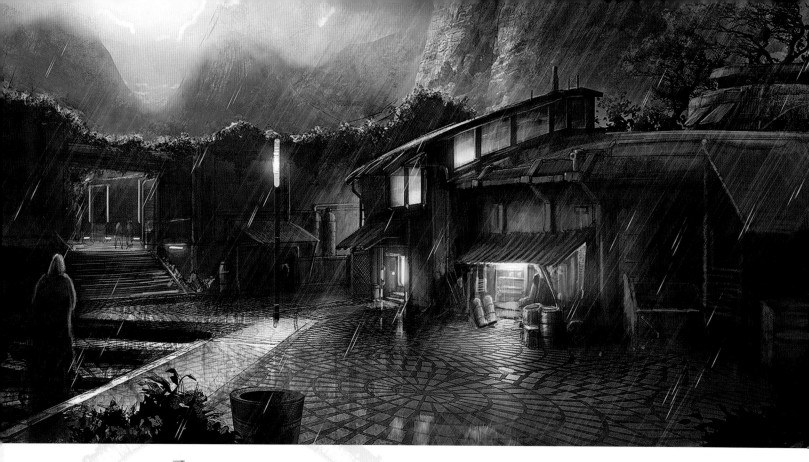

TRANSFORMER SUPPORT

HEAT VENT

ENTRANCE

DARRIUS TURBINE

STANDARD TURBINE

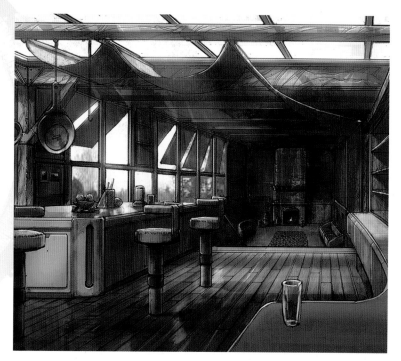

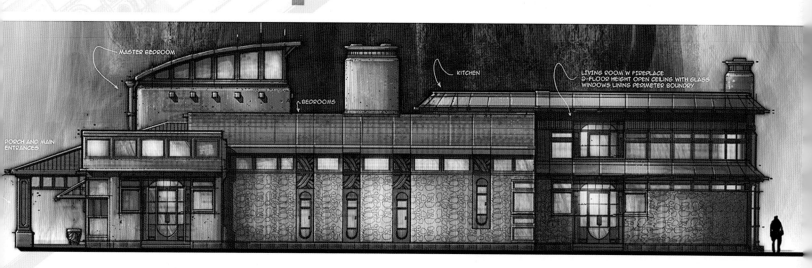

MASTER BEDROOM

BEDROOMS

KITCHEN

LIVING ROOM W FIREPLACE
2-FLOOR HEIGHT OPEN CEILING WITH GLASS
WINDOWS LINING PERIMETER BOUNDRY

PORCH AND MAIN
ENTRANCES

# FILE .004 //
# REACH INTERIORS

MAJESTIC Forerunner interiors and alien Covenant spaces had already been explored in Halo, but *Halo: Reach* was the first to really step inside civilian buildings. Homesteads—known on planet Reach as 'Kivas'—gave off a warm, pastoral glow and succeeded in coming across as real, lived-in spaces.

On the flipside a nightclub in New Alexandria showed the more hedonistic possibilities of life on Reach—something exploited with humorous effect by an in-game Easter Egg that saw Covenant forces taking to the dance floor.

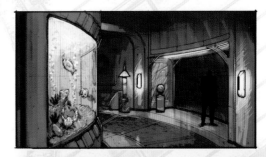

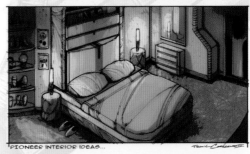

PIONEER INTERIOR IDEAS...

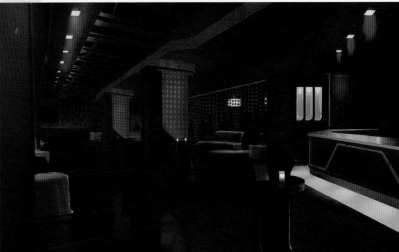

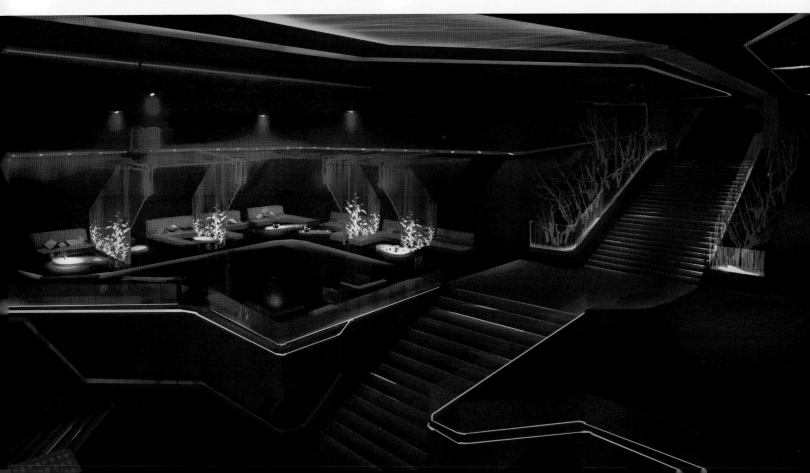

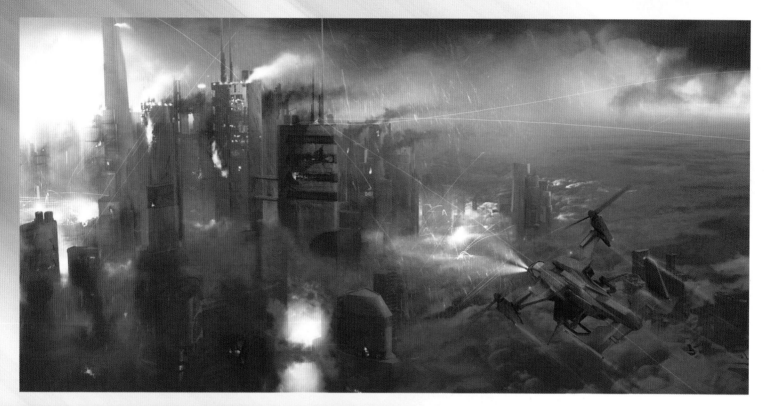

## FILE .005 //
# REACH CITY

NEW Alexandria's a city that would have done Frank Lloyd Wright proud with its bold geometry and sweeping lines. Unfortunately it bears the brunt of the attacks in the fall of Reach, a Covenant offensive leaving it smoldering.

Two levels of *Halo: Reach* use New Alexandria as their setting—first "Exodus" which takes the player through the city at ground level and, most spectacularly, "New Alexandria," which shows Noble Six using a Falcon to pick his way through the jutting buildings as the sky darkens with the city's destruction.

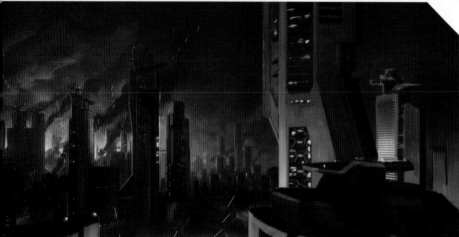

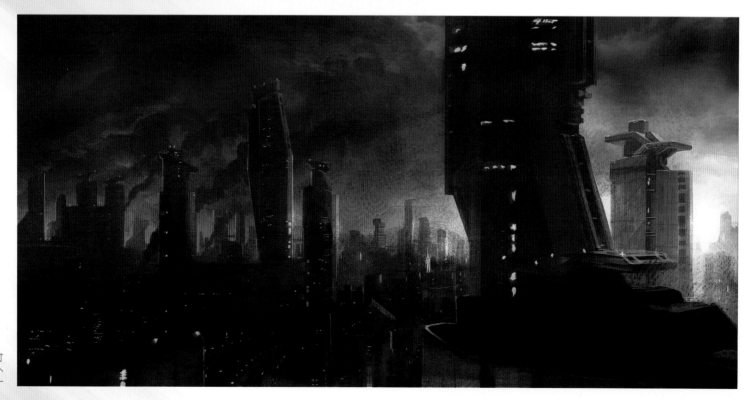

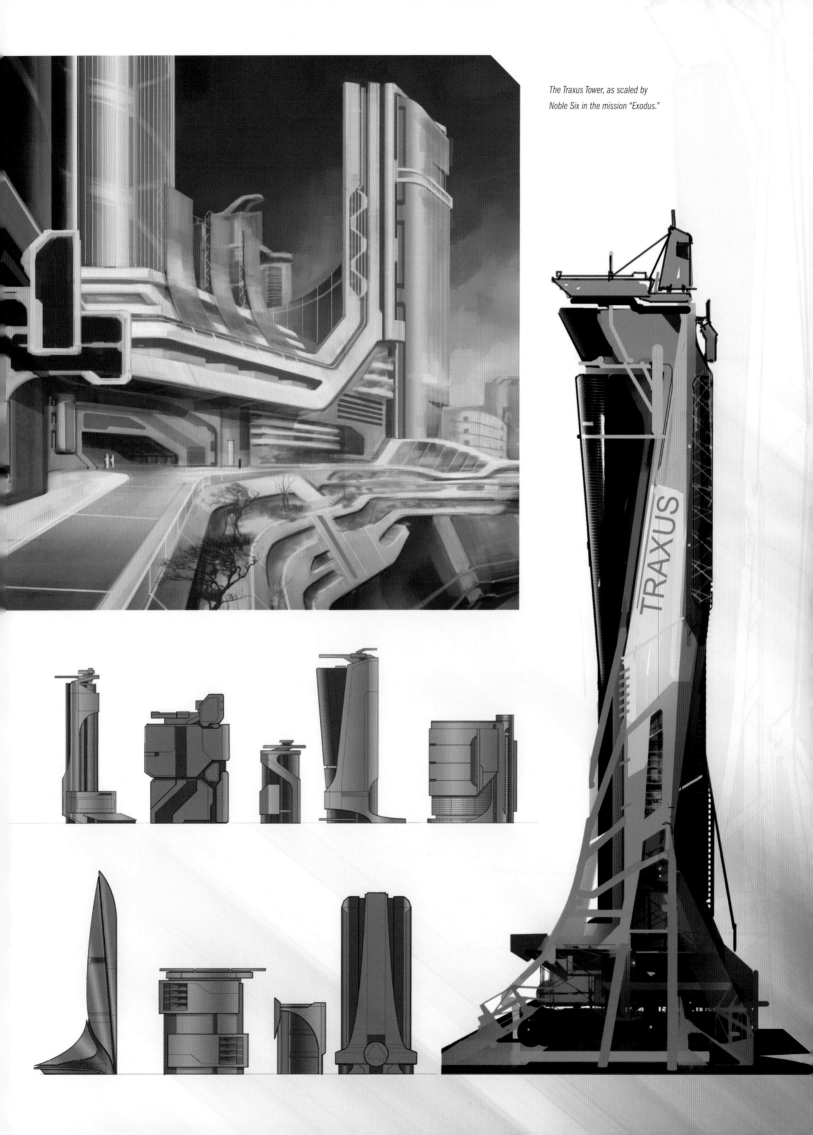

*The Traxus Tower, as scaled by Noble Six in the mission "Exodus."*

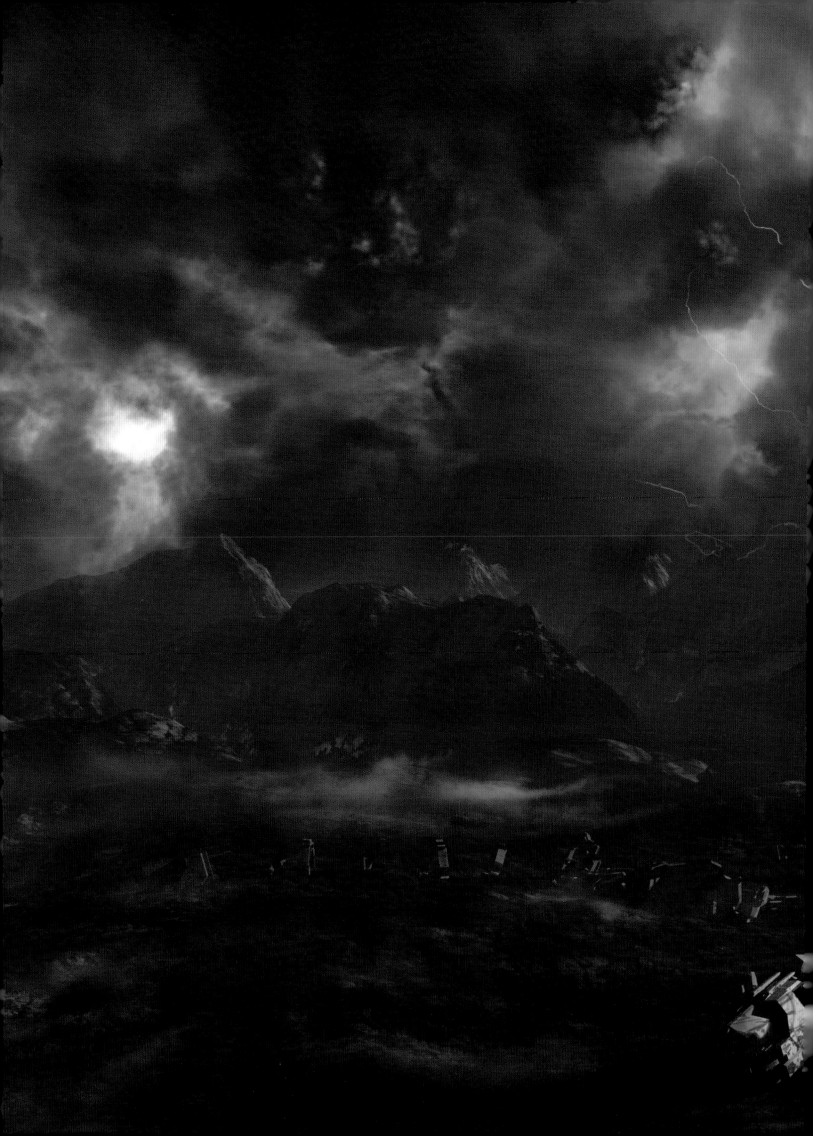

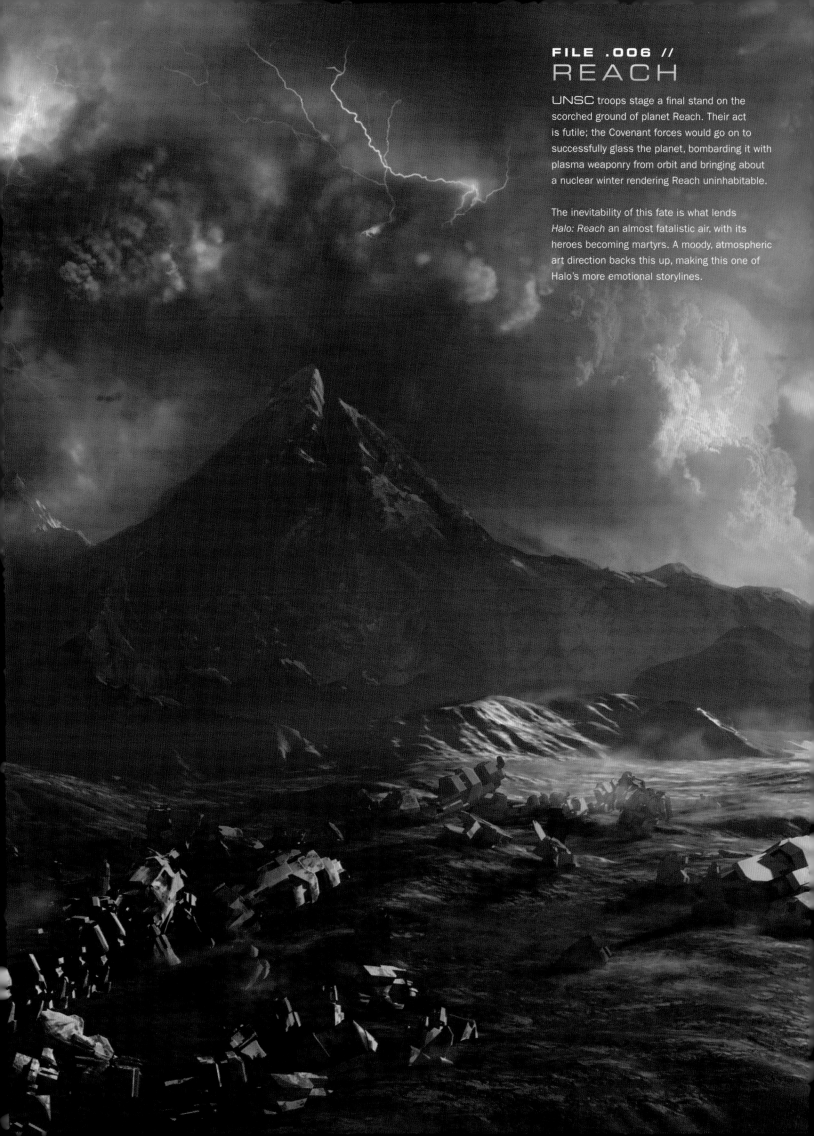

# FILE .006 //
# REACH

UNSC troops stage a final stand on the scorched ground of planet Reach. Their act is futile; the Covenant forces would go on to successfully glass the planet, bombarding it with plasma weaponry from orbit and bringing about a nuclear winter rendering Reach uninhabitable.

The inevitability of this fate is what lends *Halo: Reach* an almost fatalistic air, with its heroes becoming martyrs. A moody, atmospheric art direction backs this up, making this one of Halo's more emotional storylines.

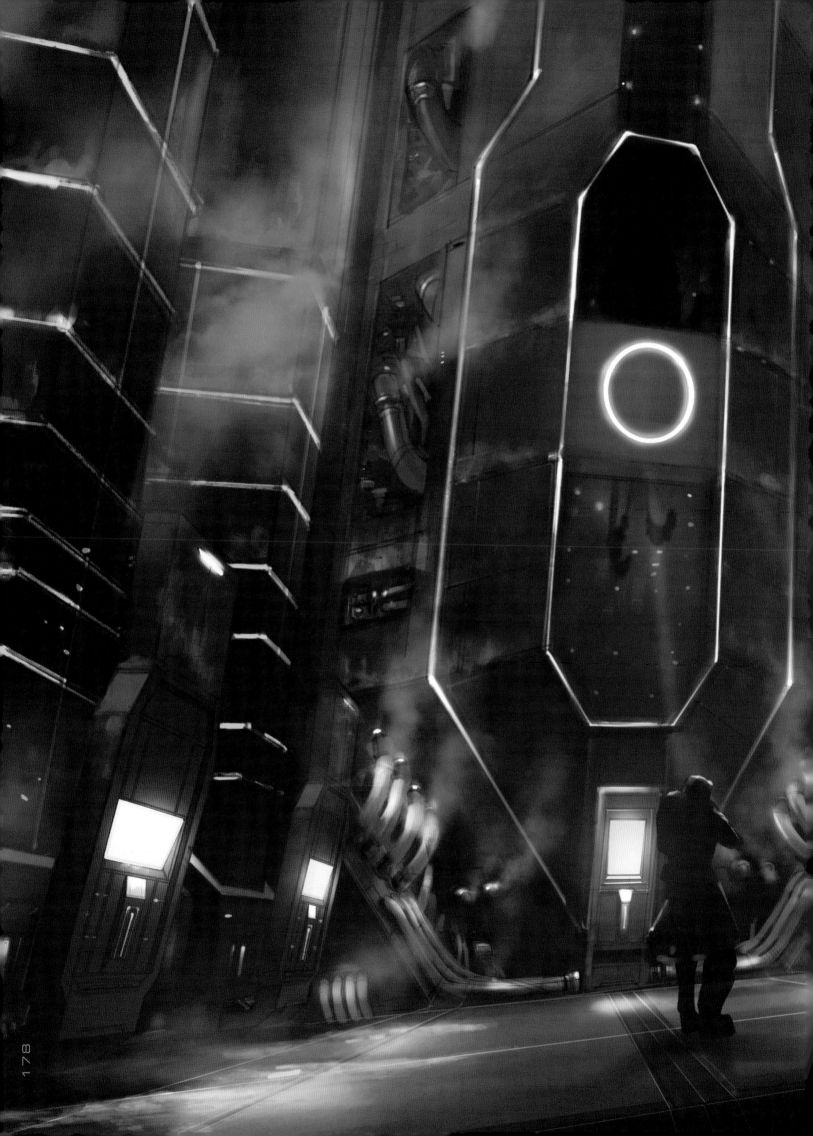

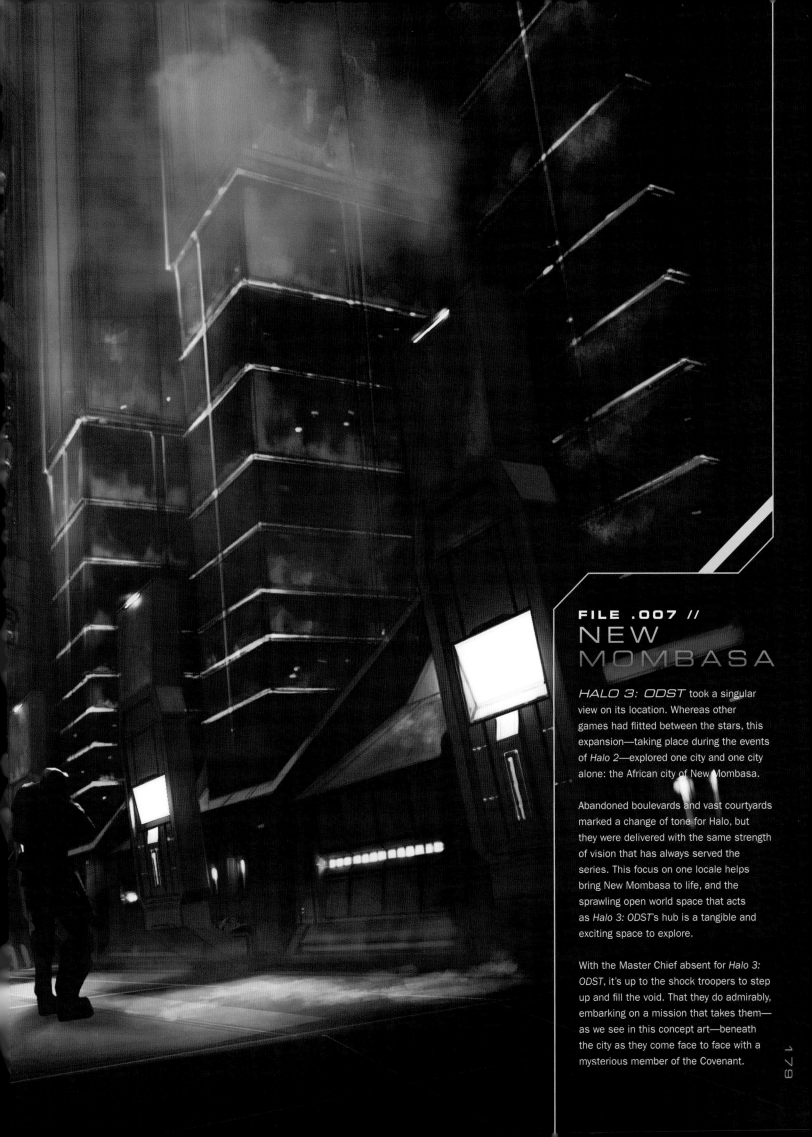

# NEW MOMBASA

*HALO 3: ODST* took a singular view on its location. Whereas other games had flitted between the stars, this expansion—taking place during the events of *Halo 2*—explored one city and one city alone: the African city of New Mombasa.

Abandoned boulevards and vast courtyards marked a change of tone for Halo, but they were delivered with the same strength of vision that has always served the series. This focus on one locale helps bring New Mombasa to life, and the sprawling open world space that acts as *Halo 3: ODST*'s hub is a tangible and exciting space to explore.

With the Master Chief absent for *Halo 3: ODST*, it's up to the shock troopers to step up and fill the void. That they do admirably, embarking on a mission that takes them— as we see in this concept art—beneath the city as they come face to face with a mysterious member of the Covenant.

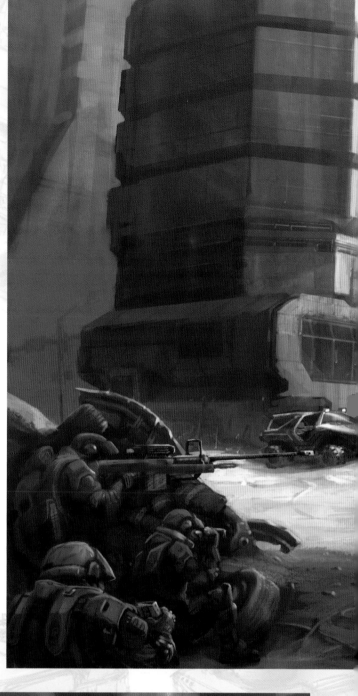

# FILE .008 //
# URBAN WARFARE

*HALO 3: ODST*'s story structure—which saw the player recount the experiences of the troopers through flashback—meant that the city of New Mombasa was explored from various angles.

Stumbling upon the wreckage of a Covenant Wraith could trigger the recollection of the battle that brought it down as the player flitted between the various members of the ODST outfit.

It's a narrative approach that allowed for more than a broad take on the story; it enabled a little visual variety too. With much of the exploration taking place at night, the flashbacks saw the city throughout the preceding day as the Covenant onslaught began.

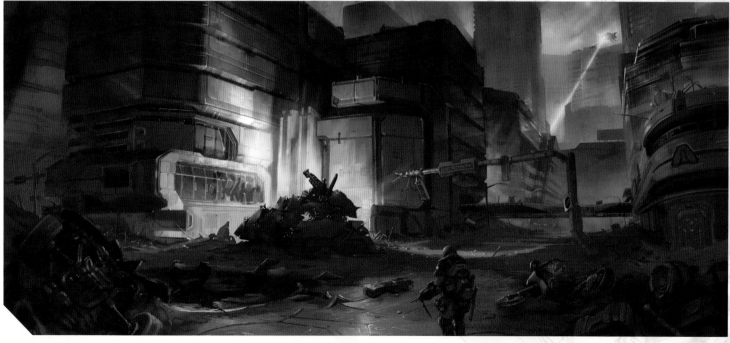

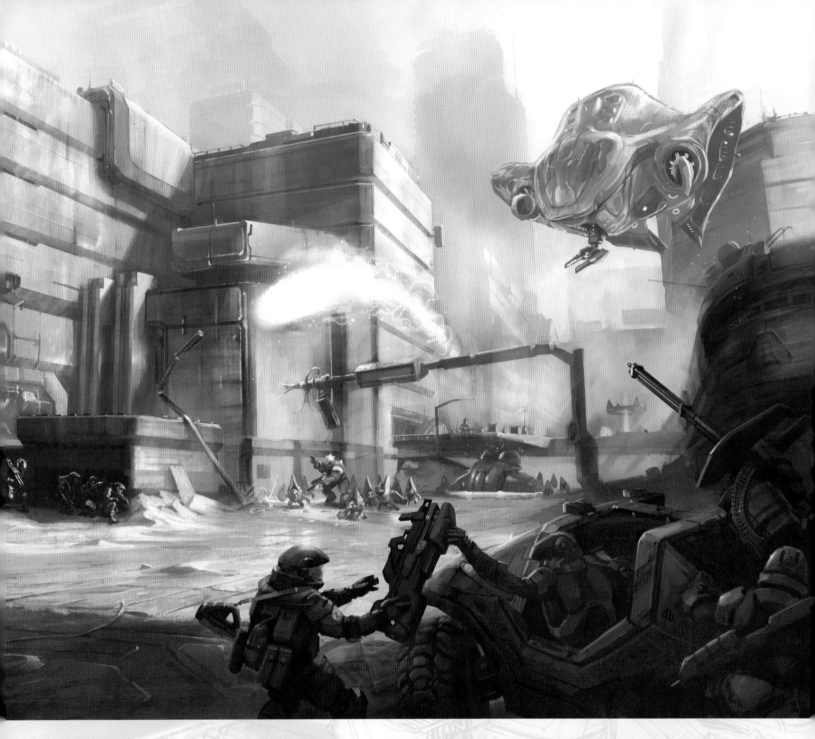

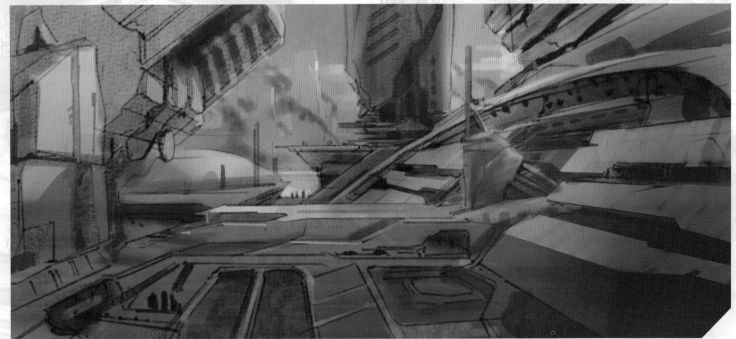

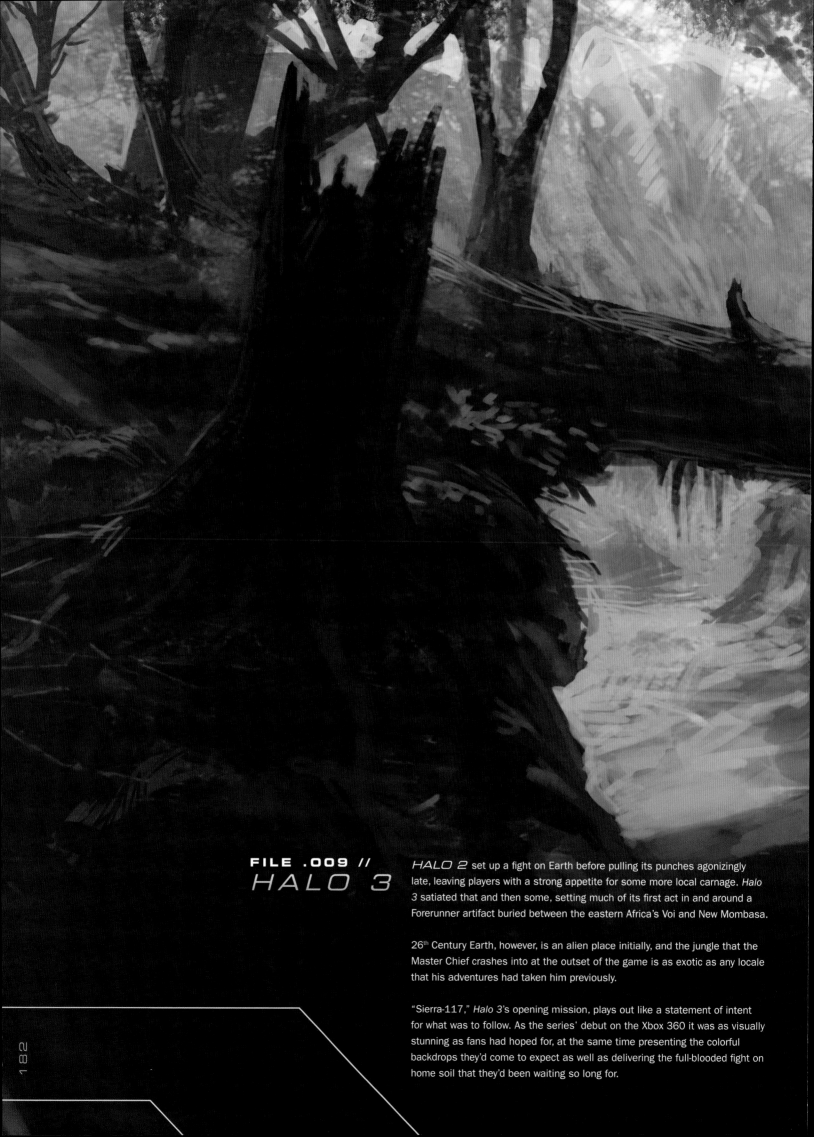

**FILE .009 //**
*HALO 3*

*HALO 2* set up a fight on Earth before pulling its punches agonizingly late, leaving players with a strong appetite for some more local carnage. *Halo 3* satiated that and then some, setting much of its first act in and around a Forerunner artifact buried between the eastern Africa's Voi and New Mombasa.

26th Century Earth, however, is an alien place initially, and the jungle that the Master Chief crashes into at the outset of the game is as exotic as any locale that his adventures had taken him previously.

"Sierra-117," *Halo 3*'s opening mission, plays out like a statement of intent for what was to follow. As the series' debut on the Xbox 360 it was as visually stunning as fans had hoped for, at the same time presenting the colorful backdrops they'd come to expect as well as delivering the full-blooded fight on home soil that they'd been waiting so long for.

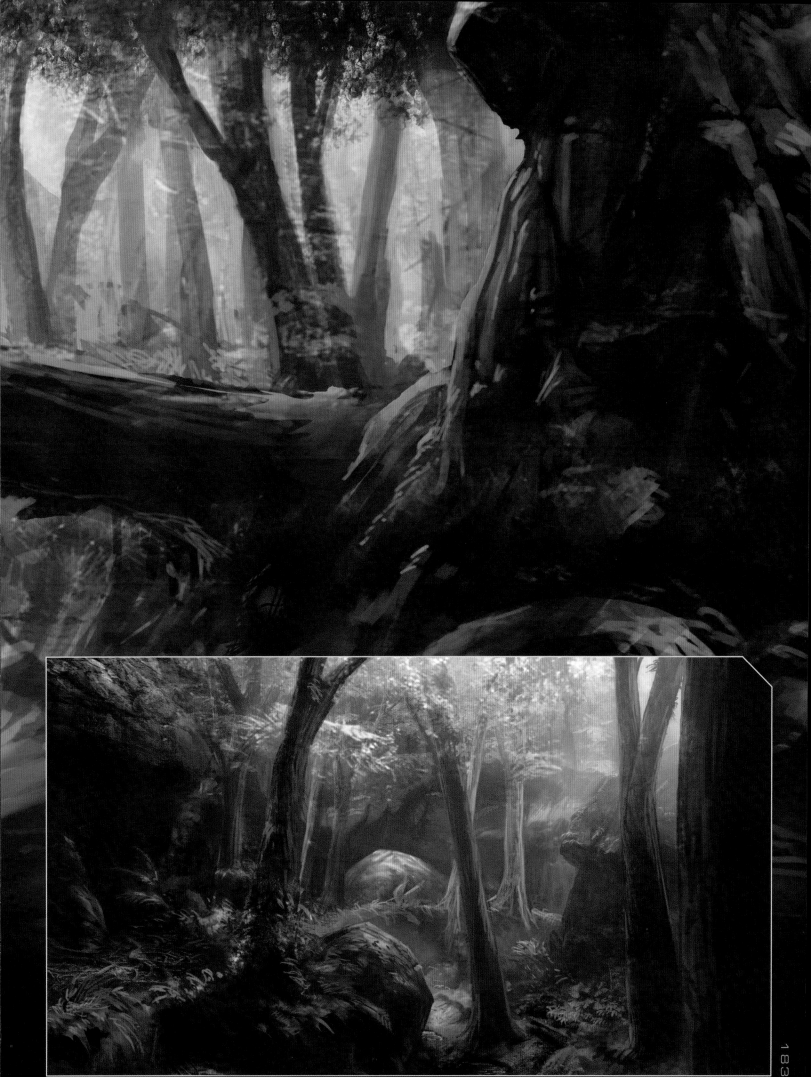

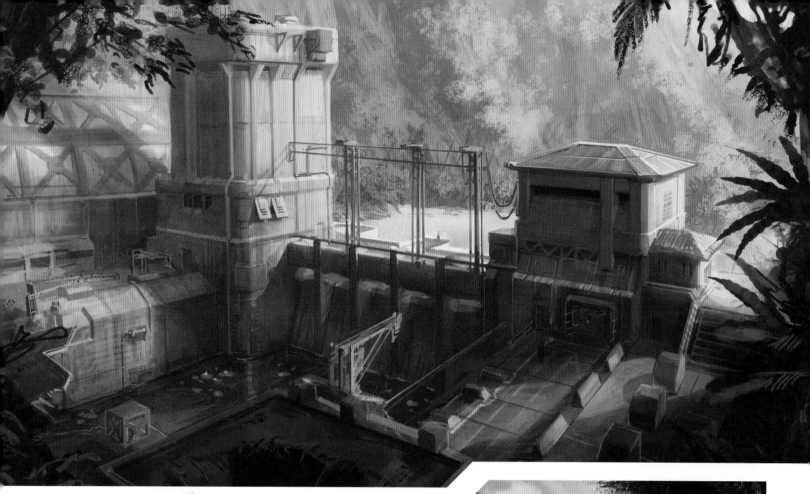

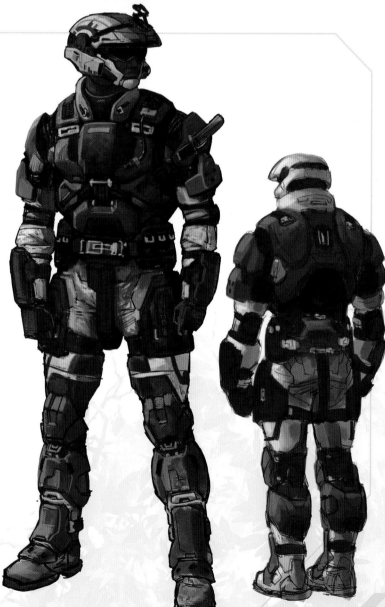

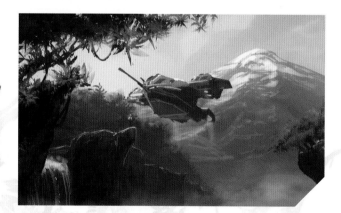

## FILE .010 //
# CROW'S NEST

TUCKED away in the wilds of Kenya is Crow's Nest, a
UNSC base that's at the heart of the human defense against
the Covenant assault. Picking Africa as the backdrop for Halo's
terrestrial missions allowed the art team to retain the trademark
vibrant color of the series—and placing it in the shadow of Mount
Kilimanjaro meant that Halo 3's early missions were just as awe-
inspiring as those set on the strange and beautiful ringworlds.

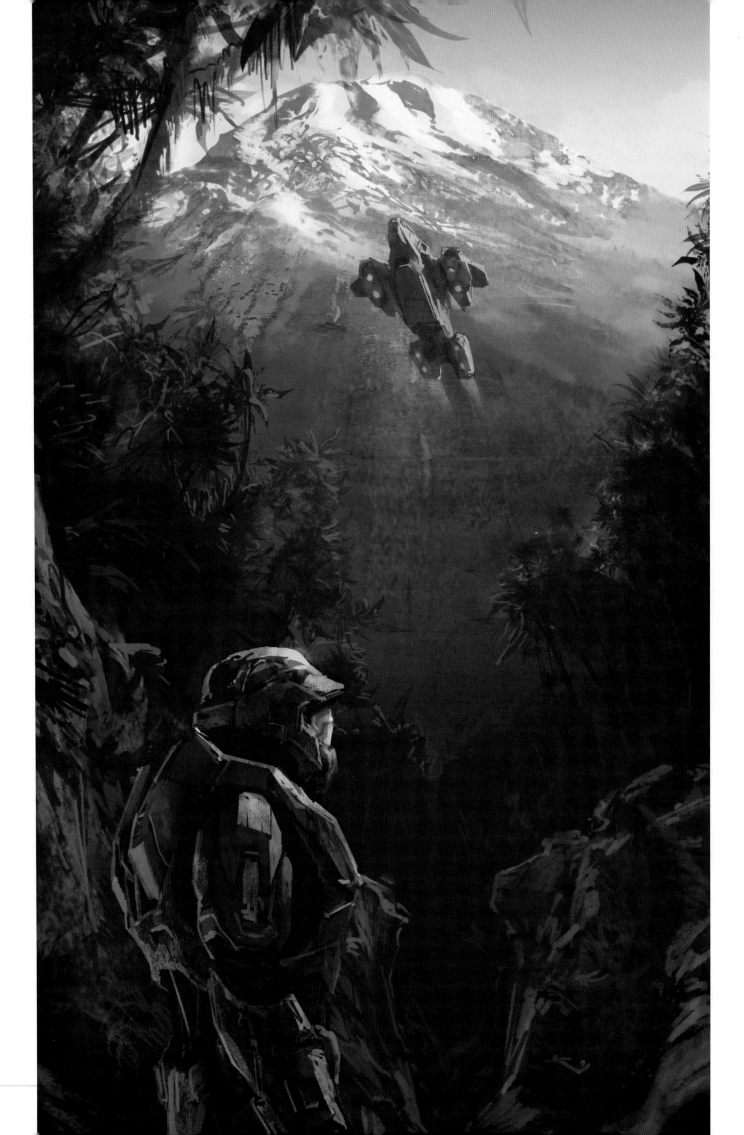

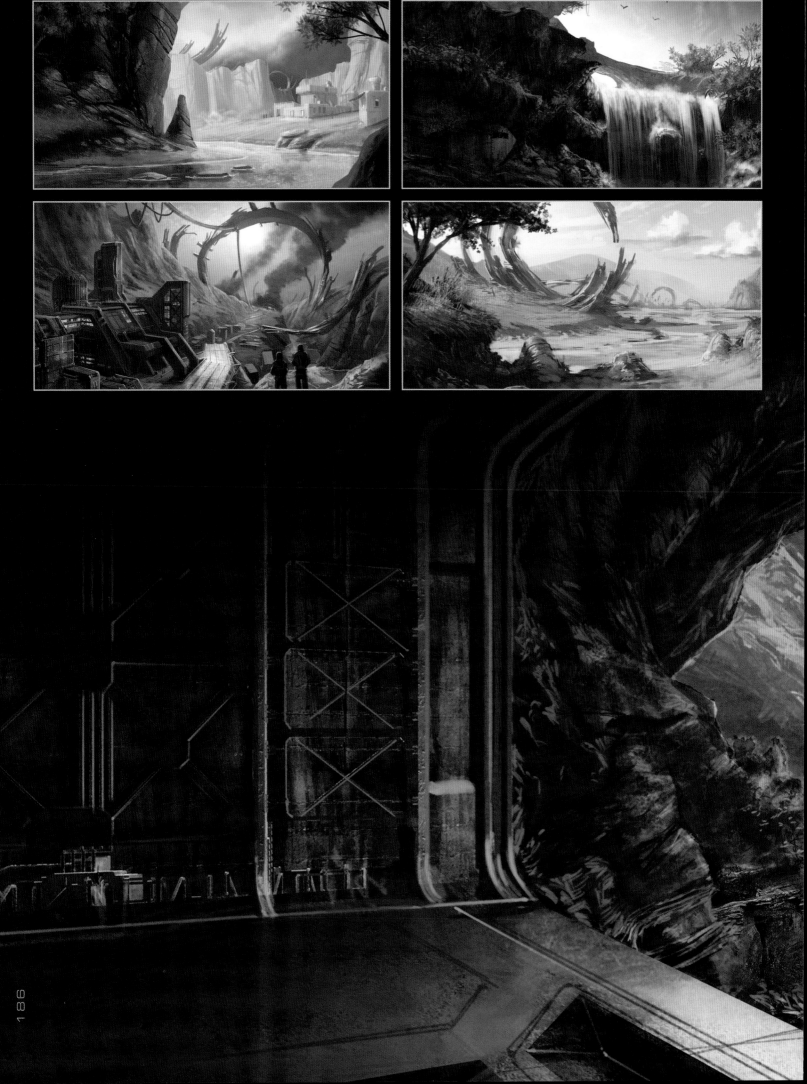

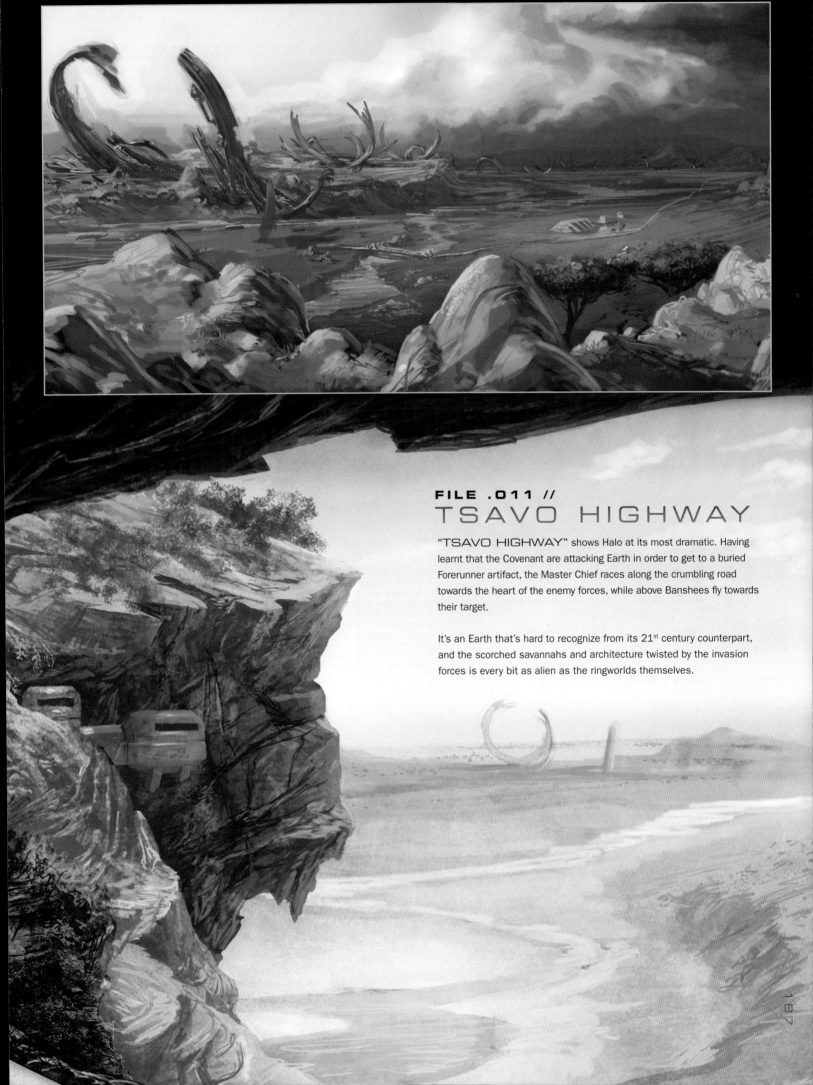

# FILE .011 //
# TSAVO HIGHWAY

"TSAVO HIGHWAY" shows Halo at its most dramatic. Having learnt that the Covenant are attacking Earth in order to get to a buried Forerunner artifact, the Master Chief races along the crumbling road towards the heart of the enemy forces, while above Banshees fly towards their target.

It's an Earth that's hard to recognize from its 21st century counterpart, and the scorched savannahs and architecture twisted by the invasion forces is every bit as alien as the ringworlds themselves.

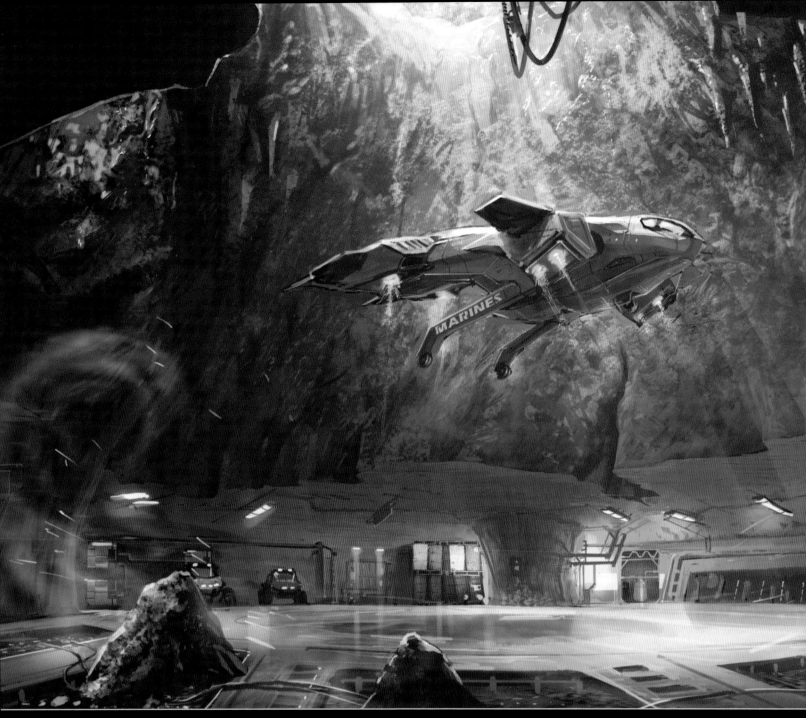
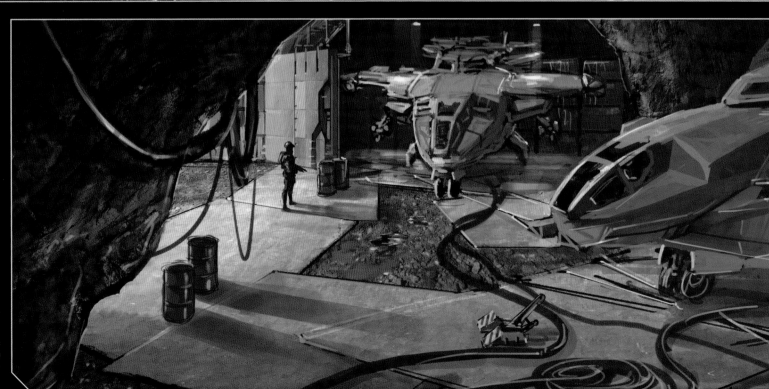

# FILE .012 //
# THE ARTIFACT

UNDERNEATH the earth, near the town of Voi in Kenya, Africa, is the Forerunner technology that the Covenant is so desperate to get its hands on. The artifact is a portal to Installation 00—otherwise known as the Ark, the gargantuan structure from which all of the Halo rings can be activated.

The artifact is an epic construction itself, and the placement of such a prime piece of Forerunner technology raises another link between this long-extinct race and humanity. From Crow's Nest the UNSC planned an assault on the artifact, sending their troops to an encounter that would take them beyond the stars.

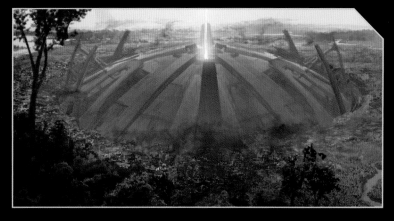

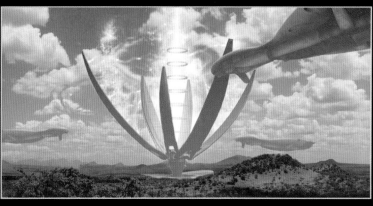

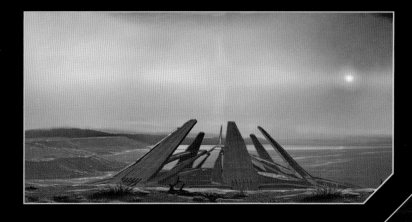

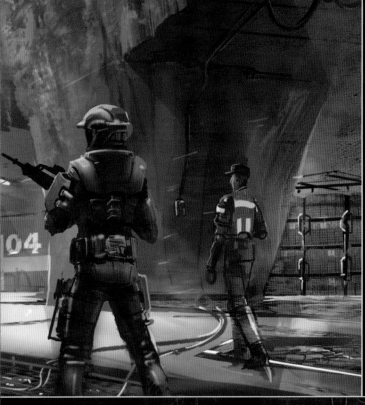

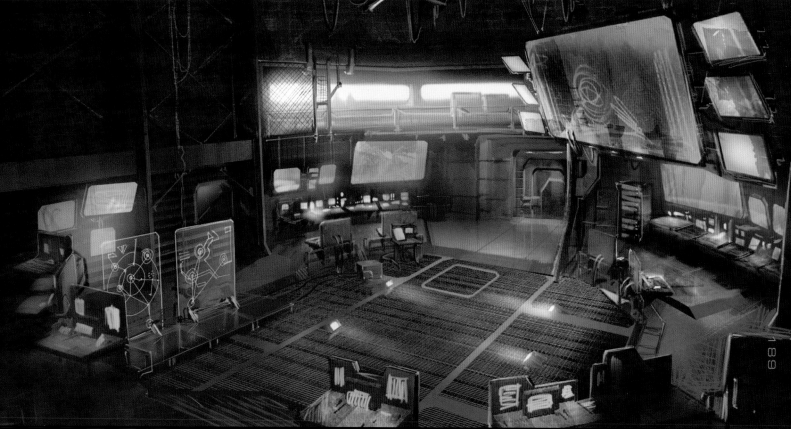

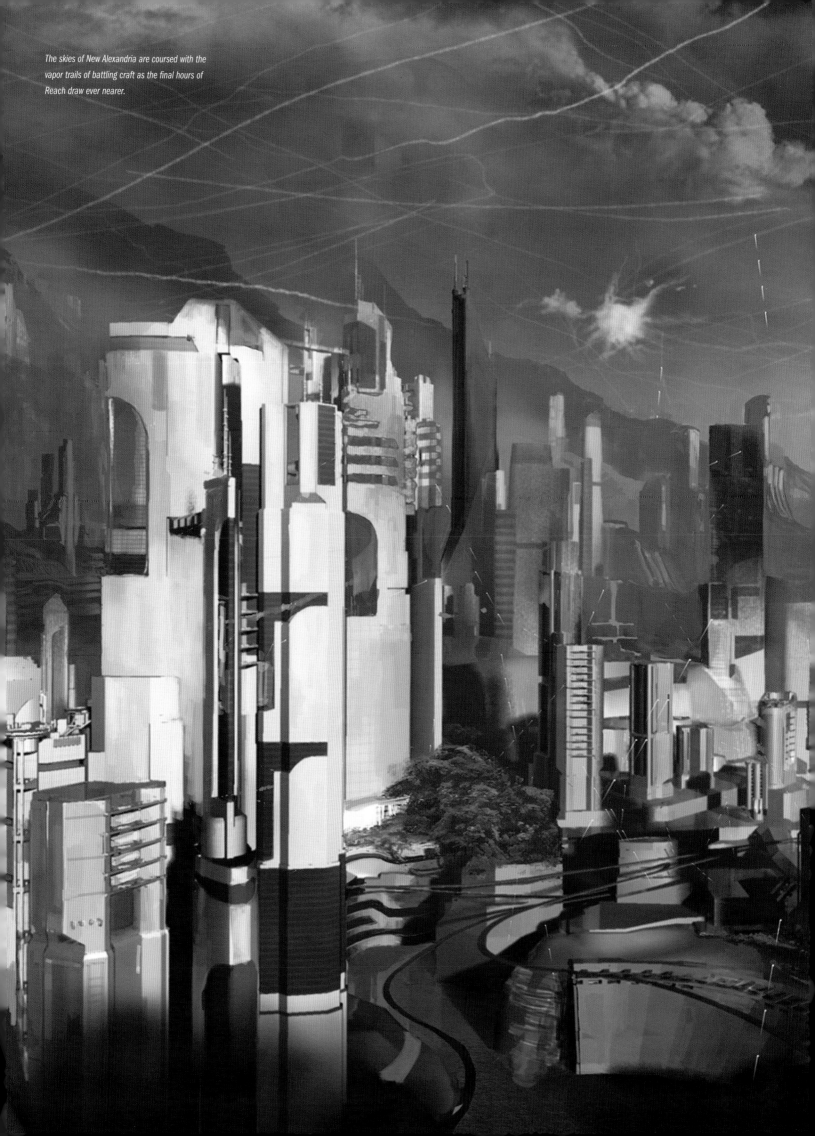

The skies of New Alexandria are coursed with the
vapor trails of battling craft as the final hours of
Reach draw ever nearer.

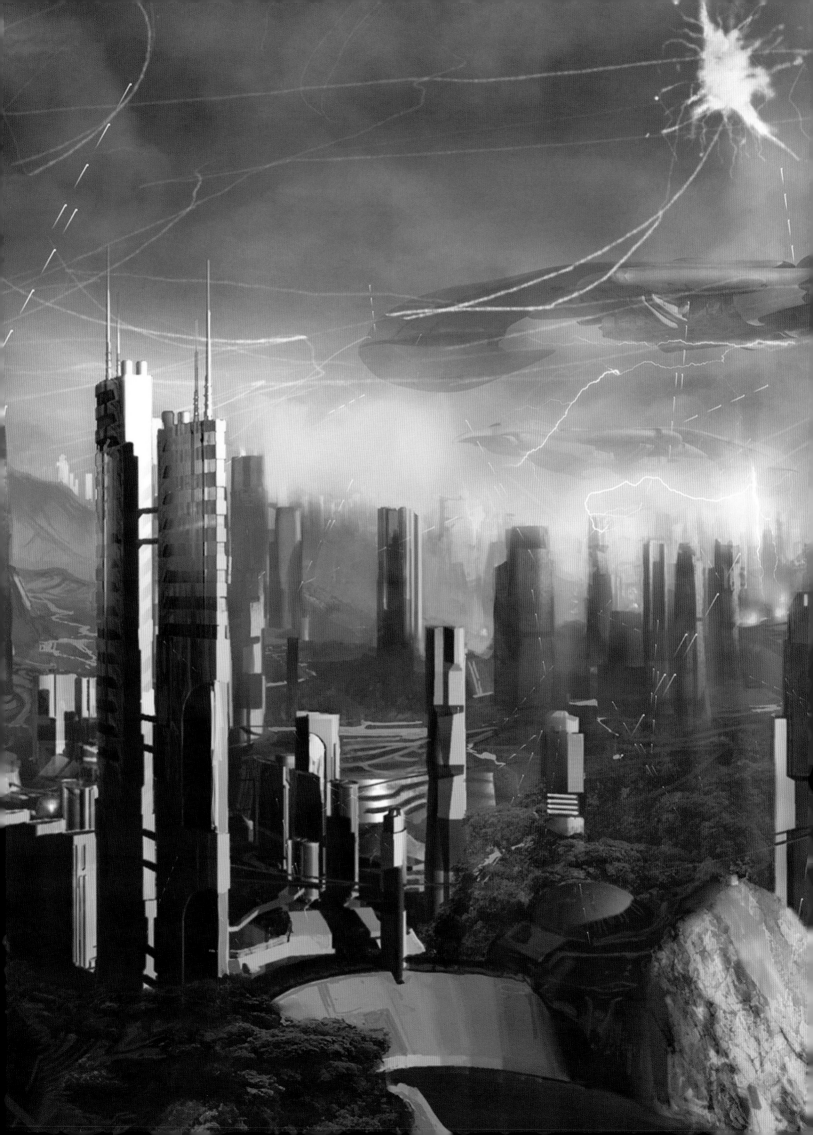

# ACKNOWLEDGMENTS AND CREDITS

TITAN BOOKS would like to thank Rick Achberger, Ben Cammarano, Christine Finch, Kevin Grace, Tyler Jeffers, Frank O'Connor, Jeremy Patenaude, Dennis Ries, and Corrinne Robinson with 343 Industries at Microsoft.

---

343 Industries would like to thank Bungie, Scott Dell'Osso, Nick Dimitrov, David Figatner, Josh Kerwin, Bryan Koski, Matt McCloskey, Paul Patinios, Bonnie Ross-Ziegler, Matt Skelton, Phil Spencer, and Carla Woo. And finally, we would like to thank the dedicated Halo fans of the last decade, who have each gone on their own Great Journey with Halo time and time again.

---

BUNGIE: During this past decade our artists had the distinct pleasure of breathing life into this ever-expanding universe, populating it with people, places, and things that captivated all of our imaginations. As the Halo universe grew to startling proportions, many of you found ways to reach back, filling it with its most meaningful stories and its most memorable characters.

Thank you for gracing our worlds with light and life, and for keeping us company on what has truly been a Great Journey.

See you starside.

*Picture credits key: t—top, m—middle, b—bottom, l—left, r—right, tl—top left, ml—middle left, bl—bottom left, tr—top right, mr—middle right, br—bottom right*
First endpaper Jaime Jones; Page 1 Ashley Wood; 2–3 Craig Mullins; 4–5 Frank Capezzuto; 6–7 Frank Capezzuto; 8 Dorje Bellbrook; 9 Mark Sinclair; 11 Eddie Smith; 12–13 Lorraine McLees and Zoe Brawley-Wolfe; 14–15 Jaime Jones; 16 Phil Wohr; 17 Sparth; 18–19 all Studio 4°C; 20–21 Dorje Bellbrook; 22 t Shi Kai Wang, b Isaac Hannaford; 23 tl Eddie Smith, tr Shi Kai Wang; 24 tl Blur, tr Blur, b Blur; 25 all Jason Merck; 26 l Frank Capezzuto, r Eddie Smith; 27 t Eddie Smith, b Frank Capezzuto; 28–29 all Eddie Smith; 30 t Mark Goldsworthy, b Jason Merck; 31 all Jason Merck; 32–33 Dorje Bellbrook; 34 t Isaac Hannaford, m Christopher Barrett, b Isaac Hannaford and Dorje Bellbrook; 35 t Isaac Hannaford, ml Isaac Hannaford, mr Christopher Barrett, bl Christopher Barrett, br Isaac Hannaford; 36 t Dorje Bellbrook, m Dorje Bellbrook, b Christopher Barrett; 37 Eddie Smith; 38–39 Frank Capezzuto; 40 t Isaac Hannaford, b Alex Chu; 41 t Vitaliy Anikin, b Vladimir Nenov; 42 t Vitaliy Anikin, m Vitaliy Anikin, b Vitaliy Anikin; 43 t Pavel Belov, ml Pavel Belov, mr Pavel Belov, b Eddie Smith; 44–45 tl Vitaliy Anikin, tr Vitaliy Anikin, b Vitaliy Anikin; 46–47 Eddie Smith; 48 t Production I.G., b Shi Kai Wang; 49 t Jaime Jones, b Shi Kai Wang; 50–51 Dorje Bellbrook; 52 all Isaac Hannaford; 53 t Isaac Hannaford, m Isaac Hannaford, b Bart Tiongson; 54–55 all Isaac Hannaford; 56 Shi Kai Wang, br Marco Nelor; 57 all Isaac Hannaford; 58–59 Bart Tiongson; 60–61 tl Shi Kai Wang, bl Shi Kai Wang, tr Isaac Hannaford, br Shi Kai Wang; 62–63 Shi Kai Wang, br Yuichiro Hayashi; 64 Nate Stefan; 65 t Isaac Hannaford, b Shi Kai Wang; 66–67 Isaac Hannaford; 68–69 Mark Goldsworthy; 70 all Eddie Smith; 71 t Eddie Smith, m Casio Entertainment, b Casio Entertainment; 72 all Glenn Israel; 73 t Glenn Israel, m Glenn Israel, b Steve Chon; 74–75 all Frank Capezzuto; 76 Eddie Smith; 77 t Isaac Hannaford, b Shi Kai Wang; 78–79 all Shi Kai Wang; 80 t Marco Nelor, b Isaac Hannaford; 81 t Eddie Smith, b Isaac Hannaford; 82 all Glenn Israel; 83 all Shi Kai Wang; 84–85 Frank Capezzuto; 86 t Shi Kai Wang, b Eddie Smith; 87 Shi Kai Wang; 88 t Isaac Hannaford, b Shi Kai Wang; 89 tl Travis Brady, ml Travis Brady, tr Studio 4°C, mr Shi Kai Wang, b Shi Kai Wang; 90 t Eddie Smith, b Isaac Hannaford; 91 all Isaac Hannaford; 92–93 Kenneth Scott; 94–95 t Isaac Hannaford, br Frank Capezzuto; 96 t Vitaliy Anikin; 97 t Vladimir Nenov, b Robt McLees; 98 tl Hirofumi Nakata, tr Robt McLees, bl Robt McLees, br Juan Ramirez, Jr.; 99 Juan Ramirez, Jr.; 100–101 tl Frank Capezzuto, tr Frank Capezzuto, b Isaac Hannaford; 102–103 all Shi Kai Wang; 104 tl Robt McLees, tr Juan Ramirez, Jr., b Juan Ramirez, Jr.; 105 Frank Capezzuto; 106 l Lee R. Wilson; 107 all Isaac Hannaford; 108–109 Matt Burke; 110 Eddie Smith; 111 Isaac Hannaford; 112–113 all Isaac Hannaford; 114 t Isaac Hannaford, b Blur; 115 all Isaac Hannaford; 116 t Tom Doyle, m Isaac Hannaford, b Isaac Hannaford; 117 all Isaac Hannaford; 118 l Eddie Smith, tr Isaac Hannaford, br Isaac Hannaford; 119 tl Isaac Hannaford, tr Isaac Hannaford, bl Robt McLees; 120–121 tl Shi Kai Wang, tr Isaac Hannaford, b Isaac Hannaford; 122–123 all Isaac Hannaford; 124 Isaac Hannaford; 125 t Isaac Hannaford, b Alex Chu; 126 Isaac Hannaford; 127 tl Isaac Hannaford, tr Isaac Hannaford, m Toshiyuki Kanno, b Dorje Bellbrook; 128 t Shi Kai Wang, m Isaac Hannaford, b Marcus Lehto; 129 t Isaac Hannaford, ml Production IG, mr Shi Kai Wang, bl Isaac Hannaford, br Production IG; 130–131 Mark Goldsworthy; 132–133 all Isaac Hannaford; 134 t Isaac Hannaford, m Marcus Lehto, b Frank Capezzuto; 135 all Frank Capezzuto; 136–137 Brad Rigney; 138–139 l Mathew Burke, tr Mathew Burke, mr Mathew Burke, br Nate Stefan; 140 Paul Russel; 141 t Lorraine McLees, b Isaac Hannaford; 142–143 Mark Goldsworthy; 144 t Eddie Smith, b Blur; 145 Eddie Smith; 146–147 Eddie Smith; 148 tl Eddie Smith, tr Marcus Lehto, bl Eddie Smith, br Shinji Aramaki; 149 tl Eddie Smith, tm Shi Kai Wang, r Marcus Lehto, bl Lorraine McLees; 150–151 Eddie Smith; 152 Lorraine McLees; 153 Casio Entertainment; 154–155 all Isaac Hannaford; 156–157 all Isaac Hannaford; 158–159 all Ashley Wood; 160–161 Dorje Bellbrook; 162–163 Mark Goldsworthy; 164–165 Jaime Jones; 166 t Jason Merck, ml Jason Merck, mr Jason Merck, b Marco Nelor; 167 t Marco Nelor, b Phil Wohr; 168–169 Mark Goldsworthy; 170 tl Phil Wohr, tr Bart Tiongson, mr Frank Capezzuto, b Phil Wohr; 171 t Jason Merck, m Glenn Israel b Marco Nelor; 172 Frank Capezzuto; 173 t Frank Capezzuto, b Alex Chu; 174 t Mark Goldsworthy, m Isaac Hannaford, b Isaac Hannaford; 175 t Isaac Hannaford, b Isaac Hannaford, r Ryan DeMita; 176–177 Mark Goldsworthy; 178–179 Steve Chon; 180–181 all Dorje Bellbrook; 182–183 all Isaac Hannaford; 184–185 all Isaac Hannaford; 186–187 Isaac Hannaford; 188 all Isaac Hannaford; 189 t Eddie Smith, m Paul Russel, b Mike Zak, br Isaac Hannaford; 190–191 Mark Goldsworthy; final endpaper Jaime Jones.

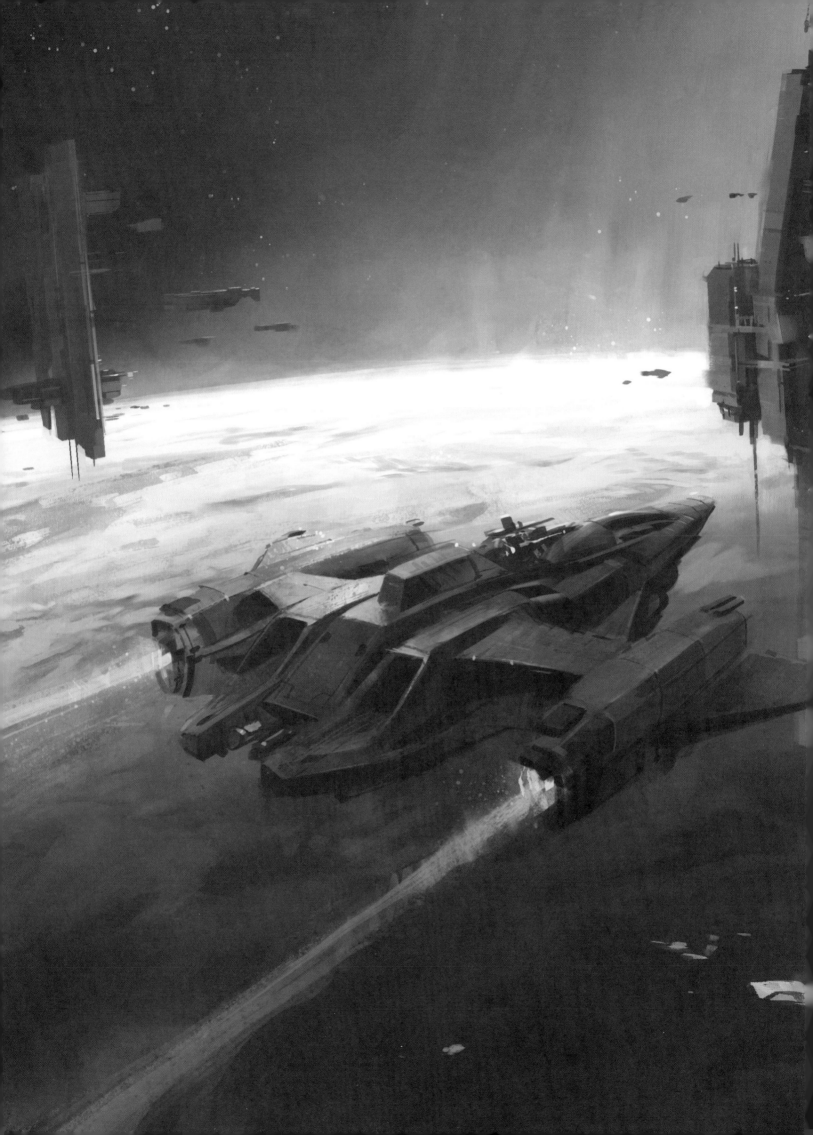